In contact with the gods?

In 1994, the Arts Council of Great Britain City of Drama celebrations in Manchester brought together the world's most innovative and reputable theatre directors to discuss what they do and why. Now, these interviews and talks are collected together in a vital sourcebook. The list of contributors is a roll-call of the directors who have helped shape the development of theatre in the last twenty years, including Peter Brook, Peter Stein, Jorge Lavelli, Augusto Boal, Lluís Pasqual, Lev Dodin, Maria Irene Fornes, Jonathan Miller, Jatinder Verma, Peter Sellars, Declan Donnellan and Nick Ormerod, Robert Lepage, Ariane Mnouchkine, Ion Caramitru, Yukio Ninagawa and Robert Wilson. The private world of the director in the rehearsal room has rarely been so frankly and entertainingly opened. In addition to the art and craft of directing, they discuss: multiculturalism; the 'classical' repertoire; theatre companies and institutions; working in a foreign language; opera; Shakespeare; new technologies; the art of acting; design; international festivals; politics and aesthetics; the audience; theatre and society.

An extraordinary epilogue by Peter Brook, Jonathan Miller and Oliver Sacks is a fitting finale to a book that should occupy a privileged place on the bookshelves of academics, students and theatre enthusiasts.

The interviews are illustrated with portraits and accompanied by an outline of the career of each director, including key productions and bibliographical data.

IN CONTACT
WITH THE GODS?

◆

Directors talk theatre

edited by Maria M. Delgado & Paul Heritage

MANCHESTER UNIVERSITY PRESS

Manchester & New York

distributed exclusively in the USA by St. Martin's Press

Published by Manchester University Press, Oxford Road, Manchester MI3 9NR, UK *and* Room 400, 175 Fifth Avenue, New York, NY 10010, USA

Distributed exclusively in the USA
by St. Martin's Press, Inc., 175 Fifth Avenue, New York, NY 10010, USA

British Library Cataloguing-in-Publication Data
A catalogue record is available from the British Library

Library of Congress Cataloguing-in-Publication Data applied for

ISBN 0 7190 4762 5 *hardback* 0 7190 4763 3 *paperback*

First published 1996

00 99 98 97 10 9 8 7 6 5 4 3 2

Printed in Great Britain by
Bell & Bain Limited, Glasgow

792.0233
Io

CONTENTS

✧

ACKNOWLEDGEMENTS

<div align="center">✧</div>

Our first debt of gratitude must be to the directors who agreed to the publication of the interviews and have waived all royalties so that the profits from the sale of this book can go towards the establishment of an annual public lecture on theatre in Manchester. They not only gave generously of their time to give the interviews in the first place, but also agreed to read and correct the manuscripts after they had been transcribed and edited. The busy schedules of all of these directors should have made such tasks impossible, but each of them has contributed in ways that we as editors could never have hoped for or imagined. The errors, of course, remain ours alone, but they have been considerably reduced by the attention and care which each of the directors has given to the publication of this book.

Special thanks must be given to Christopher Barron, Director of the City of Drama in 1994, who brought many of these directors to Manchester and thus provided the starting point for this enterprise. He gave us unlimited access to his exhaustive files (and precious filofax) and has continued a good friend to the project since leaving Manchester. Each of the public interviews was hosted at a theatre in Manchester and thus we depended on the services of the staff and technicians at the Green Room (in particular Bush Hartshorn) and the Royal Exchange Theatre (in particular Gregory Hersov, Ruth Nutter and Philip Lord) as well as Gregor Stewart at the City of Drama offices.

The two universities of Manchester have provided financial and practical support throughout the various stages of the recording, writing and editing of the book. We would particularly like to thank certain colleagues for their personal advice and support, including Colin Buckley, Stephen Kirby, Jeffrey Wainwright and Jacqui Roy (Manchester Metropolitan University), James Thompson at the TIPP Centre, Vivien Gardner, Anthony Jackson, David Mayer, Kenneth Richards, Karl Spencer and Claudette Williams (University of Manchester). Our students were both audience and inquisitors at all the public talks and kept Olympian fantasies within quotodian realities.

Félix del Cid and Olga Celda transcribed the interviews by Pasqual and Lavelli, but their personal contributions were inscribed in more personal ways throughout the editing of the book. David Price played a key role in

transcribing the majority of the interviews, in which he was assisted by Emma Reed (who also provided administrative support for the City of Drama Conversation series). Jacqui Burford and David Price were assiduous, independent and resourceful research assistants at important stages in the final realisation of the book.

We are grateful to all those who sponsored the original talks: Goethe Institute Manchester (Richard Schneider), Instituto Cervantes Manchester (Antonio Gil de Carrasco), Délégation Culturelle Française (Claude Petit-Pas), Manchester University Press, Routledge, Methuen, the *Guardian*, Manchester Metropolitan University and the University of Manchester. The British Academy funded a visit to Paris during which the Lavelli interview and a preliminary interview with Mnouchkine were carried out, and research was undertaken on all the Paris-based directors.

The research and negotiations were assisted by the generous services of the administrators, agents and personal assistants associated with each of the directors, including: Nina Soufy at the Centre International de Creations Théâtrales (CICT); Jeremy Conway at Conway, van Gelder, Robinson Ltd; Barbara Matthews at Cheek by Jowl; Florence Cadin and Florence Thomas at the Théâtre National de la Colline; Philippe Soldevila at Ex Machina; Francine Bock at Robert Lepage Inc.; Cordelia Dyer, Jessica Ford and Emily Barber at IMG Artists; Mara Negrón at Théâtre du Soleil; Misa Hayashi and Tadao Nakane at Point Tokyo; Stephen Wood at the Royal National Theatre; Kevin Higa at the Los Angeles Festival; Vera Neuroth at the Salzburg Festival; Eli Malka, Director of the Union of Theatres of Europe; Giovanni Soresi at the Piccolo Teatro, Milan; Geoffrey Wexler at the Byrd Hoffman Foundation; and Steven Bradley Beer at RW Work Ltd.

Maribel San Gines of the Odéon Théâtre de l'Europe was constantly there to help us in any crisis and solve any problem, and deserves our special gratitude.

The interviewers are each credited at the end of the book but their special place in the creation of the book must be acknowledged as it is they who helped shape and inform the interviews. They allowed themselves to be briefed for the specific requirements of each event and generously gave of their time. The book would also not take this form without the generosity of the photographers who provided so freely of their services.

Our research and preparation owes many debts and these are just a few: Ella Wildridge of the Traverse Theatre, Edinburgh; Guillem-Jordi Graells at the Teatre Lliure, Barcelona; Donna Peters of the *Guardian*; Henry Little; John London; Mercè Saumell; and Judith Hibberd at Waterman's Arts Centre. Dr Alex Unger offered pertinent comments on the transcripts of the Brook/Miller/Sacks and Miller conversations. Talia Rodgers at Routledge and Michael Earley at Methuen were friends and guides whenever they were needed, proving themselves, as ever, above the commercial rivalries of publishing.

Anita Roy, our commissioning editor at Manchester University Press, is the hidden hand and unheard voice behind the manuscript and without her this enterprise would not have been commissioned and completed.

FOREWORD

◆

T HEATRE is frequently seen as a mysterious activity. The ideas, feelings and approaches of those involved in creating theatre aren't articulated or communicated to those interested, drawn to the theatre. As we come to the end of this century, the very future of theatre seems inextricably bound up with the basic fundamental health of our societies as communal, imaginative and generous entities. Theatre is a place where people meet, see, hear, explore themselves and each other. A place where you feel less alone. Talking about theatre is a pressing, urgent need. This book is timely, welcome and inspiring.

This book has grown and broadened from its beginnings. As part of the City of Drama celebrations held in Manchester, England, a series of live conversations was organised with international artists whose work was seen as part of the celebrations. Here at the Royal Exchange Theatre, as well as other theatre venues all over the city, people came to hear and question some of the principal creative people involved in theatre over the last thirty years. The conversations were relaxed in atmosphere and lively in content, an opportunity for us in England to gain an international perspective. For all those interested in contemporary theatre who were not present, this volume collects and records these conversations with the foremost theatre directors working today.

The director is largely a twentieth-century phenomenon. Some would say regrettably so. However, it is true that the initiation and realisation of most exciting theatre has this figure at the centre. The directors in this book are the best equipped to explore the most important issues facing the theatre today. Conceptual: theatre in an audio-visual age, theatre in the computer age, theatre in the information age. Practical: where should theatre take place, what kind of groups, people, companies, can create theatre? How should

they work together, think, rehearse, prepare the work? Content: textual versus non-textual work, 'modernising', classical plays, how to create new and original work. Purpose: spiritual, religious, political, interventionist, provocation, disturbance, healing and reconciliation. All these large questions are examined, as well as a wealth of actual concrete observation on writers, actors, designers, history. For anyone interested, involved, or finding out about theatre, this book is indispensable.

However, for me, the great pleasure and fascination of reading these conversations lies in the personal tone of each of the contributors – one really gets a sense of each individual's imagination, their seriousness, wit and joy in what they do. They show that theatre is both an intensely dedicated profession, but also a galvanising, sensual and exciting way of existence. At its best, theatre is one of the ways human beings can grow in themselves, connect vividly with others and collectively with an audience, speculate, explore, and find a better way to live. The people in this book embody that aspiration.

Enjoy.

Gregory Hersov

Artistic Director,
Royal Exchange Theatre, Manchester

INTRODUCTION

---❖---

I think theatre has a lot to do with putting the audience in contact with the gods, whatever that means. That's where theatre comes from.

 (Robert Lepage, p. 143)

THE THEATRE director is both the most visible and invisible of artists. Only recently considered as a separate and distinct artistic role, the director has moved into a pre-eminent, though often disputed, position in contemporary theatre. In Britain, as in many other countries, audiences will now be drawn to the theatre as much for the person who directs a play as for the story, the author who wrote it or the actors who perform it. Despite this magnetic attraction, and the supposedly dominant position that the director now occupies, it is still a strangely undefined and shifting role with a range of responsibilities that require someone who is artist, philosopher, actor, pedagogue, procurer, coach, linguist, midwife, technician and administrator. Throughout the book the reader will discover that contributors describe directing as cooking, shopping, deciphering, conducting, cultivating bacteria, giving birth and tossing salads. The director, it seems, requires a chameleon quality of self-transformation; Peter Stein describes his ability as being the gift of the apes as he can act fantastically but for only one and a half minutes, whilst Lluís Pasqual thinks he might be a good actor for a day or two. This multifaceted role is fulfilled by each of them in very different ways. It is also, quite clearly, never achieved alone and this is reflected in each of the interviews in different ways. The most obvious example of collaborative working methods is Declan Donnellan and Nick Ormerod, but Lluís Pasqual shows that Fabià Puigserver was no less central to his work. Others discuss their creative relationships with actors, musicians, writers, choreogra-

phers and assistant directors in an attempt to reveal the collaborations that are at the heart of all significant directing enterprises. Some of these directors have been associated with one theatre for the majority of their working lives, and Ariane Mnouchkine, Giorgio Strehler and Lev Dodin in particular talk about the nature of the relationship each of them has with the 'fraternity' of their own companies.

For all their high visibility during the rehearsal process and the focus of attention that they receive, nothing is seen of the directors once the play is being performed – except in rare instances. All that remains of their work is in reflected shadows on the stage. Although their work is based on communication, their words and actions remain inside the rehearsal room. This book is a small attempt to bring some of their words and insights on theatre into a more public arena, an opportunity to enjoy the traditionally private world of the director. It grants access to a world that is normally reserved for a small group of actors. In *Theatre and Everyday Life* Alan Reid complains that, 'writing offends the corporeality of theatre by its limited range of representational forms' and that 'writing up has been removed from its proximity to the practices of theatre . . . to academies and journalism' (p. 13). These interviews are certainly no substitute for the 'corporeality' of the theatre they describe, but they do attempt in a small way to write a dialogue about theatre that is neither academic nor journalistic. By listening to these directors talk freely about their different approaches to the art of making theatre, the reader has the opportunity to make comparisons and encounter unimagined similarities from diverse methodologies. The conflicts remain, and the book offers no harmonising view of the role or perspective of the director in the late twentieth century, but each of them reflects on the ephemeral and multidimensional nature of the occupation, and also passes comment on each other's work in surprising and often contradictory ways. It is possible to read the book following themes or ideas between the interviews, as well as reflecting on the individual narratives of each director.

A number of books have been published in recent years that locate modern directors within the social and theatrical histories of their countries. Books on the French, German or American director seem logical and proper. This book offers something rather different. The inclusion of directors from so many different nations/societies gives the reader the opportunity to investigate the culturally specific function of the director as each of these artists have defined their role in relation to the theatrical and social situation around them. This is most clearly apparent in the discussion by Caramitru of his approaches to text and theatrical activity during Communist

rule in Romania, but it emerges in Strehler talking about the Piccolo Teatro, Stein's discussion of the Schaubühne, Ninagawa's response to the TV-saturated youth culture of Japan, Lavelli and Mnouchkine recalling the impact of the events of Paris 1968, Pasqual's insights into the theatre of Spain under Franco, Boal's reinventions of political theatre, or Sellars and Verma talking about inter-racial casting.

The international scope of the book also recognises the working conditions and concerns of most of these directors. Internationalism is both form and content in their lives. Most of them work in a country that is not their native land for at least part of the year; many of them are temporarily or permanently resident in another country. All of them direct plays from other cultures and have experienced watching their productions tour abroad. These experiences form an undercurrent to all the interviews, and emerge in some of the strongest debates. The city of Paris inevitably emerges as a key location in the development of the work of many of these directors: Brook, Lavelli, Pasqual, Mnouchkine and Boal each have theatres in the city, although four of them are not French by birth. But the location or dislocation of each director from their native land is a part of the understanding of their work. This seems particularly pertinent in Europe in the mid-1990s, and Strehler gives his attention to the way in which theatre can participate in the current European debates. As national boundaries are both contested and reinforced, it is vital that cultural boundaries maintain their fluidity while respect is still given to the richness of cultural differences. Each director in a distinct way discusses the issues that emerge around multiculturalism and the international terrain of the contemporary stage. In the simplest way this is expressed by a director like Robert Wilson, who acknowledges the scope of international influences on his work and expresses his gratitude for the 'conglomeration' of different influences he has borrowed from a variety of cultures.

However, as various other directors acknowledge, this rich cultural nourishment is not without its negative impact, with the risk of cultural tourism or even the neo-colonialism that is perceived by some critics in the internationalisation of contemporary theatre. Peter Brook's work at the Centre International de Creations Théâtrales (CICT) in Paris, bringing together performers from around the world, has been at the centre of such debates for the last decade. In his interview he acknowledges the dangers of the globalisation of culture and denies that the borrowing of stories or performance styles from other cultures is in any way an attempt to imitate the form of another country's performance practice. Brook

compares his own work in Paris with the strength of the artist who has never left his village and is creating specifically from the experiences of his own world. Perhaps Wilson is acknowledging the same when he observes that despite all his travels and international work, the landscape of his native Texas is still present in all his work. Pasqual, who seems central to any discussion of internationalism as the artistic director of the Théâtre de l'Europe, claims that there is actually no such thing as international theatre and finds himself feeling at his most Spanish when he is working in France. As the directors describe their work there are surprising resemblances despite the differences of practice and the various situations from which these practices emerge.

A clear thread that connects all the interviews is the importance each director places on the selection of a repertoire, which is determined by each of them according to different criteria – or perhaps by a different balancing of aesthetic, political and individual needs as described in detail by Lavelli. The reasons why and how a director chooses a play are subject to diverse forces, but it is interesting to note that Stein describes it as the director's most powerful moment. Strehler's career covers a broad repertoire of playwrights and texts, but it is noticeable how he returns time and again to plays that he has already directed, a feature which is taken up by Pasqual. Remarkably, despite the differences between the directors, there is a discernible core to a shared repertoire that is centred around certain 'classics' of European and North American theatre, even if Boal was concerned with nationalising them for the Brazilian stage. Some of the directors attempt to define what for them is important in those works that attract them. Mnouchkine in particular makes an important distinction between the classical texts of the Greeks and a playwright like Molière. There is hardly a contributor in the book whose work has not in some way been defined or tested against the established and canonical texts, and the book could be read as much for its illuminations about certain authors as it could about directing. Above all is the dominance of Shakespeare as the playwright to whom almost all of these directors have referred in their own practice, and these interviews give a chance to learn from both the detailed observation of certain moments of Shakespeare's plays and the overview that some of the directors give as they try to express what has drawn them, in their different countries, to this playwright from the English Renaissance.

Pasqual emphasises how Shakespeare offers a particular training for actors that enables them to be able to perform anything, and claims that for him Shakespeare is the basis for all theatre, as he similarly emerges for most of the directors in the book. Writing about

Shakespeare in translation in the *Guardian* in 1991, Michael Billington commented that 'foreign Shakespeare is both necessary and instructive' ('From the Stage of the Globe', p. 21). The reasons and means these directors have for approaching Shakespeare's texts offer an invigorating way to reappraise the plays. Brook's interview with Billington for this book describes how working in a foreign language means that you have to put yourself much more alertly in front of each word. The opportunity to see foreign Shakespeare, or to listen to directors from around the world talking about their approaches to the plays, is indeed to put ourselves 'more alertly' in front of the text. When Peter Stein insists that each director should prepare their own translation of Shakespeare's plays, he is reminding even the modern British actor that the words Shakespeare wrote four hundred years ago have been in a constant state of transition ever since and that we can never be certain of their fixed or determined meaning, a point echoed by both Sellars and Pasqual. Working in another language than his own, the director loses 50 per cent of his possibilities according to Stein, who emphasises that if you are working outside of your own language you must be convinced that you can give something else to the actors. Pasqual talks about the wonders of working with foreign actors, offering an analysis of the characteristics of different 'nationally' trained actors. In working with actors from all over Europe on some Greek plays, Donnellan and Ormerod acknowledge that they will not understand any of the words themselves, only the noise they make. Billington perhaps was thinking of something similar when he wrote 'there is gain as well as loss in freeing Shakespeare from the rigorous explicitness of the English tongue. There is a mythical quality in his work which transcends language and may even be liberated by a foreign perspective' (Billington, 'From the Stage of the Globe', p. 21).

These 'foreign perspectives' are in abundance in the interviews contained in this book, from Peter Sellars's detailed discussion of the time of night in Act Five of *The Merchant of Venice* to the censor's attempts to ban Ion Caramitru's *Hamlet* in Romania. Sellars shows that the fact that a Shakespeare play may ostensibly be in the same idiom for him as an English-speaking American, does not mean that he feels bound to a theatrical language that the play may have acquired throughout four centuries. Despite the apparent journalistic readings that he often makes of classic texts, Sellars explains that one of the profound reasons why these texts occupy such a crucial place on the contemporary stage is because we need at times not to be so literal about the world. The application of poetry to situations that can be both quotidian and mythic, ensures that these

plays operate for Sellars, and for so many of the other directors, in ways that the author could never have conceived. In different ways, each of the directors finds a new dialogue with Shakespeare's plays. As Sellars comments, theatre is not a monologue and the text itself must never be allowed to just speak for itself because a production is a discussion between ourselves and this play. Robert Lepage explains that he never really does 'Shakespeare'; in translating the plays into French they emerge rewritten. His statement that he never has the impression that he is doing other people's work implies a blurring of the original that contrasts with Stein who insists on drawing attention to the distance between the original text and the time in which it is now being performed. In performance that distance, or that 'discussion' as Sellars calls it, is difficult to erase completely but some directors make it a more active part of their work.

Jatinder Verma describes how that discussion is made alive for our present realities. Both he and Mnouchkine discuss the relationship they have sought with *Tartuffe*, a text that has a special significance for societies that are once again beset by worries about religious fanaticism. But the difference, as well as the resonance, between the original text and the new perspective is at the heart of any theatre dialogue for Verma, because dialogue does not come through agreement. Both Verma and Brook look to their group of actors to find what nourishes the work, and are concerned to recognise and use the cultural differences within their casts. Verma talks of how this is a matter of going beyond the colour issue that is so limited in the British cultural debate, to deal with the underlying imagery and concealed memories that might come as a result of difference and which can become a new layer of text.

Throughout the interviews, commentaries emerge that give further insight into why Shakespeare in particular should retain a fascination for directors from countries with such different political and social realities. Clearly the performance value of his work is mediated by various factors, not least the colonising effect of English language and culture. At times this cultural potency can be used to dynamic effect to protect radical work, as in the stories Caramitru tells of the productions in Romania. Other directors seek to explain the power of the plays by looking to some notion of 'universal' values in Shakespeare's work. Peter Brook describes in simple terms the wealth and depth of the human material available in over five thousand characters, each individually defined. Sellars believes it is important that we should test our own lives against the greatest wisdom that we are inheriting and thus justifies the work he does on the classical repertoire. For Lev Dodin, the real question is how to get to the core of this value of the classic play: how to penetrate

what he describes as the perfect world of the text. 'When we deal with masterpieces, if they are perfect, they are closed. To hear the music of that play relevant to your own self, and your own self relevant to the time, makes something that happens to you adequate to that masterpiece' (p. 76).

Perhaps one of the most useful and practical commentaries is offered by Peter Stein, who draws attention to the differing hierarchies of classic texts and the consequent difference in the way in which directors are able to work with the text and the actors. He observes that the hierarchical structure of the theatrical and social organisation of the age is reflected in the way in which the play is written and constructed. According to Stein, the stage is a kind of family life and as director his role in that family changes according to the nature of the play. Thus he perceives that when directing Chekhov, the director is like an elder brother in the family, whereas this is more difficult in Shakespeare because the hierarchical organisation of the characters is parallel to the social hierarchy of Shakespeare's age. Stein believes that the most crimes are committed by directors when working with Shakespeare because they feel challenged by the strange authoritarian structure of his plays and they in turn become kings and dictators. Certainly this may help to explain the continuing fascination of Shakespeare for modern directors eager to prove their value (and power) in the contemporary theatrical market. It is hardly surprising that texts which emerged from the fiercely competitive Elizabethan theatre industry should attract directors today. The potent mix of nascent capitalism and monarchical government that characterised the time in which Shakespeare's plays were first performed certainly finds echoes in many of the societies that are performing them today. Such echoes are precisely those which Stein, and many other directors in the book, have sought to achieve in their productions.

The majority of the directors that are included in this selection work with varying regularity in opera. The comparisons they make between the operatic and theatrical worlds help to define their roles more clearly. Apart from Wilson, who sees all his work as being part of one artistic whole, most of the directors mark clear differences and divergences in the function of the director on the operatic and non-operatic stage. Stein acknowledges that his position is perhaps in fourth place (behind the music, the conductor, and the set designer), which does not reflect the normal hierarchies of theatre. He describes the director's role in opera as being entirely devoted to improving the audience's capacity to hear the music better. Pasqual reflects that opera is an irrational passion for him, because although he loves it, the directing of opera is becoming less and less pleasur-

able. His dissatisfaction comes from the character of the opera audience and the musical unreality that the compact disc has brought to the live performance, which in turn influences the production and the expectations. Lavelli and Donnellan point to similar features within the structure of modern opera houses that work against directors achieving their goals. Opera houses are still marked by what Lavelli calls 'a conservative stagnation' and Donnellan describes as a collective fear. However, the 'deviant' aesthetics (Pasqual) of the operatic stage continue to attract and fascinate these directors as a particular place where the craft of *mise en scène* can be practised and re-defined.

It has become commonplace for critics to complain that we are now invited to the theatre to watch Brook's *Tempest*, Stein's *Oresteia* or Mnouchkine's *Tartuffe*, although the appellation acknowledges the artistic dialogue that characterises the modern stage. Playwrights have been complaining about the effect on their work of the rise of the director throughout the twentieth century. Most recently Edward Bond called for one of the three theatres at the Royal National Theatre in London to be handed over to a group of playwrights ('Bard of Prey', p. 13), because the way in which directors establish their reputations through the classic texts diminishes the voice of new writing in theatre. Arnold Wesker took the opportunity of using the first Raymond Williams Memorial Lecture to launch an unrestrained polemic against the licence of the director to 'distort a writer's intentions', a condition he describes as 'the Führer complex':

It is a madness which has elevated the role of the director above the role of the writer. The stage has become shrill with the sounds of the director's vanity; it has become cluttered with his tricks and his visual effects. No play is safe from his often hysterical manipulations. (Wesker, 'Interpretation: to Impose or Explain', p. 63)

There are few directors who have successfully dedicated their career to working with contemporary playwrights, and even less who have succeeded internationally as a result. The 'classic' texts have become a part of the dialogue as well as the market of theatre across nations. Robert Wilson is perhaps the most obvious exception of a director whose career was founded on original work and not the established repertoire. Other directors in the book have engaged in a variety of ways with living writers, a process which is most engagingly described from the point of view of the writer/director Maria Irene Fornes and the director/writer Declan Donnellan.

Fornes quotes a story by Lanford Wilson in her interview to show that the power relationship between author and director requires a

certain submission by the playwright. By including Fornes in the book, we are able to see the different perspectives on writing and directing united in the one vision. She is able to give insights into the position of the writer sitting at the side of the rehearsal room and trying to maintain a creative relationship with her play. Her story shows the dialogue she seeks with directors through her writing of text, and also the way she herself directs actors in her own work or the plays of others. The example that Declan Donnellan gives from his working relationship with Tony Kushner during *Angels in America*, is strangely similar to the opening story that Fornes tells of the first rehearsal she attended. However, one version is from the director's perspective and the other from the playwright's. Each gives further insight to the difficult question of who is responsible for the dramatic moment on stage and how that is negotiated around the actor.

The debate about the predominance of the director over the playwright, and thus the dramatic text, raises the issue of interpretation that ranges freely throughout the interviews. It is brought most sharply into focus by Jonathan Miller, who acknowledges the irony of his position as former cultural 'hooligan' turned defender of the classics. He bravely attempts to define boundaries in an area that is fraught with ineffective interventions. Miller denies any notion of an official or canonical production because it is in the nature of reproductive art that it should undergo successive transformations and renewals. Yet at the same time he argues against total ambiguity or freedom. His complaint is raised against productions that make the text an occasion for 'high jinks' – merely quoting the text rather than performing it. Interestingly, when he is talking about identifying the intentions of the author, Miller is surprisingly close to Sellars, who is often accused of having no responsibility to the 'original' text. Both Sellars and Miller dismiss the idea that it is ever possible to determine the original intention of the author within the text. Neither resolve the question but Miller in particular attempts to define the parameters of the debate.

In all the serious attention that is given to the director in the interviews, there is also recognition of the ephemeral nature of the job, what Miller self-disparagingly describes as being paid to listen to Mozart. In another sense there are directors who are keen to acknowledge the notion of 'theatre as diversion' in their work. Lepage describes how he seeks a sportive and active phenomenon on stage, inventing a game rather than a script. This is what he claims that the audience secretly desires because going to theatre is like going to see sport. But it is also clear that each of the directors interviewed evokes a power for the theatre that goes beyond its

capacity to divert and entertain. Fornes may be fascinated by the 'delicious' trickery of theatre and, like Verma, be unable to resist the spirit of playfulness that is endemic to the nature of performance, but theatre remains both a provocative and humanising force for all of the directors in the book.

Peter Brook starts by asking 'Why do anything on stage?'. It is a question that is answered in diverse ways throughout the interviews. For Miller, theatre shows what it is like to be us; for Caramitru, it offers both a place of worship and a forefront for political resistance; for Wilson, theatre is a necessity in society because it is a place where people come together to have an exchange of ideas and feelings; for Sellars, it is a room in which to ask if anyone out there has thought about these issues and to present 'alternative information systems'. But, as Sellars points out, it is not the information itself that is important but how you process it. Stein shows us a theatre that is always based on contradictions and fights, while Boal opens the theatrical process to discover that 'even if we do not make theatre, we are theatre. To be theatre is to be human, because only humans are capable of observing themselves in action' (p. 35). Lepage gives us the title for the book by extravagantly claiming that theatre puts the audience in touch with the gods, and Donnellan finds in the naked relationship with an audience, something potentially divine. Verma also imagines theatre, with its unique knowledge, as a contact with the gods, but he powerfully asserts the responsibility of all performers to challenge and provoke those gods because all theatrical encounters are based on conflict.

The demand for a theatre with a social responsibility is just one of the constant themes running throughout the book. David Whitton, in *Stage Directors in Modern France,* identifies one of the important shifts in contemporary drama away from 'theatre conceived primarily as an aesthetic manifestation towards a socially-motivated conception of theatre's role' (p. viii). That can be tested against each of the directors in the book, but Boal sets the boundaries of this debate very wide indeed, which perhaps enables us to see that the shift in more conventional theatre practice has not been so very great. Certainly all the directors talk in some way about the relationship between life and the stage as much as they do about the relationship between the text and the stage, but Boal, and also to a certain extent Caramitru, make the definition of this work more demanding. Pasqual, like others in the book, seeks to define the 'use' of theatre as being relative and situated in particular social moments but rooted in a common act of self-recognition. Perhaps what we are able to notice through these talks and interviews is that there are no shifts in position and the modern director has not

vacated one role to occupy another. Rather these different roles and responsibilities of the director are part of a continuum of the definition.

Whitton also argues that the emergence of the director has changed the basic relationship of theatre – it is no longer possible to speak of the actor/spectator dialogue or of what he calls the tripartite system of communication: author – actor – spectator. He makes the assumption that in today's theatre practice it is the director who 'interprets' the play. Jonathan Miller engages with precisely this issue of interpretation in his robust interrogation of modern deconstructionist directors. However, many of the directors avoid the paradigm that is suggested by Whitton and see themselves as re-working the actor/spectator dialogue in ways that do not place the director's interpretation of the text at the interface of the relationship. In diverse ways this is as true of Peter Brook as it is of Augusto Boal. The actor/spectator relationship occupies a special place for all of these directors and they return time and again to the immediacy of that relationship. For Brook the relationship is exemplified by a story about the difference between audiences in Tokyo and Los Angeles, while Verma describes how the experience of being part of a touring company without a permanent base informs and invigorates his work, ensuring that theatre 'be living in that dangerous moment of the unexpected' (p. 288).

Contemporary directors are both more and less than the sum of their parts. The director is more than a mere arranger of the scenic elements and yet is, according to Peter Stein, an impotent figure by the time the performance arrives. Stein's warning to all directors that their very existence is a sign of the weakness and decline of the modern stage is a powerful admonishment. Donnellan too describes the position of director as one that should not have to exist but is a necessary evil. Once again we are faced with the enigma of the visibility and invisibility of the role. Perhaps one measure of their impact and effectiveness is the directors' ability to efface themselves at the moment of performance and their ability to empower the other artists with whom they work. All of these directors have emerged as important in contemporary theatre because of the mark they have made on theatrical production, but not necessarily by means of their own distinctive interpretative vision of the text. It is in liberating the actor to achieve the closest possible relationship with the audience that many of them would see the defining principle of their work. Declan Donnellan and Nick Ormerod exemplify this methodology, and named their company Cheek by Jowl as a sign of the close proximity they seek between actor and audience, actor and text, or indeed actor and life. The model of the director

as an intervention in this process is neither accurate nor sufficient to describe the work of many of the directors in this book.

One of the central points of conflict in any theatrical encounter is that between image and reality. The concern with the accuracy of the copy has dominated theatrical discussion throughout the ages. Hamlet, perhaps the first recorded director of a Shakespeare text, carefully instructs the players in executing their craft and makes central the issue of the imitation of nature. In different ways this is taken up by each of the directors, but it receives the most detailed discussion in the epilogue. Imitation and intention are crucial in any discussion of interpretation for the art of the director and the actor. By locating their debate within the framework of neurological science, Brook, Sacks and Miller close the book by emphasising that theatre can never be discussed except in relation to the social, political, scientific, moral, cultural worlds around it. Each director in their way makes extraordinary links between the theatre and the world, showing in the way they think and talk the same imaginative leaps they make in the rehearsal room.

The majority of the interviews and talks were given as part of the City of Drama celebrations in Manchester in 1994. Some of the directors had expressed a desire to visit during the year but were unable to attend because of other commitments. We are delighted to be able to include their interviews in the book. Part of the purpose of the City of Drama in Manchester, and thus the series of interviews and this book, was to open British theatre, and the public that is interested, to the wider currents of world theatre that do not always reach these shores. The selection of directors is neither entirely random or wholly prescribed. Some directors were invited because of our own personal interests in theatre and because there was little available about them in English despite their international reputation. Many were visiting Manchester in association with productions that were seen in the city during the year. Although the reader is unfortunately unable to see these now, we hope that the descriptions of scenes and productions that the directors provide will in themselves be interesting. Because of the way in which these directors discuss their work, the book opens its covers to far more participants than those listed in the contents. Many directors, designers, actors, playwrights are called into the arena of this book by the words of our contributors. It is a magnificent and truly international cast. We are delighted that the contribution of the Manchester audiences can be heard exploring and questioning all these issues with the directors in a public forum.

With the exception of the interview with Strehler, the texts that

are presented here started as oral and not written language. The transition from one form to the other involves many changes. In the process of editing the interviews we have tried to maintain as much of the feel of the original public conversation while making the book functional and readable. Many of the contributors were not speaking in their first language or were talking through a translator. We have deliberately not obliterated all traces of this in the edited versions of the interviews as we wanted to retain the individual flavours of this rich and, we hope, rewarding feast.

Maria M. Delgado
Paul Heritage

September 1995

WORKS CITED

Billington, Michael. 'From the Stage of the Globe'. *Guardian,* 18 April 1991, p. 21.
Bond, Edward. 'Bard of Prey'. *Guardian,* G2, 28 June 1995, p. 13.
Reid, Alan. *Theatre and Everyday Life.* London and New York: Routledge, 1993.
Wesker, Arnold. 'Interpretation: to Impose or Explain'. *Performing Arts Journal,* 2, No. 2, 1984, pp. 62–76.
Whitton, David. *Stage Directors in Modern France.* Manchester: Manchester University Press, 1987.

AUGUSTO BOAL

❖

IN A CAREER spanning almost forty years, Augusto Boal has, according to Richard Schechner, 'created the theatre that Brecht only dreamed of'. As teacher, theorist, director, playwright and theatrical innovator, he has continued to explore, both on and off the stage, the multiple and complex operations of humans as actors and as social beings.

Born in Rio de Janeiro on 16 March 1931, Boal arrived at São Paulo's Teatro de Arena (Theatre in the Round) in 1957, having recently returned from the United States where he had studied courses on dramaturgy and directing under John Gassner, Milton Smith and Ernest Brenner (although he had gone to North America to study Chemical Engineering at Columbia University). His first production, for the young Arena company, was an adaptation of John Steinbeck's *Of Mice and Men (Ratos e Homens)* (1957) which demonstrated not only Boal's desire to wrestle with the demands of psychological realism, but made use of something he called 'selective realism' where essential details evoke a greater social panorama. Everything was justified according to the psychology and sociology of human inter-relations and sought a simplicity that indicated the richness, and not the poverty, of theatre.

Since its inauguration in 1953, the Teatro de Arena was distinguished by its refusal to privilege the aesthetic. Without ignoring the particular artistic demands of theatre in the round (which easily dispenses with elaborate scenery), Teatro de Arena, and subsequently Boal, sought to engage and integrate aesthetics with social issues. As a director, Boal rejected the star system of the era, and the *italianismo* of the leading companies which sought a correct and beautiful enunciation of phrases on tasteful, detailed and luxurious stages. In contrast, the political and thus artistic project of Arena was, as Boal himself described it in 1957, to make art as an instrument in the fight for national liberation. This 150-seat theatre in the centre of São Paulo, with its stage of 4.5 by 5 metres, provided Boal with his first opportunities in theatrical experimentation. The redefining of the audience/stage relationship through performances in the round became more than the determining design feature of this tiny theatre – it was to prove the ideological and artistic agenda of Boal's theatrical and political career.

In 1957 Boal directed Sean O'Casey's *Juno e o Pavão (Juno and the Paycock)* for Teatro de Arena and his programme notes demonstrated

clearly the links he sought to make between the stage and polit-ical/social movements, as he described his attempt to create the quotidian reality and the ideological implications of the play. The success of his first productions for Arena, and the debates that they opened in the company and beyond, led to the initiation of the *Seminário de Dramaturgia* on 10 April 1958 under the general co-ordination of Boal. This weekly series of workshops and seminars lasted nearly two years and united those destined to play a significant role in the development of Brazilian dramaturgy over the next thirty years, including Gianfrancesco Guarnieri, Oduvaldo Vianna Filho, Chico de Assis, Milton Gonçalves, Sábato Magaldi, Roberto Santos, Jorge Andrade and Beatriz Segall. This in turn led to the creation of an acting laboratory, indicating Boal's early interest in the practical study and exploration of new ways of working in the theatre, and demonstrating that the last decade of international workshops and lectures have their roots in the very beginning of his career.

During the presidential elections of 1960, Boal wrote the polem-ical farce *Revolução na América do Sul (Revolution in South America)* which was greeted with enthusiasm by critics as a total and neces-sary revision of Brazilian theatre. Although the play is credited as being responsible for the initiation of Brecht's influence on Brazilian theatre, Boal made it clear in the programme notes that his theatre was open to a wide range of influences and effects.

The desire to create a functional art, which is central to the pro-jects that Boal is evolving today, was just as basic to the work he created with Teatro de Arena. During the early years of the sixties Boal initiated a phase known as 'the nationalisation of the classics' in which he sought to bring Brazilian gestures, idioms and corporal-ity to the stage, concentrating on the human and social relations that were shared by the text and contemporary Brazilian society. He created some notable productions of European and North American classics which enjoyed immense popular and critical success, but at the same time did not reject the development of national authors and plays dealing with the immediate realities of Brazilian life. After the 1964 coup, which initiated over twenty years of military dictatorship in Brazil, the function of theatre and culture for radical intellectuals and activists became even more focused towards direct and indirect protest. Two significant musical plays, directed by Boal and written in collaboration with Gianfrancesco Guarnieri, brought all the political and aesthetic lessons of the previous years to the stage in *Arena Conta Zumbi* (*Arena Tells the Story of Zumbi*) (1965-7) and *Arena Conta Tiradentes* (*Arena Tells the Story of Tiradentes*) (1967). These texts, mixing the legends, myths and histories of national popular heroes, were collectively

created in a fusion of Brechtian and Brazilian performance traditions, and characterised by the distinctive manichean narrative of oppressed and oppressor. The actors did not own or play fixed characters, as roles were passed between them according to the demands of the scene, an ideologically and aesthetically inspired practice of dramaturgy and presentation that Boal referred to as the *sistema coringa* (the 'Joker' system), later elaborated in his book *Teatro do Oprimido* (*Theatre of the Oppressed*) (1974).

Boal's work as a director was not confined to Teatro de Arena. Before the dictatorship he worked with Teatro Oficina and with the Centros Populares de Cultura (Centres of Popular Culture). Although the CPCs were disbanded by the dictatorship, a group called Opinião (Opinion) continued their brand of political cabaret, and Boal directed their work in Rio de Janeiro as well as encouraging Arena to stage the first *Feira de Opinião* (Opinion Fair) during 1968 in São Paulo, mixing short plays with popular music performances. During his career Boal has worked with some of the leading Brazilian popular musicians of the last thirty years, including Chico Buarque, Edu Lobo, Nara Leão, Dorival Caymmi Filho, Gilberto Gil, Maria Bethânia and Caetano Veloso.

Following the infamous AI-5 legislation of December 1968, which initiated a period of imprisonment, torture, assassination, exile and silence for many political activists and artists, Boal developed the first stages of what later came to be known as the Theatre of the Oppressed. Involving the audience in the creation of the spectacle, through games and exercises to re-sensitise the participants, Boal created a version of the American 'living newspaper' called '*o teatro-jornal*' (theatrical newspaper). Five editions were created by Boal, and through these performances dozens of new groups emerged to produce similar plays using Boal's techniques. After his arrest, torture and exile from Brazil in 1971 he travelled to Argentina where he was resident until 1976, working in various Latin American countries, developing amongst other things his techniques for 'Invisible Theatre'. From 1976 to 1986 he was resident in Europe, first in Portugal and then in France, establishing a Centre for the Theatre of the Oppressed (CTO-Paris). During this period away from Brazil, through a series of workshops and publications, he developed and systematised the theories and practice of the Theatre of the Oppressed – the means by which 'spect-actors' learn to transform both theatrical and social reality. His return to Brazil in 1986 led eventually to the establishment of a second CTO in Rio de Janeiro, where Boal was elected a *vereador* (city councillor) in 1992 and began the exploration and implementation of his latest project, Legislative Theatre.

In addition to his theatre work, Boal has written a number of entertaining and popular novels. In 1994 he was awarded the Pablo Picasso Medal by UNESCO for a lifetime of achievement in the Arts. His lecture in Manchester in January 1995 won him a Manchester Evening News Theatre Award for Special Presentation.

OTHER MAJOR PRODUCTIONS INCLUDE

Um Bonde Chamado Desejo (A Streetcar Named Desire) by Tennessee Williams. Teatro de Arena, São Paulo, 1962.

A Mandrágora (Mandragola) by Niccolò Machievelli. Teatro de Arena, São Paulo, 1962.

Tartuffe by Molière. Teatro de Arena, São Paulo, 1964.

Arena Conta Bahia devised by the company. Teatro de Arena, São Paulo, 1965.

Tempo de Guerra (Time of War) devised by Augusto Boal from texts by Bertolt Brecht. Teatro de Arena, São Paulo, 1965.

O Inspector Geral (The Government Inspector) by Nicolai Gogol. Teatro de Arena, São Paulo, 1966.

A Resistível Ascensão de Arturo Ui (The Resistible Rise of Arturo Ui) by Bertolt Brecht. Teatro de Arena, São Paulo, 1971.

Candida Eréndira by G. García Márquez. Théâtre de l'est Parisien, 1982.

Das Public (The Public) by Federico García Lorca. Schauspielhaus Wuppertal, 1984.

CRITICS ON HIS WORK

A flamboyant 64 year-old, Boal has the energy and humour of a man forty years his junior. Of scholarly bearing, greying mane and battered face and looking like a theatrical Dr Who, Boal is a lord of time and space – his radical ideas about the emancipating, healing power of performance burst out of the *favelas* (slums) of São Paulo and Rio de Janeiro and spread to every troubled corner of the world.

(Robin Thornber, 'Multi-Stage Therapy',*Guardian*, G2, 25 January 1995, p. 5).

An inspiring, humane teacher, a man for whom the overworked word 'charismatic' could have been coined.

(Vera Lustig, *Plays and Players,* July 1992, p. 47).

SIGNIFICANT BIBLIOGRAPHICAL MATERIAL

Babbage, Frances, ed. *Contemporary Theatre Review. Working without Boal: Digressions and Developments in the Theatre of the Oppressed*, 3, No. 1, 1995.

Boal, Augusto. *Teatro del oprimido y otras poéticas políticas*. Argentina: Ediciones de la Flor, 1974. First edition in English as *Theatre of the Oppressed,* translated by Charles A. and Maria-Odilia Leal McBride. New York: Urizen Books, 1979.

Boal, Augusto. *Técnicas latinoamericanas de teatro popular*. Buenos Aires: Ediciones Corregidor, 1975.

Augusto Boal. *200 ejercicios y juegos para el actor y para el no actor con ganas de decir algo a través del teatro*. Buenos Aires: Editorial Crisis, 1975.

Boal, Augusto. *Games for Actors and Non-Actors*, translated by Adrian Jackson. London: Routledge, 1992.

Boal, Augusto. *The Rainbow of Desire*, translated by Adrian Jackson. London: Routledge, 1995.

Heritage, Paul. 'The Courage to Be Happy: Augusto Boal, Legislative Theatre and the 7th International Festival of the Oppressed'. *Drama Review* 38, No. 3 (T143), Fall 1994, pp. 25–35.

Schutzman, Mady and Cohen-Cruz, Jan. *Playing Boal*. London: Routledge, 1994.

Augusto Boal
at The Green Room, Manchester, 27 January 1995

BOAL There is an idea that as we grow old, we lose our memory. In my case it's the opposite, I'm multiplying my memories. I even remember very accurately things that never happened. Therefore, to give a lecture about the 'Theatre of the Oppressed', I will tell you stories instead of just explaining theoretically why something was this way and not the other way. Also I enjoy telling stories and I think that people understand much better if you tell a story.

I remember, for instance, a story that I like very much which was told by a friend of mine, who is a very good director of people's theatre. He worked in the mines in Bolivia in the same conditions that we did at those times. One day he was telling me that he worked in such a poor region that there was no light or electricity, and he had to do his shows without electricity. 'But', I said, 'if you work in a place where there is no electricity, naturally you work in the morning or in the afternoon when the sun is still there.' And he said, 'No, I cannot work before dark, because the problem is that if I work during the day the miners are in the mines. They are working; they cannot come and watch. I have to work at night.' So I asked, 'How do you light your shows?' And he said, 'I work with miners. The miners have a lamp on their head, so I tell them to put on their lamp and look at the stage. And they look and they light the stage themselves. Not only is it a lovely way of lighting, but it's a wonderful way of knowing if a scene is theatrical or not. Because, when it is not interesting enough, the spectators turn around and the lights dim and immediately the actors go quickly on to the next scene to try to see if it's better.'

I started doing the Theatre of the Oppressed many years ago when I was arrested and could no longer do plays for an audience. During the military dictatorship it was very difficult to do theatre in Brazil because we had some big enemies. The first was poverty. People did not have money, so we had to do plays in the street, and

in the street we didn't get money. We had to fight because we had no subsidy and we had to find a way to overcome that problem.

We also had censorship in Brazil during the dictatorship. The censorship was extremely violent and was implemented by stupid people. When they arrested somebody, the books that they had on their shelves could be evidence against them. I remember one book held as evidence against someone was *The Red and the Black* by Stendhal, because they said red was communism, black was anarchism. An architect friend of mine had a book called *The Resistance of Materials* apprehended. They thought it was about someone who wanted to throw bombs and he was arrested because of that.

Before doing a play during the dictatorship we had to serve the play to the censor, and sometimes he would ban it on the day before it was due to open. There was a very famous case of a censor who read *Antigone* by Sophocles and happened to like it. He did not want to ban it, but he saw that it was a play in which there is a problem of the right of the state against the right of the family. He said, 'That play is subversive. How can we try to do something, not to ban it, but to allow the play?' So he phoned the director and said, 'Come and talk about *Antigone* with me.' When the director arrived the censor said to him, 'I've read this play that you brought to us. It's a very poetical and beautiful play, and I liked it. But in the times that we are living, with this problem of the military in power, you know I cannot allow a play like that because it's clearly in favour of Antigone. But I don't want to ban it. Let's go over the text and try to do something. You bring the author here to talk with me. We can change a word here, another word there and then it can be arranged.' The director said, 'You cannot imagine how happy I would be if I could bring the author here to talk with you. But he cannot come.' And the censor said, 'But why not? Is he in prison?' The director replied, 'No, no. Much worse, he's dead.' The censor said, 'Oh, I'm so sorry. I did not know. But bring his heir. Who gets his royalties? Bring that man here and we can discuss it.'

So we had poverty on one side and censorship on the other; and we also had the police. The police literally invaded the theatres and arrested people. Sometimes they destroyed the sets and kidnapped actors: it was a time of extreme violence. Today when I remember those things I think, 'How could we be so crazy to go on doing theatre in those circumstances?' I remember, for instance, when I was doing the *Feira de Opinião* [Opinion Fair], the actors came every evening and started doing vocal and physical warm-ups as in other theatres, but we also did a shooting warm-up. We had revolvers and every night before opening we went there and we practised shooting, because we did not know how to shoot; it was not our speciality.

This was not paranoia; it was because people – the police and army – sometimes invaded our theatres and killed people. All of the actors played with loaded revolvers in their costumes, and when the curtain went down all of them stayed ready, waiting to see if the audience would come up or not. There were two people outside that would make a signal to indicate if anyone was coming up, and so we would raise the curtain and start shooting.

There were moments of great anxiety, in which to do theatre was to really run risks. We did that until 1971 when I was arrested. Then I had to leave the country and from that time every circumstance was new for me and forced me to invent forms of theatre that were not usual ones.

The first one was when I went to Buenos Aires. I wanted to do theatre in the street as I always did before. So I said, 'Let's do a play about something which really concerns the population.' It was about a useful law which existed in Argentina that said that no Argentine who was hungry should die from hunger. If you were Argentine and had an identity card, then you had the right to go into any restaurant and ask for whatever you wanted, except wine or dessert. What a beautiful law. Usually I was always against laws, but finally I had found a law that I supported. So I decided to create a play to show that law and take the play to the street.

We prepared a play in which there was a young man that went into a restaurant. We had characters sitting at all the tables and we had an actor playing the manager, and an actor playing the waiter. We rehearsed the scene as we were going to do it in several streets outside. Everything was ready. But then my Brazilian friends came to me and said, 'You had better not go with them, because if you are arrested here they will send you back to Brazil and this time it won't be prison, they will kill you. Let them do the play. They won't have a problem because they are Argentinans.' So I told my group that I could not go with them but that they were to tell me how it went so that we could discuss it. They asked me to come and see it but I was warned about the risk.

Then someone had a brilliant idea and said, 'Look, instead of doing the play in the street as we were planning, why don't we go into a real restaurant at mid-day when it is crowded? Why don't we go there? We don't tell anybody that it is theatre, we simply do the play there, and then we see what happens.' I thought it was a wonderful idea. So the next day we did that. We went to the restaurant. I was the first to enter. I sat on a table in a corner and ordered something to eat. The actors arrived and sat all over the restaurant, separately. The protagonist was a young man, not violent or aggressive. He started speaking out loud saying 'I want steak, potatoes, and two

eggs, but I don't want wine and I don't want dessert'. The waiter said, 'Don't tell me what you don't want, tell me what you want and I'll bring it to you.' And he replied, 'No, pay attention. I don't want wine. I don't want dessert. Bring me the rest.' A few people laughed but no-one really paid much attention to him.

When the food came he ate heartily to play the role well. The day before he had not eaten anything, so he was really hungry and ate everything, saying how good it was. Everyone was laughing, even the manager. That was the first act of the play.

During the second act nobody laughed. The second act began when he asked for the bill. When it came he looked at it and said, 'This restaurant is wonderful. The food's very good and it's not expensive. I'm going to invite all my friends to come and eat in your restaurant.' He then showed his identity card and got up to leave.

The manager arrived and asked who was going to pay the bill. The actor said, 'I have no idea but I know that I am not going to pay. The law permits it.' The manager went to call the police, which we knew he would do. It was written in our script. An actor who was playing a lawyer then went up to the manager and warned him that if he called the police, the police would come and arrest him, because the customer had the law on his side. He gave the manager information on the law and how it would protect the customer, warning the manager that he would defend the customer, because it was the manager who was actually breaking the law.

A discussion followed in which numerous customers participated. A pharmacist asked, 'If someone is dying, has he the right to come into my pharmacy and ask for medicine and not pay? No, he has to pay. If he has no money he dies.' Everyone in the restaurant joined in, because it was a real situation for them and not presented as a play.

All of this was happening in front of people that were eating, unaware that what they were seeing was theatre. From my corner, I saw that it was good to do this kind of thing, not only as a form of protecting me and allowing the director to attend the opening mid-day (it was the 'opening noon', not the opening night) but as a form of theatre in which the reality and the fiction interpenetrate and overlap.

From then on I developed many plays of this kind all over the world. We ask for a problem and perform it in a restaurant, in the street, in a supermarket, a little bit everywhere. This is also a way of knowing what people are thinking about a particular problem, and also to pick up on cultural differences.

For instance, there is a play that we have done in many countries in which a woman and a man are in a shop like Harrods or whatever, looking at clothes that she wants to buy. The husband says 'No', and

does not allow her to do so. The couple look more or less like the other couples that are there, only that she has a dog chain around her neck, and the husband pulls her by a chain. The first time we did it was in Italy and Italians are very extroverted, so lots of people came to see what was happening. There was an actress who came and protested, saying 'But madam you should never allow your man to do that'. The woman replied, 'But why not? He loves me.' The actress said, 'But if everyone who loves somebody leads that person with a dog's chain there won't be room to walk in the street anymore, because there'll be too many dog chains.' Then they started discussing it. I remember a fantastic thing at the end. A very well-dressed gentleman came and looked at the woman and said, 'Look here, is this man really your husband?' And the woman said, 'Yes, he's my husband.' Then the well-dressed man replied very seriously, 'If he really is your husband, he has the right to do that, but not in public.' This means that you can do whatever you want to your wife at home, but if you do it in public you are offending the other men that are there. So it was not an offence against the poor woman, it was an offence against the men who were there.

This was a curious play. Once we did it in Zurich, and it lasted for about fifteen minutes, until the civilian police came and said 'No, you have to stop that', and sent everyone away. I then tried it the other way around: putting the dog's chain on the man, and not on the woman, with the woman pulling him. We did it again very near to the original location, and it lasted fifteen seconds. The police arrived immediately to stop it. To see a woman being humiliated in that way is not good, but it's bearable. To see a man in that position became a horror.

This kind of theatre was not proposed as a joke; it was proposed to try to ask people what were the oppressions that they really felt. A play was then performed in a place where such things could happen. It's not true that it is really happening there at that moment, but it's happening now everywhere, and it has happened there at other moments. It's not a synchronic truth, but a diachronic truth. We have the right to do it even though the spectator does not know that he's a spectator.

The idea of not knowing, of not being cautioned that you are in the presence of an actor in an acted action, always made me try to find other forms of theatre in which the spectator would become a 'spect-actor'. Not only a spectator in the sense of receiving, but someone who would participate and intervene. That was when I developed another form of theatre called 'Forum Theatre', in which the spectator intervenes directly, knowing that he is modifying the action. There is the presentation of a scene that represents a

problem that exists, and then the spectators see the show of failure. The protagonist does not know how to solve a problem so we present it to an audience and ask: 'Do you know? Would you know how to solve this problem better than the protagonist? If so, replace the protagonist and show your solution.'

That's a form of learning together. Contrary to what we did in the sixties, in which we, the artists, knew everything and came to teach the audience what the audience should do, it's a form in which we come to ask: 'What do you believe we should do?' And then we do a play.

This play can be a two-minute scene, or a two-hour performance. It can be improvised in front of everyone or, like the play I'm directing now with my group in Paris, it could have been written twenty-five centuries ago. I'm doing *Iphigenia* by Euripedes. I want to know what a French audience now has to say about Iphigenia, a woman who has to choose if she is the daughter of her father or the wife of her promised husband, Achilles. She has to choose her identity. She cannot say, 'I am Iphigenia. I am myself.' She cannot choose to be herself, but has to be related to a man. I'd like to know what French women have to say about that today.

We can choose to have music or not, dancing or not, stage lighting or not. You can do Forum Theatre inside a theatre or in the street. But it must present a problem. You have to have a protagonist, but you don't have a solution. The solution has to be discovered together, with all of us pedagogically teaching one another. It's not the old didactic theatre, in which you know all the answers and then you put those answers in the throat of the spectator. We bring a true question so that everyone can freely and democratically participate and intervene.

When I came to Europe I started another form of theatre, which does not have a specific title, but generally it is the title of my recent book called *The Rainbow of Desire*. It's a book that introduces some techniques to deal with problems that Forum Theatre and Invisible Theatre cannot solve. Because sometimes the problem is not that we don't know how to solve the problem, it's that we cannot do it. The problem is, therefore, *me facing this situation* (not the situation itself).

I started worrying about this kind of oppression when I came to Europe, after I had been in exile in Argentina for five years. I arrived in Portugal, and then went to Paris. It was in 1981, more or less, that people started talking to me about oppressions that I had not heard about before. Many people came to me and said 'My oppression is not really living conditions, or working conditions, my problem is a lack of communication'. I had never heard that before. I said, 'That's not a problem because if you are communicating to me that you cannot communicate, at least you can communicate that you don't

communicate. It's a very good beginning for a dialogue, let's go on and communicate further.'

It was the same with the fear of emptiness. Someone said 'I am terribly oppressed because of the fear of emptiness'. And I thought, 'But how can I do a Forum on that? Who's going to play emptiness? These Europeans don't know what good oppressions are. The good oppressions are the ones I had back home. Here they don't have the police all over them, so they are inventing oppressions that do not exist.' I seriously thought that.

What shook me was the fact that in Europe many more people commit suicide than in Latin America under dictatorships. During the dictatorships, and even nowadays, people are killed but the percentage of suicides is not as high as in countries like Norway. In Sweden, there is an almost ideal social security system and yet suicide figures are much higher than those of Argentina, Uruguay or Chile during the 'dirty war' years. I could no longer say, 'That's not serious. That's not a good oppression.' If people prefer to die than go on living with the fear of emptiness, I have to take it seriously; fear of emptiness has to exist and we have to see what this is.

In 1981 I began a long workshop in Paris; it lasted for about two years and it was called 'le Flic dans la Tête' which means the Cop-in-the-Head. The workshop asked how it was possible to theatricalise what is not objectively present but is subjectively a part of us. I wanted a form of Theatre of the Oppressed that could help people who could not talk about immediate material problems or oppressions, but who were suffering because they had the cops in their heads. They were not generally visible, but mostly internalised; they were in the head.

So the first technique was called the Cops-in-the-Head. We saw that it was a useful technique to try to visualise who is in our heads saying 'Do this' when you don't want to do it, or 'Don't do that' when you want to and you have the right to do it. That's a terrible situation, when you can do something and no-one's preventing you from doing it and there is no adversary facing you, but in your head someone is saying 'Don't do that'. So you renounce things that you would like to do, or sometimes you force yourself into doing things that you hate or don't want to do, but someone in your head says that you have to do it.

Sometimes there are dead people in our heads. Some of us carry cemeteries in our heads, but in reality no-one ever dies. All the cops that I have in my head are very alive. No-one ever dies, only when you die do all of the other ones die at the same time. But while you are alive, all the other ones are alive and present with you. So we also have to theatricalise those forms of oppression that are internalised.

We also found that there were other problems that this could not take care of. Then came the Rainbow of Desire, which is when you dearly want to do something, but you also want the opposite. You like somebody and you hate them; you are afraid but you are also jealous. You are this and you are that. So our sentiments, our emotions, are not pure; they are not blank white light. Like the light of the sun, it rains and then you see a rainbow. That's the idea of the Rainbow of Desire. We sometimes think that we only love, or only hate, and each one of those emotions in reality is a true rainbow.

So how can we theatricalise the rainbow that we have for other people? It's another technique. Sometimes you have a problem with somebody, like the relationship between parents and children, for instance. I have two children and I call them my children. One of them, Fabian, is thirty years old and works in the movies, and the other one, Julian, is twenty years old, but when I look at both of them they are my children. Of course if I say, 'Oh, my child, come here' in front of their friends, they are not going to like it because I see them as children and they see me as the father I was.

So I project onto them an image which is made of my memories of them and also of my desires as to what they should be like. But they are the way they are. I project onto them what I want them to be and not necessarily what they are, and they project onto me what they want me to be and I'm not necessarily that. So when I talk to one of them, I am talking to a projected image, like a projected screen image and I don't see my son. I see an image of him that I have created for myself and conversely he looks at me and he does not see me as I am. He projects onto me an image made of desires, of frustrations, of happinesses, of remembrance, of everything.

Sometimes that's the way we have to live. You are projecting onto me things that I'm sure I'm not. Each one of you is looking at me, but I'm sure that not one of you knows who I am. Even I don't know who I am exactly. The moment I come here I am the lecturer and then you project onto me some expectation that you have of me.

This is inevitable. We have to project, but sometimes it's painful. Sometimes it prevents people from really having a dialogue, from really having some sort of happiness in being with one another. We have just one life, and so we have to try to solve the problems that we have in this life because when it's over, it's over. The Rainbow of Desire serves this kind of problem: when you cannot communicate because you project an image onto the other person.

We have been developing lots of techniques. One of them I started here in England. It's about fear and the future we are afraid of when you want to do something, and there are no Cops-in-your-Head, but you yourself say, 'If I do this maybe the consequences are

going to be that.' Because you are afraid of the consequences, you don't do what you'd like to do. It's a way to see what is likely to help me, to allow me to do what I want and what is going to produce bad effects.

In the book *The Rainbow of Desire*, I try to explain how these forms and techniques function: how you try to find the correspondent technique for each problem. The techniques were invented or systematised to help people and not to put people inside the technique. The 'Theatre of the Oppressed' is the theatre of the 'oppressed' and not the oppression of theatre.

Every time you come with a new problem, we have to say, 'Do we have a technique to solve this problem?' If we don't, we have to invent a new one rather than impose techniques. You have to discover what you can do to help that particular person. However, in the Theatre of the Oppressed, we never go from the particular case of a person into the singularity of that person. We try to go from the particular case of a person into the generality of the group: to create a net of solidarity and security.

Hamlet, for instance, is a beautiful character, but from a mental health point of view, he is highly melancholic. I love Hamlet, he's a wonderful person, but suppose that one Saturday night you have invited lots of your friends to come to dinner with you. You have spent the whole afternoon cooking; there is good wine and you are going to have a great night. Imagine if Hamlet were your friend and he phones to ask if he can come. You are going to think twice before you invite him. You love him as a character, but let's be frank, he's a party pooper. The friends that are coming on the night don't mix well with him, but he comes anyway. You are joyfully discussing politics and you ask Hamlet what he thinks – 'O that this too, too solid flesh would melt. Thaw and resolve itself into a dew! Or that the Everlasting had not fixed his canon 'gainst self-slaughter!' No-one stays long. And then he says, 'Yes, to be or not to be.' It's terrible. He's a wonderful character, but not a good guest.

In the theatre we ask, 'What's the character that I'm playing?' The invention of character is based on a lie. We say that we are going to perform a character. I have heard lots of people say that they have to enter into a character. You don't enter into a character. The character grows out of you. You cannot ever play a character if it's not inside you. You cannot play a Martian because you don't have a Martian inside you. You can symbolise and say, 'I'm going to play a lion.' Of course you don't have the lion inside you, but you attribute to a lion some human sentiments that you have. You start to develop in yourself whatever you consider to be a lion.

In the Theatre of the Oppressed, we base ourselves in what we

believe is the truth. We are all of us basically a person and from this we create a personality. Personality is a reduction of the person: reduction by fear and reduction by morality. There are many serial killers inside you, but you are not a serial killer, because morally you should not be so. You have to say, 'I will not kill anybody.' I am not a killer, I'll never kill anybody. I'll never kill because I think that it's not correct to kill. So it's a moral choice. I can kill, I know how to kill, but I will not because I have morally chosen not to.

But there are other things that I have inside and I don't show them, and this is not a moral choice, but based on fear. The best example I can give is that I have a bank robber inside me. I would love to rob a bank; it would be an enormous pleasure for me. Every time I go to Zurich I know that it is full of tunnels, full of those enormous bank safes. Inside there is all the gold of the world. When I'm there waiting for the tram to come, my legs start trembling because I would love to rob that bank.

Bertolt Brecht was very important for me. He said something that I believe totally: that it's a greater crime to found a bank than to rob one. We have lots of angels and devils inside us; we want to show them but the problem is that our moral instinct says 'No' for certain things and fear says 'No' for others.

Thus your personality is created, but the rich possibilities are inside you. When you are going to do a character, what do you do? You dynamise those aspects, those drives, those desires, those devils, those saints, that are inside what I call 'the pressure cooker' of your person, which do not have permission to come out in your personality. So you try to bring them into the 'personage', into the character, and for a certain time you play this. So you can play the melancholy of Hamlet, you can play the serial killer of Richard III, you can play whatever you want and after two hours you put it back. The actor who has to play Hamlet has some sort of a security net. The other actors are there playing their own characters, the public is there and the curtain goes down.

The idea of the Rainbow of Desire and the Theatre of the Oppressed as a whole, is more or less the same. Only that in the former, instead of putting everything back after playing, we try to develop those parts of our personality and our person that an authoritarian education, or society or whatever, did not allow to come out. If I am a person who has a much exaggerated fear inside me, I have also a certain courage inside my person.

The idea of the Rainbow of Desire is to develop the capacity that I have even though it's not actually in my personality; it is inside my person, and so it is not dead. I was educated in an authoritarian way, but every drive that I have inside is alive. Why not develop that

which we have inside that is alive, and then, instead of doing as the actor does, putting them back into the pressure cooker of your person, try to put that together with your personality? 'My personality is not good at this and I don't like it. So why don't I go inside my person to try to bring out what I can still stimulate and dynamise, and then make this permanent and join it with my personality?' That's the idea of the Rainbow of Desire.

This is the story of what we have been doing in the theatre. First we did popular theatre telling the people what they should do. We gave advice, and were happy because we were giving good advice. But it had no political consequence because sometimes it was good, empty advice that could not be followed.

After this we started to do Invisible Theatre, and then Forum Theatre in which we discussed problems together. We don't pretend to be better than others, but we pretend to talk and learn together.

Paulo Freire, the Brazilian educationalist, says the same in all his books. I like especially when he writes that you cannot teach if you don't learn anything from the person to whom you teach. To teach is a learning process. It's not only about throwing things at people, but it's about getting things back and learning.

There is an Argentine teacher who used a phrase which is very beautiful. He was working in a literacy programme and he said, 'I taught a peasant how to write the word plough. And he taught me how to drive it.' I like this kind of Paulo Freirean transitive teaching very much.

The Theatre of the Oppressed in the form of Forum Theatre is this: we come with the questions, let's see who has answers. We always learn from the spect-actor, not the spectator. And the Rainbow of Desire is another form, or rather several forms and techniques, which try to develop from inside our person whatever was buried in our person that can be useful to our personality.

My present work in Rio de Janeiro is a return to politics, but a return to politics does not mean that I abandon what has been done before. It does not mean that now you're old, you have to go back to politics. I believe that all the forms that were developed are important in certain circumstances. They have not been abandoned. The fact that now I have become a politician does not mean that I renounce what I have done before. On the contrary.

In *The Rainbow of Desire* I included a chapter on India, where I have worked. When I went there, I went only to discuss Forum Theatre and they said, 'But why do you want only to do Forum Theatre with us?' I replied, 'Because you have so many enormous economical problems.' And they said, 'Yes, but we have also our hearts. We also love. We also have our sentiments. If we have big

problems externally, then we also have them internally, so let's also do the Rainbow of Desire.'

I don't renounce previous techniques, but at the moment I'm concentrating on a form that we are calling Legislative Theatre, in which we try to use the theatre as a means of doing politics. Not doing political theatre, but doing theatre as politics.

AUDIENCE QUESTION 1 Do you think there's a difference between the nature of change for an individual and the nature of change for groups or societies?

BOAL Any change that happens to me is going to modify the certain group to which I belong. Modifications of the group evidently modify the people. The people of Brazil ousted President Collor in 1992, because he was a thief; he and his gang had stolen more than two billion dollars. The campaign that led to his impeachment modified many people. It was a nation's modification, but it had consequences on all of us individually.

For me the modification of one person modifies around that person extensively, so I think it's impossible to modify a group without modifying the individuals of that group. And I think that one modified individual modifies the group.

AUDIENCE QUESTION 2 Have you always been a democrat?

BOAL I first joined a political party a few years ago, when I joined the Workers' Party in Brazil. Before that I was in the guerilla movement, and that's why I was arrested. But it was a moment in which political parties meant nothing. And we really believed – in the late sixties – that we could change the world. Che Guevara had a very beautiful phrase. He said 'To be in solidarity is to run the same risk'. And this phrase rang very much in our heads. We wanted to be 'in solidarity', so we had to run the same risks. After doing exhortative theatre in conditions where we were forced to have a loaded gun in our pockets, I joined the guerillas.

So my background, my political past, is that I never wanted to join any Brazilian party, because I did not believe in those parties. I joined the guerillas when I felt that I should do so, thus abandoning party activity. Political activity I never abandoned. Even outside Brazil, in my lectures and conferences, I always denounced torture and other such activities.

I never cared very much about labels, and outside of Brazil my work involved speaking of the resistance that was going on inside the country, but I never belonged to a party. This is the first time I have joined a party. I believe that the Workers' Party is important, and that it is growing, in spite of the fact that we did not win the presidential election in 1994. Now we have five senators instead of

just one and among those five senators two are women – that's very important in Brazil. One is black and lives in a *favela* [shanty town] and her name is Benedita da Silva. The other one, Maria Osmarina Silva de Souza, comes from a very poor place in the north. She's forty-two years old, and she learned how to read and write when she was in her mid-twenties.

It's very important that we have grown to have five senators, fifty deputies and, for the first time, two state governors. It's a growing party, but I don't care if we take power or not. We are not fighting to take power. Power does not interest me. If the government that won the presidency do what they have to do, I'm going to applaud them. What I want is agrarian reform, because the peasants in Brazil are not the peasants of Europe. In Brazil the peasants live in slavery, and if we can make a better distribution of the land we can end abject poverty. If this government ends poverty I'm going to support them. We are not going to be in opposition because we want to be oppositional, or because one day we dream of having power. I want them to have power and do the things that I would do if I had power. But I don't want to have power myself, to become a politician with power. I have my power, that's enough. We are not in power but we are growing. And if they don't do what has to be done then one day we will have the power and we'll do it.

AUDIENCE QUESTION 3 Many of the philosophical ideas and techniques that you've talked about have a relationship to J. L. Moreno's psycho-drama and socio-drama. I know you have encountered his work in your journey and I'd like to hear your reflections about the relationship of your work and Moreno's.

BOAL I was invited to open the tenth world psycho-drama congress a few years ago in Amsterdam. I'm not a therapist but they invited me because they believed that my work is therapeutic. Moreno was a doctor who came to the theatre as a doctor; I am a man of the theatre who does something that can be therapeutic. This is the relationship that we have. Morenian psycho-drama uses theatre to try to help and heal people. The Theatre of the Oppressed has other techniques that have nothing to do with this because the origin is theatrical; we try not to be too close to naturalism or too close to realism. We try to create forms that are more subjective. I try to insist on this with the people with whom I work.

To be real is to make images of my life and what I feel, not necessarily the image that someone else can endorse. I don't want people to be realistic, because to be realistic or naturalistic is to reproduce what we already know. I want to discover new things. I want to discover how the person feels. You should be real, but not realistic.

The forms of the Theatre of the Oppressed are not naturalistic. They are based on a first improvisation which is more or less realistic. But from that point we go into a creation of images that are not realistic anymore.

I know that Moreno also speaks about the group, but in our case it's central. We want to know my problem to see how it resounds in other people: how other people perceive it. For us the important thing is not solely to look at ourselves and say, 'Oh, look who I am', but to look at others and say, 'Oh, look who I am', because he felt the same thing, she felt the same thing – to see ourselves in the other.

Identity is very important. Who am I? I am a man because women exist. If women did not exist I would never define myself as a man. I am white because blacks exist. If blacks did not exist, if Indians did not exist, if the Japanese did not exist, how could I say that I am white? I am white because there are people that are not.

I am a father because I have two children. I am a father because they exist. My identity is made of what I am, of course, but is also made of others. What's beautiful is when people discover that others feel the same and it is not just their own problem. So we are always concentrating on trying to know how others also feel, how others also have lived through the same, or an analogous experience. We talk about the Cop-in-the-Head. I want to know what cops I have in my head, but also about the headquarters from where they come. So I am going to analyse my cops, but I know that they were not born there. If suddenly five people say that they have similar cops, then we analyse our five cops and we see what uniform they wear, because they come from somewhere. So the relation between me and others is what is most important in the Rainbow of Desire. We aim to see the group departing from an individual who tells a particular story, but we don't go into the singularities of his story.

If I go to a psychoanalyst, I want to talk about my mother; I don't care if other people have mothers, for me my mother is my mother. She's not the mother of my brothers and of my sisters, but only mine. This is very singular. But if we are discussing my mother in the Theatre of the Oppressed, I have to see that there are other people who have mothers too and there are strange coincidences of behaviour. In some circumstances we all have mothers who behave the same way.

In our work we always try to make a bridge for people to know that 'I am what I am because other people exist'. If not I would not be what I am. Even the Theatre of the Oppressed would never exist if there were only me in the world. It exists because it's not the solitary work of one individual shut up with his computer; it's group work. In the book I always tell the reader where a workshop or a

scene happened and who did what. I try to show that it's not solitary work; it's not 'Oh, I have an idea, I want to develop a technique about this'. It's living people. I love people. People come and tell me about their problems. Okay, let's try and cope with it. I ask myself, 'What can I do?' And then we discuss it. The most important thing is to have the idea that I am an individual, but also part of a group, and this group for me is not about the English or the French. It's about humans communicating. That's why I travel from place to place, and what astounds me is not the diversity, but the resemblance. It's how we resemble one another and how we feel the same things. Everywhere I go I find the same kind of oppressions.

Sometimes oppressions become much more violent, like in India. The group I worked with told me that some widows are sometimes burned with their defunct husbands, because that's a way of getting rid of the widow; that sometimes husbands kill their wives, because the father failed to pay the dowry that he had been promised. The wife is killed and then the husband can marry again. Of course that's a form of oppression. Here in England it's not the same, but it's true that women here are also oppressed. In all countries that I have visited I have never found a place in which women were not oppressed.

It's important to see that, whether in India, in Africa, in Brazil or in England, we have many differences, but we have essentially the same identity. And that's what we try to look for in the Theatre of the Oppressed in general and in the Rainbow of Desire techniques in particular.

AUDIENCE QUESTION 4 You always say that the spect-actor must be allowed to come up and try out her or his ideas without being condemned or judged and I think that these are two very important elements in your work.

BOAL We never try to evaluate the intervention. We never say, 'Which one is better? This one or that one?' If someone comes with an intervention it's always good, because it's the person saying what he or she sincerely thinks. You cannot condemn them. Maybe what you did does not have the same resonance as what somebody else did, but it does not mean that one is better than the other. I can talk to you about some of my problems that have a resonance in you, and some other problems that have less resonance. We don't say that there is a hierarchy of problems. We never give marks. We never evaluate.

We begin from the principle that we are all artists, but handicapped artists, because education handicaps us. Children have less self-censorship. They express themselves very easily theatrically

and they love it. After a certain age we are told to stop playing and take life seriously. When you say 'Stop playing; you have to be serious now that you are growing up', you are castrating the person, because 'playing' is one of the most powerful languages that you can have. To play is to use part of reality, to create and rehearse forms of transformation. You are playing, you are trying, you are rehearsing, you are getting stronger, so that you can go and transform reality. And they say, 'Stop. You cannot play any more.' They box us in patterns of behaviour and castrate our creativity.

But what we try to restore is the creativity that we all have. They try to limit, they try to annihilate, but there is always more creativity than we suspect. I am a man of the theatre and for more than forty years now I have been working as a director, yet I am always admiring people that have never done theatre in their lives and try for the first time.

Even if we don't make theatre, we are theatre. To be theatre is to be human, because only humans are capable of observing themselves in action. By observing myself in action, this dichotomisation allows me to change my way. That's why culture is possible: because we humans are capable of looking at ourselves in action.

Culture is not what we do, it's the way of doing it. It's not singing: it's how you sing. If you can observe yourself singing, you can observe others singing. You can compare what you are singing now with what you are singing later, and then invent a third way of singing. And then you invent another way and another person sees you singing and sings in another way. What is happening is that you are creating culture. Animals don't have culture, but we have culture. Culture is not about eating or making love; it's about the way we eat, and the way we make love.

So everything that we do is cultural and it's cultural because we are theatre. Because we observe ourselves and say, 'If I am here I can go there. If I have done like this, I can do like that.' What made people become human was the discovery of theatre: the discovery that I can step away, step back from myself, look at myself, and so I see where I am.

We are capable of culture because we are theatre. The Theatre of the Oppressed is concerned with all those forms that spring from this essential fact. Everyone is creative. People may convince themselves that they are not so capable, but of course they're capable. Whatever one person can do, others can do too. Some not so well, or so quickly, or so prolifically, but whatever one human being can do, others can do. This is what we are concerned with. This is theatre and this is what we all are.

PETER BROOK

D ESCRIBED by Trevor Nunn as 'everything enviable and inimitable . . . an outsider, a maverick and a revolutionary', Peter Brook has pursued an extraordinary, unprecedented and ongoing investigation into the language and nature of theatre. His linking of the worlds of the private and the public, his exploration of the collaborative relationship between performers and spectators, and his interest in the training and preparation of actors have marked a prodigious theatrical journey which has taken him from the opulent painterly productions at the Royal Shakespeare Company to a more essential actor-orientated work at the Bouffes du Nord in Paris, with extensive periods of fieldwork in other continents.

Born in London on 21 March 1925 to parents of Russian descent, Brook left school at sixteen to go and work briefly for the Crown Film Unit before bowing to family pressure, and entering Magdalen College, Oxford in 1942. There, dismayed by the lack of opportunities available to make theatre, he set up the Oxford Film Society, making a film called *The Sentimental Journey* for which he was sent down. Moving into theatre, his production of Cocteau's *The Infernal Machine* (1945) on the small stage of the Chanticleer Theatre Club attracted favourable attention and he was invited by Barry Jackson to direct at the Birmingham Rep in 1945, where he staged three productions including a much admired *King John*. Although he demonstrated great versatility in the forties and fifties, directing operas, musicals, and contemporary works by such writers as Jean Anouilh and Arthur Miller, it was the rich controversial productions of lesser-known Shakespeares which proved the hallmark of his early years at what became in 1961 the Royal Shakespeare Company (RSC): a seductive, Watteau-inspired *Love's Labour's Lost* in 1946, an imaginative *Measure for Measure* with John Gielgud in 1950 and a painfully eloquent *Titus Andronicus* with Laurence Olivier in 1955. It was his stark, cruel *King Lear* (1962), with Paul Scofield in the title role, which is often regarded as a key turning point in Brook's career: demonstrating a heightened awareness of the actor as the pivot of the theatrical event. This was to prove the hallmark of his minimalist anti-psychological productions presented as the 'Theatre of Cruelty' season (1964), in homage to Antonin Artaud, which included a highly influential production of Peter Weiss's *Marat/Sade*.

In 1970, following a mischievously celebratory and magically playful production of *A Midsummer Night's Dream* at the RSC in 1970,

he received the financial assistance needed to set up the Centre International de Recherche Théâtrale (CIRT) in Paris (later to become the Centre International de Créations Théâtrales [CICT]): an organisation which would allow him to move away from the constraints and demands of the commercial theatre, which he regarded as a compromise on his work. Now working with an international group of actors, productions grew out of an ongoing examination into the production and reception of theatre, accompanied by appropriate periods of research, with an opportunity to evolve over a longer period of time. Methodical training in the language of interpretation was manifest in its inaugural production, *Orghast* (1971), a reworking of the Prometheus myth which explored the incantatory musical powers of the utterance utilising a new language invented by Ted Hughes.

Seeking to find an equivalent for the role of ancient Greek theatre in our fractured world of moral uncertainties, Brook's investigations into the possibilities of a global theatre with as broad an appeal as possible have provided a freedom and simplicity reminiscent of that of the Renaissance stage. Research undertaken in Iran, North America and Africa sought to place CICT actors before a culturally different audience who would question their conventions and simplistic imitations. A questioning of the primacy of the word and the redefinition of its role within the contemporary theatre has entailed the development of a corporal language which encourages the skills of the different performers. Pioneering what is regarded today as 'multiculturalism', in employing actors from different cultural traditions, Brook has established a veritable team of collaborators including Jean-Claude Carrière (Buñuel's former screenwriter who has worked on Brook's Shakespeare adaptations and scripts since *Timon d'Athènes* [1974]), producer Micheline Rozan, production assistant Marie-Hélène Estienne, and actors such as Yoshi Oida, Bruce Myers, Sotigui Kouyati and Maurice Bénichou.

Moving into the abandoned Bouffes du Nord theatre, built by Louis Marie Emile Laménil in 1874, but empty since 1952, the faded rococo decor and expansive stage provided an appropriate façade for a series of productions beginning with *Timon d'Athènes* which sought to strip texts of the tired clichés piled onto them by previous productions. Taking further Grotowski's dream of a 'Poor Theatre', Brook's work at the CICT, although always actor-centred, has encompassed both the epic and the intimate. There have been diverse productions of Shakespeare – a dramatist whose discordant contradictory elements continue to provide him with a source of inspiration – and epics such as *Conference of the Birds* (1979), based on the twelfth-century Sufi poem. Intimate chamber pieces include his

pared-down adaptation of Bizet's *Carmen* (*La Tragédie de Carmen*) (1981), Debussy's *Pelléas et Mélisande* (*Impressions de Pelléas*) (1992), and his recent four-actor production of *L'Homme Qui* (1993)/*The Man Who* (1994), based on Oliver Sacks's neurological case studies. Most of the eighties was spent adapting the Sanskrit epic poem, *The Mahabharata*, fifteen times the length of the Bible, which was premiered in the French language version in 1985. Reducing the vast poem to its core narrative of two warring families, Brook set his six-hour production on a vast empty stage bereft of unnecessary clutter, where location was defined and redefined in a number of simple but theatrically effective gestures. This was a theatre of economy where objects were used, as in his earlier production of *A Midsummer Night's Dream*, to a resonant effect beyond their literal function. Encompassing numerous theatrical traditions, it provided a fitting manifestation of a form of theatre which appears light and effortless, never stylised or artificial, and where that which seems most mysterious and elusive is made visible.

Peter Brook has also directed numerous films including *The Beggar's Opera* (1952), *Lord of the Flies* (1963), *King Lear* (1971), *Meetings with Remarkable Men* (1979), and three versions of his production of *La Tragédie de Carmen* (1983). He is the recipient of numerous awards including a CBE in 1965. His publications include *The Empty Space*, a key work of contemporary theatrical theory, first published in 1968, in which he laid out the four categories of theatre – deadly, holy, rough and immediate – as he then saw them, and *There Are No Secrets*, published in 1993.

OTHER MAJOR PRODUCTIONS INCLUDE

La Bohème by Giacomo Puccini. Royal Opera House, London, 1948.
Dark of the Moon by Howard Richardson and William Berney. Lyric Theatre, London, 1949. Then transferring to the Ambassador's Theatre, London.
The Winter's Tale by William Shakespeare. Phoenix Theatre, London, 1951.
Venice Preserv'd by Thomas Otway. Lyric Theatre, London, 1953.
The Tempest by William Shakespeare. Shakespeare Memorial Theatre, Stratford, 1957.
Irma la Douce by Alexandre Breffort. Lyric Theatre, London, 1958.
Le Balcon (The Balcony) by Jean Genet. Théâtre de Gymnase, Paris, 1960.
US. The Royal Shakespeare Company at the Aldwich Theatre, London, 1966.
Les Iks adapted from Colin Turnbull's *The Mountain People*. Bouffes du Nord, Paris, as part of the Festival d'Automne, 1975.
Ubu aux Bouffes an adapted amalgamation of the plays by Alfred Jarry. Bouffes du Nord, Paris, 1977. Then touring to Europe and Latin America.

La Cérisaie (The Cherry Orchard) by Anton Chekhov. Bouffes du Nord, Paris, 1981.

La Tempête (The Tempest) by William Shakespeare. Bouffes du Nord, Paris, 1990.

CRITICS ON HIS WORK

Other directors have assumed creative supremacy, displaced the playwright, reformed the arts of acting and stage design, devised new relationships with the spectator, and turned the theatre into an instrument of their dreams. But no-one before Brook has gone to the length of rejecting theatrical capitals to seek his primary audience elsewhere, and setting out to transform theatrical expression – the most nationalistic of the arts – into an international language.

(Irving Wardle, 'Foreword', Peter Brook, A Theatrical Casebook, pp. xiv-xv).

Refusing to be locked within any single register, he has shown consistently his complete lack of respect for abstract aesthetic notions of unity and taste, which can only preclude certain areas of response. What is important is what communicates directly, what works at a specific moment. In the search for a truly popular theatre, all possible elements must be considered.

(David Williams, '"A Place Marked by Life": Brook at the Bouffes du Nord', New Theatre Quarterly, 1, No. 1, February 1985, p. 41).

SIGNIFICANT BIBLIOGRAPHICAL MATERIAL

Bradby, David and Williams, David. Directors' Theatre. Hampshire and London: Macmillan, 1988.

Brook, Peter. The Empty Space. Harmondsworth: Penguin, 1972.

Peter Brook. The Shifting Point: Forty Years of Theatrical Exploration 1946–1987. London: Methuen, 1988.

Brook, Peter. There Are No Secrets: Thoughts on Acting and Theatre. London: Methuen, 1993.

Cohen, Paul B. 'Peter Brook and the "Two Worlds" of Theatre', New Theatre Quarterly, 7, No. 26, May 1991, pp. 147–58.

Heilpern, John. Conference of the Birds: The Story of Peter Brook in Africa. London: Methuen, 1977.

Mitter, Shomit. Systems of Rehearsal: Stanislavsky, Brecht, Grotowski and Brook. London: Routledge: 1992.

Wallace, Neil, ed. Making Space: The Theatre Environments of Peter Brook. London: Methuen, forthcoming.

Williams, David, ed. Peter Brook, A Theatrical Casebook. London: Methuen, 1988.

Williams, David, ed. Peter Brook and 'The Mahabharata': Critical Perspectives. London: Routledge, 1991.

Peter Brook in conversation with Michael Billington at the Royal Exchange Theatre, Manchester, 18 March 1994

Nobody could accuse Peter Brook of simplicity, though in the last year or so he has been straining every nerve to achieve it. His principal appeal is

still to the theatrical gourmet, not to the fasting friar, he cooks with cream, blood and spices. Bread and water addicts must look elsewhere.

(Kenneth Tynan, in Cecil Beaton and Kenneth Tynan, *Persona Grata*, London: Alan Wingate, 1953, p. 17)

BILLINGTON Peter, could I start by asking about the evolution of your ideas on theatre? Was there a moment when you began to get dissatisfied yourself with cooking with these exotic ingredients of cream, blood and spices, in other words became slightly dissatisfied with the theatre of high artifice, or was it a process of gradual evolution and change?

BROOK I think the first thing that's obvious is that Ken Tynan was writing with blood, cream and spices himself, so it doesn't mean what you read in the book is necessarily true! It is a question that I have never asked myself, so you make me look into the past, which I hate doing, to try to sort out memories. But in trying to understand the process I'd look at it quite differently. I think that from the very first production I did, I had only one simple guide, I wanted the theatre to be exciting, and when I started, exciting really meant being alive. And it was very simple because I went to theatre not much as a child and a bit more when I was sixteen or seventeen. Then when I was about eighteen or nineteen, I began to go quite a lot, mainly to the theatre in London. Most of the time I would read in a newspaper like the *Manchester Guardian*, 'This is the greatest production of Shakespeare', and I would go to see it and it would be dull, lifeless and I would look at it and I would squirm with misery. And the misery came from the fact that in those days Michael Billington's predecessors would call something that to me was without imagination 'simple', and call something badly done and amateurish 'marvellous'. I'd look at this and I'd think, 'Well, what's this all about?'

There was, in those days, a very English belief that amateurishness is like taking a cold shower, so it's good for the soul, while professionalism is suspect. The amateur obviously has good intentions and the fact that he does it badly sort of proves his honesty, and I thought 'There's something wrong with this. It doesn't make sense', because all I knew – and it really was as simple as that – was that making theatre, going to the theatre, must be in some way exciting. Today I just interpret the word exciting as meaning alive, and I think that all the work that I did for a long time was trying in different ways to make what happens on stage come to life. In a way, perhaps, it was much simpler for me than it would be for a young director today, because the first thing was so obvious – just shaking up terrible, stultifying old conventions. For instance, when I first went to Stratford, there were still productions done based on what was called the

traverse curtain. The traverse curtain was what a famous director from Norwich used all the time – what was he called? Nugent Monck.

BILLINGTON The Maddermarket man.

BROOK Yes, who was very famous because he had an amateur theatre there and in it Shakespeare was supposed to speak for itself. I remember the first season I worked in Stratford, he did a production of *Cymbeline* and Sir Barry Jackson said 'He's a marvellous man', and I crept into rehearsals just to see the way a marvellous man worked. The set was just some plain background and then a set of curtains that opened and closed halfway back on the stage which, of course, solved every problem of continuity in Shakespeare. If you had a chair and a table and you wanted to get rid of them, you closed the curtains, and then on a little narrow strip called the front stage, which was still behind the footlights, people came on from the two sides, did their scene, went off again, the curtains opened and you were in the next scene. This was highly praised because the plays were said to speak for themselves. Speaking for themselves meant that the actors came on from the wings, stood there, spoke the lines, and went off again. I watched how he rehearsed and he had his first run-through on about the third day, after which for three weeks all they did were run-throughs, which meant not even running but just walking in from the sides, running through the lines and going off again. And I thought 'Well, this can't be it'. So then began explorations, partly intuitive, partly by thinking and working them out, to see how one can bring a play to life.

One of the earliest productions I did – *Love's Labour's Lost* – was extremely pictorial, trying to bring to the stage an unexpected and romantic image with a lot of movement and a lot of music. Almost at the same time I did *Dark of the Moon*, which was a production very close to what I would do today. Nobody wanted to put this play on; it was an elaborate play which we had to do on a small stage with very limited means, so the only thing that could bring it to life was the pure energy of a very young company. In this case, the excitement was brought about by the energy of the performers, and in the other romantic production of *Love's Labour's Lost* it came through the other sort of energy that's produced by the blood and cream of colour and movement and lighting and scenery. I don't think that I was ever particularly caught by any of those things for their own sake, they were different ways of making life.

Then when I went into opera, there again it was very simple to know where to start, because when I got to Covent Garden they had just opened a brand new revival of opera in Britain after the war –

new approach, new company, mainly English singers, mainly English designers, mainly English directors. It was a real revolution in the arts because here was a grand opera, Covent Garden, being renewed in a new way, and so the first step of the renewal was to give each director for a new production five days, and so the whole of the repertory was done with five rehearsals for each work. But these rehearsals weren't even what you'd call a full day, they were three hours – five three-hour rehearsals – and already the chorus was highly unionised, so there was a twenty-minute break within those three hours for the chorus, but the orchestra, which was also heavily unionised, had a break at a different moment in the three hours, so the new productions were done in those conditions. Well, you can imagine what they amounted to. There was a lot of scenery and the people walked on from the wings and there was just time for the director to say 'You walk on, you stand there, you go off again'. Again it was very easy to see that there must be another way of doing it and that again involved trying to animate the stage. So I think that perhaps my way of animating has developed and has become more focused over the years, but the aim is still animation.

BILLINGTON You said something a moment ago about *Dark of the Moon* being very close to the kind of work you might do today, or the approach being very similar, which makes me think that this division of your career which critics and commentators always make – pre-Paris and post-Paris – is artificial because your work in the 1960s was paring down all the time. On the other hand your work in Paris has often used, like *The Mahabharata*, the ingredients of theatrical magic – back to the cream, blood and spices again. So there is not a clear-cut division in your work?

BROOK It's a very convenient autobiographical division but it's not true. I may be wrong but I would say that there is an actual point where there is a division and that is when we started what we called the 'Theatre of Cruelty'.

When in 1964 I joined Peter Hall, he was then running and developing the Royal Shakespeare Theatre alone. I'd taken a big break from the theatre to make the film of *Lord of the Flies*. It took about two years from getting the finance together, getting the film together, finding the kids, shooting it, editing it. I was away from the theatre for about two years. This wasn't only because of making the film but it was also the feeling that I wanted to reconsider and develop what I'd been doing in the theatre in a different way. When that period was over Peter Hall said, 'Will you come and join Michel Saint-Denis and myself at the Royal Shakespeare Theatre?' I said, 'Why?', and he said, 'Well, you know I want to run things in my own way but I'm

lonely. It is very difficult to do this without people that you can talk to every day and share things with, and so would you join us?' I found that a very good invitation but I said, 'There's only one thing, I've come to the point where I feel that I must have the possibility, not only of doing productions but of doing something I've never had the possibility of doing before, which is to have an experimental group. An experimental group means that one can work without having to deliver a result. Can you make that possible?' And he said, 'Absolutely, I'm doing this for Michel Saint-Denis, he wants a studio and I would be very happy indeed to see that within the budget there is the possibility of you having a laboratory group of your own.' And that's how I got together a small group of people.

We worked in a little theatre in LAMDA [London Academy of Music and Dramatic Art], in the acting school in Kensington and we called our work – just to give it a label – 'Theatre of Cruelty', but that doesn't mean anything in relation to the content. It was just a title behind which we made experiments that I'd never had the time or possibility of doing within what was always the four weeks that one had for any production whatsoever. Up to that point, when I did *Measure for Measure* at Stratford with John Gielgud, we had three weeks, and for *King Lear* it was the first time, by really fighting and insisting on it, that we had five weeks. Now, within that time you can't also spend a day or two days experimenting with a particular problem, and so that was the vital condition that we obtained thanks to Peter Hall (without him it wouldn't have been possible). He said 'Of course that can be done'. And to me that was a significant date because it was the possibility of starting a different sort of work, not only in the mind thinking about it, but practically. So while I went on doing productions that had to be ready on a certain date, I was also able to explore.

It was from the first group – this little experimental group – that gave me a wish to go farther. So in 1968 when Jean-Louis Barrault said, 'Will you come to Paris and in a season that they call the "Theatre of Nations" do a workshop for us on Shakespeare?' I said, 'A workshop on Shakespeare, no, that doesn't interest me very much. A workshop on Shakespeare bringing together actors from many different cultures, that would be interesting. You call it "Théâtre des Nations" – it's an international event in Paris, can we then bring together actors from many different parts of the world?' He said, 'fine'. So that was the link. It was through having done a laboratory with English actors that made it a natural development to say, 'Well, let's see if we can do it with actors from many different cultures who don't know one another', and that took place in Paris and it was natural for work that took root there to develop in Paris.

BILLINGTON This seems to be an absolutely cardinal point of your work in Paris. You have brought together actors from European, Asian, African cultures, not in order to merge them as is often said, but to create what you once called, I think, 'a difficult friction'. But do you think that kind of cultural ad-mixture can only work well under prolonged rehearsal conditions and if you try to simply bring a lot of actors together for a four or five-week period it's never going to mean anything?

BROOK Oh no, I wouldn't agree at all. I think that this whole question of mixed cultures is based on so many dangerous misunderstandings. I think that the moment one starts using a jargon that we've never used over twenty-five years, the moment that one talks about a black actor and a white actor and a homosexual actor and a lesbian actress then already it's finished. Why should we bring them together? For what social, political or artistic reason can one ever want to do that sort of mixture? So once you set off on that argument, you'll argue and debate around it, and all you do is reinforce the artificial categorising of people.

One has to take it from a completely different point of view which the theatre still gives one the possibility of doing. You start – whether it's a play that's to be done in three weeks or over ten years, it doesn't matter – with the need to bring to life a certain theme. In most cases, the certain theme will already be there as a play. You wish to, as I said a moment ago, animate it. You wish it to come into glorious life with blood and cream, that's what you want. Now, what is the first way of going about it? The first step for anybody in a position of responsibility, like a director, is casting. Casting is where you begin. Now, how do you approach casting? There it seems to me that it's very, very simple. You don't approach casting on any other basis than seeing who could most richly, with his blood and cream, illuminate this part. And you cast idealistically, but you cast practically, you cast from what's available. Now the first thing that you look for in casting is decent people. A group can't work together if you stupidly, artificially bring into it someone that you don't really trust, because you have some secondary reason, either because you want a star or because you want to keep some political group happy. So obviously for a group to work together, everyone in that group must be fundamentally decent. (I don't have to develop that because each person's definition is different but you know what I mean.) So you have to have people who share a wish to do honest work together. Now, if each person in that group is genuinely bringing something appropriate from his own background, he is enriching the work. Now what can an actor bring? He can bring, on the one hand, his

talent which is perhaps genetic, but he can also bring the personal understanding that he has, that has been developed through his environment and also through the tradition, through the cultural tradition with which he has grown up.

I think it's so artificial to talk about black and white actors, because black and white actors who have grown up in the same cultural tradition – black actors born in Britain, for example – are British actors. Black and white actors in America become American actors and that's very right. An African actor, and specifically an African actor, for instance, from Mali, is an actor who has been brought up in a background in which his own natural talent, the influences of the twentieth century and an ancient tradition are all fused together. So it's obvious that the living material he carries in him are obligatorily different from yours and mine; it couldn't be otherwise. So he isn't a black actor, he's a Nigerian, a Zulu and eventually an African. In the same way, an Indian actor from India, has a mixture of elements partly coloured obviously by all the British influences and partly by two or three thousand years of tradition which he carries in him which are different. Now, if the subject matter is genuinely enriched by the coming together and the friction between backgrounds (which isn't necessarily or even often a conflictual friction), the friction of healthy exchange, then whether in three days, three months, three weeks, there's no difference, the work is at once enriched. The coming together of different people is the basis of casting.

Now, to be quite precise in relation to what you are saying, today, say in an English company, nobody will question the director's choice if he brings together an Irish actor, an actor from the south of England, a Jewish actor; nobody is saying, 'How is it you put side by side a man from Somerset, a man from Lancashire and a Jewish actor from the East End in one Shakespeare production?' It's inconceivable that anyone would make those divisions. You would just look at what those actors are bringing. I think that it's artificial to change that principle when you go out into the whole world. One recognises that outside the theatre, outside the creative act of making theatre, every one of the tragic divisions, conflicts, politics, violence of the world, exists. But for the question to be looked at in the theatre it is simply what in a group nourishes the work, and if in a group each person is aware that the other person is bringing something, there is respect.

BILLINGTON But language is also very important. How much does it matter that actors obviously will bring different linguistic skills?

BROOK It's a two-sided question. For instance, for myself it's a suffering not to be all the time working in English. Now, at the same

time I've been so much in France that I speak French pretty well, but it's not the same. I can't have the same relation with the French language. So there's a gap, and at the same time one sees that through that gap there is something that is stimulated by the fact that you have to put yourself much more alertly in front of each word. Well, it's the same with the actors. For actors it does work both ways. One can't say that it's an advantage for somebody to speak badly. It would be stupid to say that massacring language is better than not massacring it, but at the same time, if we'd had a group of actors who have worked with us over the years here this morning and if you put that question to them, they would be saying that with the difficulty of being in a foreign language one's more alert, more focused and that each word has a challenge. So it's a mixture of both. That's why there is a threshold. If people speak too badly, it's too irritating for the audience. If you get beyond that threshold, the performance is understandable enough for one to be able to feel even a richness in the fact that people are not talking in a standardised way.

BILLINGTON I'd like to pursue the subject of internationalism just for a moment. We want the theatre to be based on what you call healthy exchange, actors coming together from different cultures. But do you think that there is something else perhaps going on at the moment? Do you see any danger that whatever is specific to, say, British or French or Japanese or whatever culture you name, is in danger of being eroded?

BROOK I think it's completely true. It's absolutely true that there is a tremendous strength – one sees it in writing – in the writer who has never left his village, wherever it is in the world, and who is writing directly from a specific experience in a specific part of the world. It's the strength of the tree with deep roots, there's no question about that. And I dread to think that what we're doing with our tiny group could be considered a formula and that one day there will be nothing but international groups all over the world.

There are two equally unhealthy but inevitable tendencies. As the world is gradually going towards internationalism, towards the global village, simultaneously it is shrinking into these tiny hostile, ethnically purified little knots and that is perhaps not extraordinary because perhaps all through history every movement that goes in one direction is paralleled by a movement going in the opposite direction. And so the expanding and the fragmentation, which have always existed in some ways, are more acutely visible in our world than at any other time in history. Internationalism is unhealthy because it is going towards a destruction of cultural flavour. It's going towards what television is doing and one can't say that this is

anything that anybody really wants or likes. At the same time, like King Canute, one looks at the tide coming in and one knows that one can't say stop. Whatever we say about television is not going to have any influence on the fact that by next year there may be forty channels and there'll be two hundred the year after, and this movement, this spreading movement can't be helped. If it is in itself unhealthy, because it leads to blandness, the shrinking is obviously totally unhealthy because it's making more and more fragments that are mutually exclusive, hostile and defensive, that in itself is bad.

So take this away from the global level and take it to the specific and artistic level, and there one sees that both tendencies can be respected as being healthy. It is healthy to try to struggle, to reinforce the specific of a culture where that's being destroyed, taking into account that in most cases this is a phoney action. Today, I don't think you can any longer, for instance, say what is an authentically English play. Not long ago John Major, making a statement that the essence of England is the charm of the parish church in the evening and the sound of the cricket balls in the distance, was met with a reply that said 'Balls, yes'. But what about the other side of England? One sees in African countries intellectuals sitting in the city talking about being authentic and talking nostalgically about a traditional Africa they themselves have long lost because they are already part of the city culture, and they want to make films and do television, and they get videos from all parts of the world, and they have been brought up, like any of us, in these enormously confusing cultural crosscurrents. Now, for instance, with GATT, the French are saying 'French culture'. You try to find out what they mean by it. Holding on to the authentic culture becomes very diffused. It comes back to the same thing, I think. You must look at the question differently. What can enable one to break through the clichés to the root of an authentic human experience? Either one breaks through what seems to be the specific culture or you break through the blandness of the international mixture. In either case, the real bland land, where there is no real meaning, is somewhere in the middle.

BILLINGTON Is there something in the ambience and spirit of Paris that makes it a particularly congenial place to do the kind of work you want? Paris particularly seems to gather people from a lot of different cultures to itself. You have Jorge Lavelli, an Argentinian, running one of the National theatres, don't you? Lluís Pasqual running the the Théâtre de l'Europe at the Odéon.

BROOK I think the French have always been very smart and they've always realised that if they welcome artists from many parts of the

world, which they've done in painting for instance, it enriches their own scene. Paris has been this hub of influences for a long time, and I think it shows not only generosity and sympathy but also very shrewd commonsense on the part of the French who do a lot of things better than we do. They look after their cities better, they do a number of things through the fact that they have very clear minds and they see what's useful, and I think one's always recognised that British insularity is not necessarily the result of clear thinking.

BILLINGTON You've often spoken and written indeed about a theatre in crisis. That is a constant theme in your writings over the last twenty-five years. I wonder if you still feel that to be true? Obviously if you look around the world, the big institutions are still there. The commercial theatre clings on precariously in most major cities. Don't you feel there has been a healthy tendency in theatre over the last twenty-five years, a loosening up, an emphasis on common experiences and, particularly, an exploration of new spaces. This has been one of the most exciting things which you have been obviously instrumental in achieving. Aren't there healthy things happening in the theatre internationally?

BROOK Nationally.

BILLINGTON Nationally?

BROOK Nationally. I think that there's absolutely no question that something extremely vital has happened and is going on in England. One can say all manner of things about specific events in England but one can't say the theatre isn't alive because there is – and has been now over the last thirty years – a tremendous lot of energy in the theatre. One can't say that's true internationally, I don't think it is. I think that the theatre internationally has recovered from the inferiority complex given by the cinema. The theatre has emerged from it and is no longer universally considered by any young person as being something old-fashioned and dead while cinema is the only thing that belongs to our time. Those days are over. The real releasing of energy has taken place more in this country than anywhere else and one can only hope that the current of a growing unimaginative bureaucracy, demanding all the time more and more theoretical promises and putting more and more constraints on every penny that they give out on each of the theatres, is not going to end up by in the end by blocking a tide that has been going on very well and very successfully over a long period of time.

BILLINGTON In your travels, however, haven't you found that in most countries there is this reinvention of the theatre space, the search

for new environments in which theatre can happen – isn't that happening not just in Britain but all over?

BROOK I wouldn't think so, no. I wouldn't think so at all. I think that everything comes back in the end to basic economics. Perhaps the most vivid dramatisation of this is what's happened in New York: that because Broadway was so expensive it had to become very conventional and the people who did Broadway shows had to be continually thinking of success at all costs and that had to put a strait-jacket on the type of work that was being done. So, in the sixties, Off-Broadway was a very natural alternative, and the alternative of Off-Broadway was that there was Broadway which sets these restrictions because it costs a lot. It costs a lot more to do the same play in New York compared with London. It used to be possible to do a play even in the West End quite reasonably without anybody taking a great risk – the same was already an enormous risk on Broadway. So Off-Broadway arose to be free of that. At that time, Off-Broadway cost very little, so people could go into garages and use spaces freely and easily. Then gradually, as Broadway got more and more expensive, Off-Broadway began to get expensive. As Off-Broadway got expensive it again became what it is today, another form of slightly freer but not much freer, commercial theatre because it begun to cost a lot. So you had Off-Off Broadway and Off-Off Broadway was again using these odd spaces with fairly miserable conditions because by now the cost of living has come to the point where someone even working on Off-Off Broadway wants to get into Off-Broadway itself to be able to pay for his apartment and his wife and kids, and I think that this factor is there growing everywhere. As everything gets more expensive there is – as much as there is a return today to the tie and the jacket – a return to using the conventional space. For instance, in Germany, the only available possibilities of doing a production really are in the conventional spaces and the conventional institutions, and I think that they are getting more and more in difficulties because the subsidies are getting less, so I think there is a shrinking back.

AUDIENCE QUESTION 1 Although I thought *The Mahabharata* to be an excellent production, when I went to India I talked to people who said that there was something un-Indian about the production. Do you agree?

BROOK I can only say I'm on your side. I learnt long ago – I don't know where it came from – the great saying that I think is one of the great pieces of wisdom of all humanity, 'You can't please all the people all the time.' It's quite clear that *The Mahabharata* has been the jewel of Indian culture for over two thousand years and when

we did it, it had hardly even emerged from India. We were a great deal in India, and when we made the film we went with the film and showed it, and had meeting after meeting with people in India. There were two types of reaction. There were those who were really touched and pleased that a great number of foreigners could feel that this was their story, that the African actor or the Japanese actor or the Polish actor or the English actor all felt 'This is our story'. But of course, human nature being what it is, there were the other Indians, the fundamentalists, who were saying 'Hey! What do they think they are doing? This is our story, they have no right to touch it. Do they realise that they should have done this, that this is unorthodox, this isn't right…' and so on, and so forth. And of course, we tried as hard as we could to be respectful to the Indian understanding and to the Indian meaning which is what we felt that we shared, without imitating the Indian form. If we really tried pedantically to turn ourselves into phoney Indians, however, we would have been very ashamed of the result.

AUDIENCE QUESTION 2 It's said that the average attention span of the Broadway theatregoer is about two and a half minutes, hence I think the popularity of musicals, because someone will sing a song every so often. I'm just wondering if that spread will creep out of the States and that in fact it will begin to affect us all, through all our attention spans. My second question is that I don't think you've paid much attention to the work of Bertolt Brecht. Do you find it stifling or not worthy?

BROOK The question of attention span is very simple. We started, or almost started, the big tour, the year tour of *The Mahabharata*, in Los Angeles, it was the second place we played. The last place we played was Tokyo. In Los Angeles we found that a very interested audience actually had a tiny attention span and that the actors in playing had to fight; every two and a half minutes the audience had to be 'regrabbed' and it's a way of playing, you just feel that as an actor. Speaking, as I'm speaking now, is very easy because you're all sitting there very politely, motionless, and it's a great help. But if you were really fidgeting I'd feel obliged every two and a half minutes to make a joke or perhaps to get up and demonstrate something and sit down again to recapture your attention. In Los Angeles, very nice people, very good people but conditioned by all the factors you talk about, had a very short attention span. A year later we're in Tokyo and the audience for nine hours didn't move. Totally attentive. There's television in Japan, but a tradition of listening hasn't yet been eroded. Perhaps by this year it has already, perhaps it's down to seven hours, that I can't tell you. So that is certainly true and that is again part of

the fact that if something is going in one direction, one needs for that very reason to go against it in another.

As for Brecht, I knew him. I admired enormously the productions he did as a director. I saw a lot of them, and he was the most magnificent director of plays. The plays that he did with his own company were the most staggering pieces of pure theatre craft that I've seen. It is well known, however, that if during his rehearsals one of his assistants dared say 'But Mr Brecht, what you've just said is the exact opposite of every theory that you've put down in a book', he would throw that assistant out of the rehearsal in fury. He really had almost a strangely split mind between the academic part of him that wrote theory and the man of the theatre who refused. He would, even in rehearsals, say 'I don't know what idiot wrote this theory, or what idiot wrote this part of the play', and it was a different Brecht. I think he is a landmark in theatre history, but like all landmarks, as one moves on, the landmark is behind. I don't think that today as a playwright and as a theorist one should take him either 100 per cent or zero, it's somewhere naturally in between.

AUDIENCE QUESTION 3 Do you always rehearse in French, or do you change about from English to French to Spanish? How do you arrive at a common language?

BROOK We have to have a practical basis for work so almost all the actors who come to us speak either French or English to a normal, practical degree and most of them end up by being reasonably free in both.

AUDIENCE QUESTION 3 [CONT.] And if the play demands, perhaps, like *The Mahabharata*, a totally different language, a totally different culture, then do you ever research the play in its original language, or do you just adapt it to English?

BROOK Oh no, none of us speak Sanskrit, but we couldn't have started without working on a Sanskrit text, with a Sanskrit scholar, listening to the sound of Sanskrit and weighing words that don't exist in our language, like Dharma, for which there are only approximate translations. So that is very important. You have to do that. When we did *The Cherry Orchard* it was the same thing. We had to go back to the Russian. Then as we were doing a French version for a French audience, we did it in French and then re-adapted it into English. On our travels over the years we have at times – but it's not something you can do with every play – tried to make local adaptations, and coming into a city the actors rapidly learn a bit of the text in Spanish or in whatever the local language is. In a play, particularly in a comic play where you can talk directly to the audience, even a few phrases of the language of the country make a great difference

in one's relation with the audience, because the audience know you are interested in them, that you are trying to make contact with them, and this makes a big difference.

AUDIENCE QUESTION 4 Have you ever worked with untrained actors?

BROOK What we've tried to do is to find people who can bring something to the group and that usually means bringing a mixture of openness and a specific experience. That's very hard to find because usually the people who are open haven't been toughened by experience, so they haven't got enough to bring and even enough resistance to stand up to the difficulties of work, and the people with a lot of experience are often closed by their pride in their skill. Always one tries to find those two together. Sometimes, for instance, when we did *The Tempest,* I felt that the most important thing was to have a Miranda who genuinely was fifteen or sixteen years old, and so we had, in fact, three Mirandas in the course of *The Tempest* and each one of them was for that very reason someone with no experience before they started, but it's different in each case. The ideal is courage and freedom, linked to a special skill of one's own.

AUDIENCE QUESTION 5 I noticed that you use words such as 'experiment' and 'laboratory', and in fact I think you described *The Man Who* as a piece of theatrical research. These sort of words suggest a tight methodology, things being investigated by you. They all sound like very untheatrical words.

BROOK I think it was Jerzy Grotowski who first invented the word laboratory for the theatre, and he's an extremely fine, shrewd and intelligent person. He realised that to have the freedom in a very strict communist regime to do something that was totally unorthodox he had to have an umbrella and if he had said, 'I'm founding a theatre company', he would have been under the pressures that come from people expecting him to do what theatre companies do. So he said, 'I'm making a laboratory', and the scientific overtones were extraordinarily good in a communist society because science and technology were highly respected. Had he said, 'I'm going to open a spiritual monastery', he would have been imprisoned the next day. In fact he opened a scientific laboratory and within it they did spiritual work.

Now, when we started a centre in Paris, I looked for the word that would give us the same freedom and we called it a centre instead of calling it a laboratory, and picked the words 'experiment' and 'research', calling it a centre of theatre research, partly to give oneself an enormous freedom because nobody in the world knows what you mean, so we really could do what we wanted. To start, to

get going, we had to get money from foundations and in those days foundations in America were much more generous and open than they can dare be today, and I could put forward the idea of theatre research, because research sounds academic. While in a communist country the laboratory is respectable, in Western countries, especially in America, 'academic' is very respectable. So theatre research sounded something good and serious to support. But I didn't cheat them, because even in our very first exposé of what we were doing, I said that in theatre, research means doing; it's not sitting around a table, it is exploring through doing. And from then onwards the only difference between experiment and research and doing a production is that in experimental work you don't have to deliver the result. If it's not good you abandon it. You haven't announced an opening date and you can, like in all sorts of research, make mistakes, you can change direction, you can benefit from a failure to start again. The human material, however, is the same as it is in any sort of theatre. It is bringing human material to life in its obvious, and one hopes, less obvious manners, to penetrate into human questions through human material, and for that all the time you have to put into question the means you use; whether it's the use of the body, the use of language, the use of all the things that we have talked about during the course of this meeting.

ION CARAMITRU

ESCRIBED by producer Christopher Barron as 'his country's unofficial cultural ambassador', the Romanian actor turned director turned politician, Ion Caramitru, enjoyed unprecedented success in his native country and abroad through his work at the acclaimed Bulandra Theatre during the difficult years of the Ceaucescu dictatorship.

Born on 9 March 1942 in Bucharest, he trained as an actor at the Institute of Theatre and Cinematic Art (IATC), graduating in 1964. He made his debut at the National Theatre of Bucharest that same year with the leading role in Mircea Stefanescu's *Eminescu*. From 1965 he worked regularly at the Lucia Sturdza Bulandra Theatre in Bucharest, first as an actor (while the company was under the inspired artistic directorship of Liviu Ciulei) and then a director. His dark romantic looks, exquisite timing, wry energetic playing, and intelligent interpretive skills quickly made him one of the Bulandra's key actors. His Leonce in Ciulei's engaging production of *Leonce and Lena* (1970), which visited the Edinburgh Festival in 1971, attracted dazzling reviews. The Bulandra, however, faced increasing difficulties from the reactionary Ministry of Culture and in 1973 Lucien Pintilie's production of *The Government Inspector* was closed after just three performances, effectively ensuring Ciulei's sacking and Pintilie's enforced emigration. Repressive censorship measures were introduced which ensured that all repertories had to be approved by the Councillor of Culture and Special Education. Also the Bulandra increasingly found its subsidy diminishing. Working as deputy director of the Bulandra in the late seventies, Caramitru battled against poor conditions, an unsympathetic artistic director and increasing government hostility. A politically charged production of *Hamlet* (1985) directed by the young director, Alex Tocilescu, with Caramitru in the title role, met with official indignation and international pressure was brought to bear to prevent its banning or toning down. It proved one of the Bulandra's most spectacular triumphs, a example of the theatre's power to speak out in defiance against the tightening grip of Ceaucescu's totalitarian regime. The allegoric vision of the play presented by Tocilescu had Caramitru's Hamlet battling against a despotic Claudius, despising himself for his own inaction. His prominent role during the 1989 revolution – he was a member of the Executive Bureau of the Council of National Salvation Front and President

of the Cultural Commission – and the provisional government where he served as vice president from February to May 1990 led him to stand as an independent candidate in the country's elections. When he was not elected, he refused to stand for the presidency and returned to the theatre, serving as artistic director of the Bulandra between 1990 and 1993, where he was responsible for a number of productions including David Edgar's *The Shape of the Table* (1991) and Terry Johnson's *Insignificance* (1985). Additionally, the eighties and nineties have seen him work increasingly in the fields of opera and musicals: Benjamin Britten's *The Little Sweep* (1983) and P. Urmuzescu's *Eminescu* (1989) for the Bucharest Opera. In the nineties Caramitru has worked outside Romania, following his *La Tragédie de Carmen* (1991) with an updated staging of Tchaikovsky's *Eugene Onegin* for Belfast Opera in 1994, acclaimed as an assured piece of storytelling. In 1990 he was instrumental in setting up UNITER (The Romanian Theatre Union), of which he remains the president.

Caramitru has been professor of acting at IATC since 1976. He has also had roles in over forty films including Steven Soderburgh's *Kafka* (1991), and in celebrated television series, including Tony Bicat's 1993 thriller, *An Exchange of Fire,* for Channel Four. His numerous accolades include Best Actor in the annual Romanian theatre awards in 1975, 1979, 1981 and 1985, the Filmsters Association Award in 1980, and the Special Jury Award for Interpretation at the 1984 National Film Festival in Costinesti for his role in *Luchian.*

OTHER MAJOR PRODUCTIONS AS DIRECTOR INCLUDE

Remembrances by Alexei Arbuzov. L. S. Bulandra Theatre, Bucharest, 1985
The Third Stake by Marin Sorescu. L. S. Bulandra Theatre, Bucharest, 1984.
Home by David Storey. L.S. Bulandra Theatre, Bucharest, 1992.
My Fair Lady by Alan Jay Lerner and Frederick Loewe. The Musical
 Theatre in Constantza, 1983.

CRITICS ON HIS WORK

Outstanding in a company of richly talented and idiosyncratic actors was one described by Michael Billington as the most exciting young actor he'd seen since the debut of Ian McKellen.
 (Richard Eyre, 'Noises Off in Elsinore'. *Guardian,* 13 September 1990, p. 21).

SIGNIFICANT BIBLIOGRAPHICAL MATERIAL

Bailey, Paul. 'The Romanian Revolution That Never Was'. *Guardian,* 18
 December 1993, p. 27.
Crane, Richard and Williams, Faynia. 'In Romania Theatre was Vital Food
 for Thought Before the Reforms'. *Guardian,* 4 January 1990, p. 27.
Milne, Seamus. 'Exit the Villain'. *Guardian,* 6 March 1990, p. 38.

Ion Caramitru in conversation with Christopher Barron
and Maria M. Delgado, at the City of Drama Offices,
Manchester, 11 May 1994

BARRON Theatre in Romania in the mid-nineties is incredibly powerful and strong. Why do you think this is?

CARAMITRU Romanian theatre has been strong for many years. Looking back at the history of Romania we can see that this is probably a miracle. When Shakespeare was writing *Hamlet*, Michael the Brave was only just creating Romania, putting together the three Romanian provinces of Walachia, Transylvania and Moldavia. There was no sign then that theatre would be a part of the country. The first performance in the Romanian modern language was only about 150 years ago. That's our whole tradition.

Romania has always been in the middle of the most barbarous wars. We had to create a resistance – a moral resistance at first and then an artistic one. Our folk music and folk poetry is fantastic. There has always been a balance between fighting and comedy in our culture and so the two masks of the theatre belong to our life. During the totalitarian system (particularly communism, but we had other forms of totalitarianism before that) our double life created a fantastic black humour and resistance. That's probably the definition of theatre: to play both parts, both sides of the human being.

We were terribly rich in jokes before 1989: bitter jokes but significant nevertheless. It was probably the history of what you are never able to say. Theatre used to have a very special kind of importance, not only in Romania but everywhere in the former Communist bloc. Sometimes it was a place to worship, sometimes a forefront of resistance. It created a special language, being clever enough to escape the censorship through metaphors, double meanings and allusion. Today we would consider such an importance for theatre to be a privilege. At that time, as artists, we could work in a very special kind of territory which we don't usually have. You had to create big and courageous new dimensions, to build up 'a bridge of smoke' – or something like that – between the stage and the audience. With the abolition of communism, we lost this privilege, because the action on the street was more spectacular, more important, and more vital. We had elections, demonstrations, a parliament, trials and the arrival of the miners. There was new television for fourteen hours a day, not two or three hours as we had before. Theatre lost its audience, lost the people. Could you imagine that before 21 December 1989 we had a full house when we were performing *Hamlet* or *The Tempest* or *Home*? Immediately after 5/6 January 1990, we opened the theatre. No-one came.

We had to do something to rebuild the interest, so I called Romanian people outside the country, most of whom had left Romania twenty or thirty years before. I asked Andrei Serban, Lucien Pintilie, Liviu Ciulei and Alex Tocilescu to come back to Romania. It was not only theatre people that I encouraged, but also conductors and philosophers like Sergiu Celibidache, Eugene Ionesco and Emil Cioran. Some of them said 'Yes'. Andrei Serban came and took responsibility for the National Theatre in Bucharest; Liviu Ciulei came back to the Bulandra Company to direct *A Midsummer Night's Dream* and *Spring Awakening*; Tocilescu came back and, finally, he directed *Antigone*. Others, maybe not as important as these, but nevertheless strong directors and actors, also came back. So, in October 1990, Andrei Serban opened the big doors of the National with his famous production of *The Greek Trilogy* and the people flooded in.

There were also many directors who never left Romania, like Silviu Purcarete who created *Ubu Roi*, which was selected for the Edinburgh Festival a number of years ago. The production of *Ubu* was still a very political view of history, in comparison with his later *Titus Andronicus*, which is a very poetical production and not at all political. *Hamlet* and *Ubu Roi* as productions had very strong political views about the destiny of human beings, but Mihai Maniutiu's *Richard III*, in Manchester now, is a production of our times.

BARRON Free times.

CARAMITRU Yes.

DELGADO In the past, did the opposition mainly lie in texts, approved by the Ceaucescu regime, which were then staged in a politically subversive manner?

CARAMITRU Yes. We had a huge fight over *Hamlet*. It was practically banned for three months. We did a new translation into modern Romanian which was very free but very poetical and very strong. For example, we made some changes at the end of the play and Fortinbras's people killed Horatio because Horatio says 'I am going to tell the truth about the story'. It is not possible to deliver the truth, so he is killed. The censors stopped the production and said we had to go back to the original and respect it. They became the lawyers of Shakespeare. We said we wouldn't change a word and that if they wanted to ban the production, we'd make the five of them famous all over the world because they stopped Shakespeare and *Hamlet*. So, they discussed it again and allowed the production to proceed.

Today there is no censorship. Theatre people are now obsessed with creating magic realism, which is probably the best definition of current Romanian theatre. We have a very good tradition of realism

which comes from Stanislavsky, but we have added to this realism the magical invention of visual theatre. It enables us sometimes to escape from the texts, and sometimes to drop into them meanings that would not normally be apparent. I don't have enough English words in my pocket to make you understand what I mean. This is probably the reason one needs to refuse the subtitles for Mihai Maniutiu's current production of *Richard III* which is touring England. It is simple to follow and the audience must be allowed to recreate the poetical image for themselves. Probably the destiny of Romanian theatre today belongs to this kind of theatre. We are still privileged to have big companies, of many actors, who live on a feeling of agony and ecstasy. The ecstasy comes from the potential and the powerful theatre tradition we have, and the agony is the administrative structure, which is terrible. It is the same one we had before the revolution. Even some modest initiatives to create a sort of free market for the performing arts are proving very difficult.

BARRON Are there no independent theatre companies?

CARAMITRU There is only one, the Levant, but in three years it's only managed to stage three productions, which is nothing. It is practically impossible for independent companies to operate.

BARRON Could you tell us about UNITER and how it came about?

CARAMITRU UNITER means union of theatre people. It's an independent organisation which is not subsidised. It was created in February 1990, following twenty-five years of the loss of our rights as artists in Romania. Actors, musicians and those who worked in cinema used to be considered civil servants and were paid a salary. We have never been considered artists. They used to say, 'You play Shakespeare. Shakespeare is the creator and you are the interpreter.' So I proposed a change. I said to the parliament, 'If Herbert Von Karajan and Sergei Celibidache conduct the same piece of Beethoven on two different evenings with the same orchestra, is it a copy of Beethoven? They do the same thing but they create a completely different world with the same music. They are artists not interpreters; they recreate the symphony.'

My initiative in the provisional parliament was successful. We were able to vote for a new social level as artists through the creation of UNITER as a union of theatre artists. We now have about seven hundred members who are critics, actors, directors, puppeteers, ballet dancers and so on. We work on projects and programmes, and there is a competition for new writing. Every February there is a gala awards ceremony in Bucharest. We have an idea for a theatre called the Inoportun but we have no stage yet. Nevertheless, we've had four productions so far. There is also a programme called 'Arts

School' – 'Art d'école' – and theatre workers go to the orphanages to do art therapy with theatre tools in the hope of creating an artistic atmosphere to help in the care of the children.

We also have a publishing house which has just opened as a place for new writing. We're planning some foreign playwrights' collections: one will probably be in connection with Ireland, and another, we hope, will be a collaborative venture with Great Britain.

DELGADO How is UNITER funded?

CARAMITRU We make some money renting out our home. Our headquarters is a famous house which belonged to the Communist Party in Bucharest, specifically to Nicu Ceaucescu, the son of the dictator. We have rooms to rent and we make some money from that. We have sponsors for the projects and programmes. There are also impressarios and donations.

DELGADO One of the striking aspects of Maniutiu's production of *Richard III* was the complicity between actor and audience. How is this achieved?

CARAMITRU This is a result of the long training we have had. The complicity you mentioned is probably one of the strongest things that we have discovered in our productions. *Ubu Roi* was the same.

BARRON Could you explain a little about the famous production of *Ubu Roi*.

CARAMITRU It was actually *Ubu Roi* with scenes from *Macbeth*, and it was particularly resonant at the time because Romania was run by a couple: Ceaucescu and 'Lady' Ceaucescu. The Jarry story about Ubu Roi and Madame Ubu seemed to echo our own predicament, with Madame Ubu sometimes more important than her husband. *Macbeth* is really the same story and I was obsessed by it. I talked about it in 1988 with Deborah Warner who was in Bucharest to see *Hamlet* and a number of other Shakespeare productions. When we staged *Hamlet* in Bucharest, nobody knew at the time that such great change would come so fast. Purcarete started *Ubu Roi* before the revolution; it was partly the bridge from one world to the next. He wanted to recreate, with this grotesque and strong image, the danger of Communism and the stupidity of the famous Romanian couple. It was an absolutely marvellous and very visual production.

BARRON Has the strength of theatre production been matched by the emergence of new playwriting since the revolution?

CARAMITRU *Ubu Roi* was for almost three years Romania's most successful production. We are really confused by the revolution and its results. The new leaders of the country are neo-Communists – the same people who were in power before but even worse.

Playwrights are perplexed. They need time to think. In Britain, David Edgar and Caryl Churchill immediately wrote new plays about what happened in this part of the world. I worked with Caryl Churchill in Bucharest and I did my best to help her create *Mad Forest*. But these are not really good new plays because they are quite superficial. You can't understand 100 per cent of what's going on in the country; at that time it is not explicable. Only now have Romanian playwrights started to write new, remarkable plays. I can think of two or three in particular.

DELGADO You were primarily known as an actor; how did you turn to directing? Was it a question of necessity?

CARAMITRU Originally I had wanted to be a director. I finished high school and was ready to sit the exam for the Institute of Theatre and Cinema Art, but exactly two weeks before the exam the directing class was closed for a year. So then I wanted to go to university to study literature, but an older friend of mine, who was a film director, suggested I take the acting examination. He told me to get a place there for a year, because it's good to study acting. It's important for a director to know the secrets of the profession when you're working with actors. So that's how I became an actor, without any special interest at first, and then I warmed to it. The directing class was actually closed for seven years, so after I finished acting school I started to perform. Nevertheless, while I was working as an actor, I still had in my mind this old obsession to direct. Then I started to teach at the Academy and did a couple of theatre productions with my class. One was based on a play written by Marin Sorescu, who is now at the Ministry of Culture. It's a play about Dracula (Vlad the Impaler) called *The Third Stake*. The other was Brecht's *Mother Courage*. I then moved to the Opera in Bucharest and did Benjamin Britten's *Little Sweep* with a huge chorus of children. After that I did *My Fair Lady* and moved to the Bulandra where I directed *The Third Stake* again, but this time with my company. I also did David Storey's *Home* and David Edgar's *The Shape of the Table* .

BARRON How long were you at the Bulandra for?

CARAMITRU Thirty years.

BARRON And what status does the Bulandra have in Bucharest?

CARAMITRU The Bulandra used to be the Theatre Municipale – the city theatre. We re-named it Bulandra in memory of Madame Lucia Sturdza Bulandra, a famous Romanian actress.

BARRON And it was the Bulandra Theatre that brought *Hamlet* to London and Dublin in September 1990.

DELGADO What do you think being an actor has taught you about directing? Do you think your approach is different to that of directors who have only ever directed?

CARAMITRU Many people in Romania say actors must act, never direct, and directors just direct, never act, which is quite stupid because I know a lot of people who do both brilliantly. There are some famous directors who used to be actors and they gave up this profession to move on. In the last four years, I have only played one part as an actor, Creon in Sophocles' *Antigone*. But I direct regularly.

DELGADO Being in charge of UNITER, you must obviously do a lot of administrative work. Is that something you enjoy? Is it something that has been thrust upon you rather than something you have chosen?

CARAMITRU It was difficult to structure the activity of such a new organisation because we didn't have any experience. We just had the desire to be considered as artists. The first statutes we had were a copy of the writers' union, which were perfectly absurd for us. Last year we fundamentally changed the system. In UNITER we were in sections: actors' sections, directors' sections, and so on. That didn't work because there was not enough money and no activity. Everyone is working in companies and theatres so they don't have time to do special work, or anything like that. The structure was meaningless. Some people, especially those who were important in the old regime, wanted to keep their position as president or general secretary of a section. It was absolutely stupid. We organised a general assembly last year to create new statutes and there was a big scandal but we now work as you do in Great Britain. Everyone is an equal member of the union. We have a full programme of projects and the actors, directors and designers all have their own system for fundraising and are paid from the money they get.

DELGADO You had a conspicuous and documented presence in the revolution. How does an actor/director become involved in the overthrow of a country's dictatorial government? Did your protaganism in the revolution come from being known as an actor?

CARAMITRU I realised that afterwards. At the time I didn't know if I went there as an actor or as a human being. I was waiting for such a big change for a long time. I was terribly involved in a feeling of hating the Communist system. My family was a bourgeois family with a difficult history and many problems with the regime. They are Romanians from Macedonia who lost their property and their land. They had to move to the very south of Romania, to a territory which belonged to Romania before the Second World War. In 1940,

through the Molotov/Ribbentrop Pact, the land was given back to Bulgaria as Bassarabia, and my family had to move again after twenty years. After the war the Communist and Russian tanks came to Romania and King Michael's abdication created a one-party state: no democracy, no parliament, nothing. People like my father and my family were considered public enemies. My father spent twelve years in prison. I lost two uncles in the Communist prisons. I was always in danger. Communism was such a cancer. I was at school in 1948 whilst Stalin was still alive. You can't imagine the hell we went through. I passed those years having the fear that there was something wrong with me.

My position in the revolution was like going to something you have been waiting for. People in the streets would recognise me, especially the teenagers and young people. They urged me to come. We started pressurising people to join us and the street fighters. We tried to make the soldiers, the army and the security forces come with us; they were all around Ceaucescu's headquarters. It was very dangerous but we were so enthusiastic. And then the next morning, when Ceaucescu left by helicopter, we found that the head of the army had committed suicide. It was the signal that the revolution had succeeded. The army joined us and we went to the television station.

BARRON To attack?

CARAMITRU To attack. I was riding a tank.

DELGADO I think it's had an influence on the West in that ten years ago we would not have imagined artistic figures in this country becoming involved in politics to the extent that, for example, Ian McKellen has in England with Gay Rights issues. Do you think that the repercussions of what happened in Romania have been seen throughout the West?

CARAMITRU It's probably connected to the courage we displayed in telling the truth in our performances during the Communist regime. People used to come and know that there was someone strong enough to tell the truth, even in this secret language. Some of us did it well. But there were others who used to recite poems on television for Ceaucescu and the regime.

DELGADO It's interesting because when censorship existed in Spain, under Franco, one of the things that was significant was the fact that the censors were actually quite naive about theatre because they came mainly from the military or the clergy. So there were lots of strategies for evading the censors. One of the reasons why the Catalan theatre was so vibrant was because there was a whole notion

of body language which was then employed in the production, which was not present in the actual script which couldn't be written down. They would rehearse two productions: one for the censor, one for the public. Is that in any way analogous to what happened in Romania?

CARAMITRU We had specialists in censorship. You can't imagine it. Not military personnel but literary people. They paid a lot of attention to every word and inflection.

BARRON Did you have to present scripts at the time?

CARAMITRU Every theatre had to present the repertoire for the forthcoming season. You had to wait a year before you were given a decision on a play. They had specialists who read the play and decided if anything dangerous was in it. I couldn't get permission in 1988 to stage Howard Barker's *Scenes from an Execution,* which was a very good play for that time. I met Barker twice and told him that he wrote the play like a Romanian living in Bucharest. The censors refused to give their permission. I fought with them, saying that the story is based on an old Renaissance tale from Venice, but they still said no. They were clever. If they said yes to a play, they used to come and follow the rehearsals. And there were at least two previews for the commissions before final approval was given.

BARRON When you meet one of the old censors walking down the high street in Bucharest today, what do you say to them?

CARAMITRU They are back in power. We have to knock on their door.

BARRON So they're still in their offices?

CARAMITRU Yes. The Ministry of Culture is the most incredible place now in Romania. Ex-members of the Communist Party are directors of departments and the very important positions are occupied by the most orthodox.

BARRON Is there technically any censorship now?

CARAMITRU We have terrible financial censorship. For example, paper and typing are an incredibly expensive price.

BARRON Something I've noticed in Romania is that theatre attracts young people. Very educated young people seem to have learnt plays very well; they know every scene.

CARAMITRU Not only theatre. Young people are very well educated because, waiting for better times, we decided it's much better to put your money and energy into your children.

DELGADO Where would you like to see Romanian theatre going over the next ten years?

CARAMITRU There has to be a law, or the freedom, to create very flexible companies. Most of the people in the companies are engaged for life, which can be very good, but also very bad. I'm completely convinced that the Romanian theatre needs money from the state. It needs a budget. Theatre must be subsidised otherwise the strength of the Romanian theatre will very soon be lost.

LEV DODIN

ESCRIBED by Peter Brook as 'the finest theatre ensemble in Europe', the Maly Dramatic Theatre of St Petersburg under the artistic directorship of Lev Dodin has forged a unique position for itself as the premier company of the new Russia, delighting European audiences during its extensive tours with a largely Russian repertory of plays in emotionally charged and highly detailed productions of memorable intensity.

Born in Siberia on 14 May 1944, Dodin trained at the Leningrad Theatre Institute which he entered at seventeen, studying under Borin Zon. Although his final thesis production there was a television adaptation of Turgenev's *First Love* (1967), his initial work on leaving the Institute was in the realm of children's theatre (at the Theatre for Young Spectators), and it was not until the premiere of his freelance production, Ostrovsky's *Bankrupt*, that he was hailed as a major new director. During the late sixties and seventies, he directed at the most prominent theatres in Russia, including the Bolshoi Drama Theatre where he staged Dostoevsky's *The Gentle One* (1981), and the Moscow Arts Theatre where he staged Saltykov Tscedrin's *The Golovlev Family* (1984). Dodin was first invited to work at the Maly in 1975 by the then artistic director Efim Padve, and his production of Carel Capek's *The Robber* was acclaimed as a significant debut. The emotional impact of the performances and the exquisite attention to detail were hallmarks of a production which ensured that Dodin would be invited to direct there again. His second production, the multiple storyline *House*, premiered in 1981 and adapted by Dodin from the novel by Fyodor Abramov, has been in repertory ever since.

Assuming the artistic directorship of the company in 1983, Dodin has guided the Maly towards an aesthetic which relies on lengthy rehearsal periods which permit extensive experimentation. His large permanent company provides a welcome alternative to the habitual Western approach of four-week rehearsals and an analogous performance schedule. Convinced that theatre pieces should enjoy a long life like a good book or a fine wine, Dodin keeps productions in the repertory for years. Enjoying strong links with the State Theatre Institute, where Dodin is a professor, the Maly's formidable company of actors are largely Dodin's former students. The group, therefore, have grown up and worked together over a relatively long period of time. When accused of nepotism in employ-

ing his own students in his company, Dodin has replied by stating that such a decision is based on the need to share the same theatre language.

The company are primarily known for their productions of key Russian works: encompassing both classical works, adaptations of major realist novels (most conspicuously the work of Abramov), new plays, like Alexander Galin's *Stars in the Morning Sky* (1987), and collective creations like *Claustrophobia*, a co-production with MC93 Bobigny premiered in 1994. Suffering the opposition of the authorities in the pre-Glasnost era when their production of *Brothers and Sisters* (1985) was viewed as unpatriotic, the limited funding available in the new democracy has necessitated a search for alternative sources of income. Closing down their St Petersburg base for several months in the spring of 1994, the Maly undertook a major European tour where euphoric critical reviews greeted their British and French performances. *Brothers and Sisters*, a six-hour epic adapted by Dodin, Sergei Bekhterev and Arkady Katsman from the four-part novel by Abramov and performed by a cast of thirty-six including Dodin's wife Tatyana Shestakova, offers a simulateneously epic and intimate portrait of a village engulfed by poverty in the aftermath of the Second World War. Like *Stars in the Morning Sky*, a more intimate six-hander, set in the derelict barracks where a group of prostitutes has been confined to keep them off the tourist-heaving city centre streets during the 1980 Olympics, and *Gaudeamus* (1993), a series of nineteen improvisations of great physicality and inventiveness created with the Institute students and based on a story by Sergei Kaleidin, *Brothers and Sisters* provides a searching deconstruction of the tarnished myths of prosperity, order and stability nurtured by the Communist authorities. Although the pieces are refreshingly different, an innovative use of the simplest imagery, masterful performances of great versatility and emotional reserve, and an exquisite orchestration of the stage action provide a grand theatrical experience which is not easily forgotten.

The impact that the Maly has made in Europe in recent years has ensured the invitation of Dodin and other company members to work abroad. Dodin visited Newcastle-upon-Tyne's Northern Stage Company to assist artistic director Alan Lyddiard with rehearsals for their production of *Stars in the Morning Sky* in early 1993. The Maly have won a number of prominent awards, including two from Britain: an Olivier for Outstanding Achievement, the first awarded to a foreign company in 1988, and the Award of Regional Theatres in 1992. Dodin is the current secretary of the newly formed Russian Union of Theatre Artists.

Lev Dodin and Michael Stronin have been colleagues since they

were students at the Palace of Youth Creativity in 1956. Michael Stronin is the dramaturg of the Maly Dramatic Theatre.

OTHER MAJOR PRODUCTIONS INCLUDE

The Master by Maxim Gorky. Theatre for Young Spectators, St Petersburg, 1969.

A Family Affair by Alexsandr Ostrovsky. Theatre for Young Spectators, St Petersburg, 1972.

The Minor by Denis Fonvizin. Theatre of Drama and Comedy, Liteyny, 1977.

The Rose Tattoo by Tennessee Williams. Maly Dramatic Theatre, St Petersburg, 1977.

A New Appointment by Alexsandr Volodin. Maly Dramatic Theatre, St Petersburg, 1978.

Love's Labour's Lost by William Shakespeare. Theatre of the Leningrad Theatre Institute, 1979. Co-directed with A. Katzman.

Live and Remember by V. Rasputin. Maly Dramatic Theatre, St Petersburg, 1979.

The Devils adapted by Lev Dodin from the novel by Fyodor Dostoevsky. Maly Dramatic Theatre, St Petersburg, 1991.

The Cherry Orchard by Anton Chekhov. Odéon Théâtre de l'Europe, Paris, then Maly Dramatic Theatre, St Petersburg, 1994.

CRITICS ON HIS WORK

Just why is the Maly Theatre so good? ... One could mention the fluency of the ensemble work, the familiarity that grows out of company life under the director Lev Dodin, and the longevity of the productions. But it also comes, I think, from the Maly's agonising reappraisal of a great 20th century idea, one dyed especially deeply into Russian history.

(Jeffrey Wainwright, 'Pulling Together', *Independent*, 27 April 1994, p. 26).

SIGNIFICANT BIBLIOGRAPHICAL MATERIAL

O'Mahoney, John. 'Buying Time'. *Guardian*, G2, 11 April 1994, p. 6.

Cranitch, Ellen. 'The Punishment Fits the Time'. *Independent*, 23 April 1994, p. 28.

Dodin, Lev. 'Pourquoi la Colere?'. *Théâtre en Europe*, 17, July 1988, pp. 72–5.

Lev Dodin in conversation with Robin Thornber at the Royal Exchange Theatre, Manchester, 23 April 1994, translated by Michael Stronin

THORNBER I'd like to begin by asking about the genesis of this concept of an ensemble company. How did that begin?

DODIN The ensemble work at the theatre is not my invention and not my discovery. The order of this discovery belongs to [Konstantin] Stanislavsky who, together with [Vladimir] Nemirovich-Danchenko,

built the Moscow Arts Theatre at the end of the past century (though he had used the example of the Empire Russian theatres, as well as that of the German theatres belonging to Count Mannheim). In the theatre where Stanislavsky worked there was an attempt to organise the action on the stage, but Stanislavsky and Nemirovich-Danchenko put an emphasis on the spiritual unity of the ensemble, on the actions of all those who worked in their theatre.

Before Stanislavsky and Nemirovich-Danchenko, indeed parallel to them, and even after them, there is the existence of the theatre as production line. It is like a factory which rapidly produces works of theatre, just like a mass-produced book which appears and disappears. It's particularly characteristic of our time, that parallel to the mass production of everything, especially consumer goods, there is a mass production of art and a mass production of theatre. Stanislavsky and Nemirovich-Danchenko – people often forget these names – they were the first to put theatre on the same level with great literature, great literature which is produced by one strong spirit. It is well known that great literature exists in time. It is written in a certain time, but nevertheless it changes with time, and you can go back to this literature, you can go back to these books. You can find and discover something new, more relevant to the time. You can discover new terms, new colours in these books. The same can happen to a theatre production. Parallel to Stanislavsky's theatre, there existed in Moscow a theatre owned by [Fyodor Adamovich] Korsh and this theatre invited some outstanding Russian actors. The Korsh Theatre produced new productions each week, whereas the productions at the Moscow Arts Theatre had a life of fifteen and twenty years – and when I say 'lived', I really mean that they lived, they were not like wax works, produced once and staying still over time. They developed, they really lived a life.

These are two opposing examples of theatre, and since that time these two tendencies have co-existed. There is the tendency, to put it conventionally, of a production line, and then there's the theatre which creates works through one whole spirit. One is just a place where people work, and the other is the place where people search for spiritual values and where a theatre production is a sort of by-product, but spiritual life, spiritual exploration and spiritual research are the main things. Those actors in the Moscow Arts Theatre were united by one objective, one aim, even though they were individuals, and very strong individuals. Nevertheless, their life was regulated by certain moral laws, ethical laws, and one aim.

This example of the Moscow Arts Theatre, from time to time, inspired people to create ensembles, to create a theatre governed by

this spirit. They were more or less successful and existed during different periods. For example, there was the Sovremennik in Moscow which was founded in the fifties, and then the experience of the Taganka Theatre in Moscow too, under [Yuri] Lyubimov. This was very important, particularly for Russia, because after 1917 religion was actually persecuted and was ousted from the conscience of the people, and the need for the spiritual was thus always there. Even before the revolution, the official religion, the religion of the state, didn't satisfy artists; that religion was too close to the government, to the ruling classes and it was bound by dogmas. That is why the idea of the arts as a certain religious cult was always strong in Russia, particularly at the turn of the century. (By 'religious cult' I mean the religion where man finds and discovers himself as a personality conceived by God.) When [Vsevelod] Meyerhold created the first studio, under the guidance of Stanislavsky, he wrote in the programme that theatre is a religious place where people live together, a kind of community, and an actor is a dissident. The word Meyerhold used denotes the notion of a community that does not live according to the official religion of the state. They live as hermits in a sort of cave or catacomb where they don't see others and are opposed. Coming back from history to our time, these words served as a sort of motto for us. In 1977, a company of my students and myself went to the north of the country with a strong wish to find material for our first production, *Brothers and Sisters*, and the similarity becomes ever stronger, because we lived in a monastery with no electricity and no heating and we used candles and used fire, so the similarity's probably even symbolic.

One of my teachers was directly connected with Stanislavsky and another with Meyerhold. Probably, therefore, I absorbed from the milk of my theatre-parents this idea that theatre is not only an important part of life, but life itself. Despite all the difficulties of our lives at that time, I tried to follow this idea. I tried to develop this idea in the first plays I directed and through teaching the same idea to my pupils. Those were really very difficult years because we lived under a very cruel system. There were long periods in my life when I had no job at all, because officials wouldn't let me work in the theatre, but I had all these opportunities to communicate with young people, first with my peers and then with people a little bit younger and then much younger than myself. Sometimes these young people left me because they had to work in other theatres and had to earn money, but still our bond was strong and they came back. We always retained our feeling for the theatre, as we understood theatre. It's a very interesting and strong thing; once you've given your feeling and your understanding, once you've taught it, you

72

IN CONTACT
WITH
THE GODS?

have to follow it through because the person whom you taught believed you. It is thus impossible to go back.

I worked as a guest director at the Maly Theatre in the seventies, and it was just a theatre like any other theatre. There was nothing special about it. I then invited a few of my students back to work with me. Since it was not my theatre and thus subject to other laws and rules, I sometimes had to make compromises. And once – I don't remember exactly when – there was an incident, and one of my former pupils who worked with me on the production at the Maly said, 'If that had happened during our student years, you wouldn't have forgiven us.'

When, in 1983, I was offered the position of artistic director at the Maly Theatre, I began my work (at the theatre) by inviting my former students and former pupils to this very little – because Maly means 'little' in Russian – theatre, which was in all respects (and still is) a very modest building housed within a block of flats. It was then that I began to 'collect' my pupils, who all belong to different generations. It was a process begun when I began my teaching career in 1967 and it has continued up to the present time. It happens that now, for me and for many actors, Maly Drama Theatre is not just a theatre, but part of our life. Of course this life is not that simple. As in any family, there are conflicts and there are problems and some- times we get sick and tired of each other. For example, we [Michael Stronin and myself] both met back in 1956 and there's time enough to get tired of each other!

THORNBER How do you see your own role in the ensemble, is it that of the father of the family?

DODIN It is very difficult to say that I am the father of the family. I may consider myself to be the father of the family but some actors may think of me as a son of a bitch. To a certain degree, yes, I suppose I have to be a father figure. There is perhaps some close feeling at any rate, I love them because, to a certain extent, they are my creations, and also I am their creation. When something happens I am really upset and sad, and I get nervous and the actors know this. When I have to scold someone – and it happens – when I sometimes have to use very harsh language, the next day we may kiss and embrace and be quite tender to each other, because I think that with very, very few exceptions they understand that I do it because I want things to get better and not the other way around. There is one other thing which is important. When something doesn't happen the way we want it to happen, when we are criticised or when somebody is a failure in some role, we understand that this is a certain period of his or her creative activity; there may be successes or failures and it's

normal. The next role may be much better. This is what distinguishes us from many other theatres where success is a very important thing, because if you are successful you retain your position, you retain your salary, you go on. Failure is very dangerous. Failure, however, leads to quite artistic things, because if you are not afraid of a failure you can try, you can experiment, you can search for new ways, whereas when you are afraid of failure you wouldn't do it, you would do it the way you did it yesterday, only to repeat that success.

THORNBER You're seen as being less autocratic as a director than someone like [Yuri] Lyubimov. Is this because of your holistic approach to theatre and life?

DODIN Theatre interests me, not as a place where I have realised my wealth but as a place where I have discovered something: discovered something in myself, discovered something in my acting and discovered something for myself. For me, a theatre is more interesting as a place where I can live, where I can communicate, and that's why in time a theatre production as it is becomes really of second importance, a side product, quite subsidiary. For me, the process of knowledge, the process of learning, is more interesting than the final results of the production of a play. That's why it's important for me to know what others think, what they can create, in what way we can complement each other, and so on and so forth.

Also I am grounded in the belief that in real theatre an actor is the co-author of a production. Only then can his individuality be revealed and realised. That doesn't mean that I am unable to use my will where it is necessary and sometimes where it is quite unnecessary. Sometimes you have to have as strong a will to stir and release an actor's creativity as you would need to strangle it. I also get very upset when I see a production where the only pulse beating is that of the director, whereas the other thirty people who are on the stage may also have a beating pulse; and these pulses united are not just thirty pulses, they are much, much more. It is like the notion of critical mass in physics, where this mass comes to a certain point and there is an explosion. We very often see that the fuel is used, but it doesn't burn.

THORNBER Your early work for the Maly Theatre, the [Fyodor] Abramov adaptations particularly, were seen as being precursors of Glasnost. How much have the political changes over the past nine years affected the way that you work?

DODIN I think that the sphere of art is always subjected to political changes because an artist, a creator, is always the same in the sense that there is something suspicious if he has to adapt himself overtly

to the political situation. At the same time, however, from the point of view of practical work, we've got more freedom. It's easier to work now. You can spend less energy on stupid things. In our pre-Glasnost days we had to employ a lot of energy in proving that this or that production could be shown to the audience. You were often forced to get into all sorts of arguments with the authorities. Now, there is a great freedom of choice regarding material. On the one hand this situation makes your life easier, on the other hand it is more complicated as when you have a greater choice it is more difficult to choose. A great part of the energy is spent looking for funding which is also stupid. It's interesting that at the time of great changes you suddenly discover that the amount of stupid or evil things doesn't change, simply one set of stupid things are substituted for others.

THORNBER You've gained the freedom and lost the financial security.

DODIN It's not that simple. The financial security of the past was that of a beggar, but there was equality in that we were all beggars. Also, in those days, our demands were much more modest. Now our own demands have changed and the prices have changed. There have now appeared extreme poles of very rich people and very poor people and in this sense life has become very much more difficult. Problems have arisen. Culture in Russia has always had a very poor lot. There is an illusion fostered by many who claim that in the past culture was safe and well off. It wasn't, but at least we had enough, metaphorically speaking, not to die. Nowadays the danger of death, figuratively speaking, looms large, in that theatres may die. There is still, nevertheless, a possibility of survival too. Now, you can hold many things in your hand. In the past you were held in somebody's hand.

THORNBER Is this six-month international tour part of the new independent approach, an attempt to make your own way, so to speak.

DODIN Yes, but we have sought to bring an interesting combination of our works with us on this tour. I think it's very important to tour not with one play, but with several. You can better understand what a living theatre is when you bring a fair part of your whole repertory. We also gain much when we are abroad. For example, after this tour we'll bring to St Petersburg three productions which we'll perform there. We'll all bring with us a new feeling of what's happening in Europe and also, not least, the feeling of a home. When we return to Russia our feeling of home, I'm sure, will be much more acute. I think that the broader the mind of the people or each individual becomes, the more both home and the world gain. This is particularly important at the end of our century in the current

situation when there's a lot of hatred, where nations are mutually suspicious of each other, and if there is a way we can understand each other better, then this is very important.

AUDIENCE QUESTION 1 Your productions obviously come from work within the ensemble and are developed from improvisational work. In that case, can I ask, why do you waste time with the more conventional playwrights, do they have a value?

DODIN The better the play is, the more valuable it is. Chekhov's *The Cherry Orchard*, for example, is quite a conventional play in this sense, and it's of absolute value for me. The key question, however, is how to get to the core of this value, how to penetrate into this perfect world because, for me, Chekhov provides a perfect world, a perfectly created world. How to penetrate into it, not how to break it – because it's impossible to break Chekhov – but how to get into it, this is the question of questions. The worst play or at least a less perfect play – and of course to a certain extent, I recognise that this is always relative – is easier to get into, because a less perfect play is more open. When we deal with masterpieces, if they are perfect, they are closed. To hear the music of that play relevant to your own self, and your own self relevant to the time, makes something that happens to you adequate to that masterpiece.

All the same, even if you deal with this masterpiece, you have to create this play anew because a living thing can only be created by yourself and is thus quite new. Then you begin to understand very simple things which are inside the play. When you understand that this is a masterpiece you understand very complicated things, but when you are penetrating into the play you understand very simple notions and very simple things and when these simple words become your own words, this is already an achievement. This is a very long process, but however much you may respect the play, this process must be very free because you won't go very far having only great respect for the play.

AUDIENCE QUESTION 2 I was lucky enough to see the Maly actors and it was acting of the very highest quality; it was very passionate and the Chekhov I saw was also very light, hugely emotional and generous. That quality of open-heartedness amongst all the actors on stage was just so inspiring and I would love to hear some comment about how the actors are trained.

DODIN Of course, it's difficult to describe the process in a few words, because this is an ongoing process lasting the whole of our lives. Just before yesterday's show, *Stars in the Morning Sky*, we had another rehearsal of the same play and still we criticised each other and discovered new things. This is one of the ways of bringing up actors

and educating actors. This means that the process is not over and can never finish, that the truth has not been discovered and that there is always a great space to go on and to discover. This system and this process should never close at any stage, be it a lesson at a school, a rehearsal or even the performance.

In fact there is a whole system of training (which would take too much time to describe), and this system is directed at acquiring the ability of making an actor always relate himself to the time, to the present atmosphere and the present moment of life. He should always share what he gains from his surroundings; he should share it with others, not necessarily through speech, but through his own self, through his talents as an actor. When somebody – either actors or students – begins to tell me something, to describe something, I always stop them and say, 'Don't speak, just go and show what you feel. This is your text, this is your work, you just act and play what you feel.' And thus we discovered that you can actually act everything, only you have to act with your own self and not with some imaginary figure whom you don't know. We try to become open to each other, not in life but on the stage. In life many people can be very modest and even closed because very often people confuse freedom in life and freedom on the stage. They are different things. I have very often noticed that the freer a person feels himself in life, the more constrained he is on the stage because probably he spends a lot of energy in life which should be brought onto the stage.

AUDIENCE QUESTION 3 When you're directing a play, do you ever find, when it's a production, that there's a moment when you step away from it to see if it will grow for itself or do you keep on feeding into it?

DODIN Sometimes I persuade myself to let the production grow by itself. A couple of times when I was dissatisfied with what I had done and I didn't know what to do, I let it stay as it was, and after a while I came back and saw that without my direct participation something had developed and grown. So, sometimes I think it is fruitful, or can be fruitful, to let it stay as it is and see what will happen. Sometimes, after a while, however, the opposite happens; I see that during my absence so many corns have grown that no plasters could help.

THORNBER Lev, you did work with Northern Stage Company in Newcastle a year ago on an English version of *Stars in the Morning Sky*. Would you like to come back to work with English actors again sometime?

DODIN Indeed, that was a very interesting experience because I didn't stage the play, which was very good for me. I want to say a few words about Alan Lyddiard, a very courageous and a very searching

personality, who let me, a stranger, inside his own laboratory, and we had a very nice atmosphere. We made great friends with the actors in the same way we did three years ago when we did an international workshop in Scotland, near Melrose. Every time I deal with British actors in this or that way, I discover a great reserve of energy, a great reserve of talent which is very often unused, and I think there still exists a great current of creative forces in the British theatre. It may sound a bit immodest, but if our tour and our performances here could help other people to find courage and to go on and to be more resolute in their work we would be happy.

DECLAN DONNELLAN
AND NICK ORMEROD

DECLAN Donnellan (born in Manchester on 4 August 1953) and Nick Ormerod (born in London on 9 December 1951) met at Cambridge University where they studied Law. They formed Cheek by Jowl in 1981, after a period in which they had worked both separately and together as director and designer at various fringe theatres. Since then they have become a truly international affair, taking plays to audiences from over forty countries and making the concept of world touring a company speciality. This is more than just theatrical tourism, it also reveals the distinctive art of both director and designer. Extended tours, sometimes of over a year, allow for the organic growth of the actors within the classic texts that have been the company's hallmark, and make essential the bare simplicity of the designs that allow the plays to appear so fresh and uncluttered. The work of both men is entirely centred on the actor, and the relationship that the actor achieves with the audience. The craft of directing and designing is focused upon removing anything that will disturb the actor/spectator proximity, and it is on the international stage, where the actor has nothing easy or false to rely on, that Donnellan and Ormerod have developed their skill at finding the absolute essential of the theatrical experience.

Their theatre is based on show, not pretence. Both direction and design give space to the actor as storyteller, and do not attempt to hide or dissimulate behind the display or the mechanics of the theatrical process. Thus at the beginning of their award winning production of *As You Like It* (1991 and 1994), the actors stood on a bare stage in simple black and white clothes watching the audience. They show their male bodies with which the play will be made and reveal themselves as the makers of the tale. This the chief hallmark of Donnellan and Ormerod's work.

At both Cheek by Jowl and the Royal National Theatre, where Donnellan became associate director in 1990, they have consistently chosen to work on the classics of European literature, with Shakespeare heading a list of playwrights that include Wycherley, Racine, Etherege, Corneille, Ostrovsky, Sophocles, Lope de Vega, Lessing and Ibsen. With Cheek by Jowl they have also adapted one nineteenth-century novel (*Vanity Fair* by William Thackeray, 1983), and Donnellan has written one play (*Lady Betty*, Cheek by Jowl, 1989), similarly nineteenth-century in its origins. The National has also given them the opportunity to work on two North American texts

with which they have achieved outstanding success: Stephen Sondheim's *Sweeney Todd* (Cottesloe/Lyttleton, 1993) and the two parts of Tony Kushner's *Angels in America* (Cottesloe, 1992/4).

All the work, from Sophocles to the American musical, is characterised by the same desire to build a framework that will release the actor to re-invent the play spontaneously each time, to find rules that will set the actor free. Kushner's epic fantasy on contemporary America was the first time that Donnellan and Ormerod had chosen to work on a new play with a living playwright, although they have frequently worked directly with translators as new texts were prepared for productions. With Kushner either in rehearsal or faxing new versions of the script from the United States, the relationship was combustive but immensely creative. Donnellan and Ormerod's experience with Shakespeare and other classic playwrights served them well in the masterful way they found the rhythm of the work and revealed the emotional, intellectual and moral landscape of the two parts of *Angels in America*. In working on each of these contemporary texts, Donnellan and Ormerod were once more stripping away all that is unnecessary to find the core dilemmas that form the basis of all classic drama.

Their rehearsal methods allow director, designer and actor to collaborate and explore without the imposition of a directorial intention. This open and accessible process reflects the way in which Cheek by Jowl has sought to democratise the cultural landscape of Britain with performances of classic plays in unlikely venues in small towns. With both their own company and at the Royal National Theatre, they have rigorously pursued a policy of fully integrated casting, employing black actors within the classical repertory by casting according to acting talent and not simply casting according to skin colour. The collaborative enterprise that they have made their creative lives also regularly includes the same musical director (Paddy Cunneen), movement director (Jane Gibson) and, when working with Cheek by Jowl, administrative director (Barbara Matthews).

They have directed operas for Scottish Opera, Opera 80, the Wexford Festival and English National Opera (Brecht/Weill's *The Rise and Fall of the City of Mahagonny*, The Coliseum, London, 1995). The success and enjoyment they had in making their first film, *The Big Fish* (Channel 4, 1991), indicates that this is just one of the future possible directions for the premier team in British theatre. Their work for Cameron Mackintosh, for a musical written on Martin Guerre, is another departure that will bring the work of these remarkable artists to a larger audience. All fifteen of Donnellan and Ormerod's eligible productions have been nominated for Olivier

Awards since the Most Promising Newcomer Award in 1985. Olivier Awards include Director of the Year (Donnellan, 1987, 1995), Designer of the Year (Ormerod, 1988), Best Director of a Musical (1994), Kenneth Tynan Award for Outstanding Achievement (Donnellan, 1990). Their productions have also been honoured with *Time Out,* Prudential and further Olivier Awards, and Cheek by Jowl's administrative director, Barbara Matthews, has been awarded a CBE.

OTHER MAJOR PRODUCTIONS INCLUDE

The Country Wife by William Wycherley. Cheek by Jowl, British tour, 1981.

Othello by William Shakespeare. Cheek by Jowl, British tour, 1982.

Pericles by William Shakespeare. Cheek by Jowl, British and international tour, 1984.

Andromache by Jean Racine. Cheek by Jowl, British tour, 1984.

A Midsummer Night's Dream by William Shakespeare. Cheek by Jowl, British and international tour, 1984

The Man of Mode by George Etherege. Cheek by Jowl, British tour, 1985.

Twelfth Night by William Shakespeare. Cheek by Jowl, British and international tour, 1986.

The Cid by Pierre Corneille. Cheek by Jowl, British tour, 1986.

A Family Affair by Alexsandr Ostrovsky, in a new version by Nick Dear. Cheek by Jowl, British tour, 1988.

Philoctetes by Sophocles. Cheek by Jowl, British and international tour, 1988.

The Tempest by William Shakespeare. Cheek by Jowl, British and international tour, 1988.

Fuente Ovejuna by Lope de Vega. National Theatre, London and international tour 1989.

Sara by Gotthold Lessing. Cheek by Jowl, British and international tour, 1990.

Hamlet by William Shakespeare. Cheek by Jowl, British and international tour, 1990.

Measure for Measure by William Shakespeare. Cheek by Jowl, British and international tour, 1994.

CRITICS ON THEIR WORK

Together they formed Cheek by Jowl, gave the National *Angels in America* and *Sweeney Todd* . . . Along with Manchester United, one of Britain's most formidable teams.

(Michael Billington, 'Pick of the Crop', *Guardian*, 19 April 1994, p. 48).

Nick and Declan's work has been terribly impressive . . . Nick's sets don't violate the space but enhance the stories and their themes. He's much more imaginative than that, adding useful not gratuitous elements. They really are a splendid duo.

(Sam Wannamaker, quoted in Simon Reade, *Cheek by Jowl: Ten Years of Celebration*, p. 113).

[Donnellan and Ormerod have] turned the empty space into a playground for the imagination producing silky shows ... Theatre is about telling stories and [they] have succeeded by telling old ones under new lights.
(Khalid Omar Jared, *What's On*, 19 June 1990, p. 46).

SIGNIFICANT BIBLIOGRAPHICAL MATERIAL

Reade, Simon. *Cheek by Jowl: Ten Years of Celebration*. London: Absolute Classics, 1991.
Witchell, Alex. 'A Director with a Taste for Surprise and Danger'. *New York Times*, 2 October 1994, pp. 6–7.

**Declan Donnellan and Nick Ormerod
in conversation with Paul Heritage
at The Coliseum, London, 30 May 1995**

HERITAGE What's the difference between working for Cheek by Jowl and working for a company like the National Theatre or English National Opera? Why do you still find it necessary to keep Cheek by Jowl going?

DONNELLAN Cheek by Jowl is absolutely crucial: it keeps us sane for one thing. We run Cheek by Jowl because we can manoeuvre the most in that company. It's the company which really doesn't need to have any designing whatsoever done before the beginning of the rehearsal period. We assemble on the first day of rehearsal, rehearse the play in six or seven weeks, during which Nick designs it and then we stagger in front of an audience. Those audiences are different because they vary from city to city, and country to country. We rehearse an awful lot to begin with, even on tour, and then it diminishes down to once a week by the end. But during that time hopefully the work gets 'better', but by better I mean that we find it more satisfying and I think audiences do as well. But there's nothing particularly magical about it; it's to do with a lot of hard work, and the fact that the play on its opening night is very different from the play that closes.

It grows organically from within the rehearsal period in terms of design, and we go in with few preconceived ideas of what the play is about, or rather we're prepared to ditch any preconceived ideas very quickly when we find better things. We normally find that we didn't really know what the play was about until after the last performance which is very regrettable. There are all sorts of revelations we're having now about *As You Like It* (a year after the last performance), which isn't terribly useful, is it? But there you go, all these things are work in process and they're part of your life.

Jatinder Verma talked in his interview about why it's important to him that Tara Arts keeps touring, because of the changing relationship to physical space, and the changing relation with audiences. How do you notice that working when you're on tour with plays?

DONNELLAN It's the superficial things that tend to change from country to country; the essence stays the same. You see through the banality and you start to discover bit by bit about what is essential. It was very interesting coming back to the Albery Theatre in London with *As You Like It* because you realise there are all sorts of strange and rather superficial things about the audience in London, as there are different strange and superficial things about the audience in Paris. In a curious way it's like putting different transparencies over each other: once you line up all the transparencies you see what has remained true through all of those experiences, you see what is more truly human and that gives you confidence and courage to go forward into how you develop the play, and how you see the next piece of work that you do.

It's mostly a stripping-away process, and you start to realise what is and what isn't essential. A few bits get more complex and but most things get more simple. It's very difficult to say, but you get a clearer idea of what might be 'true' by seeing it through the discipline of different cultures, cities and people, and also by seeing it in different spaces, because you're not fooled by one particular proscenium arch or acoustic. I think plays are about human beings and about what's transcendent within human beings. That's what I'm particularly interested in: the common humanity of the play. And that emerges more clearly under changing circumstances.

That's only from our point of view because we're happy to tour; that won't always be the case but it has been so far. I'm sure that could also happen by serving a community in a given theatre. It's just that for us we've found this other way enriching.

HERITAGE You work on plays that are linguistically complex and then take them to non-English speaking audiences. What's important about that, for the actors and for you?

DONNELLAN There are some very irritating things about the plays that we chose: they're incredibly old, many of them are written by dead people, and they're all full of words. I am not particularly wedded to any of these things. It's just that they happen to be very great plays that you can decide to tour for a long period of time, because they give a wonderful array of parts, that deal with apparantly modern subjects – politics, sex, love, the supernatural. All of those things seem to be explored well at the heart of those plays we

present. But we are slaves to the word in so far as our job is to make it appear that those words are spontaneously born. What happens on stage has to make the text appear inevitable so the audience should not be aware that they're watching something which is linguistically dense. The audience should be aware of the real presence of life now, not self-consciously fantasising about what a good thing it will be to have survived the three-hour ordeal.

HERITAGE What is it that the audience is connecting to? I've watched your productions with audiences abroad who are absolutely absorbed, yet don't understand a word.

DONNELLAN But what's essential is not the word. The word is only the surface of something. What's really important is what makes the word happen, which is the imagination and the belief that make the word inevitable. The actors need to see Shakespeare's words as the pretext and accept that what the audience is going to see is something other than the text, because actually they can read the text in the library. The audience is not really going to see the text. In a curious way the text is a catalyst for something else, that's one way to look at it. It's not the only way because some people do go to see the text and that has to be taken into consideration as well. But the moving nature of theatre is that thing which is born in the actor and the audience which makes the text appear inevitable – the specificness. The text is a generalisation; the actor's belief and imagination must be specific. That's why it's pointless saying 'That's not Hamlet' because there are as many different Hamlets as there are actors multiplied by the days of the week. It's seeing how the actor has made those words specific which is moving.

HERITAGE You've forged a very collaborative project over the years: collaborative with the actors, with Paddy Cunneen, the company's musical director, with Barbara Matthews, your administrator, and Jane Gibson, the company choreographer. But at the centre of all the work is your collaboration as director and designer.

ORMEROD The essence of Cheek by Jowl is our work together. I'm involved in choosing the play, in casting the actors, and making the company, in being in as many rehearsals as I can and creating it on the floor. That's the process we go through. Hopefully the complete team is present, which is Paddy, who's our musician, and Jane Gibson who does the movement. There are so many unpredictable things in the theatre that it's best to work from a permanent team, or as permanent as possible in this changing world: in which case you remove some of the variables, and you can start from step one. We believe that's the simplest way of approaching the plays.

HERITAGE Is that simplicity, which is characteristic of all your designs for Cheek by Jowl, related to what Declan says about how to make the word happen?

ORMEROD It's a cliché to say that Shakespeare paints his own scenes and that he doesn't require scenery, but it is true that the word does it in most of the plays we deal with. Nothing more is needed really than the actor and, say, something to sit on – not even that sometimes. So you start off with an advantage that you don't actually need anything. The essence of theatre is paring down to the essentials of what you actually need: cutting it back until you discover what you need, and maybe that one thing serves many different functions which is theatrical in itself. The visual side springs out of those essentials, which is similar to what Declan's been saying about refining down to the essence of performance.

HERITAGE The other clear thing about Cheek by Jowl is the collaboration with the actor. The company seems to have become almost a training ground for young actors.

DONNELLAN Yes, I think that's very important to us. It's important to me because I learn with the actors. They're not always young actors, but they're always eager to learn. I make it very clear that I'm not in the position of a teacher towards an actor, but I am maybe in the position of a coach towards an athlete. For me theatre is always at its best when I'm learning as well. So as long as we do all understand that we are learning, we gain from that. That's very important, as opposed to the idea that we're predigested experts. I don't feel in any way like that. When I go into a play I can feel I have confidence, because something has happened before, which is rather different from having technique to rely upon.

A theatre is a place in which people meet and very often when we meet people we can evade them by making too much noise. Evasive techniques so that we don't really meet are common and one of them is having too much scenery, or too much music, or too much charm, or just too much whatever. There are all sorts of ways that we can make noise. There is something about the heart of a theatrical experience which is to do with what Nick tries to achieve visually, and I try to achieve with the actors, which is the belief that somewhere, even in the eye of the storm, there is stillness and silence where we really meet. That's the sacramental art of theatre for me, and that's the only thing that interests me: the idea of meeting other people and investigating what happens from there.

HERITAGE Your work with actors has extended to international workshops in France and Brazil . . .

DONNELLAN Yes. We're on the point of going to work in Italy with actors from all over Europe, and we're going to do a workshop with some Greek plays in ancient Greek, in which we won't understand the word which will be rather interesting. All we will understand is the noise the word makes.

HERITAGE But is there still something for you that defines the English actor?

DONNELLAN No. They're people from our culture, so we're too close to be able to see them. But our actors are very much appreciated around the world, and in every culture we visit people always find our acting typically English, just as we find Russian actors typically Russian, but all our Russian friends say, 'How can you possibly generalise about Russian actors?' And we say, 'How can you possibly generalise about an English actor?' So we're far too close to see.

HERITAGE Have you got something that you want to discover in working with international actors?

DONNELLAN There is nothing really behind anything that we do. It really is a voyage of discovery and exploration, not knowing where you're going to end. I don't know what's going to happen with Russian, Italian, Polish and Hungarian actors. In the same way we didn't know what was going to happen to Cheek by Jowl and we still don't know. I think it's very important that Cheek by Jowl retains its improvisatory character, that we can invent what we're doing as we go along.

HERITAGE Why is it that in your workshops for actors you frequently concentrate on fear?

DONNELLAN I can talk about it spiritually but that would maybe seem a short cut to some. I always tell the actor in rehearsal that what I say isn't necessarily true, but it's useful. We must all understand that we are prey to fear and we must recognise that fear. Fear is only an absence – a pure negativity – it only appears to be real. Like the devil it doesn't really exist: you pull the mask down and there's nothing there. But the fact that fear doesn't exist means you can't get rid of it. It can't exist in the present. For the present exists. So it invents two non-existent times for its not-existent self to rule: the past and the future. We spend a lot of time in rehearsal trying to cure fear both by its symptom and its cause. It's symptoms are division, separation and feeling that you are being judged, which means that you start to judge. Those are the things that we try to address. It's very different with different actors, and it's very different as you go through each phase of your own life; your opinion about these things change. You try to go forward with some sort of spirit of group generosity and each of us tries to overcome our individual vanities to know that the

whole of what we do is greater than the sum of our parts. That's what's so potentially moving and transcendental about theatre: that when people gather in a room, something extraordinary can happen which isn't entirely to do with them.

HERITAGE And is it possible to bring those methodologies to your present work on Brecht/Weill's *Mahagonny* for English National Opera?

DONNELLAN To a very limited degree. Ultimately the arts of music, acting and everything else aren't separate, but practically they do become separate through fear. Fear, as usual, disguised.

One of the great problems with fear is that it tends to replicate more happily in large institutions. It's very important for us that Cheek by Jowl has only fourteen people and they are almost permanently on tour so that we don't separate off into separate parts. We don't travel as a family or as a commune, but a certain degree of closeness is often there. You can't rely on it, and if it's not present it's disappointing and the work isn't as good to be perfectly frank. Of course, sometimes you can be very close and the work is completely shit, but at it's very best you are close and you do good work as a result of that. But that's more difficult the larger the group that you have. In an opera house you've got the orchestra, the chorus, and the musical staff. The great thing about Cheek by Jowl is that we're able to be much more specific about the agenda that's addressed, rather than me doing my bit in the corner of a room, and the stage manager doing another bit in that corner of the room, and so on.

ORMEROD The primary fear for the singer is the voice. It's a secondary fear to worry about the acting, and it must be terrifying if the voice goes.

DONNELLAN I was just giving notes today to the singers and they were being very accommodating and writing them all down. But it was very interesting because they clearly saw each of the notes as one more thing to remember as opposed to being part of an organic whole of their stage life. Actors, on the whole, want notes and they want to know about their performances. They come up and talk to you about it because they know that all this is a rich stew. But it's very funny talking to singers because their emotional commitment is often to the music as if it were different; it shouldn't be separate but unfortunately it very often is.

HERITAGE So the notes become an addition, something added on to the process . . .

DONNELLAN For singers they are simply 'changes', whereas for an actor they become part of a performance, and they're not 'changes'

– it's work. It's work and you don't just give notes, you talk about things and things arise naturally so it all becomes part of an organic whole. So it's very strange saying to a singer 'I wonder if you might try X, Y, Z on certain lines', and they say either 'Yes, I can do that', or 'No, I can't do that'. That's the sort of relationship and it's very excluding, rather than 'Let's work on it', which would be very much an actor's approach. So I miss that intimacy of contact, but it's a different art form.

HERITAGE You've also written your own plays, *Lady Betty* for Cheek by Jowl, for example. Does the dynamic of working with your own words differ completely to directing someone else's text and is that something you're going to continue with?

DONNELLAN It is completely different. I would love to continue with that, but I don't see how, because I've got on a recent treadmill of work which I've got to get myself off. I would really like to write and to investigate writing more. Writing my own stuff was helpful for all the work I've later done, because then you realise the pragmatism of writing. It's so interesting once you've had to cut and shape and so on. It's very interesting to see the process of writing for a company and trying to get the story on stage with certain actors, which alters your perspective on the text. The balance shifts.

HERITAGE And how was that taken into your work on *Angels in America*? You obviously had a very close working relationship with Tony Kushner, who was still writing the second part as you were directing it.

DONNELLAN Yes, we almost killed each other. But it was wonderful in the end and we are very good friends now. It gave me a lot of insights into this work by Brecht and Weill because they clashed like hell writing and directing *Mahagonny*. And in another way Tony and I clashed over *Angels in America* and something interesting came out of the clashes of our temperaments. Sometimes watching trains collide can be very fruitful for the audience, if not necessarily pleasant for the passengers.

HERITAGE Where does that come out in *Angels In America*? Is there any way we see that as an audience?

DONNELLAN I think that I had a more instinctive and emotional approach towards the subject matter of *Angels*, an approach which was less cerebral. So I had a slightly different point of view about it. I was much freer with the actors than Tony expected.

There was one great row when Tony asked why a certain actor was standing to say a line when it was very clear from the written line that she should be sitting down. I said that I hadn't even noticed

she was standing up because the scene varied from day to day, and Tony couldn't believe that I wouldn't control whether an actor should stand or sit. He thought this showed a terrible lack of respect for detail. But I told him that on the whole it was for the actor to make the detail, it's up to me to make sure that the actors know what they are doing, which is very different from telling them to stand or sit. Tony Kushner said, 'But doesn't that let you off the hook?' And I said, 'Well, I don't know what hook I'm on.' We resolved it and I'm not saying I was right or he was right, it was just opposing poles really and we collided but something fruitful came of our collision.

The thing you've got to realise about directing is that you are not controlling the evening and that's one thing I've learnt over the last fifteen years as a director: to control less and less. And to know that all law is bad because every law acknowledges that there is a breakdown of love, but that laws are necessary because we cannot have anarchy. The ideal state is anarchy with love, but as we do not live in a complete state of love, we have an awful lot of laws to stop us from killing each other. So we introduce laws but we must always acknowledge that they are failures. As long as we know that laws are failures then that's absolutely fine. We need to know that they're intrinsically bad things, but that sometimes bad things are brought in to stop even worse things happening.

A play, a rehearsal, a scene are little microcosms of the world, and even when you direct a play you have to impose certain laws on what happens. In a scene between two people, or ten people, different amounts of laws are necessarily imposed by the director, and they will be imposed by me in Cheek by Jowl after the scene has grown organically. Whereas in opera the chorus wants to know where to stand, and basically wants me to impose masses of laws on them. I say you don't need that many laws, and they say 'just tell us when to move'. That's a generalisation and it is not always quite as banal as that, but it often comes down to that. What I have learnt in the theatre is that directing a scene between two people, for example, when it's going very well needs very few laws. You don't need to tell them where to stand, you need to make sure that they know what's happening in the scene, and then wonderful things will happen out of the scene because none of us have overburdened it with laws. If there's a good atmosphere of love between them, and by love I don't mean anything that's romantic, I mean a professional love that's based on respect, then you need to impose very few laws on it. The most terrible thing for a director to do is to start clumping into a scene that's going well because the actors know what they're doing, and you start saying 'You must sit down there', when it really doesn't matter. However, you've also got to know when

you've got to come in if that situation doesn't exist, either because the whole scene's more complicated, because there's more people on stage, or even because the two people are not working very well together. Then you have to start administering more laws. It's very important, and it can only be discovered on the rehearsal floor.

HERITAGE When you're working with *Mahagonny* are the laws coming from Brecht/Weill?

DONNELLAN Masses of laws are coming from the composer because things like time are out of your control and gradually certain things start to feel right, and things become laws. All I'm saying is that the fewer laws the better. A situation without laws could be wonderful anarchy, but anarchy on the whole is dangerous. In the theatre it's not dangerous it's just bloody boring.

So I think you need to bear in mind that there shouldn't have to be a director, but you're almost a necessary evil. Not that the revealing of those laws is necessarily a negative thing; it can be a positive thing, but the law-giving side of the director is what I'm expected to do in opera (and what a lot of people in theatre expect me to do as well) and that is a negative side to my job. The positive side in the theatre is working with actors and helping them to find out what they are doing.

HERITAGE In all the different projects, in all the different places you work, is the starting point the same?

DONNELLAN It's all about the the act of achieving a naked relationship with an audience, so that something real and human happens between them, and because human, potentially divine. Ultimately they're the same thing, and that's what's so wonderful about anything in the theatre. You can't make these things happen. You've got to remember that you can't make good theatre. It's really important to know that you can't push and strain and shove and cry and bang your head against the wall and make good theatre; you can't work and sweat and scream. It happens by grace and some of it's very often a question of when to relax. Warm-ups are very important but you don't earn good theatre on your knees, it's given to you. That's a very mysterious thing and also refreshing. Some people might think that lets you off the hook; it doesn't.

HERITAGE What's still enjoyable for you in your work?

DONNELLAN The humanity of the rehearsal period when things happen between people and you have ideas together. Then there's the excitement of that humanity reaching an audience. With Cheek by Jowl those are the very special performances. There was a whole string of performances of *As You Like It* that we did at the Bouffes

du Nord which were wonderful experiences for us all. By good performances, I mean evenings in the theatre when something very special has passed between the audience and actors. It's incredibly exciting, and uplifting, and inspiring to be part of a moment like that. But those 'nows' come by grace; you don't earn things out of your talent. You work and then maybe something happens, but the good bit isn't from you, the good bit's from somewhere else.

MARIA IRENE FORNES

◇

P RAISED by the critic Susan Sontag for 'conducting with exemplary tenacity and scrupulousness a unique career in the American theatre' ('Preface', Maria Irene Fornes, *Plays*, p. 7), the Cuban-American dramatist and director Maria Irene Fornes remains one of the the few 'first generation' Off-Off Broadway playwrights to remain a significant force on the alternative scene. An imaginative and procative dramatist and a director of precision, Fornes's work has been seen on the mainhouse stages of the major American cities, in the repertory theatres, in unconventional spaces, campus theatres, and festivals.

Born in Cuba on 14 May 1930, her family emigrated to North America in 1945. Originally intending to be a painter, in the mid-fifties she had studied in New York with Hans Hoffman and then in Paris, where she saw Blin's original production of *Waiting for Godot*, an event she credits with changing her life. Returning to New York she worked as a textile designer until, in an effort to encourage her flatmate Susan Sontag to write, she penned her first play, the absurdist *Tango Palace* (1963). There followed throughout the sixties a series of boldly experimental works, including the legendary off-beat musical *Promenade* (1965) and the reflexive *The Successful Life of 3* directed by Joseph Chaikin in 1965. She began directing her own work in 1968 – five years after the first production of one of her plays – out of frustration after spending time in the rehearsal room watching others attempt the task, and has continued to do so since. Observing the acting and directing classes at the Actors Studio Playwrights Unit, she came into contact with Lee Strasberg's Method technique, acknowledging its influence both on her writing and directing. Initiating with Julie Bovasso the New York Strategy in 1972 to produce the work of Off-Off Broadway playwrights, she returned to writing in 1977 with *Fefu and Her Friends*, entrusting the administrative work of the organisation to others. Much admired for its freshness, its ingeniously crafted simultaneous scenes and its playful wit, in Fornes's finely tuned production, *Fefu and Her Friends* proved a poignant Chekhovian homage to women's resilience and intelligence. Since then she has continued to write prolifically, providing cryptic abstract plays which defy a simple linear logic. Greatly varied in both form and content, they have proved delicately crafted pieces, often bleakly humorous but always compassionate. Attuned to the nuances of colloquial language, bereft of

exposition, these emotive plays invite a questioning, on the audience's part, of everyday behaviour and practices.

Although her work in the eighties, like *Mud* (1983), *Sarita* (1984), and *The Conduct of Life* (1985) may ostensibly appear to adhere to a pseudo-realist form, established strategies of dramatic representation, which carry within them implicit ideological statements, are skillfully disrupted and destabilised by inventive and delicate recourses to techniques associated with painting, photography and film. Often her plays are developed over years – *The Danube*, for example, was staged by Fornes in different drafts in 1982 and 1983 before its 1984 production at the American Place Theatre in what is its published form. A more recent play, *Oscar and Bertha*, received a disconcerting production which never overtly endorsed the humorous nature of the characters' speeches and gestures at San Francisco's Magic Theatre in March 1992, as a revised version of the piece presented at the Guthrie Theatre Laboratory in 1987 and the Padua Hills Festival in 1989. Her assured productions are habitually commended for their clarity, wit and lightness of touch, allowing time and space for the audience to reflect on the ensuing stage action.

During the eighties and early nineties she ran playwrighting workshops at International Arts Relations (INTAR) and was for several years director of INTAR's Hispanic Playwrights-in-Residence Laboratory in New York. She has staged produtions of her INTAR students' work (*Exiles* by Ana Maria Simo [1982], *Going to New England* by Simo [1990], and Caridad Svich's *Any Place But Here* [1995]), as well as classical plays by dramatists such as Chekhov and Ibsen which she has adapted herself. She has also translated numerous works, including Lorca's *Bodas de sangre (Blood Wedding)* which she staged in 1980, and Virgilio Piñera's *Aire frío (Cold Air)* staged in 1985 at INTAR. She is the recipient of seven Obies including one for Sustained Achievement (1982), an American Academy Award (1985), and prominent grants and fellowships from institutions such as the Guggenheim and Rockefeller Foundations. She was also a Pulitzer Prize finalist in 1989.

OTHER MAJOR PRODUCTIONS INCLUDE

Dr Kheal by Maria Irene Fornes. Judson Church, New York, 1968.
The Curse of the Langston House by Maria Irene Fornes. Premiere: Cincinnati Playhouse in the Park, Ohio, 1972.
Evelyn Brown: A Diary by Maria Irene Fornes. Premiere: New City Theatre, New York, 1980.
A Visit by Maria Irene Fornes. Premiere: Padua Hills Festival, California, 1981.

Lovers and Keepers, lyrics by Maria Irene Fornes, music by Tito Puente and Fernando Rivas. City Theater Company, Pittsburg, 1986.

The Mothers by Maria Irene Fornes. Premiere: Padua Hills Festival, California, 1986.

Uncle Vanya adapted by Maria Irene Fornes from the play by Anton Chekhov. New York, The Classic Stage Repertory Theatre, 1987.

Abingdon Square by Maria Irene Fornes. American Place Theatre, New York, 1987.

Hunger by Maria Irene Fornes. Premiere: New York, 1988. Produced by En Garde Productions.

And What of the Night? by Maria Irene Fornes. Milwaukee Repertory, Wisconsin, 1989.

CRITICS ON HER WORK

One could say that *Fefu and Her Friends* and the plays which followed it . . . have paved the way for a new language of dramatic realism and a way of directing it. What Fornes, as writer and director of her work, has done is to strip away the self-conscious objectivity, narrative weight, and behaviorism of the genre to concentrate on the unique subjectivity of characters for whom talking is gestural, a way of being . . . Fornes brings a much needed intimacy to drama, and her economy of approach suggests another vision of theatricality, more stylized for its lack of exhibitionism.

(Bonnie Marranca, 'The Real Life of Maria Irene Fornes', *Performing Arts Journal*, 8, No. 1, 1984, p. 29).

Fornes's trademark as a director . . . is a gestural and intonational formality, an emphasis on declamatory line-readings in particular, that rejects the cumulative effect of naturalistic detail in favor of the spontaneous impact of revelatory image, that rejects emoting, behavioral verisimilitude, and demonstration of meaning in favor of crystallization, painterly blocking, and layers of iron.

(Ross Wetzsteon, 'Irene Fornes: The Elements of Style', *The Village Voice*, 29 April 1986, p. 43).

SIGNIFICANT BIBLIOGRAPHICAL MATERIAL

Austin, Gayle. 'The Madwoman in the Spotlight: Plays of Maria Irene Fornes', in Lynda Hart, ed. *Making a Spectacle: Feminist Essays on Contemporary Women's Theatre*. Ann Arbour: The University of Michigan Press, 1989.

Cummings, Scott. 'Seeing with Clarity: The Visions of Maria Irene Fornes'. *Theater*, 7, 1985, pp. 51–6.

Cummings, Scott. 'Maria Irene Fornes', in Phillip Kolin, ed. *American Playwrights Since 1945*. Westport: Greenwood Press, 1989.

O'Malley, Lurana Donnels. 'Pressing Clothes/Snapping Beans/ Reading Books: Maria Irene Fornes's Women's Work'. *Studies in American Drama 1945–Present*, 4, 1989, pp. 103–17.

Fornes, Maria Irene. *Plays*. New York: PAJ Publications, 1986.

Fornes, Maria Irene. *Promenade and Other Plays*. New York: PAJ Publications, 1987.

Letzler Cole, Susan. *Directors in Rehearsal: A Hidden World*. London and New York: Routledge, 1992.

Savran, David. *In Their Own Words: Contemporary American Playwrights.* New York: Theatre Communications Group, 1988.

Zinman, Toby Silverman. 'Hen in a Foxhouse; The Absurdist Plays of Maria Irene Fornes', in Enoch Brater and Ruby Cohn, eds, *Around the Absurd: Essays on Modern and Postmodern Drama.* Ann Arbour: University of Michigan Press, 1990.

Maria Irene Fornes in conversation with Rod Wooden at the Green Room, Manchester, 20 November 1994

WOODEN You didn't start directing your own work for about five years. You allowed other directors to direct your plays, and then you suddenly decided to direct them yourself and mainly since then you've continued to direct your own plays. Why did you decide to do that?

FORNES It seemed to me natural. The very first time that a play of mine was worked on was in a workshop reading at the Actors Studio for a directors' class. It was the first time that I saw a rehearsal of any play, not just a rehearsal of a play of mine. Very soon after they started, the actor who was playing the leading role stood up as she read a monologue and began walking towards a chair. As she passed the chair she stood behind it for an instant and continued walking. I got up and went to her, and said, 'Oh, how wonderful. Stay there behind the chair for a moment longer and turn front as you say the speech.' She looked at me strangely. And I thought, 'What did I say?' I looked at the other people to see what went wrong and everybody was looking at me the same way she did, as if I did something wrong. The director came up to me and very nicely, very politely said, 'Irene, I'm going to give you a little note book and a pencil and you sit there, and whenever you have a comment to make, you write it down. Then after the rehearsal we'll go out and have coffee and you can tell me what you think.' I thought he was crazy. I thought to myself, 'Why go through all this when I could just tell the actor?' I looked at the actors and I could tell again that they thought, 'Well, now she knows.' So I thought, 'Well, okay. This obviously is the way they do things here.' So I wrote a few notes, not everything I wanted to comment on, because I had already learned it was futile. Afterwards, the director and I went and had a cup of coffee and I started giving him my comments, and he would say, 'When was that? What movement? When did that happen?' And I would say, 'You know, she went over there and she …' He didn't remember anything that had happened. Naturally, it isn't that he was out of it, or stupid or anything. It's just that ordinarily you don't remember things like

that if they look right to you – a movement or the delivery of a line. He did write a couple of things down, because he was well meaning. He really intended to listen to everything I said and then transmit it to the actors. And the next day he tried – but everything he said was turned around, so I stopped writing notes. I just watched.

WOODEN You wanted to direct from then on?

FORNES No. That story was just to make you laugh, but also to tell you that my impulse was, from day one, to put my hands on it. I didn't think I wanted to direct then. I didn't know what directing entailed. I just thought it would be good if some things were done in a certain way, which is in a way what directing is. After that I had two wonderful experiences: Herbert Blau directing *Tango Palace* and Larry Kornfield directing *Promenade*. I was happy. But then I had several miserable experiences. Writing a play is very hard work and it is very hard after you do all that work to hand it to someone else and to set it at a distance and be gagged. You become the child that's often in movies looking out the window because they're sick and cannot play with the other children who are jumping and doing all kinds of things outside. Most directors have manipulative techniques which have a down effect on the work.

WOODEN How do you mean that rehearsal techniques are manipulative?

FORNES Well, there is a lot of secrecy in rehearsal. The director speaks directly to each actor about the motivation and psychological manoeuverings. Whispering. This makes the actor feel special, favoured, and the others feel left out. When I direct, I never talk secretly to an actor. I feel that whatever I say to one actor has to be of benefit to the others. When I go to rehearsals, I see that secrecy is a very general practice. Too often I see the director going and talking in the ear of an actor. Does this mean that the director is not saying anythng that would be of benefit to the rest? I suspect so. I suspect the director is not talking about emotions and imagery in a way that describes the world of the play, the tone of the play, the spirit of the play. I suspect that the director is just creating emotional tensions and defenses. Draining the play of any texture or colour, of any life, any fresh air, taking the play's lyricism and turning it into mush. Taking the audience's good intentions and turning them into 'get the conflict, get the message, and go home thinking you understood the codes. You decoded the message. But your heart just wasn't there.' The secrecy is divisive. Not just divisive between one actor and another, but also in relation to the character. What kind of character is going to come out of secrecy like that? What you are discussing is the artistic or technical way an actor

develops the person of the character. What I say to one actor, the other actors will understand even if it doesn't apply to their characters. It is one step, two steps or even fifteen steps into entering the world that this whole play's going to be in. It's a way of thinking about the play, a way of thinking about the world. The aim is to do a good product, to have a good show and if you have to do some sneaky tricky things then it's actually detrimental.

WOODEN You told me once that Lanford Wilson has described the playwright as the female of the theatre, and the director as the male. What did he mean by that?

FORNES We were riding on a train to New Haven and he said, 'When I have a play produced I feel that I understand what women mean in relation to men. As a playwright I am in the same position. The director behaves like a guy taking a woman out on a date. He's going to show her a great time. He's going to do wonderful things to your play. He's going to take her to a great restaurant, and she's going to love it. If she says "I don't like this", she's been rude. As a playwright I have to be like a nice woman who says, "Oh, it was wonderful. Thank you very much, that was very nice."' Playwrights can be banned from rehearsals. That is the law.

About a year or so later, I was on a panel of writers, and one of them was dressed like a senior executive in a business or a big bank. He was a playwright. He was very successful. He had had a couple of plays on Broadway and worked on television and in films. That man was sitting there, six feet tall with a good solid voice and a clean-shaven appearance, wearing a very correct suit and nice polished shoes and suddenly he said, 'The playwright in theatre is like a woman.' And he went on to say what Lanford said. I'm looking at him and I think, 'Him? They mess with him? There's no chance then!'

WOODEN Since then, you've not only directed your own plays, but you've also directed other writers' plays: Chekhov, Ibsen and other classical plays. What do you think you can bring to those plays as a writer that perhaps other people don't bring?

FORNES I think I understand the text as emerging from the character's head and from the writer's head. When what you practice, your craft, deals with words as they emerge from the character's mind, you can reverse it and understand the character's mind. You can understand the character's state of mind; therefore, the tone and therefore, the meaning. Because in tone there is more meaning than in all the emotional conflicts in the world.

WOODEN And as a painter what can you bring to your writing and directing?

FORNES I started as a painter and developed a strong visual sense. In painting you make a drawing and you practice perspective; you make a drawing of two people and how, because of their position, they relate to each other. This is something you do when you are taking pictures also, if you don't just take quick snap shots but take a little more care. You move the camera, slightly, carefully, and you see how the perspective changes and you see how the picture can become a lot more interesting, more beautiful, more powerful. That kind of eye is very important for theatre, to make it a lot more beautiful or a lot more mysterious.

WOODEN Do you think all writers should train themselves as directors?

FORNES Completely. And all directors should write, but not necessarily professionally; just to develop their craft further. A playwright friend of mine is a wonderful director. He did a little film – which was part of a film course we were on together – and his film was exquisite. His visual sense – the timing, the photography, the light – was memorable. I asked him why he didn't direct, and he said, 'I know I could do it but I don't like to organise people and tell them what to do.' It's true, that's part of what you have to do, as a director.

AUDIENCE QUESTION 1 You were talking about the playwright as the female and the director as the male; don't you think that's a sad indictment of theatre today?

FORNES Oh yes. I don't see any reason for it. I do think that the function of the director is one of a delicate sensitivity and guidance; and of taking pleasure in seeing something flourish: the play, the performances, the set, lights. Women are by training or nature quite equipped to do this. So why suddenly should they be left out of this profession?

WOODEN In today's *Observer* there's as excellent review of your play *The Danube* for Shared Experience, which is now running at the Gate in London, directed by Nancy Meckler. She's directed several of your plays before, including *Abingdon Square* at the Royal National Theatre. The review talks about the play and then it goes on to discuss Nancy Meckler's direction. It includes as a comment what a good idea it was of the director to stage the section with the puppets, and yet that's in the stage directions. The critic has automatically assumed, because it was something physical realised on stage, that it was the work of the director.

FORNES It's true that it's assumed the playwright is not a well-rounded theatre person in terms of normal things and even behaviour, and that anything visual should be credited to someone else.

But the puppets are speaking words. So why would this critic assume that it was not part of the play? However, I don't mind somebody else getting credit for something I did. That, to me, is all right, as long as the work is good. I'm not in competition with the director.

When I write a play, I have no idea how I'm going to stage it. Because my approach to writing is visualising the characters in the real world not on a stage. When I edit the play, when I structure it, it's when I start imagining it in a single space. I feel if a playwright starts writing for the stage (from the very beginning) the dialogue becomes rigid and the characters stiff. It is good to get to know the characters in the real world. Then you can switch to the stage when you re-write: how are you going to do all this that you want to do in one set? That's hard to do, but it's worth it for the sake of the liveliness of the characters.

AUDIENCE QUESTION 2 I'd just like to refer back to your rehearsal technique where you talk to actors as a whole, rather than taking them on their own. Have you ever come up against any sort of barriers with particular actors, and felt they wouldn't like it unless you spoke to them individually?

FORNES No, never. I work with them individually if I think that what I want to do with them will take too much out of everybody's time. I know that in some casts one has to be sensitive to the fact that another actor is listening, so there are times when I joke about something. For example, where I want one character not to take too seriously another character who is insulting or offending them. I would say, 'No, take it lighter.' And the actor might say, 'Well, he's insulting me. Why don't you want me to take it seriously.' And I reply, 'Don't pay too much attention to him. He's dumb, he's stupid, don't pay attention to him.' I say it in front of the other actor, although I know that's not good for the other actor. So then I say to the other actor, 'But it's *he* who is dumb!' See? The feelings are out in the open and they are no less intense. In real life those things are clear anyway, if not by word, by tone, by posture, by facial expression, by breath. In training, in class, yes. To train the actor to locate, to reach deep feelings. But in rehearsal? I mean, everyone has read the play!

AUDIENCE QUESTION 3 Can you identify the qualities in other writers that attract you as a director to their plays?

FORNES It has something to do with something that is subtle, something that is usually missed.

AUDIENCE QUESTION 3 [CONT.] You staged *Uncle Vanya,* for example, in 1987. What attracted you to that play? What did you think you could bring to that play?

FORNES I don't really think I bring something to it: that's what I hear very often from directing teachers who ask the students, 'What would you bring to this work? What can you contribute?' I feel that the director doesn't bring anything to it, he just tries not to miss anything that is in the play. If you're cooking and you say, 'What can I bring to this?', that means you will be putting in ingredients that may complement the main ingredient but that are something other than the main ingredient, like a tomato sauce to spaghetti. I feel that the play, the main ingredient, gives off the solutions to its executions. They grow out of it and can be directed on it.

When I watched Lee Strasberg working at the Actors Studio I thought that everything that he said about acting was very interesting, complex and delicate. But when he came to teaching directing he always asked the student giving a presentation, 'What did you contribute to this?' And I felt that it was a strange term 'to contribute', for the director should not impose something to the play but make sure that what is in the play has come out in the production. The director has a lot of work to do. It isn't like the director should just sit there and watch it grow. But directing has something to do with watching it grow. A director should only agree to stage a play if the play has not started to grow in her or his mind. The director should not manufacture something around the play. The word 'contribute' seemed dangerous to me.

AUDIENCE QUESTION 4 Despite the precision of your stage directions, the way in which you write clearly opens out various possible interpretations to directors. You must have seen the same moments in your plays transform and mutate in the hands of different directors. Could you give us some examples of the way in which directors reinterpret your work and whether you are conscious of controlling the space between your writing and directing?

FORNES The word 'controlling' suggests a kind of uptightness or doing something you're not entitled to do. Everything I put in my plays is something I do to enhance its understanding. People seem to be in love with the idea of team work. It seems democratic, palsy and fun. But theatre is an art and what is important is not that people have fun but that the final result is an art. Sometimes when I see a play of mine I find that one or more of the characters have been directed in a manner that is detrimental to the play and I think, 'How could they have even thought that this character should be done like this?' At one point I realised that although I'm very precise about some things in my writing, I hardly ever describe the characters, as a lot of writers do. In the character's description I usually just write the age and something about their temperament, maybe like 'the

person is wiry' something about the dynamics of the character. Then I thought, 'My God, most writers do more than that. I should be more specific.' This is why I am surprised and frequently displeased by the way my characters are brought to life by other directors. But I don't mind at all if a play of mine is done in a different manner as long as I find that I'm interested: that the characters are moving and that I feel something from them.

I saw a production of *Mud* where Henry was a kind of old smart alec, a self-centred character from the beginning. That diminished the character and the whole play for me. Why would Mae be so attracted to a man like that Henry? To me it isn't just that it's not the way I saw the character, but it has to do with the whole play being demeaned. Because if Mae is attracted to him then what does that make Mae? It has all kinds of repercussions that deal with the totality of the play and I do get upset when I see that. Of course I do. Basically, what I am concerned about when I write is something that has to do with humanity; and that has to do with a kind of tenderness that I feel for the characters, no matter how cruel or terrible they may be. However bad things get, I still want to feel for them. As a writer I want to feel for them. As a director I want to feel for them. And as a member of the audience I want to feel for them even when they're terrible and bitchy and do horrendous things. I think it's boring unless you feel something for the characters.

AUDIENCE QUESTION 5 You've been closely involved in training dramatists for many years: do you think it's possible to run similar workshops or courses for directors? How would they differ?

FORNES It's different. The writer has to concentrate inside himself, the director outside: on the actors, on the space, dealing with all the people. I always try to make the writer concentrate on their own creativity. In that I mean the kind of things that are happening in the writer: not so much the conscious opinions or statements that one would make about something, but things that are more intangible. Like someone you saw on the street that moved you, or something you remembered that hurt you. The director should do that too but it is in relation to the play. They should not think, 'What can I do with this?', because then they are starting to manipulate even before they have any substance to manipulate. Rather they should read the play just to receive it, just to see what comes from the play to them. They should not start by saying, 'I'm the director. I'm the boss. I'm going to do this. Now, how am I going to do this? What am I going to do with it? How am I going to make this interesting?' They need to keep reading the play and if you do that, if the play is any good, the characters will pop out. They pop out as in pop-up books.

The characters pop out on their own, and then you continue the process when rehearsals start with the actors. You select the actors, you read the play and when an actor reads a part you already begin to have a different sense of what the part is. It's a different thing that pops out. You observe what is there. Sometimes it's unacceptable and sometimes it's wonderful how it's evolving and what's happening. Then you can see what comes up from the actors and you can see how the lines activate the actor. Then you mould it or you change it if it's unacceptable. But don't start from the beginning with fixed ideas. That is even how I direct my own work. It's not that I have actors do improvisations, and I say 'I'm going to use this and that'. What I am choosing is something that's more subtle and less conscious on the part of the actor than what would come out in an improvisation, maybe things that are more personal. It could be something I see in the way the actor walks, or the way the actor sits and listens, which I find so beautiful that I ask the actor to sit centre stage listening to the others. I may want the attention to go to the person on the stage listening rather than to the person who is speaking. All the time I'm taking from what the actors are providing. And I am also taking from the space. I would direct a play very differently if the space is different, if the space is deeper, if the space is taller: something begins to happen that's different.

AUDIENCE QUESTION 6 Do you think directing can be taught?

FORNES Of course you can teach people to listen, and you can teach people to observe space, and that's how you teach art. You teach people to become aware of things. For example, how an actor enters a space, where the entrance is, and whether the person walks in rapidly or slowly, or whether the person comes and stops and just takes two steps and stops.

I learned a great deal about space from watching friends of mine who were choreographers. They pay a great deal of attention to a movement and whether the person is two feet up or two feet down, even inches make a difference. You begin to realise how you must observe this space, and by having that pointed out to you, you learn to observe. Therefore, you learn to bring to your work the elements that have to do with space, with movement, with speed, with gesture, with colours: for example, simply the colour of costumes or the colour of a wall.

It's like writing. I teach writing by teaching people to learn to listen to their own creativity. I don't tell them how to write a play. By providing certain exercises I am pointing them in different directions so that they can observe different things, and that's how anything is taught. People who teach through the learning of formulas

haven't taught anything. They have actually prevented the person from learning what they would have learned if they had any sensibility or sensitivity. People who are given formulas don't learn by practise, because once they know the formula they are convinced they know everything there is to know. People who teach the use of formulas are actually preventing and impeding learning.

Because I am a playwright, when I say that the director should read the play, listen to the play and let the play tell them what it's all about, people may think I am inflexible and I don't like things done differently from the way I imagined them. I love it when things are done differently. I love being surprised as long as what they are doing is good. When I have a new cast, I may change the personality of a character. What I first imagined is not necessarily the best way, the only way it should be.

AUDIENCE QUESTION 7 Why did you describe your plays in terms of being show business?

FORNES There is a trickery which is part of what I adore in theatre. You see, if there's a point to writing, it really has to be the purity of creativity and getting in touch with the reality of those human beings, their flesh and their sweat, their nightmares and their hatreds. You have to get in touch with all those things. It's hard work to get in touch with all of that. But then once you're putting it together, the trickery of theatre is just delicious. Showbiz musicals and vaudeville have a kind of presentational thing. Theatre doesn't have to. You could do a wonderful play and a wonderful production without any of it. But it's something that's available to you. It's part of what you have to play with and the trickery to me is fun.

AUDIENCE QUESTION 7 [CONT.] So you don't make a distinction between avant-garde and show business?

FORNES Right now, why is there a special light on us? I can hardly see you. Why can you see me? That's trickery. That's so you don't start talking to each other, and you think that what I'm saying is very interesting. That's showbiz trickery.

JORGE LAVELLI

◇

Photograph: Photo Lot. Courtesy of Théâtre National de la Colline, Paris

ONCE referred to by Arrabal as 'an outstanding master of ceremony in the theatre' (Knowles, 'Ritual Theatre', p. 527), Jorge Lavelli, the Argentinian-born director based in Paris since the early sixties, has, over the past thirty years, pursued unflinchingly the realisation of a vision of theatre as spectacle. His perception of the theatrical event as an arena of images and an experience which stimulates, provokes and disturbs an audience in a particularly sensory, sensual and mystical manner has generated over eighty productions of a baroque and often violent brilliance.

Born in Buenos Aires on 11 October 1931, Jorge Lavelli was studying Economic Sciences at the University of Buenos Aires when he became involved with the independent theatre movement. He performed in European plays including the Argentinian premiere of *The Seagull* (1953), as well as the works of Argentinian writers like Osvaldo Dragún and Florencio Sánchez, before receiving a grant from the Argentinian government to study theatre in Paris. He took courses at the Jacques Lecoq and Charles Dullin Schools, remaining in Paris at the international theatre school (L'Université du Théâtre des Nations), established in 1961 and based at the Théâtre Sarah Bernhardt at the Châtelet. His contemporaries at the school included the French director Jérôme Savary (founder of the Grand Théâtre Panique, later the Grand Magic Circus), and fellow Argentinians Copi (the cartoonist-playwright with whom he was later to collaborate), and Víctor García (responsible for some of the key post-war productions of Genet, Lorca and Valle-Inclán). Winning the Concours des Jeunes Compagnies in 1963 with his first production, Witold Gombrowicz's *Le Mariage,* Lavelli gained overnight recognition in Paris. He was now able to continue his experiments into the ceremonial and ritualistic aesthetic of theatre where the text became almost a pretext on which to paint his bold exuberant visions. Returning only occasionally to direct in his native Argentina, Lavelli established his reputation in the sixties as a director of symbolist/non-naturalistic modern classics like Gombrowicz's *Yvonne, Princesse de Bourgogne* (1965), Eugene O'Neill's *Enchaines (Wedded)* (1965), and Paul Claudel's *L'Exchange* (1966), as well as the more provocative work of a generation of post-Absurd playwrights like Peter Handke and, most conspicuously, Arrabal. Like García, Lavelli produced a number of striking pictorial productions of Arrabal's work which met with the dramatist's whole-hearted approval.

The events of May 1968 saw a slight shift in Lavelli's agenda as he embarked on a number of more overtly political productions like *Orden* (1969), and *Bella Ciao, La Guerre de mille ans* (1972) devised with Arrabal. Both productions were also significant in the sense that they were Lavelli's first ventures into opera, a medium in which he worked extensively from the mid-seventies to the early eighties. Nevertheless, despite their evidently political subject matter – both dealt with the rise of European fascism – they proved as imaginative in their juxtaposition of the visual and the auditory as his work on more (classical) literary texts. The critical success of these productions gained him invitations to work at the more conservative venues including the Comédie Française, the Teatro alla Scala, and the New York Metropolitan Opera.

After working freelance for twenty-five years he agreed, in 1987, to accept the artistic directorship of the newest national theatre, Le Théâtre National de la Colline, a two-space venue in Paris's twentieth arrondisement. Here he has continued working with a trusted team of actors including María Casares, Michel Aumont and Christine Cohendy. Taking risks with an adventurous repertoire of contemporary work including plays by Francisco Nieva, Steven Berkoff, Thomas Bernhard and Roberto Cossa, as well as those by his favoured writers of the sixties and seventies such as Copi, Lorca and Gombrowicz, Lavelli has given the Colline a notable profile and visibility in a city endowed with distinctive companies.

Lavelli is the recipient of numerous prizes including the Spanish Critics Prize for Best Production of the Year and the Italian Critics Prize for Best Foreign Production for his Centro Dramático Nacional staging of Lorca's *Doña Rosita la soltera* (*Doña Rosita the Spinster*) (1980), and the Syndicat de la Critique's Prize for *Un Visite inopportune* (1988).

Lavelli continues to live and work largely in Paris. He obtained French nationality in 1977.

OTHER MAJOR PRODUCTIONS INCLUDE

L'Architecte et L'Empereur d'Assyrie (*The Architect and Emperor of Assyria*) by
 Fernando Arrabal. Théâtre Montparnasse-Gaston-Baty, Paris, 1967.
La Journee d'une reveuse (*The Diary of a Dreamer*) by Copi. Théâtre de
 Lutèce, Paris, 1967.
Beaucoup de bruit pour rien (*Much Ado About Nothing*) by William Shakespeare.
 Théâtre de la Ville, Paris, 1968.
L'Architecte et L'Empereur d'Assyrie by Fernando Arrabal. Stadt Theater,
 Cologne, 1971.
L'Architecte et L'Empereur d'Assyrie by Fernando Arrabal. Stadtische Bühnen,
 Nuremberg, 1972.
L'Homosexuel, ou la difficulté de s'exprimer (*The Homosexual or the Difficulty of*

Expressing Yourself) by Copi. Théâtre de la Cité Universitaire, Paris, 1973.

Sur le fil (On the Tight Rope) by Fernando Arrabal. Théâtre de l'Atelier, Paris, 1975.

Idomeneo, Re di Creta (Idomeneo, King of Crete) by W. A. Mozart. Théâtre Musical, Angers, 1975.

Le Roi se meurt (Exit the King) by Eugene Ionesco. La Comédie Française at the Théâtre National de l'Odéon, Paris, 1976.

Faust by Charles François Gounod. Metropolitan Opera, New York, 1976.

Pelléas et Mélisande by Claude Debussy. Opéra de Paris, 1977.

Madama Butterfly by Giacomo Puccini. Teatro alla Scala, Milan, 1978.

Oedipus Rex by Igor Stravinsky. Opéra de Paris, 1979.

La Tour de Babel (The Tower of Babel) by Fernando Arrabal. La Comédie Française at the Théâtre National de l'Odéon, Paris, 1979.

Le Conte d'hiver (A Winter's Tale) by William Shakespeare. Avignon Festival, then Théâtre de la Ville, Paris, 1980.

La Vie est un songe (Life is a Dream) by Pedro Calderón de la Barca. La Comédie Française, Paris, 1982.

Norma by Vincenzo Bellini. Theater der Stadt, Bonn, 1983.

La Tempête (The Tempest) by William Shakespeare. Teatro Romea, Barcelona, 1993. Co-production between Centre Dramatic de la Generalitat de Catalunya and Compañia de Núria Espert. Then touring Edinburgh, Moscow and Belgrade Festivals.

Andrea Chénier by Umberto Giordano. Theater der Stadt, Bonn, 1985.

La Nuit de Madame Lucienne (The Night of Madame Lucienne) by Copi. Premiere: Festival d'Avignon. Then touring to Venice Biennale, Théâtre de la Commune d'Aubervilliers, 1985–6.

Polyeucte by Pierre Corneille. La Comédie Française, Paris, 1987.

Le Public (The Public) by Federico García Lorca. Théâtre National de la Colline, Paris, 1988.

Greek (A la grecque) by Steven Berkoff. Théâtre National de la Colline, ̵is, 1990. Revived 1992.

Comédies barbares (The Savage Plays) by Ramón del Valle-Inclán. Festival d'Avignon, then Théâtre National de la Colline and touring, 1991–2.

Heldenplatz by Thomas Bernhardt. Théâtre National de la Colline, 1991.

Kvetch by Steven Berkoff. Théâtre National de la Colline, 1992. Revived 1993.

Macbett by Ionesco. Théâtre National de la Colline, Paris, 1992.

Les Journalistes (The Journalists) by Arthur Schnitzler. Théâtre National de la Colline, Paris, 1994.

L'Amour en Crimée (Love in the Crimea) by Slawomir Mrozek. Théâtre National de la Colline, Paris, 1994.

Décadence by Steven Berkoff. Théâtre National de la Colline, Paris, 1995.

CRITICS ON HIS WORK

He has created an exciting and highly original style of theatre . . . as far removed as possible from the everyday world . . . with productions of outstanding beauty and subtlety . . .

(David Whitton, *Stage Directors in Modern France*, pp. 209 and 190).

Lavelli has built up an impressive résumé, that includes over eighty produc-
tions, both dramatic and lyric works, in most of the major theatres and fes-
tivals of Europe. A repertory that goes from the classics to contemporary
writers, through which Lavelli has made concrete his loyalty to a concept of
theatre which is based on the rejection of naturalism and a fascination for
the ephemeral and unique nature of stage events.

> (Carlos Espinosa Domínguez, 'La libertad de escribir en el espacio', in
> *Arias, Lavelli, Quintana, Ruiz: Directores iberoamericanos en Europa*, Madrid:
> Cuadernos 'El Público' 31 – Ministerio de Cultura, 1988, p. 27).

SIGNIFICANT BIBLIOGRAPHICAL MATERIAL

Knowles, Dorothy. 'Ritual Theatre: Fernando Arrabal and the Latin-
Americans'. *Modern Language Review*, 70, 1975, pp. 526–38.
Nores, Dominique and Godard, Colette. *Jorge Lavelli*. Paris: Bourgois,
1971.
Satgé, Alain. *Lavelli, opéra et mise à mort*. Paris: Fayard, 1979.
Tcherkaski, José . *El teatro de Jorge Lavelli*. Buenos Aires: Editorial de
Belgrano, 1983.
Whitton, David. *Stage Directors in Modern France*. Manchester: Manchester
University Press, 1987.
Zatlin, Phyllis. *Cross-Cultural Approaches to Theatre: The Spanish-French
Connection*. Metuchen and London: The Scarecrow Press, 1994.

Jorge Lavelli in conversation with Maria M. Delgado
at the Théâtre National de la Colline,
Paris, 24 February 1995, translated by Jill Pythian

DELGADO You came to France at the start of the sixties to
L'Université du Théâtres des Nations where Víctor García, Jerôme
Savary and Alexandro Jodorowsky also studied, and you stayed here.

LAVELLI Those years saw the beginning of L'Université du Théâtres
des Nations, an international theatre school founded in 1961, part of
Malraux's *politique de grandeur culturel*. I was studying in Paris on a
grant from the Argentinian government. I borrowed money from
friends, intending to stay in Paris for another year. I enrolled, having
done a small production of Jean Tardieu with some good people I
had met on the 'Charles Dullin' course at the TNP [Théâtre
National Populaire]. Pierre Aimé Touchard, the Inspecteur
Général des Arts et Lettres, had suggested that I take part in the
Young Companies Competition, if I was staying in Paris. Since it
was my second year there, it seemed like a good idea and I decided
to stay to take part in the competition, which was very prestigious at
that time. My entry was *Le Mariage* by Witold Gombrowicz, in which
I worked with Kristina Zachwatowicz, a Polish woman who was also
at L'Université du Théâtres des Nations. We staged it in 1963, and for

me it was a sort of culmination, since because I was unknown, being able to take part in that competition seemed like a gift to me.

DELGADO The text was also unknown.

LAVELLI It was unknown in France at that time, as so many living writers were. The show was, I think, very surprising and I was awarded first prize. Already by that point it was hard to imagine not continuing with my professional work ...

DELGADO What was the attraction of Gombrowicz's *Le Mariage*?

LAVELLI It's a very interesting work. In Gombrowicz – I later staged *Yvonne, Princesse de Bourgogne* and *Opérette* – I found the written expression of what interested me from a theatrical point of view: the theatre as living matter. The text had an almost musical organisation to it, though it wasn't formal; when subjected to great violence, it allowed for 'shock' theatre, based on the use of energy. At the same time, it was a theatre that eluded any kind of psychological approach. That was the starting point for the staging of the play, where the characters, the use of make-up, wardrobe, the elements of the set and of the stage space, the way of using music, everything had a purpose. There was a musical organisation within the text, and a group of musicians were integrated into the performance. They were a group of percussionists, who worked with the materials of the set itself, which was made of metal. The stage mechanism was made up of the wrecks of old cars and burned-out trucks. All of these things went to make up a world that was reconstructed, but in terrible condition.

DELGADO The production had a tremendous impact. Why was this? Was it because it broke all the rules?

LAVELLI It's impact on the theatrical world was enormous. Perhaps it was because the theatre at that time was very decadent. It was a theatre based on the text, but on the text subjected to an appalling commercialisation that no-one could get away from. Of course there was a lot of theatre happening, as there always has been in this city, but it all went on within a framework of frustrating conventionalism. So this new work seemed hallucinatory or expressionist, obviously beyond the norm. The truth is that I think it was outside of all limits. It was the result of an experience, and the pleasure of applying that to a complex theatrical form such as Gombrowicz's plays. Despite the fact that it tells a story, the writing is the result of a psychoanalytical experience.

DELGADO But during this production, did you reject the idea of psychological motivation for the actors?

LAVELLI Yes. I rejected the kind of realism that teaching is based on and that helps the actors to organise a discourse. It was also a work

centred on energy, expressed violently through gesture, through speech and through the body. But this does not happen much nowadays either, in the sense that the theatre is still, as it was in the seventeenth century, thought to consist of recitation, of enjoyment of the form and timbre of the actors' voices.

DELGADO Was your rejection of realism due to the influence of Artaud to some extent?

LAVELLI Yes, that might have had something to do with it. In any case, it has a lot to do with the sensual interplay of theatre; it's attractive because of its aggressiveness, its violence, its unexpected events, its ruptures, its musical organisation and its theatricality. It goes beyond the private and the familiar to the greatest euphoria anyone can experience.

DELGADO It seems that many of your works during that period wanted to break down language and exploit it on stage. They were characterised by a tremendous dynamism and the rejection of realist conventions.

LAVELLI Yes, that was a starting point that I've used to handle many texts. And I keep on doing it because my work is always about energy and rhythm seen as rupture and variety: two fundamental elements of my staging.

Other elements also played a part. Not only the strange make-up (which looked like masks) but also the fact that the characters were deformed, with costumes that incorporated prosthetics – false legs, misshapen bodies. All the characters' actions were backed up by a physical violence.

All of my work goes beyond psychological behaviour. That's something that I've never rejected. The scream as a dramatic element, rhythm as the mainstay of a performance and the way to tell a story; these are still basic principles in my work.

DELGADO Were your productions influenced by the theatre you had seen in Argentina? Your productions of Gombrowicz were a break with French traditions. Did you bring something of Argentinian culture with you when you came here, something you wanted to introduce to French theatre?

LAVELLI Perhaps, but it's hard to say precisely what it was. Maybe the grotesque; that special interplay that goes from the tragic to its exact opposite. The grotesque is a theatrical form that is natural to me in any case. The theatre is a completely artificial space, made for staging discourses or views of reality. This artificial way of writing is linked to real life, and particularly to sensitivity, to violence, to frustration with situations, opposition between people, the use of

energy ... All of these elements are in tension but are perceptible to me. Theatre is not life as it is, but an interpretation of life, a view of life.

DELGADO In the sixties you were associated with another Argentinian director who was at L'Université du Théâtres des Nations, Víctor García. Both of you staged very different productions of Arrabal during those years. Do you think your visions of the theatre have something in common?

LAVELLI Perhaps. I find García's work extremely interesting because of something that seems to me to be of paramount importance in the theatre, which is the overall concept. That's without it needing to be explained or being part of a theory. He built machines, to the point where the operation of the machines were the starting point for his work. The machines were never my idea. I always think about having to tell a story. I think about how to tell it and where it takes place. Like García, I think in terms of what the space is. I believe that the relationship between staging and architecture is vital. That's why I can't discuss any play, whatever it is, without knowing what I'm going to do. What the writer has written might seem interesting to me, but if I don't have the idea for what I call a stage mechanism, then I don't know how to tackle it. I can't make a start if I'm dependent on what someone else is going to contribute. Later on, the staging itself becomes much more simple. But knowing what the essentials are, and where and how and in what context it is to be done, that is fundamental to me. If these areas aren't addressed, the staging ends up being everything that I hate the most, everything that doesn't interest me, a copy of the old conventions of the seventeenth century. All that is part of a theatrical routine of boredom. What touched García was something essential, especially in the way he used materials as an integral part of his shows. That's what I find interesting about his work.

García and I share the same views about the best way to approach the work of the actors. Obviously, if actors who have a conventional training are handled in a certain way and confronted with a different working method, they will have to use their own imaginations. Their imaginations can always be helped along by the staging, of course. You can't handle the work of Gombrowicz, Copi, or any of the plays I do, sitting at a table drinking coffee. Despite that, though, the real world is present in them, even if it's not recognisable from the start.

Theatre is above all an art that deals with the concrete, but not the conventional or the established. When the bases for work are 'normal', that is to say, the conventional and bourgeois ones we

know, then no-one, not even a very intelligent actor, can get away from their stupidity. The opposite is also important. It's just the same as in real life; an intelligent situation offers more chances for the imagination to expand, and a stupid situation merely brings out the stupidity in people. Theatre is no exception to that rule.

There is always a starting point which I think is of paramount importance and which sets the meaning of the performance, what it is in itself. A *mise en scène* means not just reciting a text, but presenting a view of what is written: it is another writing, or a re-writing of what is written. This is important if the meaning the actor has opted for is to be understood; it will give meaning to his performance.

DELGADO It seems that your work during the sixties was very experimental: *Orden* and another piece, a collectively written musical, *Bella Ciao, la guerre de mille ans* with Arrabal and others, an untitled play in collaboration with Copi. There seems to have been a lot of experimentation with form, and different ways of working, but always staying within the alternative scene, the avant-garde.

LAVELLI I don't think there's any difference between those works and what I do now. I do the same things, but they have evolved somewhat. The evolution doesn't mean the essential values have changed. It's a confirmation made by other means. It's not the same play all the time, but rather like a single work with variations. There's no fundamental difference, only one of form. Two years ago I did Ionesco's *Macbett*, because it hadn't been staged in twenty years. That piece was handled in a way that fits in with the essential points we've mentioned. The story was told in a different way to the one I used for Gombrowicz in *Le Mariage*, but my starting point was the same. The staging involved different doors lined up along the back and each side of the stage. This gave different meanings to the performance, to the story, and to the history behind the play.

Implicit in this 'stage mechanism' is that it allows me to create different situations, and unexpected stage events, like something from a jack-in-the-box. Every single element went to make up this 'mechanism': the tracks that the witches moved around on, the moving props and doors. Every door concealed a surprise. Behind one of them was the possibility of passing from a closed area to an open one, from the intimacy of a room to the immensity of the battlefield, from a realist form to a theatrical and imaginative form. The way in which the story is told creates the style of staging. The audience contributes by constructing their own story themselves, bringing to it the elements that have an intrinsic value to them. This is why I refer to theatre as an idea about life. Without that 'idea', the theatre has no meaning.

DELGADO You were in Paris in May 1968. Did the historic events of that year have a major impact on your work?

LAVELLI Yes, of course. But not so much on theatrical institutions. In the field of theatre, those events caused something very interesting, which was disorder. In a place where there are so many conventions, so much order in the theatrical establishment, 1968 brought a feeling of freedom. This freedom was partially translated into the aesthetic order, in the sense that values were altered and inverted; at one point it seemed like the theatre was a collective activity. The theatre had always been a collective activity, but it had been hierarchised. But a few simplistic ideas, such as 'all of us are artists', won over the streets then took over the stage. The results were absurd, often ridiculous. But regardless, they fuelled the idea that the theatre, like any artistic activity, could be within the reach of everyone, and that through this participation, people could develop their personalities, alter their lives, and also express themselves. It is this kind of concept that changes inherited ideas.

From a purely aesthetic point of view, I don't think any progress was made. But at least theatre was somehow desecrated, and that may well have been of some use. Above all, the doors were opened to see what went on inside various institutions. Questions were asked, and at the level of political discourse this allowed political figures to appropriate the language of the streets. What was going on out in the streets couldn't be ignored. I think the same thing happened with the theatre. Certain openings were created, the possibility that what was being done could be done another way. Nor did it only happen in dramatic theatre, which had always been more 'advanced' in the sense that there was no extreme rigidity imposed on it by tradition; it also happened in lyric theatre, and that was more exciting. I think those things are consequences of May 1968, a little removed perhaps but still connected.

DELGADO But 'political theatre' had never held much attraction for you. I think you were more 'militant' in another sense: that of breaking down barriers and conventions, rather than having a purely political content.

LAVELLI Yes, because 'political' is associated more with political theatre. I wasn't 'militant' in the Brechtian sense. There were a lot of 'militants' around; they were numerous in France. They were extremely strict. They stuck rigidly to Brecht's guidelines, converting them into a Bible. And I can't abide Bibles.

DELGADO Why is that?

LAVELLI Because the theatre is a place of freedom, enormous freedom. It's a kind of freedom that evolves and allows for the

unexpected, even within the most 'politicised' of political discourses. For this reason, this Brechtian influence was fairly disastrous in France; it gave a sadness and a solemnity to political theatre, making it dull and boring. It was a long way from what Brecht himself and his Berliner Ensemble were doing. This submission, later imposed by Brecht's inheritors, made political theatre almost shrivel up; it was transformed into another kind of conservatism. The consequences of this came quickly, because Brecht was immediately consumed and assimilated as a writer who had to become part of this repertory. This meant that everything that was revolutionary and subversive in Brecht was absorbed into the theatre system, leaving Brecht no other form of survival. At that time, Brecht was performed using Brecht's own books of stage directions. And when you read Brecht's writings about theatre, you realise that part of his work was improvisation, and not just improvisation but transformation, and adaptation to fit the people he was working with, like any great living theatrical director.

So politicisation in this sense is something I could never manage. But Brecht was very useful to me as a reference point for this freedom. I can see this in my work, though no-one else notices. For me it meant a discovery of the feeling of freedom that goes hand in hand with my own idea of theatricality, in the sense that the theatre is an artificial environment that allows a director to carry on a discourse. That discourse will be understood on the basis of another discourse: that of the writer. It is a way of viewing what the writer proposes, and should not be in opposition to that. I believe that you stage a work because it excites you, because it pleases you, because it incites you, and so for those reasons, you should not destroy the original work. That would be totally stupid; a waste of time. But in an artificial environment, anything is possible. I find that the most interesting writers don't pose any problems at the level of staging or character; they only pose problems that are an essential part of their own discourse.

DELGADO That can be seen in the works you have chosen to direct over the past thirty years; there's a continual tendency to direct works with a very baroque exposition, works that are very alternative. I'm thinking of your *Macbett*, your *Comédies barbares* by Valle-Inclán, your *Greek* and *Décadence*, and even the works you staged in the sixties. In these, there is an obvious attraction for baroque texts that break down conventions and celebrate a 'jouissance' in the theatre.

LAVELLI I think that the theatre is a place of celebration, and that even tragedy contains this sensual, pleasurable aspect. The theatre

is a place of energy, where at the same time all facets of the contra-dictions of being human come together: man with his energy, his nightmares, his dreams, his discourse and his body. It must be man in all his totality, and the actor must possess this totality. The fact that there are contradictions seems a positive thing to me.

DELGADO Is that what attracts you to opera?

LAVELLI Yes, that's what attracts me both to opera and to theatre. For instance, Spanish comedy of the Golden Age contains something of that mix, where contradicting storylines and tragicomic situations co-exist within the narrative. I am attracted by ways of making life complex, showing extreme alternatives of behaviour and not reduc-ing life to simplified plots, by which I mean making everything 'black and white'. It's what I call 'anti-Brechtian', in the sense that for Brecht, ideological struggle consisted of imposing a concept: com-munism. That concept went before everything, and had to be real-ised through simplification, where the good had to triumph and the others would have to fail. That final simplification of Brecht is not what interests me most. I'm interested in the complexity of behav-iour, but also his sense of distance. Not the everyday, but the idea of what the everyday could be. This point of view is always different from a cinematographic or televised appreciation of what theatre is.

DELGADO You haven't staged very many 'realist' texts.

LAVELLI That depends on what you call 'realist texts'. That's true, if a realist text is what you call a work where the story is a transposi-tion of reality. To me, Chekhov is not a realist writer in the natu-ralist sense, which is perhaps the reason why I have done productions of Chekhov.

DELGADO I'm thinking more of writers such as Ibsen or Arthur Miller, who have a very linear structure, in which everything moves progressively, in a very stable, ordered way. Chekhov is much more subtle, touching on the absurd. Ibsen and Miller appear to be the antithesis of what you represent in theatre.

LAVELLI I think Ibsen is a very important writer, but I prefer O'Neill, because I believe O'Neill achieved a synthesis of Ibsen and nine-teenth-century theatre, creating his own personal version of a multiple theatre, a theatre whose modernity has not yet been com-pletely explored. O'Neill tells stories. It's the same when one stages something; it's a matter of storytelling, although sometimes the work has no 'story' per se, like *Décadence* which I am currently pro-ducing.

I make an effort for there to be a story, so that someone coming out of the theatre, who has been given no information and does not

know who the writer is, can say, 'I have seen a play where what happened was this; there was one couple, and another couple, and one couple separated and the other two didn't; they carried on, and then they grew old, and then the story ended.' Even the simplest of anecdotes needs someone to tell it. I believe the ability to tell a story is fundamental. It's also interesting when the writer tells it, which happens in O'Neill's case. O'Neill's theatre is directly related to real life, but I wouldn't call it 'realist' in the same sense as Ibsen.

I believe that this type of theatre displays a point of view because those writers have a style and a solidity from which to begin, and because out of necessity their writing relates to their own times. A lot of opinions about this style of theatre depend upon what it is trying to prove. I have never staged Ibsen, but I have produced some writers such as Arthur Schnitzler who does talk about real life, and at the same time is very influenced by psychoanalysis, and of course by his medium. He's a man that tries to bring out what lies in the darkness inside every individual. He tells a story, but then that story becomes a point of view, some kind of synthesis. All the characters, even the minor ones, have a reason for existing in his plays, as they do in O'Neill. Those writers have a hidden substance which is very important and enough reason to encourage one to look at it closely, through a magnifying glass, to discover an inner life that doesn't show on the surface. I think this is the point of view that allows them to seek further, beyond the simple transcription of reality.

DELGADO In the sixties, you talked of tearing down the walls of theatre and building something new with the ruins. Is that what the Théâtre National de la Colline has given you since 1987?

LAVELLI I wasn't thinking of a theatre like this one. This is a modern theatre, built to fill modern needs, but those needs are not so different from those of the sixties. The theatre is destroyed by conventions, ravaged by bourgeois tastes. I can see no other way out except to use this violent impulse for destruction, but in another way, for provocation. The interesting idea is changing the theatre, not only the architecture, because the theatre is still built according to traditional architectural tastes, the product of a social form. The theatre has its own continuity, just as life does; if this continuity or routine is to be broken, it must be subjected to trials, to hard and challenging tests. It should not be left to compromise and borrowed ideas.

DELGADO Here you have tried to create a repertory along those lines. I'm thinking of the writers you have staged; over the last two seasons alone you have produced Francisco Nieva, Berkoff, Bond, Ionesco and Thomas Bernhard. Was this on your agenda when you took over as artistic director of this theatre? It's a very challenging repertory.

I can't think of any prominent theatre in Great Britain whose agenda includes staging contemporary works from all over the world.

LAVELLI That's true; there is none in Germany either. Usually theatre is produced to make the world conform. I don't agree; the theatre is open to the world but it isn't made to appease the world. The starting point is not the same. The theatre should be a space that's both open and vital, with complete freedom.

This is why the 'writer's crisis' is still a major problem. I think that the writers of this century, especially those who started to write after the war, were aware of what Auschwitz had meant; their view of life had changed. This is the reason why what these writers have to say, be it provocative or not, is going to be different from what the classical writers have to say. They have to be different, because a historic and terrible event happened in that place. Humanism was buried under the horror of Nazism. This is the end of a very important century in the life of the human race. The interesting writers are the ones who are aware of that, even though they don't write about it.

The world has changed and provocation involves not forgetting this for any reason. Hence many of the writers whose work is performed in this theatre handle these historical and political facts: major changes in society or the events of big cities, the vertigo of racism or the unbearable position of being 'different' – all the discourse that makes cities adverse to tolerance. All of these are themes for our times. They are the tragedy of this post-war period. And they were not dealt with by the writers of the past because they feed the present. It is out of these major themes that modern society is built. Therefore many of these writers are reacting against the society of their times, and they are fighting for a modern theatre.

DELGADO At the end of the sixties, you said that 'the audience is an abstract idea. I can only see a spectator through myself. If something is real to the creator of a performance, the audience will react too.' Do you think that this is what has happened here? Do you still believe in it?

LAVELLI Yes, in the case of La Colline, for example. We carry out surveys to find out who our audience are, but never to ask them what they like, because if we did, we would have to admit that people like what they've already seen and what they know. We would end up with a new Comédie Française. I think that's the exact opposite of what I'm trying to do. What's interesting to me is sending the audience off into the adventure of theatre, into the unknown, knowing beforehand that the discourse is sincere and profound, not just a

discourse of circumstances. This initiation, this curiosity, goes hand in hand with imagination; the modern audience is an imaginative audience. In this sense, I'm also interested in the theatre as a spectator myself. This is why not knowing who my audience is does not affect me. I think the theatre should offer choice and make demands. Our policy is this: we offer perspectives, ideas and discourses. 'The audience' is the same whether the theatre itself is large or small.

DELGADO The audience seems to go along with that idea. Every time I have come here, I've seen full or almost full houses. That means that the public does appreciate your work, even though they don't know what they want. Do you think there's something about Paris that the audience here is open to? Do you think Paris is a city that both attracts and knows how to encourage international collaborations? For example, it could be said that here you can see theatrical works by foreigners a long time before they are staged in England. In England, Thomas Bernhard is a virtual unknown; there have also been very few productions of Botho Strauss's work; *L'Amour en Crimée* by Slawomir Mrozek has not been seen either. Is there something about the culture of Paris that allows you, an Argentinian, to direct this theatre, and Pasqual, a Catalan, to direct another national theatre? That would be unthinkable in Great Britain.

LAVELLI There are some examples of that in Germany, not just from Latin America but from the East as well, Hungarians, Austrians and so on, who work and become part of German society – some of them are even famous! I don't know if a theatre like La Colline could exist in another city. But I would have been terribly disappointed if it couldn't have happened in Paris, the cultural capital of Europe. I do not think that the audiences for art theatre have risen in comparison to the sixties, nor that the situation has improved. I think that theatre critics are still as conventional as they were in the sixties, and that their reviews are, on the whole, not at all profound.

Theatre usually works well in Paris. You can also see boulevard theatre, second and third-rate plays and so on, more refined pieces that are sometimes appealing.

DELGADO I believe that's what happens here, but it's different in London. For example, Peter Brook came here to set up the kind of theatre he wanted. What is there in Paris? Is it the government that knows how to promote this sort of thing? Is there something 'open' about the culture? What does Paris have that allows for this sort of experiment?

LAVELLI There was a marginal tendency already present in the sixties because subsidies hardly existed. I think that the expansion of

public services over the last thirty years is very important. This is a national theatre (the last of the national theatres), but there are other subsidised theatres in the suburbs, like Gennevilliers, Aubervilliers and Bobigny. There's an impressive number of theatres just outside of Paris. They're theatres that sometimes have very important performances, on a worldwide or citywide scale. In short, there is an audience, or many different audiences. And sometimes these audiences look for different experiences. It's true that there is the Comédie Française spectator, who is interested in classical theatre, who loves the theatre of his youth, the things he studied at college, and so on. Suddenly he wants to compare his student memories with the production that's available to him. But that spectator can come to La Colline too. I mean, La Colline is not only for the initiated. It requires a minimal taste for the theatre. If the spectator has no 'taste', he should acquire some; that's not something that can be done through television. On the contrary, in fact. The perverse taste for television would make one almost an enemy of theatre, where the basic requirement is the ability to concentrate. The audience needs a minimum of concentration, which television does not ask of them. Usually, television perverts taste. The TV audience simply devour images. That's why theatre is a minority activity, even though it's open to everyone.

DELGADO Do you think this tendency will change? At the moment, no-one knows if the socialists will return to power in France. Do you think it's possible that this attitude will change? This freedom that exists in French theatre – where you can see St Petersburg's Maly theatre company one night, or come here to see *Décadence*, and the next night, go and see a British company at the Odéon – could all this be put in danger? Do you think that a threat exists?

LAVELLI No, I don't think so. I don't think there's any threat in that sense. The theatre can have big economic problems, or suffer restrictions that are economically based, but I think that everyone is ready to defend the theatre belonging to both the public and private sectors. At the moment the private sector works well in Paris. In other cities, it hardly exists. If you look at the box-office receipts for theatres, you realise that private theatre is much more successful in cities like Madrid, for example, where theatre is important, where people go to the theatre a lot and where subsidies have now been greatly reduced. People used to go to the theatre for answers they couldn't find outside. Strangely, in Paris, private theatre is successful, even when its quality is doubtful. I mean, all institutionalised theatrical activity is successful. Perhaps it's got something to do with economic activity, the fact that the economy is more balanced.

DELGADO On the subject of British theatre, there have been performances here of Bond, Berkoff and, more surprisingly, John Godber: three very different writers. One that comes from a very intellectual tradition, Godber, who is a populist in the widest sense, and Berkoff, who has a very ambiguous position in British theatre. What is the attraction of these writers? And why do you keep returning to Berkoff – *Décadence* is your third Berkoff.

LAVELLI Godber's *Les Videurs (Bouncers)* was a play I had seen in Brussels. It had caused a big reaction, an odd phenomenon, and young people had gone to see it. It came together in the idea of the *boîte* or nightclub that was the synthesis of the story. The characters were subjected to an entrance test. The idea of being able to get into that *boîte*, the centre of attraction, seemed dramatically interesting to me. It was like an obstacle that had to be overcome. And the idea of this obstacle within a human agenda seemed striking.

Bond is another matter, because he's a writer I have known very well since his first plays in the sixties. And although virtually none of them found a wide audience, he's an extraordinarily interesting writer, especially in the way he recounts real life, giving it a kind of distance, and transforming it into a philosophical tale. That was the attraction of Bond in the sixties, and now he's becoming more schematic, more acid, harder, but also much more immediate because he talks about basic problems of our civilization. At the same time, I think he's unclassifiable in modern drama; the starting point of a theatre of intellectual agitation.

Then Berkoff is something else again. There's this sort of rupture with society and with his writing. It's writing that's loaded with controversy, but at the same time constructed in a precise way that allows for a lot of possibilities in the *mise en scène*. *Décadence* was the first of Berkoff's works that I knew. Due to various problems, it was never staged. Then I produced *Greek* in its place. After *Greek*, I was going to do *Décadence*, but the two had so many things in common that it didn't seem the right time. At that point, the translators suggested *Kvetch* to me. This has meant that I'm finishing the Berkoff cycle with *Décadence*, which was actually the first work that I would have liked to direct.

Greek has a profound sense of drama, in the context of tragedy, and in the evocation of themes such as the everyday fascism and racism of big cities. These are handled with originality. I was impressed by the formidable reply to Greek tragedy, neither a caricature nor a homage. The story is a 'tragedy' that escapes from horror, saved by something as rare as love. And that seemed very striking to me.

DELGADO But he's very much a London writer. His language is poetic in a colloquial way, and it must pose tremendous problems when it comes to translation and transposition. That's why it's so surprising to me that you as a director are so associated with his work.

LAVELLI These things are sometimes coincidental. The biggest problem has been and is adapting Berkoff, and in particular *Décadence*. You realise that it's easier in English because the different accents distinguish between characters. Here it doesn't work that way; it's substituted by word play. You can't use an accent when the spoken language is the same.

DELGADO In *Décadence*, you're collaborating once again with Michel Aumont and Christine Cohendy. What's the attraction of working with those actors?

LAVELLI The fact of having greater understanding. In the case of Aumont, the fact that he's a great actor, obviously. He was already a great actor when he did his first work with me, which was an Ionesco play, *Le Roi se meurt*, at the Odéon. The central character was played by Aumont. He has this incredible ability to incorporate himself into a staged discourse; not only incorporating himself but also interpreting it, giving it his own personality, appropriating those concepts. *Le Roi se meurt* contained things that were extremely funny and others that were poignant at the same time. This is difficult to direct because it's alien to the French spirit. Tragedy does not exist in France. There's no tragedy in writing because there's no tragedy in this country. It's not like it is in England. So it's very difficult to portray tragedy and its opposite.

In *Le Roi se meurt*, the poignancy of the situation and the petty bourgeois quality of the writing create an enormous shock, from which springs the kind of humour that interests me. Aumont, for example, is very good in this area, despite, I would say, his long association with La Comédie Française, which is one of the bastions of conservatism. Continuity has meant that in actual fact we have done more things later: a piece by Arrabal, *La Tour de Babel*, at the Odéon too but with La Comédie Française, and various plays at La Colline, from *Comédies barbares* which took a whole year to complete the trilogy, *Macbett*, *Les Journalistes*, *L'Amour en Crimée*, and *Décadence*. Michel is a very modest man. It's hard work for him to be able to completely take on the immodesty of Berkoff's language, since he's an actor with a classical training. But he's someone with great intuition and a very determined way of wanting to take a proposition right through to the end. That's what I find interesting in an actor. If an actor doesn't have all these qualities, I'm not interested. I could say the same about Christine Cohendy and some others who have

worked with me. This is also the reason for staying loyal to María Casares and Roland Bertín.

DELGADO What about your collaborations with Dominique Poulange? She works on most of your productions as assistant director. How did this relationship start, and how does it work? Directing is always like the vision of one person. How does it fit together?

LAVELLI It's a collaboration as far as distribution, casting, and preparation go, but not in the basic task of staging. The basic task of staging is my job. Building a total concept for the performance is my task with my set designer and then my task with the actors. So in this pattern, collaborating with Dominique is very useful, because she knows how the staging works. She knows the way I direct actors, and she notes down the stage directions. It's a job that goes beyond being assistant director.

DELGADO You have worked with quite a few set designers. What qualities do you look for in a set designer? For example, you recently collaborated with Graciela Galán who has worked mainly in Argentina.

LAVELLI I worked with Graciela for *Comédies barbares* because I thought that a Hispanic culture would be most appropriate given the way the work was to be staged. In the simplicity of the staging – relative simplicity because there was nothing and at the same time there were many things – it was important to have someone who knew the world of Valle-Inclán and knew how to unlock that imaginative world.

What I look for in my set designers is technique, but also the way they take on the ideas I suggest to them. For example, I worked with Max Bignens for twenty years. Bignens is a set designer with an extraordinary command of technique. I don't think there's another like him. He brought a lot to me; he was technical director of the Opera and the Dramatic Theatre in Cologne, but he also taught a lot of set design. He knows how to turn into reality an idea which might at first seem surprising and complex. This allows me to do quite exceptional things. I'm thinking of sets like Stravinsky's *Oedipus Rex*, for example, where the whole stage was gradually raised to an angle of forty degrees. I remember *Madama Butterfly*, where on the main stage all the action was seen as the dream of the central character, enclosed inside a great cylinder of tulle. This cylinder was Butterfly's space, the place of her dreams as well as her prison, and this was realised as a real stage mechanism; from a technical point of view these things are enormously complicated. The starting point is being able to argue with someone who knows how to alter, interpret, transform and understand a stage discourse. Very

few people know how. Here in France, I know hardly anyone who can. I know people who can make 'sets' and that sort of thing, but not truly inventive people who are ready to develop an idea.

Sometimes I have very precise ideas; I'm bad at drawing but I can describe exactly what I want. So that I can later develop it and discover the meaning that can be given to this mechanism, I need an imaginative, high-calibre collaborator.

The operatic works have been very important for me, like *Salomé* by Strauss, for instance. A lot of the outcome depends on the technical side, since it's not only in the visual aspect that the conditioning of the characters is at stake. Lyric theatre is marked by a conservative stagnation. To do good work in this medium, one would have to work with theatre people, select people.

DELGADO To finish, I'd like to ask you about your work with opera. In the sixties you said you didn't like opera, that it was unbearable and old. Apparently at that time it was not a matter of rebuilding opera from the inside as Peter Brook did, but of trying to smash it, as you did in your first operatic productions. After that, there has been a change of attitude in the sense that you work within the traditional operatic structures that already exist; there was no question of creating another type of opera in the sense of taking the piece and breaking it up, creating a new piece. Apart from the fact that a new work is always created when it is performed, you now work with the piece as it has been established.

LAVELLI I never work in any other way. In opera, I work with the pieces I choose or that are suggested to me, without getting involved in the structure. The only work where I worked together with the librettist, orchestra and composer was *Orden*. It was about the birth of fascism in Spain, almost a story, but a story not written but evoked. That was the final culmination of a long search, where music was the basic element, but there were actors, soloists and over thirty people working together. It was performed in Avignon, and then in the old Halle de Paris. The rest of the operas I've produced, from Mozart's *Idomeneo* to the latest, *L'Enlèvement au Sérail*, were not a 'musical adaptation' of an opera. There were cuts in all the operas, but there were no changes such as, for example, taking *Idomeneo* and cutting the chorus. No. It's opera as it is, as it was written by the composer, although there are a few cuts depending on the recitatives and so on. The most important work I did was at the level of the opera's concept. I apply the same criteria as I do for the theatre. How and where is the story going to be told, and in what way? How will it be accomplished that the work of the singer, often not chosen by me, fits into the total concept of the character? How will the dramatic

action imposed on an opera have repercussions on the work of the singers and the chorus? Resolving all this means a lot of small alterations. Sometimes it means facing the opposition of the director of the orchestra, soloists, and sometimes the whole orchestra. My job is to go out there and convince them that there's a point to what I want to do.

DELGADO Your theatre has always had a musical rhythm. Your work with actors, the use of the voice, the intonation of the actor, has always had a very musical aspect. Was the chance to take this to a higher plane something that attracted you to opera?

LAVELLI No, that wasn't what attracted me to opera, because that's work I've already done. The interesting thing is to see how a situation can, with an intelligent interpretation, bring profound change along with it. An opera performer sings as if he was with his maestro, as if he was in a concert, and to achieve a dramatic transformation, he needs to ground it in his own personality. This is all fairly interesting. But at the same time, it's very complicated. The performance cannot just become an obstacle race. The singer must be ready to face problems he doesn't know about. I have often had problems with stage performance, either with the whole cast or with individuals – collective problems because they were related to the chorus involved in transformation scenes, for instance. In the case of *Idomeneo*, the chorus was the basic dramatic element used as the driving force for the performance, 'different' from the more usual character-driven presentation.

In opera, I work with infrastructures that are defined not by myself but by institutions. That's a big disadvantage. When you work at L'Opéra de Paris or at La Scala, you must adapt to those infrastructures, although whatever you do can provoke all kinds of conflict. Of course, all these conditions have been discussed before; they aren't just invented and they can't just be invented! I've always worked as an independent, bowing to no-one; that means I can discuss my previous working conditions, especially in large institutions, anticipating the kind of artistic problems that crop up.

DELGADO Do you think your theatre work has been very different from your opera work?

LAVELLI Even though they started from different points, they're the same. The criteria are the same. With the things which have given me the most pleasure to direct, like *Salomé* by Strauss, or Mozart's *Le Nozze di Figaro*, for example, it has been not only because of the difficulties they presented but because of the quality of the artists involved, who adapted just as actors can adapt to a suggestion, and enjoyed the experience. My proposition in *Salomé* had to do with the

focus I chose: desperate, difficult and laden with a terrible tragic burden that linked the characters together, a little like *Le Mariage* by Gombrowicz, where everything could be seen as the aftermath of a massacre. Starting from a post-modern society, in which a great massacre has led to the loss of memories of the past and of history in that desperate situation, I effectively represented Strauss's discourse, which has an unmatchable violence. From this came a pain, a sensitivity, a persuasion, an enchantment through this desperate vision of history, which can sometimes be seen in a Shakespearian tragedy, when it is well performed.

Opera interests me because of its fantasy content, and its music; that which, as Debussy said of his own work, 'allows me to imprint my own dream onto the dream of another'.

DELGADO It's interesting to see what you've said about Debussy because your theatre could be defined as one which presents well-known stories in a different way. Is that like 'rewriting dreams', do you think?

LAVELLI I think so; I think that's what staging is about.

DELGADO How would you define the role of a director? Has it changed at all?

LAVELLI The director of a theatre, or a *metteur en scène*?

DELGADO Both.

LAVELLI They're both different. As a director, I try to build up a coherent artistic project in the Théâtre de la Colline, with all the problems and the lack of funds. That's one of the obstacles. I can't be like the director of La Comédie Française and say 'I want to put on this play' or 'I'm going to finance this project'. I don't have sufficient means and I have to wait for proposals. Occasionally, I can make a proposal of my own. I can say, 'I'd be very interested in doing this, in producing this, but we'd have to look for a co-producer because we haven't got the money to stage it.' And that's how a lot of projects get done in this theatre. I never worked that way in my day. In the Théâtre de la Ville, they would call me and say, 'What would you like to produce?' And if La Comédie Française called, it was to ask me, 'What would you like to stage in this theatre?' I can't do that here! If someone suggests a project to me, I say to them, 'Fine. We can produce part of it.' We produce 40 per cent, 50 per cent or whatever.

DELGADO That's your job as a producer. What about as a *metteur en scène*?

LAVELLI The job of a stage director never changes. It's still the same. I read a lot of plays and I choose writers. I follow writers that

interest me, like Thomas Bernhard, for example. I've produced two of his plays here. Bernhard excites me because he's a long way from what Gombrowicz and Copi used to write, and at the same time he's a writer of language; a writer that gives the impression that everything is written down there. I love the strength of his language, the meaning in his discourse, and his destructive attitude. When we talk about how theatre can be destroyed, we're saying that ideas have to be destroyed. There has to be destruction for a new society, or a better society, to be built. What already exists must be demolished. And Bernhard does that job with humour and desperation at the same time. He also interests me because at the same time he takes his inspiration from a theatre that comes from immobility, from that 'immobilism' Ionesco had. But Bernhard has an impressive strength in his discourse. He has the double strength of violence and destruction, hand in hand with that of 'restructuring', because his discourse maintains a fiendish musical structure. This discourse gives importance and value to what we could call 'anti-discourse', the discourse of silence. This relationship between silence and discourse is a key factor in post-war drama.

ROBERT LEPAGE

◇

Described by the critic Michael Coveney as a 'Québécois genius' ('Freer, Hipper, Cheaper, Faster', *Observer*, 7 August 1994, p. 74), the actor-writer-designer-director Robert Lepage's highly visual often technically adventurous theatre journeys have questioned the traditional linear presentation of time and action. Often evolving over lengthy periods, they have habitually featured multiple enigmatic storylines and overlapping scenes, and have undermined the primacy of the written word through an emphasis on improvisation and the sculptural possibilities offered by the technical resources of the contemporary theatre.

Born on 12 December 1957 into a bi-cultural family, Lepage graduated from Québec City's Conservatoire d'Art Dramatique in 1978, then moved to Paris to study with the Swiss director Alain Knapp, reknowned for placing an emphasis on the multifaceted role of the director as both actor and writer. Returning to Québec in 1980 he enjoyed success at the Ligue Nationale d'Improvisation (LNI), where he demonstrated sound improvisation skills, and then joined Jacques Lessard's Théâtre Repère, where he evolved the RSVP cycles developed by Anna and Lawrence Halprin's San Francisco Dancers' Workshop. The working methods employed involved questioning the hierachy of the director through the elaboration of script, characters, *mise en scène* and decor, together with the company as a collective venture.

It was his solo show, *Vinci* (1986), that first gained him international attention. A contemplation of the painter, it took its lead from the European travellings of a disillusioned Québécois photographer, Philippe, seeking to escape the desperation encountered on the suicide of a friend. *Vinci* was a virtuoso display of gentle intimate acting and stage trickery, and toured to France where it won Avignon's Coup de Pouce Prize in 1987, and was subsequently presented in an English language version. *La Trilogie des dragons (The Dragon's Trilogy)* premiered in 1985 as a fifty-minute piece, developed over the next two years into various forms including a six-hour version at the Festival de Théâtre des Amériques in Montreal in 1987. A journey across three Chinatowns in three Canadian cities, the trilingual *La Trilogie des dragons* proved a fascinating exploration of cultural identity and assimilation which demystified and reappropriated simplistic stereotypes. The flimsy narrative, charting the adventures of Jeanne and Françoise from youth to middle-age,

was merely a framework on which was hung a sophisticated inventive study of the issues surrounding a multicultural Canada. *Tectonic Plates*, presented in its first draft in 1988 at Harbourfront's du Maurier World Stage theatre festival in Toronto, was also characterised by a mosaic intertextual structure. As with *La Trilogie des dragons*, it was informed by an inventive use of stage imagery, theatrical metonymies creating dazzling pictures from the most pedestrian everyday objects, and a fluid structure serving to provide a perceptive comment on the ephemeral act of theatre itself.

Although his work has been subject to much rigorous analysis, Lepage regards himself as a primarily intuitive rather than intellectual director, concerned with restoring to the stage the joyful element of 'play' and transforming the most vigorous traditions and conventions of theatre for our current intercultural and multimedia climate. During the late eighties and early nineties, firstly with Théâtre Repère and then at the National Arts Center in Ottawa, where he was artistic director of the Théâtre Français (between 1990 and 1993), he worked within flexible stage areas and with a regular group of performers, generating a prolific number of thematically rich and varied productions which fractured linear concepts of time and space, offering fascinating contemplations on the fluidity of cultural, national and sexual identities. *Alaienouidet,* co-written with Marianne Ackerman, and based on the visit of the British actor Edmund Kean to a Wyandot Indian reserve in 1826, played at the National Arts Center in 1992. His widely toured one-man show *Needles and Opium* evoked Jean Cocteau and Miles Davies in its sensual surreal recounting of Robert, a young Québécois's residency in a Paris hotel room. In 1992 he became the first North American to be invited to direct Shakespeare at the National Theatre in London where he staged a Jungian production of *A Midsummer Night's Dream* in a mud bath.

The early nineties also marked his debut in opera with a haunting expressionistic double bill for the Canadian Opera Company – Bela Bartok's *Herzog Blaubert* and Arnold Schoenberg's *Erwartung* (1993) – both designed by Michael Levine and performed in Hungarian and German respectively. In 1994 he set up a new company, Ex Machina. Its first production, the mosaic *The Seven Streams of the River Ota,* uses the story of a Czech Holocaust survivor living in Hiroshima, Jana, to probe the multifarous legacy of Hiroshima. Conceived as a seven-part epic, it was presented in a preliminary form as a work-in-progress at the 1994 Edinburgh Festival where its apparently 'unfinished' status and jarring hybrid of forms was resented by a critical and audience contingent. His recent work includes a production of Strindberg's *A Dream Play* (1995) for

eighteen actors in a single cubic dissolving set at the Dramaten National Theatre in Stockholm. Over the last year he has been heavily involved in the plans to convert an old fire station in Québec into a multimedia performance centre for his company Ex Machina, which will offer the possibility of virtual theatre – with actors enacting a work on different stages in different cities.

Lepage has received numerous awards for his innovative productions, including the Grand Prize of the 'Festival de théâtre des Amériques' in 1987 for *La Trilogie des dragons,* the Best Creation Prize at the Nyon Festival Switzerland for *Vinci* (1987), the National Arts Center Prize in 1994, and the Floyd S. Chalmers Canadian Play Award for *Needles and Opium* (1995). He is also known for his work as a radio, television and film actor – his most prominent role to date was in Denys Arcand's *Jésus de Montréal* (1988). His first film as director, *Le Confessional,* was screened at the 1995 Cannes Film Festival.

OTHER MAJOR PRODUCTIONS INCLUDE

Circulations. Also co-author and actor. La Bordée, Québec City, 1984. A Théâtre Repère production.

Polygraph. Also co-author and actor. Théâtre Périscope, Québec City, 1988. A Théâtre Repère production.

Roméo et Juliette (Romeo and Juliet) by William Shakespeare. Shakespeare on the River Festival, Saskatoon, Canada, 1989. Produced by Théâtre Repére and Night Cap Productions.

Coriolan (Coriolanus), Macbeth, and *La Tempête (The Tempest)* by William Shakespeare, adapted by Michel Garneau. Maubeuge Théâtre, France, 1993. Produced by Théâtre Repère.

Noises, Sounds and Sweet Airs by Michael Nyman. The Tokyo Globe Theatre, 1994.

CRITICS ON HIS WORK

He is a laureate and ambassador for Québec, whose genius may yet be open to question, but whose importance as an icon of national identity is beyond doubt . . . His work mixes languages and cultures, creating a sense of a constitutional outsider who regards everywhere as equally foreign. The concept of 'tradadaptation' plays a key role in his vocabulary: it's a quite specific concept that goes beyond translation towards an annexation of old texts to new cultural contexts'.

(Claire Armistead, 'Pursuit of the Trivial', *Guardian,* G2, 5 October 1994, p. 10).

Lepage's infinite capacity to surprise is his hallmark . . . Widely recognized as the most innovative theatre director in Canada, he has . . . established himself as a performing arts force on three continents . . . Lepage's range of theatrical interest is as outstanding as his talent . . . (He) set out on an entirely new path by agreeing to direct a double bill for the Canadian Opera Company . . . Yet another radical departure came when he joined Peter Gabriel, designing and directing the rock star's latest high-tech concert tour

... Beneath Lepage's eclecticism there is an underlying unity and it revolves around his entire notion of the purpose of theatre.

(Barry Came, 'Robert Lepage', *Maclean's*, 106, No. 52, 27 December 1993, pp. 19–20).

SIGNIFICANT BIBLIOGRAPHICAL MATERIAL

Hunt, Nigel. 'The Moving Language of Robert Lepage'. *Theatrum*, No. 6, Spring 1987, pp. 25–8, and p. 32.

Hunt, Nigel. 'The Global Voyage of Robert Lepage'. *Drama Review*, 33, No. 2, Summer 1989, pp. 104–18.

Lepage, Robert interviewed by Christie Carson. 'Collaboration, Translation, Interpretation'. *New Theatre Quarterly*, 9, No. 33, February 1993, pp. 31–6.

Rewa, Natalie. 'Cliches of Ethnicity Subverted: Robert Lepage's *La Trilogie des dragons*'. *Theatre History in Canada*, 11, No. 2, Fall 1990, pp. 148–61.

Salter, Denis. 'Between Wor(l)ds: Lepage's Shakespeare Cycle' and 'Borderlines: An Interview with Robert Lepage and Le Théâtre Repère'. *Theater*, 24, No. 3, 1993, pp. 61–79.

Robert Lepage in conversation with Alison McAlpine, at Le Café du Monde, Québec City, 17 February 1995

MCALPINE You've spoken in the past of using resources versus themes as starting points. I'm interested in how this process has evolved for you, specifically with regard to your most recent project, *The Seven Streams of the River Ota*, and your new company, Ex Machina?

LEPAGE We've inherited rather than invented a way of working. In our new company Ex Machina we're using parts of the method we used to work with when we were with Théâtre Repère, but it was developed before that by Anna and Lawrence Halprin's dance company in San Francisco. They created something called the RSVP Cycles: R meaning Resource, S meaning Score, V was Value action, and P was Presentation. Jacques Lessard, who went on to found Théâtre Repère, was a teacher at the Conservatory here in Québec City where we all studied. Most of the people who are part of the company today are people who went through the Québec City Conservatory. Jacques left the Conservatory for about three years, went to San Francisco and worked with the Lawrence Halprin company. He then came back, had the mandate to translate all of what he had learned, and tried to apply these work cycles directly to theatre. The people involved in the dance company were architects, philosophers, and chiropractitioners, but there weren't that many theatre people involved besides Jacques.

So Jacques translated the RSVP Cycles into Repère, which is a pun because repère means a point of reference, or a starting point. But individually the letters stood for other things: 're' for REsource, the 'p' is for 'Partition' which means Score, the 'e' is Evaluation and then the final 're' is for REpresentation. There are a lot of rules and laws to this thing. Not being the creator or the inventor of this method and using it a bit by accident when I became a member of Théâtre Repère, I wasn't that much aware of all the different rules and things. I've always intuitively used the method in a sense that I was already working in that way without knowing that it could actually be a cycle, or a way of working, or a method.

We never really respected everything. I think that Jacques on his part was much closer to the Repère Cycles system. He was using it in a very methodic way. We were using a freer form and trying to adapt the rules of it to our feelings and our intuition. I always felt that it found its way better like that; it was closer to the intuitions and feelings of the people using it when we weren't strangled by the rules.

So that created inside the company two ways of working. Even if we were all working with the Repère Cycles method, there were actually two kinds of products coming out of it: one which was more Jacques's type of stuff, which was recycling already existing texts by authors, and the other which was collective creations that I was doing with two-thirds of the company by starting from scratch. Our work started to be more and more well known and that created a kind of dissension inside the company. We ended up all leaving the company except Jacques and a couple of members who decided to continue touring in a certain way. I was one of the first to leave. I went to the National Arts Center in Ottawa because I'd been appointed artistic director there and thought I could maybe do my own thing, but of course I missed the collective company way of working. As the other members were all leaving the company, we decided to regroup and to create a new company called Ex Machina and to continue to work like we used to. It's now a year old. We don't dare call it Cycle Repère because it's not associated with Théâtre Repère any more. At the same time we try to get the idea across that we've developed our own rules and our own laws that have a certain parenthood with the Repère Cycles, but that have evolved into something very different.

There are many points that have evolved. I think the thing that we have managed to make a point of in our company is the last part: the 're' of Repère. The 're-presentation' performance aspect of it is the writing process. The writing starts when you perform and it's a difficult thing to comprehend for a lot of people in this field of work

because we're used to the traditional hierarchy of the author, and then the script being put into the hands of the director who re-shapes it, or re-moulds it, or tries to squeeze or apply his concepts onto it. Then the actors, who have their own way of interpretating it, squeeze their feelings, emotions and intuitions into the script. And once the guillotine of the opening night happens, all the creativity stops on that evening. Everything's supposed to be frozen, wrapped, sealed and delivered to the audience which has paid, and wants to have its money's worth.

I've always believed – even before I was working with the Repère Cycles or this method of working we have now – that writing starts the night that you start performing. Before that, at what people usually call rehearsals, we structure and improvise. The writing should be the last thing we do. In theatre it should be the traces of what you've done on stage. There can actually be a sportive and active phenomenon happening on stage. If you achieve that, it is very theatrical, because that is what the audience secretly desires. You go to theatre like you go to see sport.

The whole notion of 'playing' in theatre has been evacuated in this century. I think that the people who are part of our company are not interested in acting that much: they are interested in playing. As a director I am trying to find a way of devising work that gives the impression that people are playing, and you are inventing a game much more than a script, and you end up writing things on the day after the closing of the show. That's much more what theatre is about: that's a theatrical process.

MCALPINE What drew you to the subject of Hiroshima?

LEPAGE We always shop around for resources to start a new collective creation of something. When I do a one-man show there are many things that I personally want to do and talk about, and sometimes you want to talk about something that's quite limited. You know that after an hour and a half of performance with one performing artist, you'll probably go all around the subject. It's more difficult to find a subject that has a multitude of possibilities that can be divided into different avenues all converging into one point. That was the case with *The Dragon's Trilogy* where we felt we could create an event. There was enough material for the six authors and eight actors to write a saga, a fresco, and an epic.

For Hiroshima it took some time before I actually bumped into a subject, or a resource that I felt I'd be better off doing with a lot of people more than doing it myself. I was visiting Japan for the first time three or four years ago with Richard Fréchette and ended up in Hiroshima as a tourist, like a lot of people do. I was invited by the

Shakespeare Foundation – they have more scholars in Japan than all of Great Britain put together. I visited Koyoto, Osaka, Tokyo, and ended up in Hiroshima. I was struck by two things in Hiroshima. As a Westerner we always see Hiroshima as a symbol of destruction and death, which of course is quite normal. But when you actually visit Hiroshima you're struck by the beauty, the life, the sensuality, the smells, the tastes and the feelings, and it's exactly the contrary of what you expect. So that's one thing: you have the physical sensation that whatever is the context, life is stronger and it does grow back; it does start back in a very short period of time. Of course there's all sorts of consequences but that's the first strong impression that I had about Hiroshima.

And the second one is that the only things in Hiroshima that actually threw images of horror at me weren't things like visiting the museum, or the memorial, or seeing the photographs of people who'd had their skin burnt, losing their hair or seeing all the horrors that we usually see: that wasn't the horror that struck me. The horror was communicated to me through miniature events, stories or little things, which is actually very Japanese. We were visiting the city with a man who was in his sixties and who was, we discovered later, a victim of the bomb. He didn't have any physical lesions or marks or whatever, but he had seen the bomb explode and he went through the devastation of it, but he was very discreet. He never imposed that on us for the visit; he helped us as a good Shakespearean scholar. He told us all sorts of little stories, sometimes really insignificant, that were so simple, but actually translated onto the devastation much more than a lot of the films, museums and art that we were seeing: the Museum of Contemporary Art in Hiroshima houses extraordinary art, but you don't necessarily get the devastation of it. There's a lot of painting about pain and about scorched earth but you get much more anguish from it than you actually get to understand, or get a sense of what in everyday life it meant: what happened to Hiroshima?

So there were all sorts of little stories he was telling me, that really affected and moved me. For example, he told me about this woman who had been disfigured and people were hiding mirrors from her house so that she couldn't see the horror of her face. Nevertheless she desperately searched for a mirror and one day she stole one and somebody was observing her to see how she would react when she saw her face. She looked at herself. She had hidden lipstick under her pillow and she put some lipstick on her face, and then she took it off. It's a very Japanese way of saying the horror of it.

All these little stories were about people – you can't stop a man being a man, and you can't stop a woman being a woman. They were

stories about the idea of the ego, the image, and the notion of beauty. It was a fantastic two days of these little stories that my guide was throwing to me. I was so amazed to hear, for example, that in Hiroshima there's a river called the River Ota that divides into seven streams, and so it's a city where there are a lot of bridges. The first two bridges that were reconstructed were called a Yin bridge and a Yan bridge, because when the citizens looked at this devastated city they said 'Well, if we want life to start all over again in Hiroshima, we have to give the city sexual organs, so one side of the city can actually copulate with the other side of the city'. They built these two little bridges – one with a 'V' shape, and the other one more phallic. It was a weird poetic image. But then when I visited the outskirts of Hiroshima at night and was on the top of a mountain, I could see these two little bridges and the cars going from one to the other. There's always this notion of a female and male side to everything in Japan, and even parts of the city are male and female.

A lot of the stories that were told were about sex and copulating. It was very strange because in a place where you're supposed to come out with this deadly feeling – having witnessed all these charred bodies – it actually puts you in contact with the sensuality, the finality, and also the sexuality of your own life. It became obvious that if I was going to work on something about Hiroshima, it would be something extremely erotic, extremely sensuous, and extremely sexual, because these notions of finality and of hyper-eroticism are ever-present in Hiroshima.

When I came back I could feel that – amongst many other ideas I had for subject matter or resource – this seemed to resonate in many different directions. Also, because 1995 is the fiftieth anniversary of the bombing of Hiroshima, we're going to be bombarded by documentaries, information and footage from that period. It's important it happens, but actually nobody is going to be told the real horror and the real beauty of it, and the contradictions and the paradox for a foreigner to visit a city like Hiroshima and to feel very excited by it: to be sensuously seduced by a city and, at the same time, have a reflection on the nuclear threat, and on war. So it's a very exciting, paradoxical, conflictual thing and when there's a conflict from the start, there is a subject for drama.

It was also important that it's going to be seven hours by the end and that there are no Japanese in this show. Besides some little appearances here and there of a waitress in a karaoke bar or something, besides these little appearances of Japanese characters, it's all Westerners. It was my feeling that we should talk about Hiroshima, but as Westerners and not have the pretension that we're going to tell the horror or the beauty of Hiroshima as if we were Japanese,

which would be completely false and dishonest. So it became an idea that we should develop seven characters who all deal with the idea of Hiroshima – before, during, or after the bombing – and that these seven different Westerners from different parts of the world who deal with it, are all interconnected into the same story. That's where the idea for *Seven Streams* came from. The River Ota flows through Hiroshima, is divided into seven streams, and then becomes the ocean. The seven streams point in seven different directions and the idea was that we could build seven different stories that are all converging towards the same source which was in Hiroshima. The seven streams of that river are one of the reasons why they chose to bomb Hiroshima rather than any other city. It was not a military city, but important because of its different branches and affluents: a city where they could exchange armament and merchandise. Hiroshima was a strategic point of entry in Japan mainly because of its streams, and the fact that the city was divided. Actually there were originally eight streams and after the bombardment there were seven.

MCALPINE I saw your show in Manchester in October 1994. What I vividly remember is your use of mirrors and photography, and also the completely different styles of the three sections. Were these images and styles starting points?

LEPAGE Yes, they were. What we have performed up until now are our attempts at trying to find out who are the main characters of this thing, where is the action taking place, what are the styles, in which form, or what medium are we going to be using for different topics? In this five-hour version that we have just produced, things are much clearer than they were in Manchester because now we have confirmed some characters more than others, and also each of these characters brings us into a world of their own. For example, the character of the opera singer that you saw in Manchester was an embryo of a character. Now, in what we devised, she brings us to Amsterdam and we go completely into that character, and to the crisis that she's living more precisely. Being an opera singer, she obviously brings us into a more operatic way of telling her story and there's a certain dimension to what she says that is much more lyrical. Sometimes we have a character that brings us to a medium; sometimes we've found a medium that will eventually conduct us to a character.

We worked in this way because we wanted to eventually invite into the project all sorts of artists. We're trying to get away from the idea of acting that we're always stuck with when we do theatre. We want to invite people from other disciplines. When you do a story of Hiroshima, which is also the story of the century, you're going to go

through the evolution of different disciplines, of different forms of art, of different trends. For example, the idea of photography at the turn of the century and what photography stands for now has evolved and can express different facets of Hiroshima, through what happened to that form of expression. It's the same with opera, theatre, puppets, video, and film. The medium you use to tell the story locates you very quickly in a time, in a period, in a trend.

MCALPINE This process of improvisation and creation puts a lot of responsibility on your actors. Is each actor responsible for the lines of his or her character(s) and does the group, collectively, evolve the structure of the whole?

LEPAGE I try to be a kind of conductor in all of this, and not really an author or a director. All the actors improvise and write their own text. They decide for themselves what they should say. But of course all of this is put into a certain perspective and as we go on, the style of writing becomes more homogenous. The writing goes through a process that people try to avoid nowadays which I think is really interesting. It's a translation process. When you write a really lousy piece of script and dialogue, when you do a first attempt, and you get to tour in another country that speaks another language, then you have to translate stuff. Like, for example, when we went from London to Paris, we suddenly had to translate half of the scenes into French. When we translated it, what we had to say was much clearer because French is our first language. We had to consider each word: what do we really mean? And the process of translating it really enriched the dialogue. Now that we're back in Québec City there are some things we can rewrite, and there are some things we can do in English here that people understand which they didn't in Paris.

Then we're going to Vienna in June. A lot of it we have to reconsider if we want to translate it into German. If a German character is speaking to another German character in this show, he should speak German. So it forces us to always consider what is being said – what is better understood? Is this well written? Is this homogenous? Is the idea coming through? The process of translation is like an x-ray of our writing where we can see all our thoughts.

MCALPINE When you were in Manchester, the actors were improvising in French, but then they would have it translated into English?

LEPAGE But some of them were improvising in English on stage.

MCALPINE But does the actor go home and write the improvisation?

LEPAGE He does, but he also sometimes goes home and says 'Well, I'm going to re-formulate that'. And there's all this queueing going

on between the actors before a performance. That's the most exciting part of it: they say, 'Tonight I'm going to try to bring this idea into play, but I can't say this before you say this, because then what you say is irrelevant. So what's the best place to do it?' Somebody might say, 'Why don't you try to do it there? And when the waiter comes in that will interrupt what you're saying and then we can actually switch into that subject.' They all decide before the show, and then we do it. Sometimes it works, and sometimes it doesn't: it becomes a sport.

MCALPINE You mentioned the opera singer in *Seven Streams*. This is the first time you've had an opera singer in your company. Has she, given her different background and training, affected the group, and its process?

LEPAGE There is a notion of discipline that is very different in opera than in theatre. It changes the whole tempo of writing, performing and rehearsing. But there's also something free-form about opera. We always think of it as a very stuck-up form but it's actually very free-form, because what I've learned working in opera is that whatever the opera is, however the performers decide to do it, it is at first very technical. It's a very technical thing just to get to sing these things on pitch. So the first day of rehearsal you're sitting in a room and just listening to them going through all this music technically, and the room is filled with emotion. In theatre people read on the first day and it takes weeks and weeks to get a sense of emotion. You have to discuss and decide what it is, and then go fishing for it. In opera what's extraordinary is that however technical the performers are, the emotional subtext is indicated by the music. The music is supposed to be a guideline of the emotion. It's amazing how in opera you start at plus five, you don't start at minus ten like we do in theatre.

That's something that we tried to bring into play. Music is becoming an important part of our work in the sense that sometimes we don't have any emotional subtext in what we do because we're only dealing with ideas: we want to bring this idea into play. But in this work we've just done now, and it wasn't the case in Manchester, we have a musician that's following and improvising as we go on. He knows what the emotional context of each thing is, and he supports the automatic writing that evolves on stage. So it's a very important step for us and that's mainly because of the presence of one of the performers being an opera singer.

MCALPINE How do you see your role as director in all this? Is it really just as a conductor in the process?

LEPAGE I try to be a facilitator, because at one point in this way of working we all have to admit that the subject matter and the resource

that we've chosen and the stories that come out of that resource are more infinite than we are. Because everything is larger than us, we have to have a sense of humility and we have to let the story tell itself: appear by itself. At the beginning it was difficult because we were really scratching to find it. But these days it is interesting because suddenly we can feel that it's this immense force that has its own life. As an observer I can start to see it move, so when we go through the shows I try to tell them where they should look or what they should be attentive to, in order to understand who and what this show is. And they know then how to harness it and how to write it.

It's difficult to explain exactly what my role is because I'm not really directing. I am directing, of course, and I do the traffic like a lot of directors do, but I'm also writing it a bit, I'm designing it and I'm helping the actors find their own dialogue. Sometimes they wonder why this doesn't happen and why the emotion doesn't come and I say 'Because we don't have a written script you have to use other notions'. I have to keep them well informed of the beast that is starting to appear and what he looks like.

MCALPINE This method of continually evolving your work over time is a familiar process for you. *Polygraph* and *Tectonic Plates* developed over years. How do you prepare a work-in-progress on an international festival circuit? Clearly there are huge expectations involved. Do you find your commitments around the world to other people's projects is affecting this process?

LEPAGE The company always worked that way, except that instead of presenting first versions internationally, we would present them locally. But it's the same thing: people always have expectations. So a lot of people were surprised with *Seven Streams*. In Edinburgh, for example, they would say, 'Where's the show? I don't understand.' But that was the deal; that's what we explained to the people who were co-producing. We said, 'Don't make us open the festival. What we're doing is more or less a public rehearsal and should be announced that way.' Of course the Edinburgh Festival is now led by Brian McMaster, a wonderful guy who has been very generous with us. But he comes from the opera world and the group that was supposed to open the Festival couldn't do it, and the hottest ticket in the Festival was for our show so, of course, we sold more tickets and they decided to change our room. We went from a five hundred to an eight hundred seat house. We ended up opening the Festival with a show that was obviously not ready, in front of eight hundred tuxedoed people from the world of the opera.

It's difficult to define to co-producers how we work, and sometimes it's misunderstood and we can't blame them: they're used to a

certain way of doing and seeing things. So now we try to assure ourselves that people know that it's just a step, and that we feel it's interesting even if it's not ready: there's something there and we need the feedback to know where to go. I'm asking a lot of the actors to have the courage to do that, but it takes time before it becomes really rewarding, and it started to be rewarding, I think, in the last few days in London and in Paris, where suddenly people came and could see that there was something finding its way.

I spoke with Peter Brook once about this problem; I didn't bring it up, he did. We were in Munich and he did a show called *The Man Who* which he did with four actors, no sets, and only one lighting cue. It's a tiny little thing that cannot be played in a huge room. We met in Munich because he was performing in a festival there, and he was telling me how difficult it was because in Munich they had booked it in a huge, three thousand seat venue, and they had to cancel because he said, 'No way. We asked you for a three hundred seat room.' And because he's Peter Brook he got his way, so he ended up doing it in a three hundred seat room.

Nevertheless he was telling me how, even though he's Peter Brook, he has the same problems that all of us young companies have: that the only way to survive is to do co-productions with big international events, and once you've done that you're stuck with the rules of these festivals. He was telling me these surprising things that actually when he wanted to do *The Mahabharata*, it was a very expensive thing that he could not afford and he had to co-produce with festivals around the world. Then he had to do *The Tempest*, even though he didn't want to, because he said 'I promised this guy that and this guy that, and I owed this guy that'. Then he started to do *Pelléas et Mélisande* which he regretted, because the Festival d'Automne kept him to a promise. I discovered that he was stuck in the same kind of problem that we had, and he ended up opening festivals with shows that weren't ready. It's not a consolation to hear him say this, but it made me reflect that you have to get the idea across that if you're going to present something as a workshop it should be announced as a workshop. You'd expect big international festivals not to have the same commercial preoccupations as a regular theatre does. Of course people want to sell tickets, but the big international festivals should not; they should be extremely clear, because they know it's a gathering of people who are interested in the art of theatre and they would understand what kind of thing you're presenting if it was well presented.

MCALPINE Do you find your commitment around the world to other people's projects is affecting your process?

LEPAGE A little bit: not that much. I do it because I want to do it, because I want to learn. Sometimes I feel that the good learning places are these big European companies where there's a lot of potential, talent, and means and ways of doing things – although now that I've done four or five of them I don't want to do any more. Nevertheless I don't want to lose contact with these artistic directors: some of them really want to change their company and their audience. I'm not going to do it anymore now because I know what it does to my own personal work. But you do it because you want to learn and that's what's difficult.

Now I'm thirty-seven so maybe I don't have any excuses, but a few years ago I had this burden that people wanted to work with me, and I was still in a learning process. That's why you do these things because you think you're going to learn. But then people have so many expectations that you get caught into a trap. I prefer defending my own stuff now whether people like it or not. It doesn't matter; we're expressing what our company is doing, trying to develop a style, but of course we had to suffer the consequences of me not being present or me trying to get the money somewhere else so I could subsidise these projects. Now we have enough backing as a company not to do these things any more, I hope.

MCALPINE You've talked about opera and theatre as being a vertical form of art versus film/animation/TV. Can you elaborate?

LEPAGE It's vertical on many levels in the sense that I think theatre has a lot to do with putting the audience in contact with the gods, whatever that means. That's where theatre comes from. Plays were written in a vertical manner about human aspirations. A lot of the technology developed in the nineteenth century, principally in theatre, was vertical. Scenery came from the flies and from above, and you got rid of things by flying them up. So it is a vertical form in a very physical and technical sense, not only in a philosophical or symbolic way. Things are better expressed that way for some reason. When I start to do shows that are vertical I always have a very good response, like *Needles and Opium*, where the actor is suspended in mid-air and the audience is looking up, and the guy who is suspended in mid-air is talking about something that's way up above his own head.

Theatre is very close to the Olympics: even people who don't like sport are fascinated by the Olympics because they are not just about sport, they're about gods, they're about Mount Olympus. They're about mankind trying to surpass the human body, human endurance, gravity. It's a very short moment every four years where we see divers give the impression that they're actually diving up and flying, where you see people running to a speed and breaking

records, and giving the illusion that man can go five times the speed that he usually can. It's all about this transfiguration of the man into a god. Even if you don't necessarily see gods there, you see people wanting to go up Mount Olympus, and the human dramas, the conflicts, the paradoxes, and the tragedies of that. There's something in theatre that has to do with the climbing of Mount Olympus, of seeing people pretending that they're flying.

A Midsummer Night's Dream is an extraordinary example because it's all about the character called Bottom, and there's all these fairies that come from way up above and haunt these poor human beings, and these poor sleepers. Bottom aspires to be the lover of Titania, a goddess. It is a very strong vertical piece. A lot of the good plays that still stand the effect of time and trends are vertical works with vertical preoccupations.

There is a sense of spirituality in theatre: it's a medium that you could use to talk about spirituality, about spiritual quests. Of course, there's a reason why film has a horizontal frame; because cameras pan and cinema is all about everyday life and realism. Being at that level it goes from left to right, or right to the left. Sometimes it does pan up and down, but in general horizontal stories are better told with film. Maybe the shape and frames of film will all change one day. But why hasn't anybody invented a vertical screen after a century of cinema? The medium technically and symbolically is about the horizon, the land on which human beings work and walk.

There are two ways of telling a story: there's a metaphorical way and there's a metonymical way of telling a story. Metonymy is more a horizontal thing: beginning, middle and end – things happen in a certain order. Metaphorical storytelling is when you've seen a piece of theatre and you say, 'There was this thing going on, but at the same time there was another level that's going on, then there's this other level and things seem to be connected in a vertical way: things are piled up.' Something like *Needles and Opium*, for example, has layers of stories that are connecting. The action that you see is that connection, and the connection is a vertical one. I'm not saying that one medium is better than the other, I'm just saying that there are some stories that are better told in a vertical way and others in a horizontal way; and film seems to be the best horizontal medium and theatre seems to be the best vertical one.

An extreme example of the theatre is opera. Opera is mega theatre, it's hyper-theatre, everything is so theatrical, more theatrical than theatre because absolutely everything is fake. You don't sing 'pass me the salt' in opera. Some people write that, but then you end up on Broadway in musicals and that's not opera. Real opera is always vertical because it's always about myth and the gods, and, if

it's not about gods, it's about metamorphosis and transfiguration and things like that. It's a very vertical form of art with all these high prosceniums. That's what is so weird about Canada: the year of the centenary of the Confederation was the worst year ever, because that's the year that Canada built proscenium theatres all over the country and now we're stuck with all these film frames to do theatre and opera which is completely absurd. In Europe there's still this nineteenth-century architectural heritage which is a vertical one and the frames are higher. In La Bastille, which is a very modern architectural proposition for opera, the frame is extremely high, so it gives the idea that it's a contact between top and bottom.

MCALPINE Clearly you don't believe theatre is in any way threatened by film or television, but rather you've talked about how it is liberated and you've spoken of a renaissance in theatre. What do you mean by that?

LEPAGE I believe in this interesting phenomenon that in the middle of the nineteenth century when photography was invented and started to be popular in some cities around Europe, absolutely everybody thought it was the death of painting, because painting in those days was the chronicler of the time. Painting was there to express emotions and feeling within ideas, but even through all of its changes through many centuries, the purpose of it was to be a chronicler of the time. If you wanted to remember who your masters were in Europe, political figures, or important historical figures, painters were needed to do that. To chronicle battles, to chronicle how people lived in those days, it was all painting. Painting was burdened by that.

Photography came and did it better; it was a better chronicler than painting. It came and it said 'Well, this is much closer to life and this is exactly like what he looked like'. In painting you always have a good chance that the artist may have emphasised this or that thing about his personality; but photography became a much better chronicler and took over that role. So everybody thought that painting was dead. But after fifty years or less, painting became completely free-form and crazy, and it started to express emotions and feelings that had never been expressed before. When film was invented a lot of people said, 'That's the death of theatre, you can't express things better, or be a better chronicler of your time than film. And theatre will never last as long, and be a good chronicler.' They were right in a certain way because film took over and everything was through film. And then TV came along and people started to say, 'It's the death of cinema, because you have it in your living room and it's live on the spot.'

In fact these forms of art have not died, they're just going through the same process painting went through. Film is becoming a crazy, free-form, Dadaist medium that expresses things that TV can't express. And I believe that theatre is going through this same change but people are continuing to treat theatre as low-grade cinema, or the next best thing to cinema. You can't even compare it; it's completely different, and you have to use theatre with all of these things to see the many forms it can take, because it's not burdened in the same way as TV. And even television is more present as an art form now than it was when it was invented, because now we have these satellite news channels like Sky and CNN And they take care of chronicling and being the news, so they're taking the burden off regular TV. If you really want to know what's happening in the world just switch on CNN or whatever news channel. Why should you wait till eight o'clock tonight or tomorrow morning to know? The importance of news will therefore shrink, and the place it takes in the schedule in regular TV will consequently shrink more and more. TV won't be burdened anymore by having to say 'Today this and this happened'. It will have to take new forms – we see that with MTV. As television is increasingly separated into categories, then it will become more inventive, more creative, and more crazy, and express things that haven't been expressed in television.

I don't believe in death. I don't believe that something dies; I believe that it goes through metamorphosis. Maybe that's a bit like what Hiroshima is about in my mind and I'm still trying to find a way to express that. We all know that there were 240,000 deaths after the bombing, and that the whole place looked like a graveyard; people die, things die, nature dies – but life doesn't die, life continues. It's the same for me, for theatre, or for other forms of art that just evolve and become something else. At one point it becomes clear what things they better express.

MCALPINE How does the audience participate in this process of evolution? What is this new theatre audience you've talked about?

LEPAGE The concept people have of theatre these days is *The Phantom of the Opera* and *Les Misérables*. It's still theatre, but it's not as theatrical as it can be; everything is so programmed and you can be sure that things will happen like your friend told you they would happen. But I think there's something that people want to see and that's the Olympic spirit. People want to see live risks, not risky stuff, but people risking something for real. They need to see people dropping the ball once in a while to be reassured that it's a game, that there's human beings playing it, and that what you're going to see is so authentic because it's just happening that evening. The day after

they're going to try to reproduce it, but that's another part of the game. There's this sense that what an audience wants is to relax and to free their minds after a day of hard work. No, they don't want that at all: that's what they think they want, but subconsciously and consciously they want to clear up their minds, not empty them. They want to clear the mind up and put it in order. They want to see things from a logical point of view, or an illogical point of view, or have a different point of view than they have had all day. They want to be massaged, they don't want to sleep. They want to be energised.

That's the thing that's so difficult to explain to people who do theatre – that you have to stop masticating things for the audience. You have to let them masticate it themselves, because they want to. It's the same way they feel in a sport arena – they go there and they scream and however minute their influence on the game is, they feel they have an influence. They go there to change the game. They don't go to just watch; they can watch it on TV. They're going to change the outcome of things: they have banners, and they jump up and scream and sing, because if they didn't believe that this changes the course of things, they wouldn't do it. It's a weird comparison, but in theatre people have to feel that they are changing the event, even if they're just asked to be quiet and not to laugh when the actress is trying to cry her heart out. They have to feel that their presence is changing the course of things, of the development that goes on onstage, and that this is a peculiar thing.

I always remember when I stopped performing *Needles and Opium*, Marc Labrèche took over and I rehearsed with him a lot. I never got a chance to see him in front of a live audience but I heard it was going well and all that. One night I went to Chicoutimi to see him; I never thought I'd see him perform in front of a live audience. I looked at the show and it was so strange, because I was saying, 'How could people make all these connections? How do people actually understand anything of this show?' And what reassured me was that afterwards there were two young punks who came to the dressing room to speak to Marc, who is much better known in Canada than me because he does a lot of TV and has a lot of fans. These two young guys didn't know who I was, and I was sitting there in the dressing room, and they said to him, 'You know all year our teacher at the college forces us to see pieces of theatre because we have to do work. We always feel so low energy after, we always feel sleepy, but tonight it was strange, it's the first time that I didn't feel tired after it.' The energy comes from exhaustion. What do people do after a hard day's work? A lot of them chose to work out. It sounds like a contradiction, but people want to be energised and theatre is being sold to them as something that will calm them down, and not

take too much energy. Instead they should be told 'It will wake you up, it will energise you, it will make you work, and you will go back home and you will feel energised'.

MCALPINE Does this come from the way the story is constructed, a story that isn't written from A to Z? A way of revealing stories through layers?

LEPAGE But also using people's evolved intelligence. We tend to do theatre in a manner where we're using an old way of telling stories because we think people are obtuse, and that they only have this old-fashioned way of understanding a story. In fact people are extremely modern, even if they're not educated or well cultured. They have a very modern way of connecting things; they watch TV, they know what a flash-back is, they understand the codes of a flash-forward, they know what a jump cut is. They know all these things that we didn't know when we started to go and see theatre. And if you don't use that, you don't trigger that, of course they're bored. They have gymnastic minds now and a gymnastic understanding of things. People have a lot of references that we don't think they have, because we say 'They're not educated'. They have to live in this world and understand all these abbreviations, codes, symbols and colours. So they want to use these muscles that they have. And we tend to pretend that they're idiots.

MCALPINE Do you feel a shift in the perceptions and participation of your audiences as you travel around the world – say English Canadian versus Québec audiences? Or cultures which have a longer theatrical tradition? How does that participation change?

LEPAGE There's many things that are different in different countries. It's difficult to detail all of them, but one thing that stands out – and anybody that tours around the world could tell you this – is that there's a part of the world that is made of cultures that are the speaking word and another part which is visual. There's an English-speaking culture that calls the public an audience. They go there to hear stories, and you go there to tell stories. However visual you are, it goes through the ears, people are there to listen to the words, to the music. And you have a part of the world that call the public spectators, like in France. People go to see a story, go to see a show, and things come through what they've seen. When they describe shows they've seen they talk about the story visually, even if they have heard the words. For me that is a division and it makes a differ-ence when we go through borders: some cultures seem to be based more on an oral tradition, and others more on a visual one.

The reason why I'm so fascinated by Japanese and Chinese

culture is because they seem to have a three-dimensional concept of what things are, and their way of writing is both a sound and an image. It's both a drawing of a word, and at the same time it's the sound of the word, and they alternate between them. When you read Japanese you have to understand what you see and what you hear, because they alternate all the time in one sentence. So your mind is always switching and that's why the Japanese theatre and Chinese opera is the most refined three-dimensional, sculptural hologram form of theatre, because stories are told on these two levels all the time. A lot of Japanese theatre is misunderstood because of that. They come here and the French always say 'Oh yes, these big kimonos and the colours', because they go there with their eyes. Then they visit London and they listen to people from England talk about the musicality, the vocal technique, and the bewitching mastery of the music.

For me that is the fundamental cultural difference, and if you're going to be telling stories with sound and vision you have to assure yourself that one is not contradicting the other. Or one should be a counterpoint to the other: you always have to play on two levels. So when I worked at the National Theatre in London doing *A Midsummer Night's Dream* it was quite a shock for me, because the actors were terrific, their voices were amazing and they had this way of working with words, but it was from the neck up. When you try to incarnate things in their bodies and make them move – just forget it. But they were very courageous, went through the whole thing, tried stuff and felt very insecure.

For me it was a very strange thing to bump into because the English have always produced extraordinary films; they have the best television in the world; they are good visual communicators. I have always had the impression that they have a sense of colours and a sense of form that is much more developed than in many other countries. The French and the Italians are very literate and they write to each other instead of phoning each other, but their theatre is a completely visual appreciation of things. The Italians produce the most visual theatre I've seen: visual meaning including the body.

That has to be considered when we tour. Since I've been performing in Japan a lot and working with Japanese actors that has become more clear. There are a lot of things that are really misunderstood about Japanese culture, because they are only appreciated either with eyes or with ears, when in fact the whole beauty and refinement of Japanese culture is that secret connection between the two that are always harmonious, always aiming towards the same place, and never contradicting each other.

MCALPINE Getting back to Canada. Do you have any observations about what is happening in Canadian theatre? You've worked with English Canadian theatre companies like the COC (Canadian Opera Company) and such Québécois companies as Théâtre Repère. How do you see these two worlds? How do you explain what might be called the lack of communication between English Canadian theatre and Québécois theatre?

LEPAGE There's a lack of communication at every level, not only in the theatrical world. What's sad is that English Canada tends to be proud of Québec, wants to welcome its culture and tends to use Québec as an example of cultural vitality. I've always felt welcome everywhere I went in English Canada; people are really generous and interested. It's exactly the opposite in Québec. There's a wall. There isn't a large enough English-speaking community that's close enough so that there could be an exchange, and so that people here could understand how different the English Canadian culture is from the American culture and from British culture. People tend to put everything into one big English culture thing, which I think is completely wrong. A lot of people here don't travel, so they don't know what they're talking about very often, and they've built this imaginary wall where English Canadian culture does not exist on its own.

There was a strange phenomenon in Québec a couple of years ago, where suddenly there was this big crisis in writers: there were no good scripts. And most of the plays that were performed were from English Canadians: and of course they'd been translated and a lot had been disguised so people weren't very aware. There's a tradition of written theatre that is very strong that we know very little about in Québec. But there is a lack of English Canadian directors. There are some good directors now in English Canada, but I feel in Québec directors are more audacious. It has a lot to do with the fact that if you're a small French-speaking community of about seven million, you want to be understood. If you don't want to be stuck with the same audience, and just tour Belgium and France, then you have to come up with original ways of being understood. For the English Canadian theatre people there's no need to be understood, because theatre's always seen as a strictly verbal thing. There's no emergency to be understood. There doesn't seem to be this extra effort that one has to do to get the message across. I think that's because of the language. Québeckers have that need to be understood, and to have access to the market, to be invited all over the world so that people follow you and don't say 'Oh, it's not in English I don't want to see it'. You have to do this extra effort to get the story

clear, to illustrate it, to give another layer to it. It sounds like an abstract concept, but it's very concrete. I think that is something that's lacking from English Canada – there should be an emergency.

MCALPINE Given your total involvement in your work – writing, acting, directing, designing and composing – how do you feel doing other people's works?

LEPAGE When I'm being asked that I always find it strange because other people's work means Shakespeare mainly, perhaps Strindberg or Mishima, but that's it. Other people's work could mean a new author who has a script, and I've never done that. That's why I always have the impression that it's unfair to answer that kind of question because, if I do Shakespeare, I never really end up doing Shakespeare. It's so basic, with such universal themes, and in French we rewrite it like we want, so am I really doing someone else's work? I never have the impression that I'm doing other people's work.

MCALPINE You've just finished directing Strindberg's *Dream Play* in Sweden . . .

LEPAGE I think they're the best actors in the world. They're amazingly trained and intense. There is such a thing as Nordic culture that I never thought I'd identify with. I've always heard 'You Canadians are Nordic like the Scandinavians are', but what does that mean? Now I think I know. There's a mythology to Swedish theatre that is extremely close to Canadian mythology and I never thought that would come up so strongly in the work. It's not just because they have snow; it's more profound. Swedes didn't participate in the war, so it's weird to be in Europe and to be in a place that doesn't have the scars of the war.

They have a very different attitude towards many things. I always feel that we don't have the vaguest idea of what war is. Even if our parents went to war, we don't know what it is to have our territory devastated and rebuilt. And that's so present in Germany, and that's so present in France, and it's all over the place in certain parts of England: you really feel it very strongly. So you feel sometimes you are really in somebody else's territory when you're working in these countries, but in Sweden I felt at home, it was like I could really feel the same thing.

MCALPINE Can I ask you about new projects – specifically about Michael Nyman's new opera?

LEPAGE It's *The Tempest* except it's called *Noises, Sounds and Sweet Airs*. It's something he did many years ago for Karin Saporta, who's a choreographer, and it was done for a dance company. It's not really an opera, it's more of an oratorio where singers sing and actors act

in their place. It was fantastic to do: we only had ten days to do it and it was a bit crazy, but that's why we wanted to do it again because we didn't really have time to do it well. Michael Nyman's music is made to be performed live. It's extremely energetic and it deserves to be on a stage. I'm a bit stunned by the knowledge people have of his music as film music and recorded. Actually his live music is much more interesting; it's so theatrical, and so energetic.

MCALPINE Was this working with British actors or Japanese?

LEPAGE Three British singers and five Japanese actors.

MCALPINE Rumour has it that you're working on a one-man show.

LEPAGE I was working on a one-man show that was called *The Man With the Cabbage Head* based on Serge Gainsbourg, who was probably the most important songwriter in France. The husband of Jane Birkin, he died two years ago and was very provocative and scandalous. He wrote songs for everybody, including Brigitte Bardot. He was a brilliant writer. In the last part of his life he drank so much and he smoked so many Gitanes, that he didn't have a voice anymore so he couldn't sing. On his last records there would be this extraordinary music, but he'd be saying the words rather than singing them. So actually the material from that part of his work could be done by anybody, because you didn't need to have a singing voice to do it. He did a concept record called *The Man With the Cabbage Head*, and I always wanted to do this. And I started to work on it, and that was my next one-man show, a kind of homage to Serge Gainsbourg. We worked on it and it took proportions that were way too big for the actual content and subject matter, and we all decided we should do this more as a spontaneous musical thing one night somewhere; we'll do it one day.

But in its place I have a new one-man show that I will call *Elsinore*, which is about *Hamlet*. It is a project I had two years ago and I decided to start working on it officially one year ago. I had worked on it a bit, and had the concept and an idea, and then had breakfast with Robert Wilson. He was also doing something with *Hamlet*. So I went cold, and decided to forget about it. The year went by where I was trying to bury this idea, when I was investigating *The Man With the Cabbage Head* and I could see this was not what I wanted to do. So I phoned my agent, I said 'Get everybody together – we're changing it, I am doing it now'. So next year there will be two *Hamlets*, one by Robert Wilson and one by me.

MCALPINE *Seven Streams* is the first project of your new company, Ex Machina. What are the goals of this new company and research centre?

LEPAGE Ex Machina comes from Deus ex Machina. We wanted to emphasise the technological aspect of performance art, and to really make a statement that we're not necessarily a theatre company any more, that we are a performing arts company, and that video artists, actors, writers, opera singers and puppeteers are invited into our company. Because we came out of a theatre company and a lot of the members are theatre people, theatre is still the predominant form of expression of this company now, but we wanted to get rid of all of that. I was burdened by the theatrical expectations, and I never felt that I should try to define or re-define theatre, or what people are expecting me to do.

A lot of the artists who were interested in founding this company weren't theatre people, or were theatre people but with the intention of developing film ideas and cinema and sound. I could see how the theatre world is burdening and choking itself. So I decided to open up. By not defining ourselves officially as a theatre company we are conscious that we are, for example, keeping ourselves from being in the theatre category for the grants. But at the same time we are strong enough now and we have a reputation, so we can get money from other sources. It was a tough decision economically, but we decided to do it anyway, because we're interested in doing film and we're interested in not being tied to one category. We want to do our own thing, whatever it's called.

The goals of Ex Machina are to create not only a physical space, but also a symbolic or imaginary space where we can develop performance arts – whether it's dance, theatre, concerts, puppets – and work in an end of the century way. I just shot a film, I went through the editing process and I know how the editing process is a way of writing and that actually theatre does not have access to that crazy editing kind of thing. We've always naturally or intuitively worked that way, but never officially called it editing. So the space is an editing room. When you do a film there is an expression when you say a lot of stuff ends up on the editing room floor. That's what we're trying to create: an editing room floor – a place where a lot of ideas fall that are not part of shows or film any more. They can fall on the floor and other artists can come, pick them up and develop something elsewhere. It's a way of recuperating. When you're in one category and you're working on one project, a lot of energy, money, ideas and intuitions end up on the editing floor, but then you move to the next project. So we're trying to create a place where people pick up these pieces and do other things and change categories, where somebody working in the film department can pick up something from the puppets, and the puppets pick up from the opera.

Ex Machina is like the mother ship; it's like the super structure

of all these miniature little companies that we've also created. We have a little structure that we've created for film and video and CD-Rom. We've built this other little structure for printing. We have a little sub-structure for sound and recording, and for opera. So every time I now have an offer for anything in the world, I take the offer, I don't take the suggestion. If somebody says, 'We want you to do *Pelléas et Mélisande* in Paris', I say, 'Well, I want to work with you, but I don't want to do *Pelléas et Mélisande*, I want to do this opera and we're going to do it here. It's going to be built in Québec City, it's going to be designed by these people; it's going to be rehearsed here, and if you accept, we do it.' I don't want to sound pretentious or anything, but it's to their advantage to take it, because the reason why they asked me to do this is because they know they're going to sell tickets. So we say 'Well, if you don't want this, goodbye'. We want to create a place where people don't feel that they have to produce to be productive, because it's a false notion. People say we're trying to create a space so we can be creative: yes, but often these things are for people to be productive which is a very different thing.

There's also the belief that a lot of companies today always have to move to the big centres if they want to survive, because they mistake the market place and the place where you manufacture stuff. If you want to do theatre you go to Toronto, and Montreal, and New York, and Chicago and that is it. We're trying to get the idea across that you could actually do it elsewhere, if you have the right environment. And whatever comes out of there, you could show where you want in the world and have a market. It's about trying to move the creative activity away from the production activities. Ex Machina is trying to find a way so that people can plug into different currents, modes, fashions, and trends: we want to be connected with what goes on in the world. We don't want to adopt an attitude of 'We are a company and we capture things and buy them, and keep them for us'. That's why we wanted to be a company, and a space eventually, where people pass through. It's a much more energising experience to have the current flow through your machinery.

MCALPINE Will it be a venue then for other companies?

LEPAGE That's one of the things that was a bit misleading when we first presented it to the different levels of government. People were saying Québec City is one of the cities in North America where there's the largest number of venues per capita; it's the ideal festival city. It has more venues here per capita in a small space than in Avignon. So everybody thought we wanted to build a new venue, a place where we'd have a yearly schedule and programme. But we're not building another theatre. Of course it's going to be a place where

you could present work, and where you could invite groups. But never in a lucrative programme system. There's so many interesting companies from all over the world that we want to collaborate with, and we want them to come with their stuff and work with us. One way to pay for their presence here is to do a couple of performances, so that people know who they are and what they do. But we don't want it to become a theatre; it's a very different project.

MCALPINE How is this funded?

LEPAGE First of all by municipal and provincial funds (hopefully there will be federal money), but most of the projects inside the building are almost entirely funded by international money. All of our activities are co-produced by big festivals around the world: other theatres, different events, the Olympics. We're living on our own, on our own money, our own salaries, that's why I did a lot of stuff abroad last year. We could never have produced our first production if I didn't do those very lucrative Peter Gabriel shows. Now we're in a more comfortable position. Most of the money comes from international productions. We've managed to keep the company alive much better than the companies that have been subsidised by the government for the past ten years. If we can make it over the next couple of years, after that it should be fine because the company will be eligible for government funding. We want our work to be profoundly influenced by world culture without us having to go and show our stuff. You're not really influenced by another culture because you go to their festival in Australia or in Thailand. Sometimes it's better to have them here and influence you from the inside.

MCAPINE You've just finished your first film, *Le Confessional*, inspired by Hitchcock's 1953 thriller ...

LEPAGE It's not based on it, but it's present as one of the film's subplots.

MCAPINE Can you tell me about the film and how your directing for film differs from your stage directing?

LEPAGE Film is very personal. I never thought it would be that personal. I'm used to working in a much more collective way; even when I do one-man shows there are always a lot of people around me, helping me out. Also, performing for the audience is a collective thing. So the sources of inspiration are the people who help you out: it's multiple. But in film it's extremely private. It's very personal, it goes with a medium of close-ups, of things you don't usually see; it's very indiscreet. That to me was the big difference and the big shock of doing film. I was confronted with myself. The subject matter becomes much more about yourself, about your childhood

memories and stuff like that which I'm usually trying to stay away from on stage.

The film is basically about the past haunting the present. The present takes place in 1989, the year of Tiananmen Square, when the protagonist – the central figure from *The Dragon's Trilogy* – has just came back from China. The past takes place in 1952, which is the year Hitchcock shot *I Confess*, and we actually see the shooting of the film going on in the background. It's a kind of homage to Hitchcock and at the same time it is a bit of a sequel to *The Dragon's Trilogy*.

MCALPINE Who are your heroes? I'm interested in the people that have influenced you.

LEPAGE I'd say definitely Peter Gabriel. The reason why I like Peter Gabriel is because I saw a Genesis show when I was seventeen. Rock theatre or theatrical rock is more theatrical than theatre: it was the kind of theatricality that really seduced me. That was very influential. Another person would probably be Gilles Maheu in Montreal, who is a terrific director. But I'd say that the only other person would be Laurie Anderson, because she has translated information and imitation into communion and this is very different from communication. Communication can stand on stage and say 'This is what I think and this is what I'm doing the performance for'. That's communication, but then communion is actually to share, it's not just to announce but to share it, to give a sensation of what you are saying: few people are concerned with this. I think Laurie Anderson is a terrific artist and she definitely has a role in influencing my work. She's a very refined and sensitive artist and performer. She has created different, subtle characters to communicate what she wants to communicate. I think she's a terrific theatre person and she definitely was a very good influence on my work.

Of course I like Peter Brook and Robert Wilson, and I'm a great fan of Elizabeth LeCompte from the Wooster Group. I think the Wooster Group are the best, though not the easiest. Something they did called *Fish Story* was an amazing night of theatre for me, it was just like floating. People were walking out during the whole thing, including my friends, and I just thought, 'This is brilliant; they're the best performers.' I think they're misunderstood, because right now they are the real avant-garde company; they really do performance art. They're the real old timers, in their forties and fifties. But for me, they're the best.

MCALPINE You've used different forms of technology in some of your works, in *Vinci*, in *Needles and Opium*. How do you relate to technology? How do you see the theatre's role in the development of these new technologies?

LEPAGE A lot of the technologies I use in my shows are low tech, although they may look like high tech. The reason I do them is because it's extremely low tech. There are three slide projectors, a 16 mm school projector, video, a rear projector, a bit of shadow play, and that is it. There is nothing else. There is a motor that makes the thing go round, there is nothing originally high tech in any of the effects that it produces, but maybe it's a good thing it looks high tech because it means you can actually do a lot with very little.

We have to remember something very important about what theatre and opera are about: a celebration of light, that's what it is. The only plays in Greece, when there was a lot of light in the middle of the night, were when they would burn these big pieces of wood in pyres so they could illuminate the theatre. People would gather around those bonfires – you know how hypnotic fires are – and there was a communal, collective connection. It was a celebration of the light. In Japan, the first Noh plays were the opportunity to put light in the middle of a night. The idea of theatre is first of all to bring people in a dark room and do the festival of light. Of course the fire of these theatres was replaced by technology, by electricity, but people still come to the theatre to sit around the fire. If it burns bright people always want to gather around to hear stories. It's just our relationship with technology that has changed. It's something revolutionary for a lot of directors. Always their first show, or early show, is done with candles and flashlights, there's a reason for that.

JONATHAN MILLER

D ESCRIBED by Melvin Bragg as having 'a fair claim to being today's Renaissance man', Jonathan Miller is unique as a director, moving effortlessly between the worlds of theatre, opera, television, academia and medicine. In the theatre he has worked mainly on classics – although he claims it is largely by default – providing vibrant, observant productions which have paid a sharp, scientific attention to the mechanisms of human behaviour whilst exploring the work through the social and cultural context that generated it.

Miller was born in London on 21 July 1934 into a family active in both the sciences and the arts – his father was a doctor and neurologist who founded the Institute for the Scientific Treatment of Delinquency, his mother, a novelist and the great-niece of Henri Bergson. Educated at St Paul's School, he then read Natural Sciences at St John's College, Cambridge, qualifying as a doctor of medicine in 1959. Although he had acted in a number of productions at Cambridge, it was the success of *Beyond the Fringe* (which he co-authored and appeared in with Alan Bennett, Peter Cook and Dudley Moore) first in Edinburgh in 1961, and then in London (1961–2) and New York (1962–4), which launched him into a career in the theatre. His directorial debut came in 1962 when he was invited by George Devine to direct John Osborne's *Under Plain Cover* at the Royal Court. A career in medicine was temporarily abandoned as a succession of productions ensued, including a much admired production of Robert Lowell's *The Old Glory* in 1964 which opened New York's American Place Theatre and a revolutionary *School for Scandal* first staged at the Nottingham Playhouse in 1968 and then revived for the National Theatre at the Old Vic in 1972. Miller's anti-romantic production went against popular tradition by brilliantly evoking the sordid world of the minor eighteenth-century gentry amongst whom the play is set. During the early 1970s he worked extensively at the National Theatre (where he was also an associate director, 1973–5). His productions there included a Victorian *Merchant of Venice* (1970) with Laurence Olivier and Joan Plowright, and *Danton's Death* (1971). His Shakespeare productions, including an austere *King Lear* (1969) with Michael Holdern in the title role and Frank Middlemass as an elderly Fool, and three productions of *Hamlet* (the third at the Donmar Warehouse in 1982 shifting the habitual presentation of Claudius as an avaricious lecher to a

moving concept of an able politician greatly in love with his queen), established his reputation as a meticulous director of actors concerned with rediscovering texts for contemporary audiences. At the Greenwich Theatre (1974–5), he presented a season of 'Family Romances' (*Ghosts*, *Hamlet* and *The Seagull*). His productions of Chekhov during the seventies were clinically detailed and characterised by overlapping dialogue – a technique he was to use again to great effect in his 1986 production of *Long Day's Journey into Night* with Jack Lemmon in the role of James Tyrone. Between 1988 and 1990 Miller was artistic director of the Old Vic where he presented two adventurous seasons bringing together international practitioners (like Angelika Hurwicz of the Berliner Ensemble and the Swedish actor Max von Sydow), new directors and designers like Richard Jones and Richard Hudson, and respected British actors like Penelope Wilton and Alex Jennings. His productions included the first staging since 1604 of Chapman's *Bussy D'Ambois* (1988) and the British premiere of Corneille's *The Liar* (1989).

Miller made his operatic debut in 1973 with the British premiere of Alexander Goehr's *Arden Must Die*. Since then he has worked extensively in opera, enjoying success at the major houses – La Scala, New York Metropolitan Opera, Los Angeles Music Center Opera – as well as forging a productive relationship with the intimate Kent Opera (1975–82) where his productions included a Dickensian *Rigoletto* (1975) and an austere *Traviata* (1979). Between 1978 and 1987 he was an associate director of English National Opera where his most acclaimed productions were a stylish *Rigoletto* (1982) set in the Mafia underworld of 1950s Italy, and a satirical *Mikado* (1986) set in the foyer of a 1920s seaside hotel. More recently he has been responsible for a Mozart Cycle at the Maggio Musicale in Florence (1990–2) where he will return in 1997 to direct Strauss's *Ariadne auf Naxos*, and a production of Bruno Schrecker's *Die Gezeichneten* for Zürich Opera. Early in 1995 Miller made his debut at the Royal Opera House with his fifth staging of *Così fan tutte*. This production differed from his previous Mozart forays in its 'updating' of the opera – all his other productions fastidiously reproduced eighteenth-century idioms of performance. Although the set was deliberately abstract, the costumes, designed by Giorgio Armani, fixed the production within a contemporary society.

Miller first worked in television in 1964 on the groundbreaking series *Monitor*. Since then he has written and presented a thirteen-part series on the history of medicine, *The Body in Question* (1977), and another fifteen-part series on madness, *States of Mind* (1982). He was producer of the BBC Shakespeare series in the eighties for which he directed twelve plays. He has also directed several TV films, and

numerous operas including Gay's *The Beggars Opera* (1984) with
Roger Daltry as Macheath. He has held numerous research fellow-
ships in the History of Medicine and Neuropsychology and has
given lecture series at the Universities of Kent and Cambridge, the
National Gallery (1995), and the Metropolitan Museum of Art
(1995). He has published books on a range of topics including Freud,
Darwin, medicine, opera and theatre. His awards include Director
of the Year from the Society of West End Theatres (1976), the Silver
Medal from the Royal Television Society (1981), the *Evening Standard*
Opera Award for *Rigoletto* (1982), and the CBE in 1983.

OTHER MAJOR PRODUCTIONS INCLUDE

King Lear by William Shakespeare. Nottingham Playhouse, 1969.
Measure for Measure by William Shakespeare. The National Theatre at the
 Old Vic, London, 1974.
The Importance of Being Earnest by Oscar Wilde. Greenwich Theatre,
 London, 1975.
All's Well That Ends Well by William Shakespeare. Greenwich Theatre,
 London, 1975.
La Favola d'Orfeo by Claudio Monteverdi. Kent Opera, 1976.
The Three Sisters by Anton Chekhov. Cambridge Theatre, London, 1976.
The Marriage of Figaro by W. A. Mozart. English National Opera at the
 London Coliseum, 1978.
The Flying Dutchman by Richard Wagner. Frankfurt Opera, 1979.
The Turn of the Screw by Benjamin Britten. English National Opera at the
 London Coliseum, 1979.
Arabella by Richard Strauss. English National Opera at the London
 Coliseum, 1980.
Otello by Giuseppe Verdi. English National Opera at the London
 Coliseum, 1981.
Così fan tutte by W. A. Mozart. St Louis Opera, Missouri, 1982.
Don Giovanni by W. A. Mozart. English National Opera at the London
 Coliseum, 1985.
Tosca by Giacomo Puccini. Maggio Musicale, Florence, 1986.
The Emperor by Ryszard Kapúscínski, co-adapted with Michael Hastings.
 Royal Court Theatre, London, 1987.
The Taming of the Shrew by William Shakespeare. Royal Shakespeare
 Company, Stratford upon Avon, and then Barbican, London, 1987.
Misura per Misura (Measure for Measure) by William Shakespeare. Teatro
 Ateneo, Rome, 1987.
Andromache by Jean Racine. The Old Vic, London, 1988.
The Tempest by William Shakespeare. The Old Vic, London, 1988.
Candide by Voltaire and Leonard Bernstein. The Old Vic, London, 1988.
La Traviata by Giuseppe Verdi. Glimmerglass Opera, New York, 1989.
Mahagonny by Bertolt Brecht and Kurt Weill. Los Angeles Music Center
 Opera, 1989.
La Fanciulla del West by Giacomo Puccini. Teatro alla Scala, Milan, 1991.
The Magic Flute by W. A. Mozart. Mann Auditorium, Tel Aviv, 1991.

Le Nozze di Figaro by W. A. Mozart. Maggio Musicale, Florence, 1992.
Capriccio by Richard Strauss. Deutsche Staatsoper, Berlin, 1993.
Anna Bolena by Gaetano Donizetti, Monte Carlo Opera, 1994.

CRITICS ON HIS WORK

He has a wonderful sense of scale. Looking at things with his painter's eye, he has an extraordinarily precise sense of scale – I don't think he would ever direct a production that did not fit into the frame into which it would go. If he did an opera at the Old Vic, it would fit the stage just as well as his work fitted our big stage at the Coliseum. Certainly the scale of his work for Kent Opera was very precisely right for those small theatres . . . That is what is unique about him – he rises easily to the large scale of opera, and then comes up with something . . . intimate.
(Lord Harewood, in *A Profile of Jonathan Miller*, pp. 189–90).

[His] work in the theatre seems to be based on a forthright commitment to directing as appropriation – not projecting or translating a text, but constructing one of a 'divergent series of alternative versions of alternative versions . . . at least minimally compatible with the text'.
(Graham Holderness, *The Shakespeare Myth*, Manchester: Manchester University Press, 1988, p. 195).

SIGNIFICANT BIBLIOGRAPHICAL MATERIAL

Allen, David. 'Jonathan Miller Directs Chekhov'. *New Theatre Quarterly*, 5, No. 17, 1989, pp. 52–66.
Bulman, J. C. and Coursen, H. R., eds. *Shakespeare on Television: An Anthology of Essays and Reviews*. Hanover, New Hampshire: University Press of New England, 1988.
Halinan, Tim. 'Jonathan Miller on the Shakespeare Plays'. *Shakespeare Quarterly*, 32, No. 2, Summer 1981, pp. 134–45.
Miller, Jonathan. *Subsequent Performances*. London: Faber and Faber, 1986.
Miller, Jonathan, ed. *The Don Giovanni Book: Myth of Seduction and Betrayal*. London: Faber and Faber, 1990.
Romain, Michael. *A Profile of Jonathan Miller*. Cambridge: Cambridge University Press, 1992.

Jonathan Miller at the Royal Exchange Theatre, Manchester, 28 October 1994

MILLER I used to spend my time justifying the modernisation of plays, the bringing of plays up to date, the changing of them, the messing around with them. When I was a young producer and first began to talk about this, the producer was seen as a villain, a person who stood between the author and the audience, who dropped a heavy coloured curtain between the work of a great genius and the audience who'd come to see or hear that play produced. Now I find myself having fallen behind in the race to modernise. You get to my age – I'm now sixty – and start to feel all around there are people

who are much younger who feel that there is practically no limit to the sort of thing that you can do to plays and that there is a mood of what I describe as deconstruction: a deconstruction which is not entirely justified by, or explained by, the familiarity of producers in the theatre with theories of deconstruction. I don't think that many people who work in the theatre are even aware of there being a critical body of thought on the subject of deconstruction, but nevertheless they behave as if they were. They behave as if anything goes at all.

It isn't just simply that things are taken and up-dated in the ways that we sometimes used to do back in the seventies and eighties, but that there is no particular reason for them to be in any date at all. What matters is a visually striking configuration which simply produces a startling sense of refreshing and invigorating novelty. I find that, in a strange way, I am now defending an idea of tradition, or defending a notion of classicism, in a way which would have appalled me in the sixties or seventies.

At the moment there are two millstones of folly which are threatening to grind the theatre into a state of pulverised idiocy. On the one hand, there is the existing notion that there is some sort of canonical version, the original version, the version which would most have pleased the playwright, the version which most realises the playwright's intention. And on the other, the notion that there is no such thing as a playwright's intention, that there is no such thing as a standard canonical formal meaning in a text, and that actually these texts constantly renew themselves under the pressure of interpretation, which allows there to be almost anything and the text is taken as an unstructured thing altogether. Both of these seem to me to be a misunderstanding of what the nature of a text is.

In opera and in the theatre, people still talk about the idea that the author 'must have meant something by it' and diligent application of intelligence could identify what the author meant by what he wrote. But if it was the case that all human intentions were unequivocal and clearly identifiable by simply going to the source, then psychoanalysis would never have flourished because people would simply be able to go to someone who had acted puzzlingly and say, 'What did you mean when you did that?' We very rarely go to an author of an action to ask them; we usually go to the friend of an author of an action, in the knowledge that the author of the action is probably the least qualified to give an account of what they meant by what they did. We go to a mother, or to a wife, or to a child and say, 'What on earth could they have meant by doing that?' They'll tell us that they meant so and so, and so and so. Eventually there is an elaborate superstructure of interpretations built around

something which is theoretically identifiable; because once you start to cast some sort of doubt on the nature of intention, you might seem to end up with the idea that all actions are unintended. Of course we know that's not the case, otherwise we wouldn't distinguish between intentional actions and unintentional actions. We wouldn't be able to offer, as we do, understandable and intelligible excuses, mitigations and justifications for actions. It's quite clear that we do understand there are actions which were meant to do something, actions which were meant to realise something, actions which were intended. At the same time, however, while we do recognise this, we also know that they're extremely ambiguous and it's very hard to identify what was meant by an action. If that's true of an action, where we usually have the person or members of the family or friends to discuss the action, think how much harder it will be when it comes to a text where the author is dead, and all you have is a few ambiguous commentaries, which are as open to interpretation as the text which you're actually considering. The whole thing is fraught with ambiguity.

This is where the deconstructionists get their ugly little wedge into the business. They think that because it is as ambiguous as that, because you can't get access to a genuine, clear notion of what was meant by the play, or what was meant by the opera, that we're in business to do what we like with it. The text becomes an occasion for something else; it's a pretext rather than a text. It becomes something which permits high jinks which happen to quote the text, but doesn't actually express it or mean it. And that seems to me to be hardly worthwhile doing. Why bother to go back and find texts which you are simply using as pretexts to let you have high jinks? There are all sorts of ways of having high jinks without having to exploit Shakespeare, or Chekhov, in order to do it.

I found myself in the old days saying 'It sounds as if I am writing a vandal's charter'. And I now find myself saying 'It sounds as if I'm writing a conservative philistine's charter'. So I've always been running a risk: either seeming to validate, or allow, or legitimise hooliganism in the theatre, by giving the impression that I think that everything goes, and now defending positions which are rather embarrassingly taken up by people I can't stand. I find myself in a state of despair about what sort of strategy, or what sort of policy, one can adopt as the century draws to its unforgivable close. What ought we to be doing with the theatre? And what are we doing when we put on plays and operas? I know that when I'm in control of what I feel to be the text, and at the same time controlled by it, that I am referring to a past which seems to be worth acquainting oneself with, but at the same time I am not acquainting myself with the

recent past of theatrical precedent. That seems to me where one has to drive a wedge between the notion of the past which is referred to in the play, and the notion of the past in which the play has been subsequently performed. And I think people very often confuse the two.

In the old days when people were talking about there being an official, good, canonical, standard production, their assumption was that it corresponded to the production that Shakespeare or Chekhov, or whoever, first saw and approved. Of course, usually what they are talking about is a production which they themselves saw when they were fifteen, or twenty-one, and that's been the one that they liked and from then on that's the one that defines how all subsequent performances should be done. We are enormously susceptible to our first exposure to a particular performance of a particular play, unless it was horrible. Even if it was horrible, very often if it's our first visit to the theatre we don't know that it's horrible. We consequently remember that's how it ought to be done, and from then on everything seems to be a deplorable lapse from some form of orthodoxy.

That's something from which we have to free ourselves, because it's in the nature of reproductive art that it undergoes these successive transformations, and renews itself all the time. It can't avoid doing that even if you don't intend it. Long before the explicit director appeared on the scene, and he is quite a newcomer after all, these plays and operas were drifting off course, in the sense that they were already departing from the prototypical performance, merely by virtue of the fact that an interval separated the inaugural performance and a subsequent one. It starts drifting off course and enriching itself, or changing, or deteriorating, or however you like to describe it. If there is a gap between the last performance of the inaugural production and the next performance of the subsequent one, there is inevitibly a transformation because people can't actually copy things. There's no such thing as copying. There's xeroxing and that's a very different thing, but xeroxing involves deterioration. You know that if you xerox a xerox and then xerox the xerox of the xerox and so on up to the -nth xerox, what you get is a decay in legibility.

It's not quite like that with successive performances because it is not a mechanical copying; you can't actually reproduce the same thing anyway. You can see this when you ask someone to copy a movement. Stand in front of someone and give an example of what is to be copied. It's very interesting to see how various the offers are. For example, if you look very carefully at my fourth finger, I am holding it slightly out from the palm of my hand. But it all depends

what someone thinks is being exemplified by the object held up as an example. You may think that that's an irrelevant feature of it. I may actually regard that as a very distinctive feature of the sign, and certainly if you're in the business of using sign language to communicate words for the deaf, it may be absolutely what the linguists call a distinctive feature. Nevetheless, if you copy it without knowing that there are distinctive features in the examples, you might diminish or eliminate them. You then ask someone to copy that copy and people may then misinterpret the angle at which the little finger is held from the palm and it may dwindle down until finally it vanishes all together until it becomes a fist, and so on and so forth. You don't know what to copy until you know what description the copy is offered under. Until it's offered under a certain sort of description which specifies what it's an example of, you are actually baffled by what is going to count as a compliant example of it.

I think that the reason why there's this enormous drifting is that the reproduction of something according to a prototype depends on all sorts of variables over which we really have very little control. Even if we specify what the example which is to be copied is about, then of course there are still defects due to the copying devise itself. This occurs at the two ends, both at the sensory end which detects the features of the model and also at the executive end, which is the motor performance, which actually accomplishes the reproduction. In between there may be all sorts of intervening variables between the detecting of the model and the executing of the repetition, which can also produce a warp into it which is not there in mechanical copying devices.

Have you ever noticed the way in which on British television they never allow anything other than drawings of a scene in a law court; there are no photographs of the witnesses, of the person standing in the dock, of the judge, or of the learned counsel. But there may be vivid chalk sketches, which are then shown on television. Why is it that one form of witness is allowed and the other form of witness is not? I think the reason for it is perfectly simple: that we recognise in a mechanical copy something which means that we're almost looking at the thing itself, rather than simply having an account of it. It is because we know that the intervention of a human copier is so imperfect, that somehow it doesn't violate the notion of the privacy of the court. Although it violates it in the sense that there was an artist, a draftsman there to do it, in some strange way it hasn't allowed us into the court in the way that a camera does. A camera is an extention of our eye, whereas an artist is an extention of our interests, so we therefore don't feel that we are present in the court and we have not violated the sanctity of the court.

I think this has a bearing back on this notion of copying. The introduction of a copier means that it doesn't quite look like the original and it drifts off course; it varies because there is a very elaborate apparatus of interpretation involved. That's why every time you do a play for the second time, the third time, the fourth time, the longer the gap, the greater the drift off course will be, because the criteria by which you judge what is exemplified by the example will change. That's one of the reasons why when you copy something at a fifteen-year interval, you copy it differently. It isn't just that the records are poor, it's because you approach it with a totally different idea of what is going to be worth copying. This is why, for example, the famous case of the Van Meegeren forgeries of Vermeer took the form that they did. If we were going to forge Vermeer in 1990 we would not forge him in the same way that Van Meegeren forged Vermeer in 1930. That's not because we've got smarter than Van Meegeren; it's hard to imagine someone approaching forgery with more skill than Van Meegeren did. It isn't a question of manual dexterity, nor is it a question of optical sensitivity. Van Meegeren could see just as well as we could; we could see just as well as he could; our hand is just as steady as his. But we approach the Vermeer with a totally different idea of what it exemplifies. In copying the same object, we would copy it in a totally different way; we can't avoid doing that because we think of it as a different sort of thing altogether. We cherish and value Vermeer for a different reason to that which made Van Meegeren choose Vermeer as a subject for copying. Vermeer was thought to be interesting for reasons which we actually find rather baffling: a rather romantic interest. We look at Vermeer now for reasons which are to do with a classical formalism, which would really have been very puzzling to people forging Vermeer in the 1930s. Therefore we would copy him differently.

If that's the case of something where you actually have a physical copy in front of you, think how much harder it is to create an historically accurate version of a play. I think the whole idea of fidelity is a non-starter, because it doesn't mean anything philosophically and also it's impractical. You've only got to watch people in opera houses trying to reproduce subsequent productions of operas which are already in the reportoire. In opera houses they keep a televisual record of the production so that six months later, or a year later, or five years, or ten years later, they can do it again according to the original prototype. The longer you wait, the harder it is to act upon the basis of that prototype, and that's not because the tape deteriorates. They only start to deteriorate if you copy them, so it can't be anything mechanical. But there is something perplexing about looking at the tape of a production ten years after the

inaugural performance. It becomes less legible in some peculiar way. It's not that the text is illegible; it's not that you can't see it; it's that you don't know what it means.

That sounds rather odd. Why is it that it meant something at the time and yet only ten years later you can't quite tell what it means and therefore you don't know what it is to produce a successful copy of it? Unfortunate staff producers get closer and closer to the video screen in the belief that actually getting closer will help them, but of course it won't, because actually it's not a question of optics, it's a question of cognition and they're more and more puzzled by it the older the tape is. They don't quite know what it is they're meant to copy, what it is that they are meant to reproduce when they are bringing the thing back to life again. They are sometimes helped by having a stage manager who was present at the time of the rehearsal – someone who can say 'the reason why that strange enigmatic drift across the stage occurs then is because we thought that she was turning away from the window in a state of despair'. And you say 'Oh, I see'. Suddenly you see what was previously invisible in that particular configuration of movements; it becomes visible under another description. It becomes visible under the description of it being an expression of despair. Quite suddenly what was previously not noticed, which will have been maybe a slight movement of her shoulder as she moved towards the window, will enable you to say, 'Ah, it isn't just a move towards the window, it's a move towards the window with a peculiar movement of her shoulder. I thought she was just adjusting a bra strap, but she wasn't doing that at all. She was doing something else. What she was doing was expressing despair.' Quite suddenly a movement, or a gesture, or a slight phrasing of a body part, which might have been missed in the absence of a description, becomes salient under that new description.

I think that all copyings are more or less successful according to the extent to which you are asking someone to repeat it in the mode, not just simply to repeat that singular action. They're only successful if you internalise the general grammar of which that particular gesture is an instance. It goes back to Chomsky's idea about what is generative grammar: an abstract generalised structure which will generate an infinite series of sentences in accordance with that grammar. And that's actually what produces learning in someone to whom you're teaching something. You teach someone an item of behaviour in such a way that you introduce them to a rule from which they can generate an infinite series of completely original performances which are in accordance to that rule. Now that's a very difficult business.

It's also the case when you're actually working as a director with

performers. What you're trying to do with an actor is to give them an example of something, in the hope not that they will copy what you are doing, but that they will do a whole series of subsequent actions of their own in accordance with what you have shown them. In other words that they will be able to generalise from the specific example and say, 'Oh, I see what that is an instance of', rather than 'I will have to copy that instance slavishly'. You can always see actors who are simply copy cats. What they do is a blurred copy of the gesture, movement, accent, tone, or expression. They'll just simply do it again and again and again. But it won't permeate the rest of the performance. Whereas what happens with a really intelligent and creative performer, is that you'll give them an example and they do not reproduce the example, but learn something from the example so that they know what it exemplifies. They know that it exemplifies a general rule from which they can then produce an infinite series of different instances, all of which are consistent with that first instance that you gave them.

Knowing what went on involves an enormously elaborate array of instructions, which themselves are open to interpretation. That's the reason why these things drift off course. They drift off course because people think that they're doing a different thing anyway when they're producing plays at intervals of fifteen years. They ask themselves what's the nature of the enterprise? What is the unfinished business of the profession, of the community, at that particular moment? The agenda itself, without explicit agreement, changes. By the time a play has been produced in 1950, under the auspices of one unstated, unwritten agenda and is then reproduced by what seems to be the same community, the drama profession, forty years later, the agenda has changed. What we think is the point of putting on plays has changed, and therefore there is a reason for there being a bias, so that what you get is what biologists call speciation. As the plays are done by different, widely separated communities, you get divisions and splittings because people have a different agenda about what they think they're doing. They see the thing in a totally different way and so you get variation.

It was bound to happen anyway, so you might as well be in control of it to some extent, in so far as anyone is in control of anything in the theatre. But once you seem to allow the possibility of a total and radical deconstruction, which assumes that texts are simply pretexts for any exercise, what happens is that you use those words as a voice-over to a spectacle. It becomes a running commentary upon something which happens, of which you are the maker. The *auteur* theory of theatre, although never explicitly stated, has become so powerful that people feel they have to win

their spurs in the theatre with some spectacular event that occurs on the stage to the accompaniment of a text by Shakespeare. I can remember seeing a much applauded Ruth Berghaus production of *Don Giovanni*. I must admit that had I not known by listening to the music (and the overture told me what was coming up), I would not have known that what was going on was *Don Giovanni*. 'Ah, *Don Giovanni* I hear', but certainly not '*Don Giovanni* I see'. Thirty years ago, there wouldn't have been a newspaper critic who would have thought that was wonderful, but now there are all sorts of hysterical approvals of it and I never thought I'd find myself expressing such conservative sentiments.

AUDIENCE QUESTION 1 How much does your sense of humour help or hinder you to understand the world and yourself?

MILLER I suppose I could say that in doing drama, I introduce an idiosyncracy of my own which leaves my handwriting on it and because I am amused by almost everything in some way or another, I can't avoid some sort of humorous approach to even the most tragic or disastrous stuff. I have more fun laughing in rehearsals of *King Lear* than I do when I'm rehearsing *Twelfth Night*. That's not because I feel 'Oh God, *Lear* needs to be lifted off the ground a little bit, let's inject a sort of baking powder of jokes into it, in order to make the thing lighter'. It's just that such silly tragic behaviour is bound to be funny.

You all know what sort of idiotic things occur at funerals, which you may not be able to laugh at at the time, but there's a great deal of giggling about things that happened at the funeral going back in the cars after the hearse has departed. If you're alert to what human beings are like, unless you get very pompously engaged with mystical or fundamental ideas about the human condition, everything becomes amusing. And that's not because I think life's absurd or ludicrous, it's just that if you look at life accurately it's impossible not to see and to notice that things make you laugh, and that it's no respecter of occasions.

My sense of humour arises out of an almost promiscuous interest in the minute details and foibles of human behaviour. I just like getting it right. I like seeing what people do with their hands and not seeing what they do with their hands, and seeing little tiny foibles of behaviour. I like noticing things which are regarded very often as the junk of human behaviour. The pay load is in the junk. People go looking for the great moments of the human condition in the highlights, but it's not often to be found there. The places where we find out what we're really like is often in the junk, the throw-away parts, the disposable parts of human conduct, the things which you don't

notice because they don't seem very important. The elaborate gestures and behaviours, the remedial and apologetic behaviours of human beings, have always struck me as extremely funny and interesting. If you leave them out you may not be aware of it in the production, but if you've taken the trouble to put it in, the audience comes out saying 'Oh God that was fun', or 'that was real'. They can't put their finger on it, because it's almost like white noise, or like some scarsely noticed line played on two of the double basses in a very large orchestra. If it's not there there's some sort of tone missing in the production and I endlessly fill in the production with all this junk, and it's the stuff which gets left out of texts because authors don't put it in.

It isn't that I approach anything with a sense of humour; I approach with a sense of observation which seems to be humorous. A very large part of laughing is just simply the shock of recognition. The things we really enjoy most in humour tend to be those things which have been previously overlooked. They're so negligible, so small and yet so frequent that when they are pointed out you suddenly notice them. It's that wonderful moment of 'I see it', and that sense of levitation and lightness which is introduced just at the moment when someone points out something which you hadn't noticed before, but you had actually known implicitly all along. It's the release of recognition which actually makes you amused.

It's not so much that a sense of humour is important to the production of a play, but I feel that what's important is observation of behaviour which seems humorous to those who are made to notice it. I'm not saying that this exhausts the nature of humour, but I think that it's an extremely important part of what humour is. It raises all sorts of interesting cognitive questions, about why such a thing should produce this rather peculiar barking convulsion of the respiratory system. Why is it that when things are pointed out to us we go, 'Uh, uh, uh, uh?' Darwin and those who followed have got all sorts of explanations for it, but they never go into the cognitive explanations. There have been all sorts of daft explanations by Bergson (which I think are wrong), that it's a sort of herd instinct: noise to draw attention of the animals to some anomalous behaviour on the part of some deviant member of the herd. That's nonsense. But here is this funny thing called laughter, the sense of humour, which is accompanied by so much pleasure that we will pay a lot of money to get our funny bone tickled.

You have to ask the question why is it so nice to laugh? There must be some pay-off. My theory is that the biological pay-off to the sense of humour is not the value it gives to a play, but that it is associated with the exercise of certain cognitive skills, in the

absence of which we would be much more inflexible and less versatile as a species. One of the things that makes us as smart as we are is the fact that we can re-catagorise things very quickly: not to see things under rigidly previous catagories which might otherwise standardise our behaviour in ways which would make us much less flexible and much less fruitfully enterprising than we are. The sense of humour covers a wide range of seeings. That's why we talk about seeing the joke. We are seeing things which had previously been invisible or inaudible or unrecognisable to us; they are made visible, audible or recognisable to us by the joker. It gives us a more explicit sense of things which had previously been implicit and therefore not under our control. That's what I think humour is all about.

It's not what jokes are about. Jokes are a rather different thing and simply hitch their wagon to a sense of humour in order to realise other functions. The joke is not personal property; it's common property. Otherwise we wouldn't preface jokes 'Have you heard the one about . . .', which means that it's in circulation. It doesn't belong to you. It's like a rented car: other people have driven that joke before you get into it. We therefore have to ask, 'Why do people circulate jokes?' They are like gifts which are meant to be handed on to other people, so that other people in receiving them should hand them on again. The function is to create social cohesion. Jokes are like mini-gifts which you bring to a community when you've recently arrived in it and it establishes a charitable relationship to the people to whom you've come. They will then go and tell the joke to someone else. It's a device for binding communities together and it's a substitute for intimacy as well.

AUDIENCE QUESTION 2 Is there a play that you'd really love to do but haven't yet done?

MILLER I wish I could say there was. I don't think I've ever dearly wanted to do a play at any time in my life. I've usually drifted into them, or someone has invited me to do one and I've said, 'That'll be interesting.' And it turns out to be something that I've enjoyed doing at the time. But I've never really had a burning desire to do anything in the theatre at all, I've just gone from one thing to the next; it simply happened. In a way it's rather like Sorin's reply in *The Seagull*, when Konstantin is talking to him and he says, 'Well, you became a councillor.' I find myself, after many years, in a certain sort of eminence in the theatre, just simply by accumulated achievements. They simply happened; I never tried to do them. There's nothing I particularly look forward to doing any more or any less than I ever did before. It would be quite nice not to do it anymore at all. There are actually more interesting things to be looking at. I've always had

this slight tug in the other direction because I'm a renegade and a fugitive from biological science and from the human sciences, and those are the things that really turn me on. I find myself much more interested when I'm reading about that and I constantly feed it back into what I do in the theatre.

For example, I recently spent a month in San Francisco, in the Museum of Science; it's been a happier time than anything I've had for the previous year or two. It was just deeply interesting. There's so much that is interesting happening at the moment in the biological sciences that you'd have to be very dumb not to be absolutely, incandescently excited by some of the things that you hear. I wish there were slightly more hours to the day. If I could be guaranteed a thirty-six hour day, I wouldn't mind because I would actually devote eight of them to neuro-psychology.

AUDIENCE QUESTION 3 At the begining of your career in the theatre did you always think it was a temporary thing?

MILLER My attitude to it was exactly the attitude of President Kennedy at the outset of the Vietnam War: 'We'll put a few advisors in and then get out.' Seven years later: 750,000 men and a complete mess.

I've had a good time and I've done some good work, but sometimes I think about the other stuff . . . It isn't that I wanted to do good to humanity or anything like that; to hell with that. It was just that in the last twenty years it has got so interesting. Do you remember that line in Chekhov? Do you remember *The Seagull* where Trigorin is talking to Nina in that very long scene in the garden when they're sitting on a bench together, and he's talking about his career? Finally in the last reduction he says, 'I feel like an old Russian peasant who has missed his train.' Well, that's the sort of feeling I have: that I just got on the wrong train and I ought to have got on a better one going somewhere else. More interesting things are going on elsewhere. I don't think the arts are very interesting at the moment at all.

AUDIENCE QUESTION 4 What are your ambitions?

MILLER I've got no ambitions now. How can you have ambitions at the age of sixty? You can have hopes for certain things you'd like to do and I enjoy the things I do. But you can't have ambitions at that age; you can't set them up. You can change directions and do all sorts of things, but you've got to put up with what you've done. I'm making it sound tragic; it's nothing like that at all. There are all sorts of foolish regrets one has about making decisions which often seem very small at the time and they start you off in directions which become quite irreversible. It's just that when you go back and see

what fun all these other guys are having, you think 'Oh I wish I was with them, they have such fun'.

The danger of the theatre is that it rots the moral fibre. It makes you extremely lazy and sloppy. People think they work very hard in the theatre; they do nothing of the sort. It's an easy life. One of the things I discovered when I left medicine was that I realised how hard I'd worked when I was doing it. And how hard I was going to have to work in order to keep doing the things that were of any importance. Then I discovered this extraordinary world of the theatre in which you went to work against the traffic, because all the rehearsal rooms were on the edges of town. There were all these poor sods standing strap-hanging in trains going in the other direction, and there I was. You go and fool around for the whole day pretending to be other people. When it comes to opera you go in at ten o'clock and people start singing Mozart at you, and they pay you. It's an easy game; it's completely relaxed. There are moments of fraught tension when it doesn't come off and there are frictions and difficulties, and then bad reviews and all those sorts of things, but they're nothing compared to the ease of the life. If you've had thirty years of it you run to seed. I would find it very hard to gird my loins and go back and do that business of being in the lab at 7.30 in the morning and not coming back from the lab until 11.30 at night. That's what doing science properly is about. Texts let you have high jinks.

ARIANE MNOUCHKINE

DESCRIBED by scholars Denis and Marie-Louise Bablet as 'the most important adventure in the French theatre since Jean Vilar and his TNP' (Bradby, *Modern French Drama*, p. 191), the Théâtre du Soleil has consistently questioned established theatre conventions in its exploration of the politics of theatrical representation. The company, unequivocally associated with Ariane Mnouchkine, its *metteur en scène* and one of its co-founders in 1964, has moved away from psychological realism towards a militant approach to theatre which has drawn on numerous ritualistic traditions and carnivalesque popular forms. Providing a stylistically eclectic and formally inventive theatre, Mnouchkine's productions have been credited with offering ravishing fusions of Oriental and Occidental cultural scenographies and simultaneously denigrated as a naive and offensive recourse to exotic ornamentation.

Born in France on 3 March 1939 of an English mother and French-Russian cinema producer father, Mnouchkine was educated at Oxford (where her contemporaries included the radical theatre and film directors John McGrath and Ken Loach) and the Sorbonne. In Paris she co-founded a student theatre group, the Association Théâtrale des Etudiants de Paris (ATEP) directing with them an outdoor production of Henry Bauchau's *Genghis Khan* (1961). Abandoning her psychology degree, she chose instead to travel in the Far East where she first became acquainted with Asian theatre traditions which have proved such a pervasive influence on her work of the eighties. Returning to Paris in late 1963, she reassembled the student theatre group which was to become Théâtre du Soleil – the name originally chosen by Mnouchkine as a homage to a select number of film directors (Minelli, Ophuls, Renoir) whose work was characterised by light and sensuality. Forging an aesthetic based on a lengthy creative process and a commitment to collective ethical socialist principles (including a parity of salaries), the company explored new ways of working which questioned established theatrical practices. Freeing themselves from the customary four-week rehearsal period, Théâtre du Soleil established a reputation for detailed textual work, moving away from the constrained acting style of the naturalistic theatre towards a more overtly theatrical performance style which celebrated the visual, sensory and musical power of a medium which seemed to have become a slave to the dramatic text.

Early acclaimed productions included the French premiere of Arnold Wesker's *The Kitchen (La Cuisine)* (1967), staged in an abandoned circus in Montmartre, which proved a veritable contrast to the earlier Royal Court production in its dynamic and disciplined performance aesthetic and its exquisite orchestration of stage action. An emphasis on physicality was also evident in her next production, *Le Songe d'un nuit d'été (A Midsummer Night's Dream)* (1968), again translated and adapted by Philippe Léotard: a ritualistic and violent reading which betrayed an Asiatic influence in its costumes and musical accompaniment. Plans to tour the production were halted by the events of May 1968; the company chose instead to tour *La Cuisine* around occupied factories around France. A commitment to the collective creative process was visible in their next production, *Les Clowns* (1969), which marked Mnouchkine's move towards a directorial style which put a greater onus on actor creation, and was largely concerned with forging a production aesthetic during rehearsals rather than arriving at rehearsals with a determined concept. A series of political productions followed which sought to interrogate the failure of the 1968 upheavals by focusing on the French revolution. *1789* (1970) and *1793* (1972) were thoroughly researched, inventive ensemble pieces which provided imaginative multiple-perspective commentaries on the events of 1789 and its aftermath. These productions were also the first to evolve in what has become the permanent home of the Théâtre du Soleil, the Cartoucherie in the Bois de Vincennes, a cavernous disused munitions warehouse which was renovated by the company in late 1970 after *1789* premiered in Milan.

Further explorations into political theatre continued with *L'Age d'or (The Golden Age)* (1975) and *Mephisto* (1979), an adaptation of Klaus Mann's novel, before the company turned to Shakespeare, embarking on a three-play cycle beginning with a ritualised heavily choreographed production of *Richard II* (1981), which critics regarded as heavily influenced by Meyerhold's biomechanics and Japanese cinema. Although *La Nuit des rois (Twelfth Night)* (1982) appeared lighter and less obviously stylised than *Richard II,* which drew on Indian imagery for costumes, *Henry IV Part I* (1984) marked a return to the Japanese iconography of *Richard II.*

The mid-eighties saw the beginning of what has proved a productive collaboration with the dramatist and cultural theorist, Hélène Cixous. *L'Histoire terrible mais inachevée de Norodom Sihanouk, roi du Cambodge (The Awesome but Unfinished History of Norodom Sihanouk, King of Cambodia)* (1985) was an epic eight-hour exploration of the controversial ruler and his fall from power. *L'Indiade, ou l'Inde de leur rêves (The Indiad or the India of Their Dreams)* (1987), a retelling

of the partition of India, again sought to challenge audiences' assumptions about the East, attempting both a destablisation of Eurocentric stereotypes and an alternative reading of a world habitually perceived as dangerous 'Other'.

A pervasive orientalism, often acknowledged by critics as similar to that which imbued Brook's *Mahabharata* (1984), was located in the 1990–2 productions of *Les Atrides*, a Greek cycle comprising Euripedes' *Iphigenia in Aulis* and Aeschylus's *Oresteia*, realised by a large international cast through a powerful and ravishing fusion of Eastern and Western performance traditions. Théâtre du Soleil's most recent production, *Tartuffe* (1995), provides a contemporary reading of Molière's classic comedy through the metaphor of Islamic fundamentalism.

Although Mnouchkine's status as 'director' of the company may appear at odds with their collective ethos, the commitment to a co-operative structure remains. Prominent members of the company, like Philippe Léotard and Philippe Hottier, left amongst a degree of much publicised acrimony, but key collaborators, including set designer Guy-Claude François, mask-maker Erhard Stiefel and composer Jean-Jacques Lemêtre, have remained with the company. The company's work with film includes *Molière, une vie* (1977), a radical study of the celebrated French dramatist within the context of his society often interpreted, as with so much of the Théâtre du Soleil's work, as a statement on the politics of theatre.

OTHER MAJOR PRODUCTIONS INCLUDE

Capitaine Fracasse adapted by Philippe Léotard from the novel by Théophile Gautier. Montreuil, 1965, then Théâtre Récamier, Paris, 1966.
La Ville parjure ou le réveil des érinyes (The Forsworn City) by Hélène Cixous. Cartoucherie, Paris, 1994.

CRITICS ON HER WORK

One of the first women to achieve an international reputation in this largely male-dominated profession . . . Mnouchkine is best known for the innovative nature of her productions and the Théâtre du Soleil has at various periods in its roughly thirty-year history created performancs which were unlike anything else which had been seen at the time. The clearest example of this was the Shakespeare cycle in the early 1980s which was heavily influenced by a variety of Asian theatre forms . . . No other production of *Richard II* has ever combined the same qualities of spaciousness and grandeur, such visual luxury in settings and costuming, together with a sense of hieratic formality in the staging and stylisation of acting. Mnouchkine above all is an extremist, a quality which has characterised all her best work.
(Adrian Kiernander, *Ariane Mnouchkine and the Théâtre du Soleil*, pp. 2–3).

In 1970 Ariane Mnouchkine's company Théâtre du Soleil came to the Roundhouse with *1789*, about the French Revolution. It was the same

summer as Peter Brook's *A Midsummer Night's Dream*. There was a feeling something was happening . . . Walking into the Roundhouse and finding 1,000 people milling around as if at a pop concert was pretty new. Suddenly this event exploded in the middle of us. There were six stages, simultaneous action, people talked over each other. There was anarchy. There was energy . . . I saw what theatre could be: not an intellectual form but something sensuous, sexy, alive and eight inches in front of your nose . . . I also saw the the power of the community and realised that theatre is not just about witnessing a story unfold, but something in which the audience could and should be central . . . To it I owe my love of the physicality of the actor and a distaste for naturalism.

179

———◇———

ARIANE
MNOUCHKINE

(Adrian Noble, 'Dramatic Moments: 6'. *Guardian*, G2, 18 October 1995, p. 9).

SIGNIFICANT BIBLIOGRAPHICAL MATERIAL

Bradby, David. *Modern French Drama 1940–1990*. Cambridge: Cambridge University Press, 1991.

Kiernander, Adrian. 'The Role of Ariane Mnouchkine at the Théâtre du Soleil'. *Modern Drama*, 33, No. 3, September 1990, pp. 322–31.

Kiernander, Adrian. *Ariane Mnouchkine and the Théâtre du Soleil*. Cambridge: Cambridge University Press, 1993.

Whitton, David. *Stage Directors in Modern France*. Manchester: Manchester University Press, 1987.

Ariane Mnouchkine in conversation with Maria M. Delgado at the Cartoucherie, Paris, 14 October 1995

DELGADO 1995 seems to be the year of the *'Tartuffes'*. Here in Paris at this very moment we have two major productions: yours at the Cartoucherie and Benno Besson's at the Odéon. What attracted you to Molière's comedy and why do you feel it's proving so topical?

MNOUCHKINE The theme! It's a play which, every ten years, becomes actual. Ten years ago I would have liked to have done it, but it wouldn't have been like it is now. Twenty years ago I would have probably set it in Russia or something. And if I was Polish I would do it now with the Catholic Church. That's the point of a real classic masterpiece. But I'm French. I'm French and I have friends who are coming from many countries. Some of them come from Muslim countries and the Islamist – I'm not saying Islam but Islamist – fanaticism is the one we have to deal with here: the one with which the youth of our country has to deal with. And so, that's why.

That's what *Tartuffe*'s speaking about. If you believe what Molière says in the play you see that it's a war play; Molière describes a state of war, a sort of hostage situation. He shows that the house, the family, is taken as hostage not only by a man but by a

movement. In Molière's time the movement was La Compagnie de Saint-Sacrament but now it happens in other countries, not completely in our country. It's the same though, exactly the same.

DELGADO Théâtre du Soleil consolidated its reputation in the eighties with key theatrical re-readings of the classics: firstly the Shakespeare cycle, and then, more recently, *Les Atrides*. What is the attraction of these plays? What do they say to us in the 1990s?

MNOUCHKINE Well, it depends on which classic. Somebody like Molière is, I would say, directly of our time. The Greeks are probably much deeper and more universal. I wouldn't have actualised *Les Atrides*. I didn't need to. On the contrary, I wanted to show how strange and how far we are. How strange we are, deep inside. Our unconscious is hidden and the Greeks knew that, and they did theatre with that very far away part of ourselves.

DELGADO It seems to me that the Greek plays were about societies in transition, societies in chaos.

MNOUCHKINE Yes, but I would say that Molière's *Tartuffe* is also about a society which could easily fall into chaos if Orgon took control. If Orgon had won who knows what could have happened. So in a way Molière is talking directly about society. He's more political than the Greeks. The Greeks are more metaphysical and psychoanalytical. Even so, it's not as simple as that.

DELGADO What about Shakespeare? What's the fascination with Shakespeare?

MNOUCHKINE Shakespeare's such a mystery, but Aeschylus is too. For me both Aeschylus and Shakespeare are gods. They're not human. When you work on their works it's so magical. Everything is there. They invented it. What Aeschylus did not do, Shakespeare did, and what Shakespeare didn't do Aeschylus did. Victor Hugo called Aeschylus 'Shakespeare *l'ancien*'. And I'm sure he would have called Shakespeare the 'new' or the 'young Aeschylus'. But Molière's just a man – a wonderful man, a wonderful actor, a dear director of a company, but just a man. He's a genius but he's not superman. Those two, Aeschylus and Shakespeare, are supermen. And so it's very strange, when you present a play by Molière you just have to understand and feel what he has gone through: the suffering, the wrath, the anger, and the courage also – he's so courageous. Shakespeare's courageous too, but it's different. Molière's just a man, and he's so near us that he's modern.

DELGADO That was one of the strengths of your production of *Tartuffe*. The way you created that sense of a family which we, as an audience, could feel close to. We feel they're 'like us', we learn about

their workings and get intimate with them. That's why it's so terrible then when they get swept away by this movement. I think it's different with Shakespeare. I never feel that intimacy.

MNOUCHKINE No, because also although there is a sort of conflict between Orgon and Elmire, and between Orgon and Dorine, it's not the same war. It's not *Les Atrides*. You see, Shakespeare and Aeschylus always talk about internal wars, civil wars. They are wars in the family, but cruel wars. This is not the same. This family is at war with something which is exterior and which has come into the house because one of its members has gone mad. Orgon's a coward, and maybe he thinks he will have a strong ally in Tartuffe. But still, it's not a murderous war in the family although the scene between Orgon and Damis, the son, is murderous, or could be murderous. But Damis comes back, he's not Orestes. He returns and helps his family.

DELGADO Visually, I felt your production suggested that Tartuffe was almost like a surrogate son to Orgon. He cut a very different figure to the feminised Damis and there were moments when I thought 'Oh, no, this is the son he feels that he doesn't have, the son he wants'.

MNOUCHKINE I don't know that he wants another son, but he certainly wants support, he wants an ally. He thinks that this is a good party to be with. He's thinking to the future, not realising that it's just fascism.

DELGADO It's a wonderfully detailed production which goes to great lengths to provide a sense of how the family live. We have a real sense of their rituals and activities. It's also a long production, over an hour longer than Besson's.

MNOUCHKINE I've never understood how *Tartuffe* can be played in two hours. The actors have to speak like bullets. If you want to understand each moment of the text, if you want to find the flesh, the reality, the truth of it – not just the conventional music of the language which can be the most beautiful thing but also the most mechanical thing – then you cannot go too fast because then those people who were here yesterday, those young people they don't understand a word.

DELGADO Although this is your first production of one of Molière's plays, you did make a film of Molière's life in the late seventies. Is he a figure who fascinates you?

MNOUCHKINE I have a love for the man, Molière. I love him! I like him. I'm sure he was a good and great man, I'm faithful to him, because I think, in a way, he is like the boss of all theatre companies. You can't live in France and do theatre and have a company, without thinking at least once a week of Molière. But I couldn't put all his

work on stage and I could think of putting *nearly* all Shakespeare's plays on stage. I don't like all of Molière's plays but it doesn't matter. I feel close to certain of his plays, not all of them.

DELGADO What about your collaborations with Hélène Cixous? You've worked with her three times now. How different is it collaborating with a live author?

MNOUCHKINE I think it's the same.

DELGADO Why?

MNOUCHKINE Because we decided that we would deal with Hélène as if she were, not dead, but absent. We decided that we would not phone Hélène to say, 'Listen, this scene is not very good, what can you do about it?', because we can't do that with Shakespeare or with Molière. So we made a point of not doing it. Sometimes, when we have been trying very hard, and when we are sure it's not our fault, then we'll talk and she'll say 'Maybe we should change this'. She has no possessive attitude over her work, so she will change it, even maybe sometimes too quickly. Very often I would say, 'No! Wait! Don't cut this. We'll wait and see.' So, in effect, it's the same as with Molière ... With Molière there are still sometimes a few lines in the play where we wonder, 'Why did he do that? What happened that day?' We can't phone him, so we just do our best. And it's the same with Hélène's plays. At times it's difficult, but until we're sure it can be better if she changed something, we won't ask her. And most of the time she's right. And sometimes it's just a question of structure.

DELGADO Does she come into rehearsal?

MNOUCHKINE Very often, but she doesn't say anything. She likes to remain silent. She always thinks its beautiful. She's very easy to work with. First of all she understands our work very much, she understands the way we use the classics as masters and she used the classics as masters herself. So, you know, she follows Shakespeare and Aeschylus. She's part of the company really. I think she works completely differently when she's working with another director or another company.

DELGADO Do you ever think of working with any other live writers? Do you feel that any live writers can give you the inspiration you get from Shakespeare or Aeschylus?

MNOUCHKINE No. I always go back you know, every two years or two plays, I go back to what we call the masters, because we need that.

It's strange but only yesterday people came out of the play and asked me, 'Did you publish your adaptation of *Tartuffe*?' And I say, 'What adaptation?' And they reply, 'Well, the one we just saw.' And I have to tell them, 'There is no adaptation. This is it. It's Molière's

text.' So that must mean that it's modern, that it's saying something to us.

DELGADO How different is it working on productions where you're writing the play as you go along. I'm thinking back to your productions in the early seventies: *1789, 1793*, and *L'Age d'or*. These productions involved a very extensive process of documentation, improvisation and collective creation. They were put together in very different ways, because you don't have a play, as such, to begin with. How different is it when you don't have a text in front of you? When you don't get a script from Hélène or you don't have *Richard II* to work from?

MNOUCHKINE I think that's a question of degree. You just start higher when you have a text. But the way of improvising, researching, and working collectively is the same. The only thing that you don't have to look for is the words. They are there and they are magical treasured words. So you immediately start higher and go higher. But I don't think the method is so different. The actor has to improvise anyway. They have to improvise because, who knows what they are doing or why they're saying that. I don't know. We always work as if the author, whether it's Aeschylus or Shakespeare or Molière, had sent us the play yesterday by fax. I don't know these plays, I don't want to know them. They are creations for me. So, sometimes I will even work with the actor like that. I give him one phrase and I wait and wait and wait before giving him the next phrase. I do the same for me. As such, with *Tartuffe*, it was for me as if this were the first time that the play had been on stage.

DELGADO You spend a lot of time rehearsing each project. These are not plays that you rehearse in four weeks and then put on the stage.

MNOUCHKINE No. I can't do that. I admire people who can do good work like that but I can't. I'm slow. I need four months.

DELGADO Do you think that's a luxury?

MNOUCHKINE Yes, it is a luxury but we pay for it. We pay for it because we have very modest salaries. You can't do that if you are paid like actors are paid elsewhere. If you want to rehearse for four and a half months then you have to give something in exchange. I think we give a lot in exchange. We work a lot, we take risks, but we are not paid so much. It's a luxury, I admit. We have the space, we have the time, we have the light, we have in a way everything we need to work. That's where the money goes, it doesn't go elsewhere.

DELGADO Your early work was very overtly political and recognised as such. I think, as *Tartuffe* clearly indicates, your work is still very

political, but in a different, less obvious way. Was there a very clear political agenda in the early days and is there still?

MNOUCHKINE No. At the beginning we were leftish, we knew we were, but we were not Brechtian or communist. We were just looking for progress, freedom and justice. We didn't have an ideology as such, but we were idealists. That means that we were not taken very seriously at the beginning because we did not pretend to have a very strict Maoist, Trotskyite or Stalinist ideology. We were not leftists, just *de gauche*, and we still are. We never obeyed any dogma.

DELGADO But you are seen as a political director. Perhaps it's because you've been linked with political causes in some way and have shown a commitment to that in public places – I'm thinking especially here of your work with AIDA [Association Internationale de Défense des Artistes] which you co-founded, and its commitment to achieving the freedom of individuals imprisoned for their political beliefs – and also because of your political theatricalising of history in such pieces as *1789*.

MNOUCHKINE Yes, but I would call it more historical, you see. Of course it's political and you're right *Tartuffe* is very political, but Molière's play is political so you can't 'de-politicalise' it without betraying it. We don't start in rehearsals trying to be politically correct. We don't dismiss things because they are not politically correct. We do what comes, and then see if it's fair and just. But we don't say 'Ah! Well, we can't say that because this would not be politically correct'. If it's in the play we keep it.

DELGADO Your experiments with the language of the stage have involved breaking with conventional forms of theatre on numerous levels: your early non-single authored texts, breaking with the two-hour slot, a commitment to collective working methods. What did you think was so wrong with theatre in the early sixties that led you to break away from it on so many levels?

MNOUCHKINE When you are young you can even be against something which will prove to be very important to you after a few years. I was against everything. And then after a few years I began to understand. You're always against your parents and then you realise that they gave you life. So it's the same. But, it's not as conscious as that in me. I was not theatrically rich so I was not very conscious of the fact that I was breaking away from conventions. It felt normal. For me *1789* was just a fair. It was just a fair with little stages as in the markets – that was all. What was not so normal for me was this box which was always littered with the same light and the same sets and the same look. That was not normal. It was not a reaction. Maybe I'm

not as revolutionary as you think. The nature of the Théâtre du Soleil, I think, is not to be provocative or anything. It just aims to follow the path of traditional theatre, of popular theatre, of a theatre of pleasure, depth, truth, beauty, movement and celebration.

DELGADO You've worked with a lot of international actors at the Théâtre du Soleil. Do you think there's any such thing as a 'French' actor or a 'German' actor or a 'Brazilian' actor?

MNOUCHKINE No, but there is such a thing as a French education and a German education, and that produces a French actor or a German actor. Well of course, if you talk only about great, great, great actors, there is no such things as German or French, but if we're talking about young actors who are talented but not yet great, then you often see where they come from and the formation or education is terrible.

DELGADO Why?

MNOUCHKINE Because it's closed. Because it's generally lazy and it doesn't involve the body. When people come from all parts of the world then it sort of explodes, they can't just impose their German or French training, because there's suddenly a Brazilian there who doesn't have an actor's training but a dancer's training, and she's free, and she suddenly moves and everything is dislocated. Everybody feels destabilised, and also free – freedom has come. There is such a thing as a French actor, or a German actor, or a Russian actor – and what I want is an actor.

I like the fact that there are, at the moment, about twenty nationalities at the Théâtre de Soleil. I love that. Also I love the fact that even the French actors now, are not French any more – they're just actors. They don't only have this French accent; their way of acting is full of accents. And that's what I like.

DELGADO Do you think there is any way directors can be trained? Or do you think it's a craft that you learn over years and years and that changes as you change and as the actors you work with change?

MNOUCHKINE I think there is a reciprocity. I trained the actors. I formed them really, but they formed me, of course. Each production shows my mistakes repaired by them or else there's a catastrophe because they didn't know how to repair the mistakes. All the time I see actors doing something much better than what I proposed to them. They may hear me proposing things to them which are much better than what they're doing, I think that was my luck when we created the Théâtre du Soleil. I didn't know anything and nobody around me knew anything. My luck was that some people

who did not know anything and knew that I did not know anything, still trusted me and agreed to wait for me in a way. We were waiting for each other. We've been waiting for each other. And then after that, at a certain moment, we started progressing, and as I said, teaching each other without knowing it, and without knowing what we were teaching each other.

DELGADO Théâtre du Soleil is a collective which has attracted some extraordinary performers, musicians and designers, but you are the figure most conspicuously associated with the company, and you've remained with them since the very start. Does the idea of the collective remain of key importance to you?

MNOUCHKINE Yes, absolutely. It is very important. I always said that when I would not be able to do it anymore like that – because it's difficult, it's hard, very painful, and sometimes heartbreaking – I would stop. It's the way to do it. It's the only way I can work. And the day I feel I'm not strong enough to do it like that anymore, I will stop. It doesn't mean that the Théâtre du Soleil will stop, but I'll stop. For a long time I was just on the verge of saying 'Oh, maybe it's time to stop'. When somebody leaves, you feel so sad and so betrayed, and then you look around and there's somebody else looking at you with so much hope and enthusiasm, so much devotion, courage and talent that you say 'okay, let's go out again'.

DELGADO Do you never feel tempted to go and work elsewhere?

MNOUCHKINE No! Never. I'm not strong enough for that, I'm not mercenary at all. I think it's already so difficult to do it in your own home. I have a small home here. It's an island so we protect each other in a way, although we are very fragile sometimes. When I see all these directors going to very big theatres and having to deal with such institutions, I admire them, because I wouldn't be able to do that. I don't want to do it, but also I would not be able to do it.

DELGADO You and the company are based in Paris, and have been based in Paris all your working life. Do you think there's something special about Paris that attracts and nurtures international directors like Jorge Lavelli, Lluís Pasqual, Alfredo Arias, Víctor García. Michael Billington recently referred to it as the theatrical capital of the world. Is it a particularly receptive place to create theatre?

MNOUCHKINE Maybe it still is. Yes, maybe there is still, luckily, something remaining of the spirit that made it so receptive to painters or sculptures or musicians for a while. Yes, I think it is. Whether it's going to go on like that I don't know. London was supposed to be the theatrical capital of the world a few years ago, and it isn't anymore. But there are also economical reasons for that. The left made mistakes but they did a lot for culture in Paris and France in general, and

it gave results, although they were not always good. People are worried now whether it's going to be kept like that or not. It's not only really due to the fact that theatres were helped economically by the state which was not the case in England, or is not the case in America, because it's the case in Germany much more than here. So it's not solely due to state support.

DELGADO What about running a theatre building? Is it a very big problem in our current economic climate? Is a director, by necessity, having to take on many more administrative tasks? Is your work increasingly involving raising money to keep afloat?

MNOUCHKINE No, that's not my business or my work. My work involves seeing that the food is good, that there's no rain coming through the roof, and dealing with the money we have. I'm not looking for sponsors. We refuse that because we don't want to be slaves to the sponsors. But that's maybe why Paris is still the capital, as you say, because it still has subsidies. Although that's changing, has already changed. I hope it does not change any more.

DELGADO You're seen as one of the world's most respected *metteur en scènes* . . .

MNOUCHKINE Am I?

DELGADO I think so! So what do you see the role to be? Do you still hold with the opinion that it involves just letting things happen rather than specifically choreographing them?

MNOUCHKINE I'm like a midwife. I help to give birth. The midwife doesn't create the baby. She doesn't create the woman, and she's not the husband. But still, if she's not there, the baby is in great danger and might not come out. I think a really good director is that. Let's say I am a good director when I don't fail to be that.

A midwife is not somebody who just looks at the baby coming out easily. Sometimes she has to shout at the woman, sometimes she says 'Push'. Sometimes she says 'Shut-up'. Sometimes she says 'Breathe'. Sometimes she says 'Don't do that'. Sometimes she says 'Everything is alright. Everything is alright. Go! Go!' It's a struggle.

DELGADO It's almost like the opposite of someone like Strehler who is, maybe because he's also an actor, a great demonstrator. When Strehler directs he gives you a one-man show. Do you not demonstrate? Do you just watch and guide?

MNOUCHKINE Sometimes, but very seldom, I think. You should ask the actors that, because I don't know. But I certainly don't do what Strehler does because, as you say, he's a one-man show.

DELGADO Adrian Kiernander states that your greatest virtue as a director is patience. You're willing to wait with things.

MNOUCHKINE Yes! I am very patient with patient actors. If I feel that an actor needs more time but that he is really searching for it, and that he is really working, he's really suffering, he's really not just wasting time, then I can wait years.

DELGADO Is that why certain productions have taken so long to rehearse? *L'Age d'or* took twenty months.

MNOUCHKINE Yes, but *L'Age d'or* was particular. What I mean is that I can wait years for an actor or an actress who is not still very good in this production because I know in the next one, or in the one after, he or she will become good. I can no longer wait years for a production, but I can wait for a decent human being. If I see him or her struggling and hoping, then I'll trust them and yes, I'll wait.

DELGADO You once described directing as a minor art, unlike composing or painting. Why do you regard it as a minor art?

MNOUCHKINE Because a play exists without a director. A painting doesn't exist without a painter, and a play does not exist without the writer. So, yes, I think it is a minor art. I don't feel frustrated by that, but I think one has to recognise it. It is an art, but it's a minor art. Minor is perhaps not a good word because it's pejorative. We're artisans.

DELGADO You've spoken in the past of your attraction for theatrical traditions which much contemporary Western theatre has lost touch with . . .

MNOUCHKINE Our sources, our tools at Théâtre du Soleil are traditions – wherever they come from. Our inspiration comes from traditional theatres, real traditional theatres – wherever they come from. Asia, of course, is very important, but any traditional form of telling, any acting with logic, comes from something very deep and very religious and very mythological and very theatrical. They are fonts of information, and they are pedagogical. So we want to follow traditions because they are as important to us as Shakespeare or Aeschylus.

My love for Asia and for Asian theatre has determined much of my work. My theatrical parents are India, Japan and China.

DELGADO Is it because you feel that these countries are rich in traditions that we've lost here?

MNOUCHKINE Yes. And I'm not sure we ever had them. I think we have the writers. We have Shakespeare. They don't. Even Chikamatsu [Monzaemon] in Japan is not Shakespeare. Also they have very few writers. They have big epics like *The Mahabharata*, but it's always the same. They don't have Chekhov, but they have the actors. They invented actors. They discovered the art of acting. And

I think when you succeed in having both the Western dimension and the Oriental, then you have the theatre I aspire to.

DELGADO What about your work in film? Do you see your work as a film director as a progression from your stage directing? Or are they completely different?

MNOUCHKINE No, there's some progression but it is also completely different. This is to do with the relationship towards money. When you're shooting a film in the mornings, something starts and you know that it costs a lot of money every minute, so you can't think, you can't wait. You have to act quicker.

DELGADO A number of critics draw parallels between your work and Peter Brook's. Perhaps because Brook is also concerned with the mergence of East and West and similarly works with an international company. Do you think that there are comparisons between your work? Or do you think that critics draw attention to the parallels because few others are so conspicuously involved in such practices? He was working on *The Mahabharata* at the same time that you were working on *L'Histoire terrible mais inachevée de Norodom Sihanouk, roi de Cambodge*.

MNOUCHKINE Yes, but that means that there are comparisons. If it's true that there are so few people working like we do, then it means that a comparison can be made. Although I think the results are completely different, the search is probably familiar. But I haven't seen his work, so I don't know.

DELGADO Are there any directors that you particularly admire, or directors that you feel have influenced your work?

MNOUCHKINE Well, I think there are some cinema directors who influenced me a lot, certainly. I think Strehler was very important because when I saw *Arlecchino, servitore di due padroni* and *I giganti della montagna* it was a real shock for me. I saw *Arlecchino* when I was very young and I think it was in Montaux, in the South of France, in summer, and I saw it with [Marcelo] Moretti. I felt that something had happened that day. I suppose I was about fourteen or fifteen. And then, much later when I had already started to do theatre, I saw *I giganti della montagna* and I felt that I wouldn't be able to do any theatre because it was so beautiful. So I suppose it was very important. But otherwise I think it's more to do with individual plays, like Roger Blin's *Les Paravents;* things like that have been very important for me. But otherwise, you never really know what your influences are: scenes in the street or something you see or hear or read. I don't know.

DELGADO Do you think as a company that you moved away from the meticulous naturalism which you are credited with bringing to your production of Wesker's *The Kitchen*.

MNOUCHKINE Which is not true. I think in a way *La Cuisine* was not put on the stage with meticulous naturalism, because that's the genius of the play. You never use real things, so it can't be naturalism. It's all immediately transformed. Probably, little by little, we tried to find forms for each play. But I do hate naturalism and realism – that's not theatre.

DELGADO Why not?

MNOUCHKINE I don't know, but it isn't.

DELGADO Certainly when one thinks of your productions at Théâtre du Soleil one thinks of an opulent celebratory theatricality and that's what makes the work very special. But studies of your work are at pains to point out the Stanislavskian influences on your early productions.

MNOUCHKINE Everybody says what they want, but Stanislavsky is not naturalism. If you read it very carefully, you see that in a way he knows what he's saying. He's not saying what has been put in his mouth since. Although, even if you sometime you think, 'Oh, come on!', what he says is that you have to be true. He always says that. It has to be true. He doesn't say it has to be real, which is different.

DELGADO What about the future?

MNOUCHKINE Well, I'll tell you that in the future. I'm at the present for the moment. We just want to know if this play is going to work, which I hope it is, so that we can earn our daily bread with this; and then we'll see.

YUKIO NINAGAWA

◇

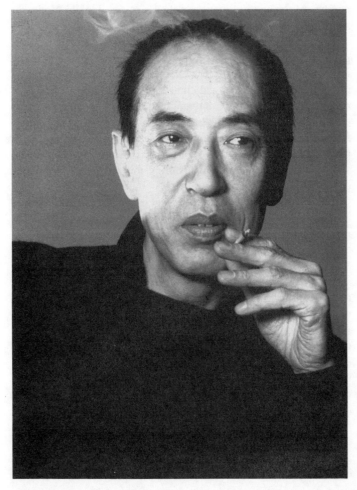

Courtesy of Point Tokyo

D ESCRIBED by actor Brian Cox as a 'theatrical supremo... whose productions are guaranteed to stir curiosity and heighten expectations', the Japanese director Yukio Ninagawa's inventive and visually audacious productions of Western classics, Mishima and Noh dances have delighted European festival audiences throughout the eighties. Shrewdly providing a mergence of Eastern and Western traditions, his captivating kaleidoscopic ventures have survived in the commercial theatrical climate of Tokyo as well as the discerning international festival circuit, despite being denounced by a number of Japanese writers and directors, like Hideki Noda, for supposedly pandering to a foreign penchant for the exotic.

Born in Kawaguchi on 15 October 1935, Ninagawa sought to study painting but failed the Tokyo University of the Arts entrance exam. He then worked as an actor for twelve years before turning to directing in the politically charged climate of 1968, when he formed an agitational company, the Contemporary People's Theatre. It was his politically charged production of Kunio Shimizu's *Shinjo Afureru Keihaku-sa (Sincere Frivolity)* in 1969 – a veritable state-of-the-nation piece – which established his reputation as a director of consummate skill, a reputation consolidated during four years of productive collaboration with Shimizu.

In the mid-seventies he was courted by the successful producer Tadao Nakane of the Toho Group (who later set up Point Tokyo in 1987), with whom he has enjoyed a productive twenty-year collaboration which has generated such epic ventures as a 160 chorus *Oedipus* (1976), a hallucinatory *Peer Gynt* (1990) with a dashing Japanese pop star in the title role, a magical opulent *Macbeth* (1980) set in a late sixteenth-century Japan of Samurai warriors (a time of bloody upheavals as well as artisitic splendours), and a beautiful outdoor *Medea* (1983) with regular actor Hira Mikijiro as the eponymous protagonist. Brash conceptual frameworks, an expansive stage bathed in colour and light, operatic performances of inspiring precision, imagistic splendour, rich Oriental imagery, a superb orchestration of expansive casts, and a delicate underscoring of the action with key classical pieces, characterised Ninagawa's productions with Nakane. All proved captivating theatrical experiences as well as sophisticated commentaries on the contradictory cross-currents co-existing in contemporary Japan. The late eighties witnessed a severe creative block which made him contemplate the abandonment of a career in

directing. His confidence was restored by a vibrant metatheatrical production of *The Tempest* (1987) which sought to make the play accessible to Japanese audiences through a reframing device which had a troupe of Japanese actors rehearsing Shakespeare's play on the island of Sado – an appropriate location as the founder of Noh theatre, Zeami, was exiled there by Shogun during the fifteenth century. Until 1990 Ninagawa's reputation abroad lay largely with the quintessentially Japanese productions of Western classics, although he was well known in Japan for his stagings of contemporary Japanese works. The 1990 production of Mishima's adaptation of a Noh story, *Sotoba Komachi (Beautiful Lady of Stupa)* – a play he had previously staged in 1976 – was marked by a dreamlike austerity, economy of movement, and dazzling theatrical effects.

The 1991 Edinburgh Festival provided the British premiere of Ninagawa's staging of Shimizu's 1978 play, *Tango at the End of Winter*, a subtle and moving study of a disillusioned emotionally dysfunctional actor Sei, engaged in an illusory existence from which he cannot be shaken. Adapted by Peter Barnes, with a high-profile cast including Alan Rickman and Suzanne Bertish, it was acclaimed as a bold seamless production gloriously employing light and sound to evoke the dreamworld of the protagonist. This audacious English-language debut encouraged producer Thelma Holt to join forces with Nakane to produce an English language *Peer Gynt* (1994) but this met with less success. The international cast of Welsh, Japanese, Irish and Norwegian actors battled unsuccessfully with Ninagawa's ill-fitting futuristic concept of *Peer Gynt* for a mechanical age and the production was generally regarded as a failed experiment in interculturalism. The following year, however, saw a return to form with a rich Japanese production of *A Midsummer Night's Dream* set in a stone garden adorned with five illuminated columns of cascading sand.

Ninagawa received the Grand Prize at the Arts Festival in Japan for his production of Matsuyo Akimoto's *Chikamatu Shinju-Monogatari (Suicide for Love)* at Tokyo's Imperial Theatre in 1979. He was awarded the Arts Encouragement Prize by the Japanese Minister of Education in 1987, an honorary doctorate from Edinburgh University in 1991, and has been twice nominated for an Olivier award in London.

OTHER MAJOR PRODUCTIONS INCLUDE

Asukoso e Hana wo Saso yo (Let's Display Flowers There Tomorrow) by Kunio Shimizu. Rehearsal Hall, Gendai-jin Gekijo (Theatre of the Modern), Tokyo, 1970.

Karasu yo, Oretach wa Tama wo Komeru (We are Loading Our Guns, Raven) by Kunio Shimizu. Shinjuku Culture Hall, Tokyo, 1971.

Modo-ken (A Seeing-Eye Dog) by Juro Kara. Shikjuku Culture Hall, Tokyo, 1973.

Romeo and Juliet by William Shakespeare. Nissei Theatre, Tokyo, 1974.

King Lear by William Shakespeare. Nissei Theatre, Tokyo, 1975.

Hamlet by William Shakespeare. Imperial Theatre, Tokyo, 1978.

Shitaya Mannen cho Monogatari (Story of Mannen-town in Shitaya) by Juro Kara. Parco Seibu Theatre, Tokyo, 1981.

Kuroi Tulip (The Black Tulip) by Juro Kara. Parco Seibu Theatre, Tokyo, 1983.

Nigori-e (Muddy River) adapted by Yasuaki Horii from the novel by Higuchi Ichiyo. Nissei Theatre, Tokyo, 1984.

Kyofu-Jidai (The Age of Fear) by Junichiro Tanizaki. Nissei Theatre, Tokyo, 1985.

Naze ka Seishun-Jidai (For Some Reason, Adolescence) by Kunio Shimizu. Parco Theatre, Tokyo, 1987.

Sannin-Shimai (The Three Sisters) by Anton Chekhov. Ginza Saison Theatre, Tokyo, 1992.

Samayoeru Oranda-jin (The Flying Dutchman) by Richard Wagner. Kinagawa Ken-min Hall, Tokyo, 1992.

Waiting for Godot by Samuel Beckett. Ginza Saison Theatre, Tokyo, 1994.

CRITICS ON HIS WORK

It seems that along with Bergman, Brook, Stein and Strehler, Yukio Ninagawa is one of those theatrical directors whose every production becomes something of an event . . . Ninagawa's directorial trademark is spectacularly choreographed stage effects – snowstorms, cherry blossoms, rivers, peacocks, and great chariots flying across the heavens.

(Peter Barnes, 'Working with Yukio Ninagawa', p. 389).

Ultimately, Ninagawa is one of nature's great synthesisers. He proves that East can meet West, that an aesthete can work in a commercial industry, that a sense of the past can be reconciled with experimental flair.

(Michael Billington, 'Noh Way', p. 27).

SIGNIFICANT BIBLIOGRAPHICAL MATERIAL

Barnes, Peter. 'Working with Yukio Ninagawa'. *New Theatre Quarterly*, 8, No. 32, November 1992, pp. 389–90.

Billington, Michael. 'Noh Way'. *Guardian*, 28 November 1992, pp. 25–7.

King, Robert L. 'Edinburgh and the Idea of a Festival'. *Massachusetts Review*, 33, No. 2, Summer 1992, pp. 305–12.

Nobuo, Miyashita. 'Yukio Ninagawa, Theatrical Pacesetter'. *Japan Quarterly*, 34, No. 4, October–December 1987, pp. 400–4.

Yukio Ninagawa in conversation with Michael Billington at a private address, London, 14 March 1994, translated by Yuriko Akishima

BILLINGTON Mr Ninagawa, can I ask you why you wanted to stage *Peer Gynt*? Why this particular play?

NINAGAWA I have liked *Peer Gynt* all the time since I was young, but it's not just wanting to do the play of *Peer Gynt* but *Peer Gynt* for today's young people. For today's youngsters it is very difficult to discover oneself and realistic help is very scarce these days to find yourself, so they tend to find identity within the framework of virtual reality and that's what today's ordinary youngster is about. And if I direct with that concept, then *Peer Gynt* becomes a very interesting project. And also this is a nineteenth-century play which has many elements that predict the theatre to come in the twentieth century. For instance, the Theatre of the Absurd, Symbolism and the traditional side of the play; *Peer Gynt* is a melting pot of all these elements of twentieth-century theatre. So this is – as a theatre person – a very interesting thing: to grasp the world with these elements and achieve the theatre.

BILLINGTON Can I ask you a bit more about the concept? We see Peer Gynt in a video arcade at the beginning of the production. Is the idea that Peer is watching a video, a dreamlike video of what his life might be? Of what his life might become?

NINAGAWA It is the machine's impetus and then in his mind the story develops; he's not directly realistically watching it.

BILLINGTON About the concept – I wondered how much the concept derived from Japanese society specifically? I took it to be a warning to the young people of Japan about the dangers of living a life devoted to self, power, materialism. Did it spring from Japanese life and society?

NINAGAWA Yes, I think there are more Japanese youngsters embedded into life with TV and video things than European youngsters. Instead of meeting reality they'd rather try to see reality through a video or the TV and that's a cowardliness, but that's what they think reality is. So there is something different from the actual thing that is happening. During the rehearsals one of the actors brought a newspaper clipping which is the result of a survey that today's young people know more about the characters of famous video games than traditional stories like *Alice in Wonderland* and things like that, and that's a danger, so the actor said 'Your concept is right'.

BILLINGTON It's a universal problem. But Ibsen's play seems to pose problems or difficulties, one of which is that Ibsen switches between reality and fantasy within *Peer Gynt*. Is it difficult to capture that when you have such a strong concept of your own?

NINAGAWA The reality of this play is about how human beings move and behave in a particular situation or within a community; for instance, relationships of mother and son and other relationships.

In order to express this I don't think it will clash with my own concept.

BILLINGTON What I meant was Ibsen switches very suddenly in the play. To take an example, Ibsen shows you a peasant wedding which is like Bruegel and then goes straight into the Troll King, which is like Hieronymous Bosch. Is it difficult to capture those sudden switches?

NINAGAWA Yes, it is difficult. Those things exist to make it credible to the audience. For instance, there is a very hot relationship of people and then suddenly it becomes very conceptual like the Troll scene, which is the expression of something ugly that is expressed as a troll. I don't want to make it too anecdotal so it is very difficult to express.

BILLINGTON I wanted to ask also specifically about the last act of the play, Act Five, in which Peer seems to come back after all his travels to Norway. But do you think Peer actually does die at the end of Act Four, and Act Five is simply taking place in his imagination or is a vision of his purgatory?

NINAGAWA I don't think that is about life after death. It's just very much towards the end of his life so that everything is within the prediction of the death that's coming, so the shadow of the death is hanging around him. Something that I didn't notice when I was reading the script but I did notice when I was directing this work is that this may be in parallel with my fear about the end of my theatre life, so Act Five suddenly becomes . . .

BILLINGTON I hope it's not a parallel with your own life. Can I ask you about the casting of the play because you have a great mixture, you have a Welsh Peer Gynt, Irish actors around him, English actors, one Norwegian actor, one Japanese actor – was it always your intention to have a multinational *Peer Gynt*?

NINAGAWA I think this is a very warped play. From Act Four to Act Five there are many elements mixed and so I call it a warped masterpiece. So how does this happen, where does this come from? I think it is because it mixes up elements from different cultures and it's a clash, but you still have to make it into one piece of work. How are we going to do it? And that was a very interesting challenge.

BILLINGTON This is the second time you've worked in London with British actors. Is it very different from working at home with Japanese actors?

NINAGAWA It is very different. Japanese actors do not have to be backed with logic in order to do something and don't have to be told about every behaviour. But English actors, they have to have subtext about everything otherwise they can't act. In that way the British

actors are very detailed. And the other thing is that British actors can be almost animalistic and real in acting, and they have that as a basis of their acting. The Japanese don't have it. In order to express realistic things they have stylisation. So there is a very clear contrast at the end of this play in Act Five when Peer (Michael Sheen) and the Button moulder (Itarahiko Jah) meet; you can see two clear examples.

BILLINGTON Does that mean Japanese actors are more obedient to authority or to the director, whereas English actors ask more questions?

NINAGAWA It doesn't mean that English actors are not obedient to the director. It's just that in my generation, the theatre education that was, we studied the subtext in the way they do here, so to me it is no hardship to come to these English actors today. But today's Japanese actors are not my generation. They have not been given that kind of training, so if things are ambiguous or vague they don't get this subtext in their mind in the training. So it seems that today's actors are not very serious about trying to learn different cultures and they are not very serious about challenging those cultures.

BILLINGTON Can I ask you how you organise your rehearsals when you're directing British actors? Do you explain in advance what the intention of the scene is and then give them a lot of freedom to find their own way towards that intention?

NINAGAWA First at the beginning of the rehearsals I explained the concept of the whole play and of course there were lots of questions about it that we discussed. Then we get into individual scenes and in each scene I give them the situation; I give a briefing on the situation and then they start doing it freely.

BILLINGTON Is the language a problem though? In that you have to give a lot of trust to the individual actor, don't you?

NINAGAWA Yes. As for Michael Sheen, the moment I met him I decided on him. I wanted to make a Peer out of him but he went much more lively, much more than I had imagined, and this is not a Chekhov play so I gave him great freedom to try different things and then when he goes off the track I stop and tell him. I decided to do it that way. So specially in the scenes with Ase alone, I told both the actors 'You can just do it as freely as you want and we act, we talk, we act and we talk and then improve it'. That's the way I did it.

BILLINGTON You've done *Peer Gynt* in Tokyo, I believe. Is this production in Britain very different or very similar to the one you did before?

NINAGAWA Almost totally different.

BILLINGTON Almost totally different? In what way?

NINAGAWA For instance, if you call this production digital then the Japanese production was analogue or slot machine. This one is digital, meaning video or computer, but the Japanese one was like a pinball machine.

BILLINGTON But both productions began and ended, did they, with Peer in an arcade, playing games? That concept, the framework was the same, was it?

NINAGAWA Yes, that's the same.

BILLINGTON What are the details of design and music. Are they very similar in both versions?

NINAGAWA Both different . . . In the international production he goes into the television screen. We changed it to that because this Peer was watching it and then broke the machine and tried to look through, inside.

BILLINGTON But in both productions you had a young Peer Gynt?

NINAGAWA The Japanese Peer was a rock singer. Maybe it's a difference in the actors' training or a difference of talent, but they were not the same. This British Peer was a poet and lonely, a liar and attractive.

BILLINGTON Can I ask about other areas of your work, about your work in Japan? How many productions a year in Japan do you personally direct?

NINAGAWA Usually about three productions a year . . . but this year it happens to be a bit more and when I go home now I have a revival of my own old production and also new productions that include *A Midsummer Night's Dream* and *Waiting for Godot*.

BILLINGTON Have you worked out a framework or a concept for *A Midsummer Night's Dream?*

NINAGAWA It's a Japanese stone garden, that's the setting. I'm thinking about asking an actor from the Peking Opera to play Puck. From Taiwan, not actually from Peking, but from that kind of opera

BILLINGTON And *Waiting for Godot*, have you worked it out in detail? Is that more straightforward?

NINAGAWA I'm using two pairs of Godots, men and women. One pair of men, one pair of women.

BILLINGTON Why women?

NINAGAWA In order to make it clear that the theatre can be made totally different by actors. I'm going to use actors, old actors that I used to work with in the sixties.

BILLINGTON Do you think that Beckett would have approved of women playing in *Waiting for Godot?*

NINAGAWA Maybe not.

BILLINGTON You often work with a particular producer, Tadao Nakane. Is each production that you do with him a commercial venture that has to make its money back?

NINAGAWA Yes. But I'm using a venue of 150 seats for *A Midsummer Night's Dream.* So of course it's going to be in the red, so the producer has to make money somewhere else. When I came to Britain with *The Tempest,* I saw in The Pit a production with Judi Dench directed by Peter Hall using very good actors in a very small venue. I thought, I must do that too, so I'm using very good actors in a very small venue and I feel sorry for the producer, but we have to do things like that.

BILLINGTON Do you have a regular company of actors, or do you recast each production totally fresh?

NINAGAWA I have a small company of young actors only and that's one of my companies. For other, more normal productions, I collect different actors each time.

BILLINGTON On my only visit to Japan I was very surprised that the idea of state subsidy of theatre was almost non-existent. Has that changed in any way or not?

NINAGAWA Not really changed.

BILLINGTON Why is that? Why is there no acceptance of the principle of subsidy?

NINAGAWA I think that the biggest reason is that in the process of creating a modern theatre in Japan they were always criticising the government; they were always on the other side from the government, so if you get money from the government you feel like you're bought out. And that was the fear theatre people had in the tradition of development so maybe that's the reason ...

BILLINGTON To be clear on that you mean theatre people were worried that subsidy would carry political strings. Is that what you're saying?

NINAGAWA In reality I don't think there would be such a problem but only in the last thirty years has that kind of fear withered down.

BILLINGTON Who mainly goes to the theatre, particularly in Tokyo? Do young people go to the theatre a good deal or not?

NINAGAWA There are different kinds ... One kind of audience is for small theatres with young actors. That audience is usually very

young girls, up to twenty-two or twenty-three years old, and the other one is normal commercial theatres which is 90 per cent women and housewives. And then another one is a more comprehensive kind of theatre with all different elements in it, from every section of society, and I'm part of that.

BILLINGTON Why do Japanese men not go to theatre as much as Japanese women?

NINAGAWA Japanese men have to work very hard to catch up with Europe. So they get more income but they forget how to enjoy culture.

BILLINGTON I wonder if the big Western blockbuster musicals like *Les Misérables* and *Cats* have made a big impact on Japan? Do they play in Japan?

NINAGAWA Yes they are very popular. It's like a fashion and then draws a big audience but I'm saying that the musical is not the only style of theatre.

BILLINGTON Do you feel you personally have a mission to preserve classical theatre against all these great big musicals?

NINAGAWA Yes, I think so and you really have to get the space in society for that kind of theatre, the sort of thing that I like, not musicals but more proper theatre and in order to do that I am doing more productions this year.

BILLINGTON More productions to fight against the attractions of the big musicals?

NINAGAWA Yes, and doing them in big venues as well to give the style of theatre a very strong impact. This is my last battle, I keep saying.

BILLINGTON That's a great battle, it's a great and important battle. Can I just ask finally: you obviously have a great love of Western classics, Shakespeare, Ibsen, Chekhov, the Greeks – where did this love start for Western theatrical classics? Does it go back to your childhood or your student days or reading or from seeing the plays or what? How did it start?

NINAGAWA I liked reading since childhood because there is not a very good text in Japanese theatre that moved me deeply. The Japanese theatre was led by actors, not by texts, and so when I started to read European theatre, that was just like reading literature. There were many things that moved me and I studied on my own so I just read and read whatever I got hold of. I read and found many good plays which now I am directing.

LLUÍS PASQUAL

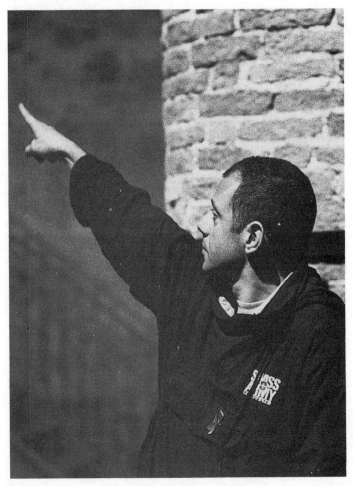

Photograph: Ros Ribas

ONCE referred to by Giorgio Strehler as 'one of my theatrical grandchildren' (*ABC*, 12 December 1986, p. 87), the Catalan director Lluís Pasqual is undoubtedly the most successful Spanish director this century. From his roots in the independent Spanish theatre movement he has gone on to direct at the major theatres of Europe where his innovative, beautifully realised productions have frequently played with the traditional performance space, creating spectacles of magical intensity.

Born in Reus, Tarragona on 5 June 1951, into a working-class Republican family, as a child Pasqual was taken to see a range of *zarzuelas* (popular operettas), *sainetes* (comic musical dramas) and melodramas. At sixteen he became involved with the independent theatre group, La Tartana, where he took an assortment of secondary roles before directing Arnold Wesker's *Les Arrels (Roots)* (1968) and Salvador Espriu's *Antígona (Antigone)* (1969). In 1969, he entered Barcelona's Autónoma University were he specialised in Catalan philology. Whilst at University he also studied at the Estudis Nous de Teatre (where he met the founder of Els Joglars, Albert Boadella), and became involved in the Grup d'Estudis Teatrals d'Horta, then directed by Josep Montanyès, where he developed his acting and technical skills. During the early seventies he taught at the Institut del Teatre, where he co-directed *Duplòpia* (1974) with Iago Pericot and Pere Planella (an Artaud and Grotowsky-inspired treatment of Adrià Gual's *Misteri de dolor)*, and at the Escola de Teatre de l'Orfeo de Sants. It was here that he directed his first major production, *La setmana tràgica (The Tragic Week)* (1975), a Mnouchkine-influenced dramatisation of the failed revolt of 1909, devised from improvisational work with the students and developed in collaboration with the dramaturg Guillem-Jordi Graells and the Polish trained designer Fabià Puigserver, two collaborators with whom he subsequently worked regularly. With Puigserver and Planella he co-founded the Teatre Lliure Collective in 1976 in a building renovated for the meagre sum of nine million pesetas (£45,000). Their inaugural production, written and directed by Pasqual and designed by Puigserver, *Camí de nit 1854 (Path of Night, 1854)*, followed the documentary drama vein of *La setmana tràgica* in its chronicling of Josep Barceto and the working-class struggles of the Bienic Progresista. Pasqual left Spain temporarily between 1976 and 1978 to work first at the National Theatre of

Warsaw, where he assisted Adam Hanuszkiemiez on Chekhov's *Platanov* (1976), and then at the Piccolo Theatre Milan where he was Strehler's assistant (1978), returning to produce what is generally regarded as the finest work at the Lliure. In the years following 1978, although the Lliure demonstrated a responsibility towards the staging of Catalan drama, it became primarily known for its elegantly staged productions of European classics. In its flexible auditorium (designed by Puigserver), the permanent company presented a series of highly acclaimed mainly Catalan-language productions created by the Pasqual-Puigserver team, including Chekhov's *Les tres germanes (The Three Sisters)* (1979), Shakespeare's *Al vostre gust (As You Like It)* (1983), and Goldoni's *Un dels últims vespres de Carnaval (One of the Last Afternoons of the Carnival)* (1985). The success generated by these productions brought invitations to work with other companies. In 1981 he directed both *Medea* for the Compañia Núria Espert at Barcelona's Teatre Grec and Calderón's *La hija del aire (The Daughter of the Air)* for Madrid's Centro Dramático Nacional at the Teatro María Guerrero. In 1983 he was named artistic director of the Centro Dramático Nacional where he remained until 1989. Here he encouraged international collaborations, fostered co-productions and opened a second performance space. His adventurous emotionally charged productions – again all designed by Puigserver – toured extensively generating intense international praise. *La vida del Rey Eduardo II de Inglaterra (The Life of Edward II of England)* (1983), the first of his collaborations with the Argentinian actor Alfredo Alcón, played at Avignon in 1984. *Luces de Bohemia (Bohemian Lights)* (1984), a co-production with Strehler's Théâtre de l'Europe, premiered in Paris, displayed a visible relish for the staging possibilities offered by Valle-Inclán's radical urban tragicomedy. As with his later productions of Lorca's 'impossible' plays, *El público (The Public)* (1986) – a co-production with the Théâtre de l'Europe and the Piccolo Teatro di Milano – and *Comedia sin título (Play without a Title)* (1989), Pasqual's staging provided a dramatic and defiantly clear rendition of a play which defied a simple linear logic. In 1989, Pasqual became the first Spanish director to direct at the Comedie Française where he staged Shakespeare's *Comme il vous plaira (As You Like It)*. In 1990 he succeeded Strehler at the Théâtre de l'Europe. Since his appointment, he has attempted to pursue the idea of a 'European' theatre, staging Romanian, Hispanic, Russian and British seasons, as well as bringing to the Odéon the work of major European directors (Klaus Michael Grüber, Strehler, Stephane Braunschweig, Patrice Chéreau, Deborah Warner) and dramatists (Botho Strauss, Frank McGuinness, Bernard-Marie Koltès, Alexander Galin). In addition,

he has undertaken a major structural re-organisation of the Odéon – which had previously been shared between the Comédie Française and the Théâtre de l'Europe – which has now become a major producing venue. In 1994 he became the first foreign director to work at the Maly Dramatic Theatre of St Petersburg where he directed Koltès's *Roberto Zucco* (1993), which he had previously staged in Catalan with the Lliure at the Palau de l'Agricultura (the site of the new Lliure building) in 1993. Both productions were designed by Frederic Amat, who collaborated with Puigserver on the design for *El público* and created the magnificent merry-go-round set for Pasqual's adaptation of Valle-Inclán's *Tirano Banderas (The Tyrant Banderas)* (1992).

Pasqual made his operatic debut in 1982 with Camille Saint-Saëns' *Samson et Dalila* at Madrid's Teatro de la Zarzuela. Since then he has worked repeatedly at the Teatro de la Zarzuela where he has staged *Falstaff* (1983), *Don Carlo* (1985), *Il Trittico* (1987) and *Il Turco in Italia* (1990), as well as at other major opera houses including the Opéra de Paris, where he staged Italo Calvino and Luciano Berio's *La vera storia* (1985), the Théâtre de Châtelet, where he staged *L'Enlèvement au Sérail* (1992), and the Salzburg Festival, where he directed *La Traviata* (1995).

Pasqual is the recipient of numerous awards including the Chevalier des Arts et des Lettres de la République Française (1984), the Promu Officier des Arts et Lettres par la République Française (1991), and the National Theatre Prize (Spanish Ministry of Culture, 1991). Pasqual is the current director of the theatre section of the Venice Biennale, and a member of the three-person programming team at Madrid's Centro Dramático Nacional.

OTHER MAJOR PRODUCTIONS INCLUDE

Un barret de palla d'Itàlia (The Italian Straw Hat) by Eugène Labiche. Teatre Fortuny, Reus, 1969.

Leonci i Lena by Georg Büchner. Teatre Lliure, Barcelona, 1977.

La vida del Rei Eduard II d'Anglaterra (The Life of King Edward II of England) by Christopher Marlowe and Bertolt Brecht. Teatre Lliure, Barcelona, 1978.

Una altra Fedra, si us plau (Another Phaedra, If You Please) by Salvador Espriu. Compañia Núria Espert at the Teatre Municipal, Girona, 1978.

El balcó (The Balcony) by Jean Genet. Teatre Lliure, Barcelona, 1980.

Primera història d'Esther (The Story of Esther) by Salvador Espriu. Societat Cooperativa Teatre Lliure and the Centre Dramàtic de la Generalitat de Catalunya, at the Teatre Municipal, Girona, 1982.

Duet per a un sol, violí (Duet for One) by Tom Kompinsky. Companyia Rosa Maria Sardà at the Teatre Poliorama, Barcelona, 1982.

Madre Coraje y sus hijos (Mother Courage and Her Children) by Bertolt Brecht.

Centro Dramático Nacional at the Teatro María Guerrero, Madrid, 1986.

Lorenzaccio, Lorenzaccio by Alfred de Musset. Teatre Lliure, Barcelona, 1987.

Julio César (Julius Caesar) by William Shakespeare. Centro Dramático Nacional at the Teatro María Guerrero, Madrid, 1988.

Los caminos de Federico (The Steps of Federico) adapted by Lluís Pasqual from the works of Federico García Lorca. Centro Dramático Nacional at the Teatro María Guerrero, Madrid, 1988. A co-production with the the Teatro General San Martín, Buenos Aires.

Le Balcon (The Balcony) by Jean Genet. Odéon Théâtre de l'Europe, Paris, 1991

Le Chevalier d'Olmedo (The Knight of Olmedo) by Lope de Vega. Avignon Festival and Odéon Théâtre de l'Europe, Paris, 1992.

Falstaff by Giuseppe Verdi. The Netherlands Opera, Amsterdam, 1994.

Le Livre de Spencer (Spencer's Book) by Christopher Marlowe and Bertolt Brecht, adapted by Lluís Pasqual and Zéno Bianu. Odéon Théâtre de l'Europe, Paris, 1994.

CRITICS ON HIS WORK

To say that Pasqual's production is definitive is, perhaps, to overstate the case, for *El público* is a play that lends itself to highly imaginative productions which may be very different from each other. In its use of space, movement, lighting, and language, however, it remains a production that in its realisation of the potential of Lorca's play will be, for a long time to come, difficult to better.

(Gwynne Edwards and Maria Delgado, 'From Madrid to Stratford East: *The Public* in Performance', *Estreno*, 16, No. 2, Autumn 1990, p. 14).

Even without intending to, the Maly Theatre continues to produce some of the most exciting theatre in the city. The latest addition to its repertory is *Roberto Zucco* . . . The play is a shot across the gargantuan bow of a theatre obsessed with decorative productions of the classics. Pasqual's most impressive achievement has been to rein in the normally indulgent tendencies of the actors, coercing them into streamlined performances of brittle power.

(John O'Mahony, 'A Chill Wind from the West', *Independent*, 15 February 1995, p. 26).

SIGNIFICANT BIBLIOGRAPHICAL MATERIAL

Cabal, Fermin and Alonso de Santos, José Luís. *Teatro español de los 80*. Madrid: Editorial Fundamentos, 1985.

Delgado, Maria M., ed. *Contemporary Theatre Review. Spanish Theatre 1920–95: Strategies in Protest and Imagination* (forthcoming, 1996).

Graells, Guillem-Jordi. 'Lluís Pasqual: La formación de un estilo'. *Primer Acto*, 238, March-April 1991, pp. 114–19.

Miquel Martí i Pol, Emili Teixidor, Lluís Pasqual, Fabià Puigserver, and Francesc Burguet i Ardiaca. *Teatre Lluire, 1976–1987*. Barcelona: Institut del Teatre, 1987.

Ytak. *Lluís Pasqual: Camí de teatre*. Barcelona: Alter Pirene, 1993.

Zatlin, Phyllis. *Cross-Cultural Approaches to Theatre: The Spanish-French Connection*. Metuchen and London: The Scarecrow Press, 1994.

Lluís Pasqual in conversation with Maria M. Delgado and Paul Taylor at the Royal Exchange Theatre, Manchester, 25 November 1994, translated by Jill Pythian

TAYLOR Lluís, you are currently artistic director of the Odéon Théâtre de l'Europe, where you succeeded Giorgio Strehler in March 1990, and your productions have been seen all over the world, except Britain, where the only example of your work to date has been a workshop of Valle-Inclán's *Bohemian Lights* which you gave at the ICA in March 1992. I saw my first Pasqual production, *Le Livre de Spencer*, just a few weeks ago in Paris. A fascinating exercise in cultural exchange, it offered itself as a bilingual edition performed in quick succession by a French cast and then by one in English of Marlowe's *Edward II* as adapted by Brecht and further reworked by Pasqual into an arresting fifty-minute montage of memories. The stalls at the beautiful neo-classical Odéon were gutted and the audience sat around a central oval arena of earth which served as both the sewer prison where Edward passes the final hours of his life and as a site where the flashbacks were played out in a dream-laden drama of great physicality and emotional intensity. It's not often you get to see a German's adaptation of an Englishman's text staged by a Catalan director in both French and English. If that's not internationalism, I don't know what is. But then internationalism, and what has been termed a 'European mission', are precisely what the Odéon, one of France's national theatres, has been funded to pursue. Given that an English equivalent of this is virtually inconceivable – our government's more likely to set up a Michael Portillo award for the deterrents of theatrical internationalism – could you explain to us the philosophy and function of the Theatre of Europe?

PASQUAL Le Théâtre de l'Europe was created exactly ten years ago as a symbolic gesture, with the idea that a theatre should exist where the audience can see performances in a foreign language. But its intention was to avoid being a festival, a purely specialised thing, where the audience is usually also specialised. Instead, there would be a programme of productions that come from other countries. This happened in two stages. The French Ministry of Culture provided a national theatre where this could take place, for only four months of the year. That theatre was dependent on La Comédie Française. When they called me, it was to make the Odéon independent from La Comédie Française, and to make it into a production theatre where plays would be produced, either in French or in

other languages. It is very hard to define the Théâtre de l'Europe, because it was created at a time when there was a lot of excitement about the idea of Europe, an idea that is slowly collapsing, more and more every day.

I would say that it's a place that goes beyond language. It's a question of presenting a country's way of acting, the way its actors perform. A little like the quintessential nature of that country. It wouldn't be like a cologne, it would be a perfume, concentrated. It's not a question of finding a common European language – which I don't believe exists, and if it does exist, it's only visible when you are far from Europe – but instead of seeing that kind of mosaic of different cultures that Europe really is. France is the only country that has a state-funded national theatre devoted to the task of foreign language theatre, all year round. Last season, I did seventy-two days of Russian-language theatre, and if a city doesn't have big audiences, you can't do that. And if the audience isn't involved I'm not interested.

TAYLOR What is it about the French, who we tend to think of over here as a rather chauvinistic people, that moves them to fund this extraordinary exercise? It seems the reverse of chauvinism.

PASQUAL Because the French, who invented chauvinism, also wrote down human rights. They don't work, but they are written down anyway. France as a country is divided between two very distinct poles: absolute chauvinism and enormous generosity. As it is traditionally a very rich and curious country, they adapt anything that they don't have. To explain it very simply, it's very hard for them to call me Pasqual, so they call me Pascal, just as they called Picasso Picassó.

TAYLOR If the acting style of the country tells us something about the country, what did you learn about England while working in English with English actors?

PASQUAL English actors are fantastic, but because the English audience is fantastic. I think England is a nation with such a special upbringing that all their demons are let loose on stage. And the audience also recognises itself in those demons. Artaud invented the Theatre of Cruelty, but Artaud was a lamb compared to Shakespeare. There's something generous, open, relaxed about English actors that I also find in the audiences. There's an unspoken exchange, something that exists before the beginning. There's a faith. That doesn't mean it can't become mannered or mechanised, but at its roots it's very good. When you see theatre in Stockholm, you think 'how they must suffer'. When I see

theatre in England, I think 'how much money they must save on psychiatry'.

Then, there's Shakespeare, who is the basis for all theatre; he's the Bible. There's a Shakespearian training. When you perform Shakespeare well, it's like singing Bellini well; you can sing anything. In Paris, people go to the theatre a lot, but it's like going to a cultural activity. I get the impression that it's like the continuation of a badly done exam. I don't notice the word 'culture' when I go to a theatre in England. I notice the word 'theatre', but not the word 'culture', which is something that annoys me in the theatre.

TAYLOR You once said that 'If when I read a play I know how to do it, then I would not do it'. How is it then that you have been drawn to certain plays, like *Edward II* which you have done four times, or *As You Like It* which you have done twice? Is it because the previous attempts have been failures in your terms?

PASQUAL I don't know. I haven't done that many repeats. I've repeated three plays, and each time for a different reason. I repeated Genet's *Le Balcon* because I promised Genet that I would stage it in French; and *As You Like It* because they asked me in La Comédie Française, since they'd seen it in Barcelona. I was wrong to do it. In Barcelona, something came out of it, good or bad, but at least something, and at La Comédie Française it came out like a piece of shit. I've repeated *Edward II* because it's like an obsession. You find five or six works in your life that grab you by the throat, and *Edward II* is one of them. It grows in me over time. It goes with me. It's nearly always out of the desire to work with one or two actors. In Barcelona, it was to work with a Catalan actor, Josep Maria Flotats; in Madrid to work with Antonio Banderas, to whom I had given his first ever role; and in Paris to work with Linus Roache, Michael Sheen and William Armstrong.

TAYLOR Are you also drawn to *Edward II* because it's about eternal warring principles?

PASQUAL To explain it, I'd have to begin by saying that I'm a Gemini and that has a big impact on my life. Those two principles between Edward and Mortimer – the rational being and the totally impulsive being – also struggle inside me: I can't get them to agree with each other. I think they're both right, but they're two truths that can't be united or reconciled.

TAYLOR With Edward there are two sides too. The visionary and the fascist.

PASQUAL Edward's the magnificent, dreaming, individualist poet, and the fascist. In Mortimer, there is the working man, the historical

man, the politician, the man that builds, but there is also the man of boundless ambition. It's like a prism with many sides. Each one doubles, and doubles, and doubles.

TAYLOR *Le Livre de Spencer* is the first production in a season of English work at the Odéon, which includes the first production in Paris for forty years of *Love's Labour's Lost*, and a number of works by English writers: Edward Bond, Howard Barker and Gregory Motten – interestingly not writers the English have taken to their own hearts. What was your criteria of choice, in terms of trying to reflect this culture?

PASQUAL Directing a theatre is like going to the market if you're a housewife. It depends on what you think you're going to buy at the market. One thing that can happen is that you see something at the market and you think about buying it. Another factor is what your children or husband likes. I've only got nine months and one theatre. I can't give a complete panorama of English theatre, but I can choose a few things, some contemporary texts that are very popular in France, by writers such as Motten who I know isn't performed much in England, but they like him in France. I think they won't understand any of it (and Motten thinks the same thing) because he's a writer that writes with a very particular sense of humour, and the French have a very different sense of humour – just the opposite. But every country takes what they can from his works. Edward Bond is also represented. The great revelation at the Avignon Festival last year was Edward Bond's *War Plays*. I've programmed a production of Shakespeare's *Love's Labour's Lost*, a little-performed Shakespeare play, and then I'm doing *Hamlet*. Not having *Hamlet* in the repertoire is like going to Moscow and not having caviar: inconceivable.

TAYLOR Given the nature of the theatre you run, you must come across works of dramatic art which are good but specifically conceptive of a particular society. Do you feel any of them cannot be translated from one culture to another without the exercise becoming invalid in some way?

PASQUAL I think so, but I wouldn't dare to say so outright. It depends on the era, because in one era, something won't say anything to us, and in other times, a work will speak to us. The thing is that in the twentieth century, a load of terrible information is bearing down on us and battering our brains. I don't think Sophocles was thinking about the future when he wrote. However, we can perform his work. But I don't know. I think that after English theatre, Neapolitan theatre is the best in the world. And then you can see it in Milan or in Trieste and it doesn't work. It needs its own audience. I don't know.

DELGADO You are the best known Spanish director this century, but you actually began as a an actor and as a writer. You acted in *La setmana tràgica*, an early collaboration with Fabià Puigserver, and in *Camí de nit* which you also scripted. How and why did you move into directing? Was it a natural transition?

PASQUAL I came to the theatre as everyone does, wanting to be an actor. But I didn't just want to be any actor. I wanted to be Richard Burton at least. Then one day you realise that you're not Richard Burton, and I realised quite soon, and said to myself, 'Let's leave this. Let's do something else.'

I was a voice coach at the Institut de Teatre in Barcelona because I had worked with some voice specialists, and with the American police, who are the best voice specialists in the world. Sants Theatre School's third-year students asked me to do the end of year show with them, and I said yes, I wanted to do it. I was twenty-two or twenty-three then, I don't recall. I thought that no-one had yet told the story I wanted to tell. I wanted to write it down. I did a show that should have lasted three days, and it took a year and a half. From there, I found myself directing, I don't know how. I stopped writing very quickly, on the day I realised other people were better writers than I was. I've written two theatre pieces in my life, and I don't think I will ever write another one.

I kept on directing because I think I'm a good actor for a day, maybe two maximum. But as a daily exercise I can't do it at the level I think it should be done. There must be something perverse in me that makes me feel like a Celestina, or the one that makes the bed so that other people can make love. I have nothing to do with it. I can't even watch, without bringing myself into it. I've never seen one of my own productions. It wouldn't agree with me.

Sometimes I get bored with just directing, and I need to do other things. I enjoy acting, but I don't have that quality that I think actors need. I don't have that intensity, that generosity. There's only one role I've been able to manage: the role of the director. But if I can never do Hamlet like Laurence Olivier did it, then I don't do Hamlet. If I can never do Edward II like Linus Roache did it, then I don't do Edward II.

DELGADO I would like to turn to your work with the Teatre Lliure. You were one of the founder members of this co-operative venture back in 1976. Since then you have moved to the Centro Dramático Nacional at Madrid's María Guerrero where you were appointed artistic director at the age of thirty-two, and then to the Odéon in 1990. You were also the first Spanish director at the Comédie Française this century. Now you have moved on to direct the theatre

section at the Venice Festival, but you keep returning to the Lliure. Only last year, 1993, you directed *Roberto Zucco* there.

PASQUAL I go back to the Lliure like you might go back to your house to eat the cannelloni your mother makes, and that is like nothing else in the world. I go back to the Lliure like someone going home: looking for that taste that is deep-rooted and that you love and that is like none other, something that opens your mind.

I think I'm a kind of pioneer, a rare prototype. I do believe in Europe, in my Europe. I don't know if I believe in a European theatre. I believe in European theatre when I'm in Seoul, but when I'm in Europe, I don't know. But I've worked from Moscow to Seville and I don't feel like a foreigner anywhere. I believe that we can all exchange really positive things, and that's why I do it, because I believe that in the theatre, we can dream, we can travel, we can learn something good about what other people are like, and make it part of ourselves: something that existed in Europe of the fifteenth century, that existed in Europe of the eighteenth century, so why shouldn't it exist in the Europe of the twenty-first century? Mozart suddenly started to write librettos in Italian, with great freedom, because he thought German wasn't good enough to explain the theme of *Don Giovanni*. Well, there are lots of other things like that, and that's why I'm in Paris, that's why I do it.

DELGADO The Teatre Lliure was founded at the beginning of the country's transition from a dictatorship to a democracy. What kind of problems did you experience working at that time? How did it differ from conditions under Franco in the late sixties and early seventies?

PASQUAL The problems under Franco were every kind of problem. It was like a rain of dandruff constantly falling. It was very squalid, because Franco's great aesthetic category was yogurt and Nescafé. I was lucky to live in Barcelona, which was close to the border so I could buy a theatre book or a book by Sartre or a porn magazine. But living under a totalitarian regime like Franco's, and living in a family that was basically Republican but silent, such as my own, gives you a political education that you never forget. Not having a peseta to put on theatre with, having to rehearse for six months for a three-day performance with the police in the theatre, it gives you a civic training you never forget. At that time, there was no public money in Spain, but there was a potential for imagination and complicity with the audience that I've never had again since.

I'm not going to tell anecdotes about censorship, because we'd be here until next month. I've had friends dress up as priests to convince the censor. I've even bought whisky in the port at Barcelona and paid a whore to sit next to the censor at the dress rehearsal of the play.

I've done everything. We made theatre that was probably very bad, objectively. But very bad in the theatre means nothing if the theatre is useful; just as being very good doesn't mean a thing if it's useless. We and the audience were closely united.

It also has to be said that the Franco regime didn't believe it would last long after 1939. That's why they never worried about building up a strong structure. It was a police structure, it wasn't strong. So there were leaks, full of escape routes. When Franco died in 1975, we all wanted to do everything: Shakespeare in the normal way – the word 'normal' defined as what was closest to us, because most theatre works before 1975, at best, were about an imaginary dictator, who was oppressing an imaginary people. Everything was imaginary. We wanted to do *Romeo and Juliet* or *Le Balcon*, like the painters and the singers, singing for singing's sake, rather than singing against something. We were lucky that when Europe was very tired, since Europe had been rebuilt forty years earlier, we still had a lot of things left to invent, and we could copy the good and avoid the bad. Now we're in chaos again, but we had twelve extraordinary years, from 1975 to 1987. I was lucky to produce three Lorca plays that had never been performed before. That doesn't happen to anyone. Where are the plays by Bernard Shaw that were never performed because the Queen didn't want them to be? They don't exist. But I was lucky, and so were many others.

DELGADO You are a director who is irrevocably linked with Lorca. You programmed a season of Lorca while you were artistic director at the Centro Dramático Nacional, and have staged his two 'impossible' plays: *El público* and *Comedia sin título*. What is it that attracts you to these plays?

PASQUAL A coincidence: we were born with years between us but on the same day at the same time. When I tackle a text, generally, my work directing it is very much like that of an actor performing it. I have to picture myself in a physical way, in a psychological way: 'What the hell was this writer thinking at that moment to write this?' 'Who was he angry with?' 'Who was he in love with?' 'Why was he desperate?' I need to know this just as an actor needs to know what's happening to his character, because I believe that's the only way I can do my job. That's the way I approach the writer. I believe I understand Lorca from within. It's very close to what could happen to me, what has happened to me, and what is happening to me. I can't explain it. The ones who can say it are the poets; they're called Lorca, Koltès, Genet or Marlowe, people who are a centimetre closer to the truth than we are. But to serve them, I have to put myself into their state of mind, which might not be the correct one;

I have to make it up, but it's useful to me. That happens to me with Lorca. The works that seem impossible to other people seem logical to me; they have a poetic logic. That's why I do them: to share with people something that I enjoy. That's why I do theatre: to tell stories, and to share what I enjoy with other people.

DELGADO This idea you spoke of earlier, of doing 'normal' productions in the years following 1975, was this the governing aesthetic of the Lliure?

PASQUAL It's similar to what a young English director, Robert Delamere, said to me when he wanted to open a theatre. I asked him 'Why?' and he said, 'to do good plays with good actors.' We wanted to do good plays with good actors; to have a fixed company; to have a workshop to make the costumes; to have a place to perform day after day, and not to have to look for a place every time. This seems so normal now, but in Spain in 1975 it wasn't. Then an aesthetic develops. I'm not the person who can tell you about the Lliure's aesthetic, because I don't know what it is. I just lived it. It was the first Spanish theatre, not in the Italian style, that could be called multipurpose. I mean, where we could put the stage anywhere, wherever we wanted. That seems normal today, but in 1975 it wasn't, not in Spain or in any other part of Europe, except Poland.

Poland is very important in my life. Firstly because one of the people who founded the Lliure was Fabià Puigserver, a great set designer, who was brought up in Poland. Poland is a country where theatre was for a long time the national sport, where actors were the guardians of the language. An actor's manner of speaking could be recognised because they spoke extraordinary Polish, and that was what they learnt on stage. That freedom that I mentioned earlier in connection with the English stage was something I also found in Polish theatre. In 1976 or 1977, when the Lliure had already been founded, I realised that although we were putting all our energies into it, we had no masters, only photos from theatre books and theory. All the masters died during the Civil War, or were exiled. I needed to learn, and I went to Poland because it's a little like the Catalonia of Europe. Polish actors are as good as Russians, they're from the same school, but they believe it less. I think that the Polish people have survived because of their sense of humour, which is the greatest sign of intelligence. And they have a sort of distance in relation to what they do. I learnt that freedom there, and I learnt that the level of theatre wasn't just in front of my face, but further away. Then Fabià, a man with great expressive power, created an aesthetic. Let's say that we shared the work; he looked after things in a plastic way, I looked after the actors.

DELGADO In the interviews you gave in the eighties you talked particularly about the influence of Ariane Mnouchkine and her Théâtre du Soleil on your first productions.

PASQUAL Especially the first one. I saw two productions by Ariane Mnouchkine. I think it was on a weekend in Paris: those crazy weekends where Spaniards used to go there and end up seeing three theatre shows and seven films. You used to come back to Spain full of energy and lugging forty books. Of Ariane's, I saw *1789* and *1793*, the two productions about the French Revolution. It was done so freely, and it was political, not by being ideologically schematic or simplistic in a reductive sense, but was very rich, and this had a great influence on me. Then there were two people who influenced me until I thought I could find my own way, and they were Strehler and Brook. Obviously, each of us is an accumulation of everything we have lived through and all the theatre we have seen, sometimes by assimilation and sometimes by negation; sometimes you react against something. But what I've never tried to do, and what I don't think anyone can do, is 'be original'. That's a stupid term, invented by the nineteenth century, and we just can't get out from under it. Shakespeare never wanted to be original, and look how far he got.

DELGADO It's very interesting that you mention Brook and Strehler.

PASQUAL They're made of the same stuff.

DELGADO But they're so different.

PASQUAL They're so different that they're two sides of the same coin; you can't see it, but they're linked together. They're like one whole. No two productions of *The Tempest* are as different as those of Strehler and Brook. In the circle of life and the universe, they're almost touching, even though they're far apart.

DELGADO What did you learn from Strehler and Brook's productions?

PASQUAL From Strehler, lying, because Italy is a country of lies – and also illusion, because illusion is a lie of artistic quality. I learnt the idea of the illusionist, the magician, of making what doesn't exist appear, done in a majestic, artistic way. From Brook, I learnt simplicity, authenticity, purity, where earth is earth and wood is wood. In Italy, wood is anything, and earth is anything; not for nothing is it a country of set designers. Brook comes from an English tradition on one side, and Russian on the other, which gives him a certain purity. On one point they coincide. Strehler comes from Trieste, and Trieste is the least Italian of all cities. There's something Slavonic that they have in common. They have that depth that the Slavonic people have, that Brook has on one side and Strehler on the other. On this point, they're similar: one in illusion, and pure, deceptive

playfulness, and the other in the search for the truth in a philosophical and metaphysical way.

DELGADO All three of you have been working in Paris: Strehler before you, at the Odéon, and Brook at the Bouffes du Nord.

PASQUAL It must be because Paris is a kind of meeting point. What happens is, Brook works in Paris, but he doesn't produce French theatre. He's done very few shows, such as *La Cérisaie*, with French actors. Brook does theatre that could be in Paris, in Berlin or in New York. Paris is certainly the most comfortable for him because it is a sort of crossroads, where he feels at ease. Not for nothing is the land a very important theme in Brook, because he creates his own world, his own planet. Strehler is much more connected to his homeland, both deep down and on the surface. He has only done two productions in Paris: one many years ago, Goldoni's *La Trilogia della villegiatura* with La Comédie Française, and Corneille's *L'Illusion* during the seven years that he was directing the Théâtre de l'Europe. He's closer to his roots.

TAYLOR I was fascinated to hear that you do not ever see any of your productions, which seems to me to be the opposite extreme of a director like Deborah Warner, who saw her production of *Titus Andronicus* sixty times, fine-tuning it as she went along. How do you ensure that the actors do not hijack a production and drive in a different direction to the one you originally intended?

PASQUAL I listen to it. I don't see it, but I listen to it. I don't see it in the early days, because I never think I'm a 100 per cent right. I think that the work ends with the audience, I really believe that. I'm not just saying it. Once that point has been reached when it is adjusted to the audience, when it breathes with the audience, then I can listen to it, and I know a lot more if I listen to it than if I see it. To me, one of the many things that a work represents is that learning process; like a passage in *The Divine Comedy*, when Dante goes hand in hand with Virgil; going hand in hand with Mozart, or hand in hand with Genet, or hand in hand with Lorca. It's wonderful to spend two months with them. It's like a learning process, and afterwards it's not important. I produce theatre for the public to see, so that people will fill the theatre. I'm not the public, and I feel guilty. I can rehearse for months if actors ask me to. I can re-rehearse, but to sit down and watch, I prefer to stage another work.

There was something I was saying earlier about English theatre, that I said I would explain if we had time. You all have one thing, which is a language that has vocal form, and that's very important in the theatre. In *Le Livre de Spencer*, when the queen arrives at the camp, the king says in Spanish 'No te doy la bienvenida'; in Catalan 'No et

dono la bienvenguda'; in French 'Tu n'est pas bienvenue'; in English 'Not welcome, madame'. With that, he's already given her a slap in the face. It's not the same. Where French theatre is concerned, they're not the same. Classical French theatre invented the alexandrine. In twelve syllables, you can say everything, but structured and well measured. Corneille, Racine, at the tick of a metronome. English verse is the most open verse there is. Oddly, the other great theatre of that era, Golden Age Spanish theatre, does not have a single metre for its theatre. It doesn't have a single verse form. There are different types of verse, depending on the subject matter of the scene. This is just a reproduction of its origins. In Spanish theatre, Christian, Jewish and Arab poetry combine and produce different forms that Spanish theatre then uses. In English theatre, feeling is born in the body, rises, and at that moment the brain sends the information to the mouth, and it comes out. In French theatre, feeling is born in the body, then goes to the brain, and is dictated to the mouth. It's just the opposite. It's another language structure. That's the difference between the French language and the English language.

AUDIENCE QUESTION 1 After working with Spanish actors like Josep Maria Flotats and Núria Espert, what's it like working with French actors?

PASQUAL I'm very old, and I started out a long time ago. I always try to work with the best, like everyone does. French actors have been the ones I've found it most difficult to get along with, because of what we call those poles that the French have; they distrust their intuition, which is one of an actor's founts of knowledge. If something could be said to define a French actor at the point of starting work, it's that he's a shameful actor. So it was very difficult for me because I'm the exact opposite. I believe that in a rehearsal room, you can do anything. I need to get out there and fight. To me, a rehearsal is a life and death situation, like a bullfight. And the intellectual retention of French actors has been the hardest thing for me to understand. Of course, it's wrong to talk about French or English actors as if they are all the same, but they have certain characteristics in common.

AUDIENCE QUESTION 2 I understand the sexual atmosphere of Paris, but does an artist not get their energy from the soil and society they come from? Does a foreigner not feel like a fish out of water? Maybe a well-fed fish but a fish nevertheless working in Paris?

PASQUAL No, though I don't know. What happens to me is what happens to anyone outside of their own country, even though they're integrated into another culture. I'm more Spanish in Paris than I am in Spain. There's no such thing as international theatre;

there are crazy people like me, but that's something else. I try to use what I carry in my backpack, and exchange it with other people. Sometimes that enriches me, and at other times it makes me poorer. Peter Brook is very English in Paris.

AUDIENCE QUESTION 2 (cont.) It's always seemed to me that part of France's genius is that it's backed individuals – one thinks of Peter Brook, Samuel Beckett, Pablo Picasso, Ernest Hemingway. But the Odéon seems to be in contradiction to that because it institutionalises Europe. It's much more according to the British model – Britain loves institutions and hates individuals.

PASQUAL In France, they like individuals and institutions. You know better than I do what happened to the theatre during the Thatcher era. Not only the small companies suffered, but great institutions suffered too. I finished my first three-year period of mandate at the Odéon when the government changed. I insulted the Minister of Culture in the newspapers. I called him every name I could think of. Of course, I can't expect my funding to increase, but they didn't reduce it. They have a great respect for institutions. My position in Paris is more difficult, because I have to say to them: 'Hello, I'm just like you. I'm a foreigner, but I'm just like you.' There are two ways of being accepted in Paris: either as a political refugee, or as an exotic. I'm neither a political refugee nor an exotic. I'm like they are, and that's more difficult, though not impossible.

DELGADO What's the attraction of programming the theatre section of the Venice Biennale?

PASQUAL The attraction of Venice is Venice. It's the city with the most lies and the most truth, the most theatrical city in the world. Venice is the largest cemetery in the world. Although it doesn't seem that way, I would link it strongly to the idea of the Odéon. I took on Venice, and I took it on because I said to myself: 'We don't have a second theatre, but we can have a second city.' That allows me to do other kinds of activity that I can't do at the Odéon. Venice could be called a 'thematic festival'. It's a series of productions that don't fit any of the usual criteria of festivals, but instead more personal themes that touch me in particular. The logic of festivals is an absurd logic. The festival's theme is set around a triangle, the three most obvious things that Venice represents to people: travel, love and death.

DELGADO During these past ten years you've worked more and more in opera. What attracts you to it?

PASQUAL It's different now to when I began. Opera is an irrational passion for me. I love it. But I'm aware that I enjoy producing opera

less and less. I came to the opera at a point where even the stage director was an important new development. Opera was trying to shake the dust from itself, and renew its audience. Together with the record industry, it was completely renewed. It lost part of its bourgeois audience, and renewed the rest. This called for a new aesthetic, and beginning with people like Visconti, followed by people like Strehler or Chéreau, opera became something else: a place where it was possible to have an aesthetic discourse to accompany the music. Now there are less and less possibilities. The new audience for opera has been becoming more bourgeois in a certain way, and opera is already not what it was twenty years ago. The compact disc has created a great musical unreality. However, I have always held that opera is like a kind of aesthetic deviation. I like opera in the same way that I like a seventeenth-century bureau or a nineteenth-century chest of drawers, as a fine antique. Going to the opera is like going to an antique shop; I can go crazy over a piece of furniture in the shop, but it's not like going to a contemporary art gallery, it's different. That is opera for me. Personally, it's being able to be in contact with dramatisable and dramatised music for twenty-four hours a day, for a month and a half of rehearsals, and that's fantastic.

DELGADO You've talked to me recently of leaving the theatre and devoting yourself to the cinema. Is it because you think you've done everything possible in the theatre, or is it because you're tired of the theatre and want something different?

PASQUAL I think there are things that I can't do in the theatre, although it seems that the theatre can tell any story. That's not true. There's a point where you can't go on explaining everything through metaphor. Realism in the theatre bores me. In the theatre, I demand of myself and others the capacity for metaphor, for the poetry I was telling you about: the capacity for a door to be many things, a door being the least of them. There's a point where I need a door to be a door, and that bores me in the theatre, but in the cinema it doesn't.

Then, to explain human feelings, there are times when you want to bring the actor right up close to the audience, putting a kind of submarine periscope in the actor's mouth, to get deep into his guts. That can't be done in the theatre, and that sort of thing rarely happens. Cinema does allow for that.

AUDIENCE QUESTION 3 You talked earlier about 'useful theatre'. What do you mean by that?

PASQUAL When I was talking about the theatre we did under Franco, I meant that it was useful to us. Theatre is one of the most useless things that exists. I think that at that time, it had very few reasons left

to exist. But theatres are like centres of energy where you go to be able to feed your spirit. In the childish game for adults that is theatre created by poets, we come a little nearer to everyday truth. I think that's why it's useful; I ask nothing more from it. Producing theatre today in Sarajevo is not the same as it is in London. The purpose is different; a purpose that can hardly be seen. I think that in one moment when we are deceived by technology, when it makes us see that if we go to New York on Concorde we earn three more hours of life, it makes us perceive a different rhythm of reality. The theatre is the only place where space and time can be crossed, and Shakespeare is an example of that. The actors and the audience have the same internal metronome as a collective. Although its only use is to recognise ourselves collectively, it is still very useful.

PETER SELLARS

\diamond

Photograph: Marc Enguerand

ONCE decribed by Edward Said as 'deft, creative ... an extraordinarily gifted man' (*The Nation*, 18 September 1989, p. 291), Peter Sellars, the 'enfant terrible' of the contemporary American theatre, has through radical stylish reworkings of classical plays and operas sought to redefine the function and tradition of theatre in contemporary society. Over the past twenty years, reacting against what he regards as the commodification of theatre, he has prominently sought to re-establish its role as an arena for political discussion and debate. Both in the major subsidised theatres of Europe and North America and in the work co-ordinated for the Los Angeles Festival (of which he was appointed director in 1987), he has provided provocative, dissonant, and often controversial productions which have been heralded as sophisticated studies of contemporary alienation and simultaneously denounced as frivolous and indulgent experiments in empty aestheticism.

Born in Pittsburgh, Pennsylvania, on 27 September 1957, Sellars's interest in theatre was awakened through puppetry, serving an apprenticeship with Pittsburg's Lovelace Marionettes between 1967 and 1971. Whilst at the Phillips Academy (1971–5) and later at Harvard (1976–80) he directed over sixty productions. His prodigious talent was quickly recognised by Robert Brustein who took him to the American Repertory Theater in Boston where he staged a much admired production of *The Government Inspector* in 1981. While artistic director of the Boston Shakespeare Company (1983–4), he collaborated with Elizabeth LeCompte of the Wooster Group on a multitextual version of Flaubert's *La Tentation de Saint Antoine*, finally produced in 1986. Appointed artistic director of the American National Theater at Washington's Kennedy Center in 1985, he staged an impassioned *Count of Monte Cristo* (1985), and proved a willing innovator. But after only two seasons his radical ideas met with increasing hostility and he left after an evocative and violent *Ajax* (1986) set in the Pentagon with a deaf-mute, the extraordinary Howie Seago, in the title role.

Sellars has continued his political studies of classical texts in his freelance work during the nineties. Aeschylus's *The Persians* (1993) was adapted by Robert Auletta – a collaborator on *Ajax* – into a stark and savage comment on American militarism in the Gulf War. Javanese dance, sign language and microphones were all employed to provide a multilayered discussion of the suffering and desolation

of war. In 1994 his liberating historicist rendition of *The Merchant of Venice* for the Chicago Goodman Theater, with a black Shylock, a Chinese-American Portia and a Latino Antonio and Bassanio, offered a bleak vision of the play as a chronicle of the moral crises of a society where market values are all pervasive: the rise of capitalism witnessing the demise of certain key virtues. Rather than iron out the play's contradictions and inconsistancies, Sellars's setting of the play, in a high-tech world of video monitors and microphones where all citizens are subject to society's watchful regulation and oppressive observation, provided a dark interrogation of the ambiguous but dangerous nature of power and obsession. As with his earlier productions of *Ajax* and *The Persians*, Sellars demonstrated a veritable ability for highlighting the cruellest aspects of the works in question, emphasising their conflictive or transgressive facets.

It is perhaps in opera, however, that Sellars has enjoyed his most resonant success, redefining operatic acting in his quest to expand the parameters of an art form which he views as ripe for innovation. Perhaps best known are his notorious relocations of the Mozart/da Ponte trilogy, with *Don Giovanni* (1980 and 1987), *Così fan tutte* (1986) and *Le Nozze di Figaro* (1988) set respectively in Spanish Harlem, a seaside diner and Trump Tower. His deliciously baroque production of Handel's *Giulio Cesare* (1985) set at the poolside of the Cairo Hilton, however, is regarded by many as his finest work in opera to date. More recently he provided a controversial *Die Zauberflöte* (1990) for the Glyndebourne Festival which was denounced by the Festival's director, and an updated and Americanised production of *Pelléas et Mélisande* (1993) for the Netherlands Opera. Not that he has worked exclusively within classical opera. He has enjoyed a fruitful collaboration with the American composer John Adams, having staged an elegant production of *Nixon in China* (1987), and the politically sensitive *The Death of Klinghoffer* (1991) about the killing in 1985 of a Jewish American by Arab terrorists. *I Was Looking at the Ceiling and then I Saw the Sky* (1995), his most recent project with Adams, does not bring together the same team that worked on the previous two works – poet June Jordan replaces Alice Goodman as librettist and Mark Morris is no longer responsible for choreography – but it shares a similar preoccupation with the dynamics and ideology of contemporary America.

However idiosyncratic his modern operatic visions may appear, they could never be described as trivial. On the contrary, the technical virtuosity of his productions, the intense but fresh performances he solicits from his singers, and his careful reading of the

texts, appeal both to aficionados and to those who would not habitually populate the bastions of high culture. Sellars's deconstructionist readings offer both a rediscovery of theatricality in its most playful sense and an informed and engaging commentary on the artifact's relevance to a contemporary audience.

Sellars's many awards include an Emmy received for *Nixon in China* in 1988, the Boston Eliot Norton Award and the Berlin Werkstatt Prize. As well as working as a guest director at many of the major European festivals, he has taught at UCLA and Georgetown University, and given guest lectures at the Universities of Harvard, Yale, Columbia and New York. He has also worked as an assistant to Jean-Luc Godard on his film *King Lear* (1987) and made music videos for such performers as Herbie Hancock.

OTHER MAJOR PRODUCTIONS INCLUDE

Orlando by George Frederic Handel. American Repertory Theater, Cambridge, Massachusetts, 1981.
Pericles by William Shakespeare. Boston Shakespeare Company, 1983.
The Mikado by Gilbert and Sullivan. Chicago Lyric Opera, 1983.
The Seagull by Anton Chekhov. American National Theater, Washington, 1985.
The Last Summer by Nigel Osborne. Glyndebourne Festival, England, 1987.
The Nose by Dimitri Shostakovich and Nikolai Gogol. The Netherlands Opera, 1988.
Saint François d'Asissi by Oliver Messaien. Salzburg Festival, 1992.
The Seven Deadly Sins by Kurt Weill. Opéra de Lyon, Paris, 1993.
Oedipus Rex by Igor Stravinsky. Salzburg Festival, 1994.
Mathis der Maler by Paul Hindemith. Covent Garden, London, 1995.

CRITICS ON HIS WORK

Opera . . . is where he does his best work – in part because the music keeps his imagination on a tight leash. In straight plays, Sellars does not scruple to cut and paste, to rearrange, to splice in foreign matter, with results that have frequently been condemned as sophomoric. In opera, Sellars accepts the discipline imposed by the score. No matter what antics he cooks up for the singers, he never monkeys with the music. If nothing else, the dramatic pacing of the composer's master plan is always intact.

(Matthew Gurewitsch, 'Best Sellars', *The Connoiseur*, 217, February 1987, p. 32).

What has marked Sellars' work throughout his career is an unceasing effort to use the most topical images to evoke the most contemporary reactions, an effort he pursues whether the underlying art he is directing comes from the classic past or from the present time. For Sellars the goal is always relevance and immediacy; unlike the avant-garde director Robert Wilson who sacrifices clear meaning to an aesthetic preoccupation with hieractic movement and highly subtle lighting, Sellars aims for the audience's jugular, and usually manages to hit it square on.

(Samuel Lipman 'Sellars Trumps Mozart', *New Criterion*, 9, April 1991, p. 38).

SIGNIFICANT BIBLIOGRAPHICAL MATERIAL

Bartow, Arthur. *The Director's Voice: Twenty-One Interviews*. New York: Theatre Communications Group, 1988.

Green, Amy S. *The Revisionist Stage: American Directors Reinvent the Classics*. Cambridge, New York and Melbourne: Cambridge University Press, 1994.

Jenkins, Ron. 'Peter Sellars'. *Theater*, 15, Fall 1984, pp. 46–52.

Letzler Cole, Susan. *Directors in Rehearsal: A Hidden World*. New York and London: Routledge, 1992.

MacDonald, Heather. 'On Peter Sellars'. *Partisan Review*, 58, No. 4, Fall 1991, pp. 707–12.

Flynn, John J. 'Transiting from the "Wethno-centric"' An interview with Peter Sellars, in *Interculturalism and Performance: Writings from PAJ*, Bonnie Marranca and Gautam Dasgupta eds. New York: PAJ Publications, 1991, pp. 184–91.

Trousdell, Richard. 'Peter Sellars Rehearses *Figaro*'. *Drama Review*, 129, Spring 1991, pp. 66–89.

Peter Sellars in conversation with Michael Billington, at the Royal Exchange Theatre, Manchester, 18 November 1994

BILLINGTON I've been glancing through the reviews of Peter Sellars's *Merchant of Venice*, in London this week as part of the 'Everybody's Shakespeare' Festival at the Barbican. I seem to be almost alone in having found it rich, provocative and moving. But Peter Sellars has, in a sense, been through some of this before. His production of *The Persians* by Aeschylus played at the Edinburgh Festival, and again attracted what we call in the trade 'mixed reviews'. It's as if people seem to resent the fact that he'd used Aeschylus's play as a metaphor for the Gulf War. Peter Sellars's work does often transpose the period; when he directed the Mozart/da Ponte trilogy, he set *Così fan tutte* in an American diner, *Figaro* in Trump Tower and *Don Giovanni* in Spanish Harlem. All, however, were greeted with much more enthusiasm than *The Merchant of Venice* this morning.

SELLARS Although at first attacked equally viciously, it must be said.

BILLINGTON Only later did they become classics?

SELLARS Alas.

BILLINGTON But not your production of John Adams's *Nixon in China*?

SELLARS Oh, 'A total piece of trash', the *New York Times* said!

BILLINGTON One objection that seems to run through most of the reviews I read this morning, is to the whole principle of multicultural casting, because you've set the play in modern California, and have a black Shylock, a Portia and Nerissa who are Chinese-American, and an Antonio and Bassanio who are Hispanic. The critics seem to be saying several things: one is that this diminishes Shylock's sense of isolation if there are the these racial groups and minorities on the stage, another is that it's actually false to the experience of the Los Angeles riots, which is the context to this production. Why did you decide from the outset on a multicultural cast?

SELLARS I think, right now, if you're alive in the late twentieth century that a decision on a multicultural cast is not a really big debate. We live in a multicultural society. Our task as artists is to put something on stage that reflects the society. So I think you have to put that on stage no matter what you are doing, and so that's my choice even if I'm doing Noel Coward. Theatre has always been about processing as much of the world through your life as you possibly can. So you have this tradition of Voltaire writing a play, *L'Orphelin de la Chine*, about the childhood of Ghengis Khan: there's always this trying to imagine some other side of the world and how we process that through our lives. I think the reason why Shakespeare called his playhouse The Globe is this genuine interest in the world, and a sense of what slice of the world are we able to present in theatre? How rich can the sense of a world be on stage? And so, for me, it's very important to have in every show 'the world' on stage in some real way.

I think what's hard for a lot of critics here, who are used to a highly homogenised and beautifully cultivated sense of ensemble, is that that's not what I'm looking for in theatre at all. I deliberately cast actors who have completely different speech rhythms, or completely different backgrounds: I have TV actors next to film actors, next to Beckett actors, next to Broadway musical stars, all on the same stage. Their sense of what acting is, is totally different. So there's not a uniform acting style because, to my mind, you can't be alive now and assume that anybody you're talking to has any background in common with you at all.

BILLINGTON I asked this same question of Peter Brook when we were talking at the same venue earlier in the year, about his policy of creating a cast from various backgrounds, and he said, 'the first thing is to cast decent people.' Do you think that's a good principle?

SELLARS Actually I phrase it slightly differently; I cast people who I want to have dinner with, and who I want to know as friends for the rest of my life. Because theatre, for me, is a life choice. I'm not

particularly into doing shows. You could hire a professional director to clean up my *Merchant of Venice*. It would be easy to make it into a show the critics would like. I'm incapable of it but just hire a professional director and I'm sure they could clean it up.

I do shows because I want to work through material that I feel is in the society, and I need a group of really powerful people in the room to work through it with, because I have a very dim view of my own capacity or expertise. Theatre is not a solo activity. It's actually the understanding that we will never be able to understand any of these issues until we search for a collective understanding. Individual expertise or point of view is no longer adequate in this world, if it ever was. Knowledge has to be an understanding, has to be conceived much more as Plato would, as an ongoing dialogue. So the question is, where is the dialogue and how can that dialogue be as rich as possible? So when casting I have people come in and do their little monologue or whatever and then that's over with. Then we sit and talk for a while, and I base my casting choices on the quality of the person, on what is there; because on stage what we're presenting is human beings, and so you want to put people on stage who are in some way exemplary.

BILLINGTON But how much is the casting slightly out of synch with the social reality? What we see in *The Merchant of Venice* is a Chinese-American Portia running rings round and, you could say, exploiting, oppressing and even persecuting a black Shylock. Now that isn't a reflection of the social reality in Los Angeles in terms of racial relationships, is it?

SELLARS One of the reasons one does Shakespeare is one doesn't want to be so literal about the world, and the reason we apply poetry to these questions is because in the end it's more interesting than journalism. Shakespeare can go further than *Newsweek*. Shakespeare's equipment is better calibrated to deal with what we are actually facing as a society.

So I always deliberately have things that are out of place in my productions – which does tend to infuriate people who are looking for everything in place. I always have things that do not fit, that defy the stereotype that you want to see completed. Because the point is no stereotype really is true. I always try to cast against it in some way so that you can't just say 'Oh right, that's that, that's that and that's that'. You can't do this one for one parallel. One of the things that annoys me when I see a lot of updated staging is that everybody says 'This is just like this, this is just like and that's just like that'. Well, no it isn't. There are parallels, there are correspondences, but there are also differences. I try to leave those differences

sitting there on stage staring at you, rather than try to lop off every-thing that didn't fit.

With this cast I tried very hard to do what I think Shakespeare tries hard to do. You cannot generalise about the Asian-American experience or the Latino experience, because the Asian-Americans on stage are as different from each other as possible; both the women may be Chinese-American, but they're worlds apart. And when they have a conversation it's already a multicultural discussion between them. Shylock and his daughter are not of the same mind about any-thing; they may both be Black, or in Shakespeare's term Jewish, but they take exception at being lumped together. The daughter goes out of her way to say 'I have nothing to do with him'. So I think Shakespeare is trying to break apart any of that kind of mono-cul-tural thinking of 'all the Blacks think this way, all the Asians are like that, and Chicanos always do this to Guatamalans'. Those types of generalisations are totally destroyed by the structure of the play itself.

BILLINGTON One of the other things that you always have, or have certainly had in your recent productions, is a lot of technical equip-ment. In particular, hand-held cameras, video images, monitor screens around the auditorium, and though I didn't mention it in my review, an extraordinary soundtrack that kept reminding me of a David Lynch movie: all those sizzlers, lawnmowers and pool clean-ers functioning as a constant undercurrent to the action. Why? Because when people try and defend or justify theatre as an act, they always talk about the magical and direct contact between actor and audience, unimpeded by the things that surround you in a TV or film studio. So why do you use these resources?

SELLARS And those same unbelievably sentimental people will say 'Of course the only person who has ever sung this correctly is Chaliapin and let me play you the record'. Then it comes out of a speaker and they weep.

BILLINGTON But why the technology?

SELLARS Technology is just part of our world. Everything that we experience, most of the decisions you make about most of the things in your life, are profoundly mediated; you're getting your information from television, you're deciding you like or don't like this person based on what you saw on TV one night. That sense that our experience is so profoundly mediated must be shown, used and critiqued all at the same time. And so I'm constantly trying to present that. These days, it's a waste of time, for example, talking about the government, because the government is a minor inciden-tal side-effect of the media empire. Media is what controls the vote

in America. This is where we really have to strike – what we really have to deal with right now. In many of my productions I'm trying very consciously to say, 'Wait a minute, what is the position of media in your life? How much direct information are you getting? And meanwhile how much information are you getting from another point of view?'

The other element, of course, which is essential to Shakespeare is simultaneous levels of experience. From the very first moment of that show the audience has to realise that you're seeing the actors there, but you're also seeing the actors from an opposite point of view up there. So you have to realise that at every moment in this world we are in the presence of multiple points of view, and to ever talk about something from a single point of view is really inadequate. And to my mind microphones and cameras can also give you what the Greek mask used to deliver which is an amazing sense of public address, but also this private interior monologue. If I speak close up to the microphone I can speak very quietly and suddenly something very personal begins to happen. You can create different levels of address with a microphone. In Shakespeare it's so hard to know in the middle of a speech whether a character has suddenly gone into the most private utterance of their lives. Did they intend everyone in the room to hear this? Or is this part of some giant political presentation that they're making?

BILLINGTON How far would you press this argument? In the two recent productions of yours I've seen – *The Persians* and *The Merchant of Venice* – the majority of the action is in the public realm. What would you do with a Chekhov play, which is set in the world of private experience? Would it be as relevant a technique there?

SELLARS Film, in order to get itself started at the beginning of the century, borrowed all this stuff from theatre. I think it's only logical at the end of the century that theatre borrows a whole bunch of stuff from film to keep going. A close-up is a great thing: you can see what's happening in someone's eyes. This theatre is beautiful, but in most theatres, at the Barbican for example, you're really not close enough to see what's going on in the actor's eyes. But with the video monitors people in the third balcony at *The Merchant of Venice* can really see deeply what's happening in an actor's eyes; that's marvellous. At the same time, when you want to get intimate on stage you don't want to have to peel the wallpaper off the back of the auditorium every time you make an utterance. So you want to have actors genuinely able to whisper to each other and have a sense of privacy, which in film we have in this extraordinary way because there's somebody with a microphone standing right there just out of shot.

With a microphone you can hear how someone's breathing, and their whole physical presence in a movie, which is fantastic. One of the things I love in *The Merchant of Venice* is the senile judge, who every once in a while gets it together to come up with some inane deadly utterance or other. The whole time he is wheezing and breathing on the bench with his back to the audience, and the only thing you hear is the kind of 'uugghhhuhhhh' while Portia takes over the whole scene.

Theatre is about the ways in which we are aware of human presence, and electronically we can learn a lot. I think we're in the infancy: what we're doing now is primitive, but we're on the verge of the most extraordinary developments. Every year there's more equipment, prices are cut in half and it's more and more democratised. There's a whole alternative media world of e-mail and Internet which we're just starting to open up. Again these are just ways in which people are in contact. And to me theatre is about the many ways you can be in contact.

BILLINGTON One of the things that interested me most about your *Merchant* was the pained sadness of the conclusion, because Act Five of that play is always difficult after the trial scene: the tendency is to look for reconciliation, harmony, a coming together through marriage, through pairing off as in other Shakespeare comedies. You seem in contrast to confront these characters with absolutely painful moral choices. In your production Portia has to live with and adjust to the fact that she is married to this bi-sexual, like it or not. Were you trying to overturn the traditional notion of Act Five of Shakespearean comedy, saying 'Look at the reality'?

SELLARS My problem is that I've never seen the play, so I don't know what the traditional ending is. I'm just curious: I look at the page, ask what the words mean and go with it. I hope that most artists are making theatre from their own personal experience of what it feels like to be alive right now. That's why we do a show. I'm not as consumed with adding to the performance history of *The Merchant of Venice*, so much as I am consumed with adding to the sense of how can we express what it feels like, at this moment, to be here in this world, and the pain of a sense of a system that's out of control, and moving in a way that nobody really wants it to move. I'm interested in the very compromised sense that we have, again and again, that it's too late for us to make a bunch of moral choices because we already agreed to make a bunch of immoral choices by proxy. I'm asking, 'What would it be like if we wanted to be moral?' This is an awkward and yet essential question, which is where the pain comes from. Portia's opening words are 'If to do were as easy as to know

what were good to do. I can easier teach twenty what were good to be done, than to be one of the twenty to follow mine own teaching.' The play is about the pain between the life you know you should live and the things you should be doing in the world, and then every day what you're actually doing: which is the betrayal of your own ideals, let alone the ideals of a society.

That is why the last act is so extraordinary. Shakespeare knows how to end a play happily; he's a guy that really knows how to send the audience out happy. The man who wrote 'If we gentles have offended think but this and all is mended' ends this play with 'Well, while I live I'll fear no other thing / So sore, as keeping safe Nerissa's ring'. That is sexually disgusting; it's a horrible, mean, ugly line. We've come four hours for that? It's awful. I think it's in the tradition of the last line of *Hamlet*, and you're meant to be disgusted by it. You're meant to say, 'Okay, we're in for more and worse. Doesn't anybody have the courage to break out of this here? Isn't there some alternative to that?' Shakespeare's perfectly capable of, on the last pages of that play, saying, 'Oh, it's night now, but here comes the dawn. Hark, I feel the first warming rays of sun upon my flesh.' But instead he goes out of his way to say, 'It's not yet morning, it's two hours yet till dawn.' We keep emphasising that Shakespeare deliberately chooses to end the play in the darkest hour, and so you have these crazed, depressed yuppies lying to each other and screaming in the driveway at four in the morning: the darkest hour.

Shakespeare goes out of his way to have Portia's last line saying 'I know you're not yet satisfied'. You bet we're not yet satisfied! And I think Shakespeare's intent in that scene – because it's a continuation of the trial scene – is to say that if you are willing to lie about questions of social justice in public, then you go home at night, and you won't suddenly remember how to tell the truth when you're talking to the person you're sleeping with. You shut off that type of vulnerability and you're not able to be honest in personal relationships if you're not willing to take the honesty to insist upon social justice. Shakespeare's point is that it will follow you home. You can't walk away from it: wherever you go it will be there with you. I think Shakespeare is trying to make the audience very displeased, and saying, 'Okay, if you want a dawn, get up, go out of this theatre and bring in a new day in this society because we need one.'

BILLINGTON Can I move on from there to a kind of job description of a director, because what you said a moment ago was fascinating: expressing what it is like to be alive now, dealing with the moral issues that we face. I remember once asking Peter Hall exactly this question – what is the director's job? His reply was pretty straightforward; he said, 'it is to actually do what the man [and he meant

woman] meant.' In other words your job is to get inside the skin of Shakespeare, Mozart, whoever. How do you yourself reconcile those two needs? Obviously there is an obligation, is there not, a duty to the work you're dealing with? At the same time there is the necessity to express what is current in the air now. How does one bring those two things together as a director?

SELLARS I'm unwilling to make the presumption that I know what the person who wrote this had in mind. Who was the last person who spoke with Shakespeare?

BILLINGTON But don't you have to make that presumption?

SELLARS No, I refuse; it's just simply a lie. Anybody that tells you they know what Shakespeare meant is lying. I'm sorry. They don't, they really don't. I do not want you to tell me you know who Shakespeare is. You don't. Nobody does. I don't want anybody to announce to me what Mozart intended. Intentions are such a dangerous thing. We lie to ourselves about our own intentions. For God's sake what do any of us intend when we do anything? And what does an intention really mean? Beckett went out of his way to lie about every word he ever wrote. How can you trust 'the letters'? Everybody's covering their tracks all the time, that's what human existence means. People are trying to get away with something and hoping that no-one will notice. So to be so dim-witted as to think 'Well, that's what the guy said so he must mean it'. It's just crazy.

Obviously, I've spent a lot of my life with these texts. As you know I work on a comparatively small body of material: I work on a single production for five years. I work in enormous detail. This is the only time I'm sure most people in that audience will have ever seen an uncut *Merchant of Venice*. I do the most uncut version of any Mozart opera: I do arias Mozart didn't even include. I am scrupulous and go out of my way to give the most complete text possible. I do feel a very specific obligation and if something doesn't fit my conception I leave it there, because I don't wish to pretend that my conception covers, blanket-style, everything the author had in mind: of course not. That's one of the interesting tensions about being alive: how much of what you're thinking is anybody else ever thinking? That's why we do theatre; it's just to compare notes and to say, 'All of us in this room thought about this, is anyone out there thinking that way?' That tension is exactly what it's all about and to presume that that tension is not there, or to say our job is to remove that tension, seems to me to miss the pleasure.

I do material because I feel an obligation to the subject matter. Shakespeare wrote the play to get at certain subject matter. That subject matter remains on our minds, so let's talk. I try and create

my productions as a discussion between ourselves and this play: not a monologue on the part of the playwright of course, because theatre's not written as a monologue. Inevitably we're processing these words through our own lives, and the only reason I have to put everything in contemporary America whenever I stage anything, no matter what, is because that's all I'm qualified to talk about, because that's my experience. I'm frequently asked to direct things, here in England, or in Germany, or France, or Japan, and I have to say no; because I didn't grow up there. I don't know what that's like; I can't say that every single thing on stage is authentic. Whereas in *The Merchant of Venice*, you can like it or not, but whatever you're seeing up there, I can testify to its authenticity to people's life experience.

BILLINGTON Does the nature of directing inevitably change when you are dealing with a living composer or writer? Mozart is not in the room with you, John Adams can be. So does the whole relationship change?

SELLARS It's marvellous to be able to ask someone, 'What did you mean here?' That's a relief, but again it's only part of the story. Its their point of view about what they meant, so of course one's interested. At the same time frequently my job is to get something out of it that they're very deliberately concealing.

BILLINGTON Was that true of *Nixon in China*?

SELLARS That is the point of collaboration, and the definition of opera – multiple voices. John has certain things in mind, but like any great composer ends up writing something so much richer. And I have to stage those things, and of course they're marvellous and they're there.

BILLINGTON Like what?

SELLARS John has for so long been assailed by official music critics who are frightened that he's bridging some gulf between serious and popular music, and his music is just too low brow, as if he constantly must apologise that he's not Elliott Carter. When he writes something just juicy, he will not deal with how juicy it is. He'll say, 'Yes, that's in this time signature', and he'll try and come up with some technical reason why it's this way, when in fact it's just totally juice, sheer juice. And the cheerful vulgarity of it, which the composer might be embarrassed to acknowledge, I can put on stage. Then later eventually John can say, 'That's fine, that's great.' But we fight a lot, and by 'fight' I don't mean that to be so dramatic; I just mean like with any human being that you're working with, living with, or having a relationship with, it's not that every day you get up and say,

'Honey, we're in total agreement about everything today, aren't we.' Of course not, it's a life; we're working through it.

John will say something one day and the next week he'll say the opposite thing about the same passage. So often the composer is in one very specific world at that moment; and then later in another set of circumstances he says, 'Oh, of course let's change the tempo marking.' And so I know not to put everything into this written record.

I think we are living in a society that privileges writing, indeed vastly over-privileges writing in terms of its relationship to human experience. Writing happened to be what we felt that moment when the pen touched the paper, but we were still alive ten minutes later and maybe we were thinking something else also. To refract all those elements of our life back through that page is not only a privilege, but a necessity. You only have to look at the Tibetan or Buddhist tradition of dealing with scripture. The whole point in Buddhism is not just that you sit there with a book alone in a room, but that it's actually oral transmission that you get from a teacher. The human element is as important as the text: equally important, if not more. No Tibetan Buddhist would say, 'Oh, you've been reading books for five years and now you're ready.' It's this understanding that what we're doing is profoundly human, and human contact is an equal part of the content of the experience.

BILLINGTON I wonder which artists have left their specific imprint on your life. I'm really talking about directors. You are a very original, special and idiosyncratic director. But watching *The Merchant of Venice* the other night, Orson Welles kept coming to mind. And I was thinking back to those productions that I read about: the Mercury Theatre's *Julius Caesar* and *Macbeth* which obviously were using Shakespeare in order to explore contemporary political realities. You use certain devices, such as overlapping dialogue in the trial scene, that struck me as very Wellesian cinematic techniques. Is he an influence on you or not?

SELLARS Just before he died I actually had a phone conversation that was my only conversation with him. He was stunned that I had studied the light cues in his voodoo *Macbeth* that he did in Harlem in the thirties. He didn't think that any of it existed, and I had researched that and found it: it's in a library in Virginia. He just didn't imagine that anybody still knew about that stuff. I work within a tradition. I've had a really fortunate life, in that being a director is not a solo occupation; you're always working with other artists, and so most of my life I'm in a room with artists who are a lot more interesting than I am. The range of perspectives that are in every one of

my productions are because I invite artists who really interest me to challenge me, to all be in the room, so it's not just my voice. That said, in theatre, I'm influenced a lot by things like Orson Welles's productions that I never saw, that I just have to imagine.

When I was eighteen I lived in Paris for a year, and saw Peter Brook's work when he just got there, Strehler, Mnouchkine, Chéreau, Stein, and the Bread and Puppet Theatre. That was an incredible year for me where I took in a lot of information. But actually before that I started my apprenticeship in the Marionette Theatre when I was ten. So my first images of theatre were of Javanese shadow puppets and Japanese Bunraku. This theatre did plays that the puppets could do better than people, such as the French surrealists, plays by Cocteau with stage directions which asked that snails surround the stage and begin to slobber. And I thought, 'Okay, that's theatre.' Fifteen years later I read my first Arthur Miller play, and thought, 'What's that?' I came to theatre through the surrealist and modernist tradition. I had a strange school. I didn't read Dickens until I was twenty-five, but we started off in high school with *Finnegan's Wake*. And so that's what I thought was normal.

The other thing that is important to me is theatre traditions that are about states of being, rather than the simple conveyance of information. I think so much of the British tradition is about brilliant people serving up to you something that they have prepared – dazzlingly and movingly. Whereas in a kind of a Javanese court tradition, the emphasis is on the effacement of the performer and, as the performance moves into it's seventh hour, the state of consciousness that you enter. I'm very influenced by theatre that is primarily experiential; rather than being about an experience, it actually is the experience. For example, an actor will say, 'How should I react here?' My answer is always, 'React. I don't know, just react. I don't want a simulated reaction, I would like a reaction.' And it's not about working it out so you get a perfect reaction and then you can do that every night on cue, which is what a lot of these critics are justifiably looking for, because they're expecting that kind of organisation of the information they're about to see. I do exactly the opposite. I create a structure in which the actors on stage are as surprised as the audience about what happens moment by moment, and where the performance is never the same any two nights in a row. When people tell me they saw one of my shows, I say, 'Oh, which night were you there?' That was the night that scene was hilarious and the next night everyone was crying. Again for me the point of theatre is that it's not ever fixed. It's about how immediate can we get to how we feel about this at this minute? And one night

the actor has a lot of emotion about something and the next night not. And so I ask the actors not to fake it. I say, 'If you're really not feeling that in that scene just don't do it, take it another way.' That of course has a cumulative impact across the evening. Therefore, the way I usually rehearse, particularly with something like *The Persians*, is to stage the whole show quickly in the first week, and then we do run throughs. We do one every day and then stop and talk, because to my mind it's important that the actors have a stake in it, that there's no exit door. If a scene doesn't go the way you want, it's too bad, you have to just stay in it and figure out a way for that character to deal with whatever's happening. And meanwhile that will then affect the scene two scenes from now. So when you next walk on, you'll be walking on with everything that upset you two scenes ago. Frequently what happens in my shows, because they are so inept, is that they crumble – you're getting this sense of collapse all the time. But there's this weird organic thing that the audience that makes it to the end realises that you have had, even if along the way it looked like it was falling apart; by the end you realise this was a really complete organic experience. And I admire people who can rush out of the theatre and try and write about it. But for me I need a long time to process what happened. That's why I try and make a show about which the audience doesn't know what to say at the end. You can't just turn to the person you're with and say, 'Well, that was that, and that was that', and then go and find your car. The experience lives with you in some way and you don't know what you think of it.

I saw Chéreau's work when I was eighteen, and I hated it. I said, 'This is terrible.' And I went around for years saying, 'That's really bad.' Five years later I realised it was one of the most important productions I've ever seen in my life, and I still spend a lot of time twenty years later thinking back on certain scenes and what was really happening, that I didn't get while I was sitting there watching it. To my mind, theatre isn't necessarily about whether you liked it or not, and the people who hated it are still getting it, and in fact will carry something away with them that will keep working. Actually what we do in theatre is just plant seeds. And to assume that the experience is what happened while people were sitting there is silly. That's why I don't really care what happens while people are sitting there; if they're restless or if an act is too long, it's not really important. Because what will be important will emerge much later. And meanwhile we're just trying to stay in a real experience.

BILLINGTON At the moment your life seems to be commuting between these temples of high culture: you've done Stravinsky in

Salzburg, Mozart in Glyndebourne and so forth. There's that side of your work: the big festivals, the big cultural venues. The other side of your life seems to be the LA Festival, of which you are artistic director. You told me the other day that's more and more directed towards street theatre, community work and so forth. Are you in the process of moving away from the high culture to this other world of the LA Festival, or is that where you really feel your roots are at the moment?

SELLARS I think we have both things operating in our society, and our task is to take the large institutions – and I'm not just talking about culture, I mean government – that are basically almost non-functional at this point, and try and achieve some accountability, and try and say, 'No, no, no let's not throw this away, let's try and use it. Let's go in there and try and make the government work. Let's not walk away from it and say it's useless', even though God knows we're vastly outnumbered. But also at the same time we have to be getting new initiatives going at the grass-roots level. Unless the grass roots is really moving, you'll never really be able to renew the large institutions. And again I'm not so much thinking culturally, I'm thinking much more in terms of governments right now. Right now nowhere in the world is there a head of state who anybody truly likes. It's a really interesting situation. Right now every government in the world is in trouble and every set of voters are just voting out whoever is in. It's not a vote for anything, it's just a vote against whatever. We're in a very painful period of real disjunction, particularly in the democracies. And the voters are thinking, 'If this is democracy, fascism looks better and better.' And so people are voting for fascism. Where I come from, in the state of California, last week people voted in Proposition 187 which is something Hitler would not have proposed in Munich in 1933.

BILLINGTON Remind us what that is.

SELLARS It's the anti-immigration bill which begins 'We the citizens of California are suffering', and provides for police round-ups of 'illegal aliens', a term that Woody Allen could not have invented. How do you call a human being an illegal alien? It's just shocking. And of course every study shows that the only thing that keeps the Californian economy going at all is the presence of undocumented labourers. It's not that they're taking jobs away from anyone; they're doing the jobs that no-one else will do and supporting the state. But the press refuses to report those studies and meanwhile the voters are whipped up, as in Germany, into this insane feeding frenzy. How do you convince people to vote, as the citizens of California voted this year, to remove money from the school system and put the same

money into hiring three thousand more cops for the streets of Los Angeles? How do you convince people to vote against the education and health of their children and for the increasing of the profits of the top 4 per cent of the population?

BILLINGTON How as an artist can you counter that?

SELLARS We talked about the media earlier, I think our task is to present alternative information systems, to try to get other information out there that doesn't necessarily reach the public – not just information, but a way of receiving information, because information by itself doesn't mean anything. The question is how do you process it? How do you assess in your own life what we mean by human costs? Not just what it looks like on the balance sheet, but what are the larger costs that actually are the real economy? Human productivity is not just a function of the job market; it's how people feel motivated to achieve something and feel their own sense of identity, to take pride in that and have a sense that they are fully empowered actors on the stage of history. That is human productivity. That's our task in theatre.

Now theatre, of course, is separate from advertising. So that I can't say that nine out of ten people who see one of my shows will change their brand of toothpaste the next morning. We don't operate that way. Arts operate contrary to numbers. And so it's always a tricky thing when we're talking about the function of the arts within a democracy. I tend to think, for example, of someone like Boetheus, who wrote in the fifth century and was the chief of staff for one of the last Roman emperors, Theodoric, who was a Goth in multicultural late Rome. There was a palace coup in the upper echelons of the staff and Boetheus was thrown into prison where he spent his last five years and was tortured once a week. And he wrote something called *The Consolation of Philosophy*, in which philosophy as a woman came into his cell every day, and they sang songs together about the meaning of justice in this world. And finally they were tired of keeping him alive and one day they didn't just torture him, they clubbed him to death, they just smashed him into putty. And this beautiful book that he wrote, it got out – I don't know how. It's the only book written in the fifth century that you can get in paperback today. And the only reason we even think about his period is because he lived and we're looking at it through his eyes. Five centuries after his death this was the most copied manuscript in the early Middle Ages, because when monasteries were trying to deal with independence of thought against the feudal structure, this manuscript gave them hope.

So I tend to think, as the Native Americans would say, 'We do

everything in our lives for the children of the seventh generation.' It's not that we're doing anything that we expect to see in our lives; it's that two-hundred years from now someone will be pleased that somebody now had the courage to stand for something and that will be useful to them.

AUDIENCE QUESTION 1 Is it more effective to treat modern situations through classical or contemporary work?

SELLARS I think as human beings both are necessary, that of course things are happening now that have never happened in the history of the planet, and we need to talk about those in new ways. So new material has to continue to be produced and I divide my time evenly between the two. At the same time to think that we just got here is a mistake: we're inheriting a whole world. Not to hear the voices of your ancestors is a deafness that is not helpful. And I think it's really important to constantly test our own lives against the greatest wisdom that we're inheriting: people who are trying to tell us something, who've been here before and have tried this before we got here.

I also think of the work that we do as two-hundred years into the future. So I try and work in a large continuum in which the work that we do is part of something that we were inheriting, part of something that we are making now, and part of something we're trying to hand on. And that all three of those have to be in some equilibrium in your life as well as in your personal work.

PETER STEIN

✧

REGARDED by the director of the Edinburgh Festival, Brian McMaster, as 'simply the best director in the world' (*Guardian*, G2, 2 April 1993, p. 6), Peter Stein is considered one of the finest directors of actors at work in the contemporary theatre. Largely perceived as a 'political' director in the sixties and seventies through his confrontational productions of agitational plays and his commitment to collective working methods, the eighties and nineties have seen him turn increasingly to the classics, providing a series of meticulous, finely tuned productions possessed of an immediacy and accessibility which have consolidated his reputation as a masterful and observant orchestrator of stage action.

Born in Berlin on 1 October 1937, Stein's involvement in theatre began while at Munich University where he studied literature and fine art, and largely involved performing, and translating works from the French. Abandoning his doctoral studies he worked as an assistant to Dieter Giesung in the early sixties, moving with him to the Munich Kammerspiele in 1964 where he did some freelance dramaturgical work before joining them on a full-time basis as a dramaturg and assistant director. It was here, after a number of formative years assisting the fastidious but radical Fritz Kortner, that he staged the German premiere of Edward Bond's *Gerettet (Saved)* in 1967. It proved an audacious debut. On a bare stage adorned with a few selective objects, Stein realised his bleak but resonant vision of the play. Adapted into Munich dialect by Martin Sperr, it resulted in a harsh but immensely apposite production, shocking the more conservative elements of the Munich public and infusing the younger audiences with its aggressive energy and dynamism. His production of Brecht's *Im Dickicht der Städte (In the Jungle of the Cities)* in 1968 was also characterised by a lengthy rehearsal period and an economy and clarity of style. It also proved important in that it initiated Stein's relationship with the designer Karl Ernst Herrman who has worked regularly with him since then.

During the sixties, first at the Munich Kammerspiele and then at Bremen and the Zürich Schauspielhaus, he established his reputation as a director willing to provide confrontational productions and committed to pursuing alternative working practices. His epic multilayered production of Goethe's *Torquato Tasso* (1969), which he transplanted to Goethe's Germany, followed the success of his earlier *Kabale und Liebe* (*Love and Intrigue*) (1967) at Bremen in its util-

isation of a group of actors, Jutta Lampe, Edith Clever, Michael König and Bruno Ganz, who were to form his core at the Schaubühne. These productions were marked by a directness and a distinct understanding of the socio-political context in which the plays were first written and produced so that their relevance to the current climate could be better comprehended. Although he was to abandon the heavy-handed posturing which was to inform his production of Peter Weiss's *Vietnam-Diskurs (Vietnam-Discourse)* (1969), co-directed with Wolfgang Schwiedrzik, he remained indignant at the hierarchical working practices which marked the conservative state and municipal theatres at Munich and Bremen. The increasing frustration he experienced working within what seemed to him excessively bureaucratic structures and the controversial response which greeted *Vietnam-Diskurs* encouraged him to pursue the possibility of a permanent ensemble company committed to collective working methods. The generous subsidy made available to house a company at the West Berlin Schaubühne am Halleschen Ufer in 1970, enabled Stein to pursue his ideal of a collective theatre company organised around a democratic socialist model. Despite the opposition encountered from the Christian Democrat Unionists in Senate in its early years, and the modifications it underwent during the seventies, the Schaubühne did abide by the principle of seeking to involve participants in making all the decisions relating to each production. Experimenting with different working practices – including a Workers and Apprentices Theatre in the early seventies – it encompassed overtly political theatre, including mannered but direct productions of vigorous texts like Brecht's *Die Mutter (The Mother)* (1970) and Vsevelod Vishnevsky's *Optimistische Tragödie (Optimistic Tragedy)* (1972), before moving on to a series of productions of classical texts beginning with a resourceful *Peer Gynt* in 1971 which, employing six Peers, sought to explore the text's political status, specifically the individual's relation to society. Stein's dramaturg on *Peer Gynt* was Botho Strauss, with whom Stein was to work on Eugène Labiche's *Das Sparschwein (The Piggy Bank)* (1973) and *Summergäste (Summerfolk)* (1974), as well as Strauss's own plays, *Trilogie des Wiedersehens (Trilogy of Return)* and *Gross und klein (Great and Small)*, both in 1978, and *Der Park (The Park)* in 1984. Careful, conscientious research and a methodical, thorough rehearsal period characterised Stein's work at the Schaubühne. The research undertaken for the production of Euripedes' *Bacchae*, directed by Klaus Michael Grüber in 1973, was presented as *Antikenprojekt (Antiquity Project)* in 1974. During the seventies, the company undertook a series of Shakespeare seminars which served as preparation for a busy multilevelled production of Shakespeare's *As You Like It (Wie es euch*

gefällt) in 1977. The investigative work was presented again as *Shakespeare's Memory:* a mosaic of activities in which Shakespeare was clearly placed within the artistic and cultural traditions of his time and where the audience were able to choose what to see. Both pieces were performed in the expansive CCC Film Studios. The possibilities offered by this venue encouraged Stein to pursue the possibility of relocating the company to a more flexible location which would allow for more versatility in the staging arrangements.

The increasing success enjoyed by Stein both at home and abroad – *Sommergäste* was the first foreign language production invited to the National Theatre in London – facilitated access to the sums of money necessary to ensure the construction of a versatile new building which would permit multiple staging requirements. The new Schaubühne, housed in an old cinema in a more desirable area of the city and designed by Jürgen Sawade at a cost of £25 million, created a degree of controversy. Stein was accused of 'selling out' – an accusation which pursued him when he left the Schaubühne in 1985 and moved to be director of the theatre programme at the Salzburg Festival in 1991. The intense performance style of his productions of the late eighties and nineties, including a delicately observed *Drei Schwestern (Three Sisters)* in 1984 and a superbly orchestrated *Julius Caesar* in 1992 with a cast of thirty-seven and two hundred extras, met with erratic degrees of critical success in Germany, although they consolidated his reputation abroad. His 1994 reworking of his 1980 Schaubühne production of Aeschylus's *Oresteia* with the Moscow Army Theatre, offered an impressive example of Stein's ability to make distant texts appear pointedly immediate, fresh and politically relevant. Although Stein's first experience with opera – a production of Wagner's *Der Ring des Nibelungen* at the Paris Opéra in 1976 – proved largely unimpressive, the 1980s saw Stein lured to Welsh National Opera by Brian McMaster, where he produced an alluring, unanimously acclaimed *Otello* (1986), and a boisterous but elegant *Falstaff* in 1988. He returned to the WNO in 1992 where, with Pierre Boulez as conductor, he staged a beautifully controlled production of *Pelléas et Mélisande*. Stein is the recipient of a number of awards including the Commandeur de l'Ordre des Arts et Lettres and Chevalier de la Légion d'Honneur (1992) and the Erasmus Prize (1993).

OTHER MAJOR PRODUCTIONS INCLUDE

Early Morning by Edward Bond. Schauspielhaus Zürich, 1969.

Prinz Friedrich von Homburg by Heinrich von Kleist. Schaubühne am Halleschen Ufer, West Berlin, 1972.

Fegefeuer in Ingolstadt (Purgatory in Ingolstadt) by Marieluise Fleisser. Schaubühne am Halleschen Ufer, West Berlin, 1972.

Die Unvernünftigen sterben aus (They Are Dying Out) by Peter Handke.
 Schaubühne am Halleschen Ufer, West Berlin, 1974.
Klassen Feind (Class Enemy) by Nigel Williams. Schaubühne am Halleschen
 Ufer, West Berlin, 1981.
Titus Andronicus by William Shakespeare. Teatro Ateneo, Rome, 1989.
Der Kirschgarten (The Cherry Orchard) by Anton Chekhov. Schaubühne am
 Halleschen Ufer, 1989.
Roberto Zucco by Bernard-Marie Koltès. Schaubühne am Halleschen Ufer,
 Berlin, 1990.
Antony und Cleopatra by William Shakespeare. Salzburg Festival, 1994.

CRITICS ON HIS WORK

Stein is a great innovator and emulator: imaginative, honest, painstaking...
He analyses a play exactly, pulls it apart, dissects it with incredible curios-
ity... He tries to get to know a play completely. He clarifies the piece, peels
off its different layers with all his curiosity and imagination, but he does not
change it. The play is there, one only has to bring it alive. Stein does just that
... Stein has much of the quality of Brecht and has the same way of working
... As a director Stein is Brecht's immediate successor.
 (Therese Giehse, quoted in Michael Patterson, *Peter Stein*, p. 8).

Peter Stein's contribution to directors' theatre is to have clarified the contra-
dictions that inevitably confront a director working within the structure of
a collective company today. His distinction is never to have sought to evade
these contradictions but rather to have welcomed them.
 (David Bradby and David Williams, *Directors' Theatre*, p. 186).

SIGNIFICANT BIBLIOGRAPHICAL MATERIAL

Bradby, David and Williams, David. *Directors' Theatre*. Hampshire and
 London: Macmillan, 1988.
Case, Sue-Ellen. 'Peter Stein Directs *The Oresteia*'. *Theater*, 11, Summer 1980,
 pp. 23–8.
Lackner, Peter. 'Peter Stein'. *Drama Review*, T74, June 1977, pp. 79–102.
Patterson, Michael. *Peter Stein: Germany's Leading Theatre Director*.
 Cambridge: Cambridge University Press, 1981.
Zipes, Jack. 'The Irresistable Rise of the Schaubühne am Halleschen
 Ufer: A Retrospective of the West Berlin Theatre Collective'. *Theater*,
 9, Fall 1977, pp. 7–49.

**Peter Stein in conversation with Peter Lichtenfels
at the Royal Exchange Theatre, Manchester, 25 August 1994**

LICHTENFELS You've directed a prominent number of English plays
during the past thirty years – Jacobean plays, Shakespeare, Bond,
Nigel Williams. What attracts you to English plays?

STEIN In the first place, what attracts me is the enormous skill which
is traditional in English playwriting and also certain skills in the
acting. A lot of words in German theatre language are taken from

the English, like the famous 'timing' which is the big problem, the big difficulty for German actors. They never know exactly how to organise the right timing and we have no German word for it, just 'timing'. A lot of things come from English acting in our language. But I must admit that the basis of all this interest is really Shakespeare and the Germans have a very special relationship with Shakespeare. They have, let's say, invented their own Shakespeare by taking a special translation of Shakespeare as the classic translation. All the quotations from Shakespeare texts which went into the common language came from this translation. It was done at the end of the eighteenth century and continued into the beginning of the nineteenth century. It was done by [August] Schlegel who was a very famous romantic thinker, [Ludwig] Tieck who was a romantic poet, his sister Dorothea, and a man called Wolf von Baudissin. Together they did the so-called Schlegel-Tieck translation which is the basis of all German Shakespeare, even the new translations. Now we have about seventy translations of Shakespeare, and in the last forty years every production has, more or less, had its own translation. Shakespeare is, in the German states and town theatres, the author who has the biggest number of productions and a large public who come to see them. He is a big star, leading by 50 per cent.

LICHTENFELS Over any German playwrights?

STEIN The next is Brecht. The German theatre is orientated to the English theatre and there are historical reasons for this. When the English closed down the theatres in the seventeenth century, the English theatre crews had to go away from this island, and they went to the continent and especially to Germany. They got homes there and they became German. So, a lot of English theatre figures, became resident in our tiny little provincial towns. So the German theatre is highly influenced – much more than the French or the Italian – by wandering English troupes from the seventeenth century. Shakespeare was the point of the spear in the fight for artistic freedom that started in the seventeenth and eighteenth centuries. The so-called famous 'Sturm und Drang' based all their aesthetic opinions on Shakespeare, and Goethe was one of the big propagandists for Shakespeare. They opened up the only revolution that the German bourgeoisie was able to make – the revolution of the mind. They never had the possibility of initiating a political revolution, in contrast to the French. That is the big shame of political development in Germany in the nineteenth century. The clandestine cultural revolution which was so important for the identity of the German bourgeois middle class started under the lead of Mr Shakespeare.

LICHTENFELS He was a German playwright!

STEIN He was a German playwright – more or less – you are right. But for that reason, because he's such a polar star of orientation for us, it was not so easy for me to approach Shakespeare. It is still a problem for me, because I'm simply afraid. For me he's just a giant and I know a lot about him, and the more you know, the more difficult it is to touch him. It's better to be young to touch him. If you are older, it becomes harder because you want to grab everything that is there. It's difficult to decide, 'Okay, let's go in that direction', but theatre people have, more or less, to decide, after lots of reflection, to go in one direction. Therefore, for me, it's a problem.

LICHTENFELS When I've seen your work, or even when I've read about you working, one of the things that I understand is that you prise apart the play and you try to understand the contradictions in the text and in the society that it was written, and in that way dig out what it might mean to us today, rather than, say, imposing easy interpretations.

STEIN It's more fun: intellectual fun but also emotional fun. If you want to make theatre today, take a contemporary text and don't lament the shame of those texts that are nothing in comparison with Shakespeare. Accept it if you want to make theatre for this day and age. The interest in Shakespeare is something completely different. We can learn a lot if we feel the distance of Shakespeare as an author of his time and, at the same moment, also something that is near to us. We can get in contact with a guy who died a couple of centuries ago. We can also do this with Aeschylus. This is the interesting point, to have made a telephone call over centuries and centuries; to have the illusion that there is a direct contact possible. This is only fun if there is tension in the contradiction between feeling yourself near and feeling very disassociated. In fact, it works because we are in a theatre and theatre is based on contradiction; it is based on fights.

LICHTENFELS As a German, how do you dig out the English cultural context and how do you then deal with that in a German setting?

STEIN I am very lucky in that I do not have to dig out the English cultural context of today. I have to dig out the English cultural context of Shakespeare's time. That's much more fun. And it is not only the English who can contribute to understanding the personality, the face, the testicles of Shakespeare. There are a lot of other people who provide a lot of information on him – Russians, Americans, Germans, French, Italians – even if you must admit that English Shakespeare philology is the guiding light. It is clear that what is

going on from my side is deciphering. Deciphering is the thing that I like most. It is through the process of deciphering something that I can also start addressing, 'What is this? How does it work? What does it mean?' And so this is what is interesting. It is very boyish, very childish.

To me, theatre people are, and should be, very naive. We come up with this kind of talent, curiosity, and try to decipher and understand the little things. We can go into very complicated tasks with our stupidity. We theatre people are not able to do anything. We cannot really move like dancers. If we could move, we would dance. We cannot sing, if we could sing we would earn much more money. And we cannot write, we cannot even think. But we can be curious, and mix our sticky, dirty fingers in lots of things. And as the spoken theatre structure is a very rich one, an open one, this kind of attitude helps a lot. It is clear that any kind of unilateral approach to theatre can produce wonderful things, but it cannot produce a profession, and it cannot really produce continuity in an art.

The most important thing in theatre is that it is collective. It is taken together from hundreds of types of things, especially in Shakespeare. This is very effective. In contrast, if you see the French classics, they are much more elemental and totally simplified. Racine provides a play with only eight hundred words and no props. Now, this can be very strong, but the scheme of Shakespeare was much more successful. And so we have this versatility, incorporating even bears walking over the stage. 'What a shame!' a French classicist would say, 'A bear on the stage, come on!' I think this kind of curiosity is necessary and this is what I'm doing.

I'm also creating my own translations. This is crucial. If, as a director, you want to tell the actors something about the original, then you must study it. Most of the actors speak English and they can understand Shakespeare, just as a lot of English people think they can understand him. But then they have to learn it's not so easy. A lot of words have completely different, sometimes opposite, meanings. So they have to go to school if they want to know him really. And so, I must study things to give the actors a slight idea of the original. This is what is fun for me.

LICHTENFELS In Berlin you had a company and you were rooted in a city that was very special at the time, partly because of its isolation before the Wall came down. What do you feel the difference is between when you worked in Berlin running the Schaubühne, and now that the Wall has come down?

STEIN The German theatre is based traditionally on a strict ensemble theatre that stems from these strange times in the eighteenth and

nineteenth centuries, of which I was speaking earlier, where we had the situation in Germany where every little duke tried to copy 'Le Roi Soleil', Louis XIV. Each wanted to have a Versailles in his little residence, and therefore it was absolutely necessary to have an opera and a ballet and a spoken theatre. Slowly the bourgeois class took over cultural power and they made a kind of religious need out of the fact that each city had a theatre. Therefore there was not the slightest discussion of the fact that the theatre needed a subsidy, because it was necessary for the duke, the lord of the country, to subsidise the theatre and an ensemble of actors who performed there. Every city was proud of these theatres and they tried to attract actors whom they sought to keep together to make theatre for these places. It was never something, like in Italy or France, where the troops were wandering around. That never existed in Germany. There was the same situation in Russia, Finland and the other Nordic North European countries: stable ensembles that staged plays in one place. That is normal in countries where you have a strong movement of amateur theatre, and they provide the best public that you can have because they see every show that is done in their tiny little town. And it was a place of representation for the ruling classes or members of the ruling classes who were there in Germany.

On the other hand, it was also a kind of school for people, providing intellectual information for life. Theatre had a function like the Church. That is very, very special, and I stem from that tradition. I reformed that idea when I founded the Schaubühne Theater in 1970, as the problem with this kind of theatre is that it quickly becomes very bureaucratic. Actors in Germany have the same status as civil servants, they have the same contract as street cleaners or bus drivers and, more and more, they have the same kind of thinking. And this is very counter-productive for the arts and that became very heavy in the sixties. Increasingly, also, the trade union had an enormous influence. It is the most 'rightist' movement in any theatre, because it just tries to reduce the working time and increase the money. And the result was that rehearsals were cut from a day to two hours. This goes against the actors' interests as actors want to rehearse to improve their work. They have other interests besides the financial interest, and there is always a kind of conflict in that. What we proposed was a renewed idea of the ensemble through the actors themselves running the whole theatre, every aspect of the theatre. So it became a self-determinated theatre. It was the only one in Germany.

It's clear that you need special people for that. People who are interested in all the aspects of theatre, not only the artistic or the organisational aspects, but also the political; all these impact. And

you need people who are able to make democracy in a simple way, people who can suffer to be outvoted. I am a guy like that. So that if a majority of people vote against me, I'll say, 'Okay, I'll do what you want. You will see what comes out of that.' I try to follow my ideas through other channels. A director must have the ability to think as his actors are thinking. You have to be flexible or you cannot achieve anything. If you want to impose your own position on another individual then join the army and become a general.

So, that was the idea. Clearly it was very much boosted by political developments in Germany in the late sixties. It was necessary to reform, and we reformed the German city theatre. Whether it was for the better, we never know with these reforms. You always pay a price for so-called progress, and we also know very well that very often, perhaps in the majority of cases, we give more than we receive. This is our big problem at the end of the twentieth century, that we have a profound consciousness, we are aware of this tragic problem. Greek tragic authors were very aware of that 2,500 years ago, and therefore they invented nice speeches, like 'It is better for a man not to be born', and similar encouraging lines. It is absolutely clear, however, that if you work in theatre you must accept all different positions, take them together and make something out of them. This I did for twenty years. Always working in one place, with the same group of actors. I couldn't kick anybody out because there was voting, and no ensemble kicks out a colleague. They are afraid that it will hit them the next time. I insisted that we stay in one place, knowing and developing our audience and so developing long-ranging projects that involved working for fifteen years in one direction, as we did with Shakespeare, as we did with the Greek tragedies, as we did with Chekhov. It is only through continuity like this that you can do things like that. I do not think that it's necessary and that it always produces great theatre, but if you want to work like that you need to stay in one place. Because I am a German provincial I am profoundly convinced that theatre is a very local thing. It is based on locals. We are now, however, living with this enormous explosion of festivals and the reduction of local theatre work.

LICHTENFELS Now, of course, you are responsible for the theatre side of the Salzburg Festival. I wonder, in terms of working for a community, what the differences are.

STEIN There are enormous differences but everything in theatre, as in life, has its time. You can create an ensemble which is elastic enough to govern a theatre, but then everyone becomes old, more individualised, and more formed. The individual gets a face and becomes hard. This is problematic but, on the other hand, is also

very beautiful. So it's actually impossible to imagine a self-determined ensemble of seventy-five year old actors.

Strangely, by doing absolutely provincial German theatre work, very, very German indeed, slowly through transparent political and cultural reasons, my productions went abroad (subsidised by the Goethe Institute and the Foreign Ministry). They had 'success' or at least attracted attention and a certain interest. And so, step by step, I became known outside my country and that, for a German, is very dangerous, because, on the one hand, we are extremely provincial, and on the other hand, we tend to hide and make a camouflage of our Germanness. We go to Italy and we are a little bit Italian and we go to England and we are a little bit English, and so we copy what's going around. Especially after the Second World War, the Germans felt instinctively that it was necessary to re-orientate. If there is any difference between the Germans of the thirties and forties and the Germans of the nineties, then this difference comes from contact with the other European countries. Therefore we have to be very grateful for that and with me it was exactly the point where I started to think. I got seduced into looking around and started to speak languages. Then I gave up the the Schaubühne to work in other places, like Wales, Italy and Russia, knowing that when a director is working in another language than his own, he loses 50 per cent of his possibilities.

LICHTENFELS Why haven't you directed a play in England?

STEIN There are a lot of reasons. I have the feeling that I cannot give anything to English actors.

LICHTENFELS What sense do you have of English actors?

STEIN They have enormous skill and extreme talent on stage. It is the same with opera singers. It is absolutely stunning how they have a kind of self-understanding, natural behaviour on stage. This is what is highly interesting here and I always make a pilgrimage to hear Shakespeare's English and not especially to see the *mise en scène*. I never saw any Shakespearean *mise en scène* which could convince me in England. But the music and the acting is fantastic and very special. When I'm working outside my own language I look to whether I can give something to the actors. It's clear you need a justification for what you are doing. So when I, as a theatre director, do opera for instance, I'm choosing scores where a straight theatre director can give a hand: as with, for instance, the two last operas of Verdi which he wrote after a pause of twelve years. Verdi didn't want to write any more Italianate opera, he wanted to do something new and therefore he studied Shakespeare. He wanted to make theatre on the opera stage, which is 'à la contradiction', it's not possible. But he wanted

that and he created the music and the score in order to fulfil this dream.

And so if you work outside of your own language you must be convinced that you can give something to the actors. In the case of *The Oresteia* it was that I could convince the Russian actors that they are fantastic players and actors for Greek tragedy. They are profoundly convinced that the Russian actor cannot play Greek tragedy. It's one of those irrational stupidities and it is deeply rooted, although where it stems from exactly I don't know. Perhaps it stems from the cutting of all so-called humanistic traditions after the revolution. They claim that they cannot play Greek tragedy. I tried to tell them what Greek tragedy is, what it's about and how it can be done and so on. I can give them something by introducing a different acting style, introducing the necessities you need for making the chorus work.

Working in Italy, I was much more interested in using the special possibilities of Italian actors to move on stage: the sense of space of the body, the relation of the space of the body in the theatrical space. It's just fantastic with the Italians. And this I wanted to combine with my Shakespeare problems because I think that is also necessary for Shakespeare. So I took more from them than I could offer them. The problem in Italy, however, is that they have not got the slightest idea of what dramaturgy is. Dramaturgy is a Greek word, it stems from the invention of European theatre. It is how you guide the action, how you need the action. That means, more or less, how you tell the story, how you organise the running of the story: whether it is a kind of steady process which starts here and goes along its way and ends there. It has nothing to do with what was suggested at the beginning of the story, everything has totally changed. Even if it came back to the same point, everything has changed during this voyage. You must have a certain idea of that if you make theatre. If not, actors are solipsistic players and they are very ugly on stage even if they are great actors.

LICHTENFELS What do you mean by 'very ugly'?

STEIN They do not fill the space. They are not together with the others. The theatre is not about one person on stage, it's about a couple of things – at least two – that meet. The public can stand one person on the stage not longer than five minutes because then they ask, 'Where is the other one?' If another actor comes in and contradicts him and even kills him, then they say, 'Come on, come on, it's okay, it was very nice', or 'Do it once more', and then a third actor could revive the man who has fallen down and then you can take the action in a different direction. This is what the spectator wants. So

an actor must know that he is responsible for the whole dramaturgy, for the whole running of the play; that he is serving the structure, that his presence in itself is even the most important thing in the theatre. But it is not the only aim. If that was the only aim, the monologue would be the highest form of theatre, and it is not.

In Italy they don't have the slightest idea of that. They like to be on stage so much that they prefer all the other actors to go away. They therefore recite as in the tradition of *commedia dell'arte*. This is very limited. With this kind of style you cannot create a real dramaturgy. Italian theatre-makers often claim that they have no real dramaturgy and no real theatre. In a certain way they are right. I could give this to the Italian actors because it is my speciality and also the speciality of German actors. German actors are the best at respecting that they are part of a whole, that they are not solipsistic and this is very good. I haven't found that in any other theatre tradition.

LICHTENFELS How have you taken that to your work in Salzburg?

STEIN The decision to take over a festival is totally opposite to my thinking. I hate festivals. I had never been to Salzburg. I was full of prejudices. But I left the Schaubühne because I thought that after twenty years it was time to go. I then worked as a freelance director but I have a certain talent for organisation, and so after six years I decided to return to organisation because this can also be fun. If you are working as an artist you have your crisis. The crisis is more or less the mother and the father of your work. Then you shoot yourself. But if you also have another business which involves organisation, you can go in there and you feel very successful because you can solve organisational problems. You then go on organising and you get some organisational crisis and you quickly find a response for that in the organisation. Also, if you are in crisis in the organisation, you can go back and become an artist again and be happy because it is so wonderful to be an artist. And everything works perfectly like that because you can work with two heads and it is sometimes very helpful.

LICHTENFELS You are happily schizophrenic.

STEIN Exactly, and so I thought it would be good perhaps to have this second head. But I wanted to organise something completely different. It couldn't be like the Schaubühne because with the Schaubühne I created everything that I thought possible in Germany. And here I am not talking about artistic results but I did organise all the successes you can imagine. They even constructed a theatre for me exactly to my plans for a couple of million deutschmarks. It is not a theatre building in the traditional sense. It

is a flexible space that can be changed. What I invented there was like three film studios, where you open the curtains and unify it to become a huge production space. So there are no flies or anything like that. You can put the public where you want. I always try to work in spaces like that, to set up my own stage. I am interested in this idea of the space for the show following exactly the needs of the play, or at least the needs of the play as I or we have calculated it. So for *The Oresteia* I created a kind of small Epidauras, and for the Shakespeare plays there was an open situation like the Globe, and for Chekhov a precise set-up, a proscenium arch theatre with the so-called 'fourth wall' missing. So for twenty years the stage was changed for every production. I always decided not only the space where the actors were to work but also the space where the public was to sit. So, sometimes there was space for two hundred people or six hundred, sometimes a thousand. It always depended on how we calculated the thing and this was possible in the space they constructed for me. The working conditions in the Schaubühne are still now very good and completely different to those of other spaces. In our rehearsal rooms, we have lighting, an audio system and the set. We work it all out in the rehearsal room, step by step, and at the end the set is, more or less, what we then have on stage. The actors therefore also have something to say. They can state if they want anything moved. This is absolutely unique and the structure is still there. Whether this is used, I don't know.

Now what can be more different than organising a festival where you buy everybody in from all over the place and where you have a rehearsal time of only one and a half months, which is a quarter of what we had in the Schaubühne. So this really is the opposite, but as an organiser I found it a rather attractive prospect. And clearly in Salzburg you have a large amount of money at your disposal. I started to rebuild a theatre. I tried to form a kind of festival ensemble, so it means the actors come back and there is some continuity. I tried to fight against worsening working conditions by staging and reworking revivals so that productions are not only shown one summer but two or three summers. I also tried to introduce the knowledge and the friends that I had acquired whilst abroad, inviting them to come and do something in a very doubtful situation. I told them that if they came to Salzburg or worked in Germany and couldn't speak German their worth would only be half of what it was in their own country. Nevertheless, these experiments are interesting because there is a kind of confrontation between German acting and the acting standards of German theatre schools and those of the different theatre schools of Europe. These are the aspects of Salzburg that interested me.

AUDIENCE QUESTION 1 When you talk about ensemble acting, I usually think of the life that actors create on stage: rather than being directed where to go, they are creating a life. So, in that sense, what is your function as an ensemble theatre director?

STEIN The ensemble theatre director has more or less the same function as any theatre director. As I always say, the function of the director (as a job in itself) came very late in the history of European theatre. Shakespeare was the director but he was also the author and the owner of the work. He didn't own the whole thing but he owned quite a nice portion of the cake and he was its architect. So he had many more functions, just as Aeschylus had. But later all these things split, so we had the separation between author, actor, stage designer, architect, director, dramaturg, and choreographer. Nowadays you even need somebody to teach you to breathe. More and more positions are created. We have so many unoccupied people working for us and we create more and more working places in our theatres and this is clearly a sign of decline. But the theatre has been in decline for 2,500 years. It doesn't mean that it's not productive but it is in decline, let's admit that. The director came into the business of theatre at a time of and as a sign of decline. It's very important that the director has that in mind.

I always say that the real power of a director is at the very beginning of a show because that is when he decides what he shall direct. Sometimes he is not free to make that decision, especially if he is young. Nevertheless he has the power to refuse. Next he has the power to engage the actors, to decide who plays what. This is an enormous responsibility. When the work starts, it is absolutely clear and necessary that the director, who was so strong at the beginning in organising everything, slowly disappears. And at the very end he has no power because the show is going on. What can he do at the venue? He has no function there. He can say, 'Do it better! Come on! Come on!', but nothing concrete. The audience should have the impression that it was all invented by the actors, even the text. It's fantastic if you can create this illusion.

It's absolutely essential at the beginning that the director gives some indications. Then, more and more, he tries to find out the best solution for the material and the material is the actors. Therefore, as a director, you must go into these actors. You must feel as they feel. You must copy their movements. You must copy their manner of speaking. So, therefore, we have the phenomenon of directors who have this gift of the apes and can act fantastically but only for a maximum of one and a half minutes. It's what I do. I take on the movements of the actor that I am watching on the stage and I follow

him indicating to him how he should do it. I take his acting design and put something on it. It is easy if you see somebody on stage working. You see his faults easily. But how can you interfere? You can only interfere by using the actor's system of movement. You get in there and help him to look at what he is doing. The inventing power of the director is therefore based on what he sees. He is deeply dependent on what he sees. As I become older and lazier, as I exhaust my talent, I'm more and more dependent on the actors bringing something. For even if it is wrong, there is no problem because in time we can get it right.

It's clear that what is going on on stage is a kind of family life. The function of the director is not that of the father, but perhaps that of the elder brother. It is clear that there are plays, theatrical structures, which are very helpful for that, as with Chekhov, for instance. Chekhov is fantastic here because he is a choral instructor; there is no principal role. The terrible thing in Shakespeare is the hierarchy: a strong hierarchy of characters which is parallel to the hierarchical organisation of Shakespeare's society. We are not organised like that. We do not have the strength to fulfil such a hier-achy. We don't like to be at the bottom of the ladder and we don't feel well if we're on top. Chekhov offers the twentieth century a different kind of theatre-making. The fascination comes from the group's relationships. We can work much better together with this. Shakespeare creates a director 'dictatus'. Shakespeare is the author where the most crimes are committed by directors because they feel challenged by the strange authoritarian structure of his plays and they want to be kings there. With Chekhov all the directors are much milder, because they know very well that if they go in at Chekhov like that, they destroy it. A director's approach should always depend on what is needed for the play. I find that the best stage dynamic comes if I am accepted as a brother who has very good eyes. I like the actors to ask me to help them. If I am forced to go in to say some-thing to an actor who doesn't want to hear it, it's a nightmare. I need an actor to ask me, 'What did you see?' And then if I am able to tell him what I saw and I see in the eyes of the actor the glimmer of light that says, 'Oh yes, I understand, I have to change this', I can go on and I'm happy.

AUDIENCE QUESTION 2 Is there any difference of approach for you between directing a play and directing an opera, or would you treat the operas in very much the same way as you've just described you treat the plays?

STEIN I try to treat them in the same way, but it's simply not possi-ble. If I do opera, which I very rarely do, in the first place I have to

accept that I am not the most important element. It is the music which plays the primary part. Therefore, I have to accept a secondary, even a lesser role, because the most important man is the conductor, the person of secondary importance is the set designer, and then perhaps comes the director. Now over the last twenty years we have seen many crimes on the stage because the poor directors have been crying out for attention. They've been inventing ridiculous things and this doesn't help. There is also another development to be seen in opera. More and more singers want to act on stage. God knows why! I sometimes think that it's because their voices aren't so good and they're trying to cover that up with their acting activities. But that's fine with me. When I'm directing opera I am guided by the principle that everything I do on the stage should improve the audience's capacity, not to understand, but in the first place to hear the music better. In many senses, for instance, if you have weak singers, it's better not to invent some huge sets where the voices are lost, but to invent small wooden boxes. You can do a hundred things like this so that the singers feel happy and the audience is able to see the singers and better understand the structure of the music.

To serve is fun and a director should learn that very early. This is my opinion. It is possible that there are other opinions on the matter. I like to serve somebody. I would not have been able to organise a theatre for twenty years if I could not, when necessary, be a technical director or dramaturg for another director if something is going wrong. I enjoyed being Deborah Warner's dramaturg when she did *Coriolanus* in Salzburg. It's sometimes very good not to have all the responsibility. You have to realise this in opera. If you can work like this, it can be really great fun, especially if the musicians are good, like my co-operation with Pierre Boulez who is a fantastic musician. You can learn enormous things from musicians and singers. But I couldn't stage an opera every year – it's impossible and it would kill me. I always leave a distance of three years and that's fine.

AUDIENCE QUESTION 3 How did you find creating your own *Julius Caesar*?

STEIN That was a very special experience because in a festival it is better to do something that is not done all over the place. Salzburg is a producing festival, it is not like Edinburgh which is a receiving festival. All the opera and theatre productions are created there, and so in seven days we have seven premieres. Therefore, in order to get people there, it is necessary to do things that are not staged all over the place. We also have to respect special places. The founding play of the Salzburg Festival was staged by Max Reinhardt, the famous

German director. It was the *Everyman* play, translated into German by Hugo von Hofmannsthal. And that was produced in front of the cathedral in the open air, in a city where 65 per cent of the time it is raining. They have always had a tendency in Salzburg to use special spaces. The whole festival takes place in a space which is based on the horse stables of the Archbishop of Salzburg. They never created a proper festival house or anything like that. So, for the theatre we have a place that is called Felsenreit-Schule which is a horse riding school for the summer; an open air space cut into a really huge rock. This is a space that has no flies, nothing. It is just a wall. It also has an enormous umbrella which means that the space can be closed when it is raining. So what I proposed for this great space which was nearly 50 metres long and seats about 1,500 people, was to do the Shakespeare plays which work best in a semi-open space; plays where it is necessary to shout a little. Therefore, I thought it would be good to do *Coriolanus* and *Julius Caesar*, and then to also put on the other Roman play, *Antony and Cleopatra*, and that was perhaps a mistake because *Antony and Cleopatra* is completely different stuff. It has nothing to do with that theme and I had major problems bringing it into this space.

The other thing is that this place during the festival is totally focused on the festival, like Edinburgh and all the other festival locations. Salzburg, however, is a much smaller town with only a hundred thousand inhabitants. For the opera, there are a lot of people ready to be extras, because, for them, it is fun to participate on stage. And so I decided to do *Julius Caesar* with 250 extras. It is not that I think you need 250 extras to do *Julius Caesar*, you can do it with four or even less. That is no problem. They say that Shakespeare had about eighteen extras for that purpose. For me it was fun and it worked marvellously because these 250 amateurs liked to work. It is my principle to always handle extras exactly as I would do stars. I have no problem with that. Stars, therefore, do not like me. (I have these little egalitarian tendencies and I don't know exactly where they come from. Maybe it's because I'm a German protestant.) It was amateur theatre in the end, it's clear, but it was a beautiful experience. The public liked it and the critics hated it. That happens very often with my shows.

AUDIENCE QUESTION 4 You said you worked with the Russians because you thought they would be wonderful for Greek tragedy, and you could teach them something about chorus work. Could you pretend we're Russian and in the chorus?

STEIN It is clear that the decision of how to create and stage the chorus is really a decision the director must make. You have to

decide how you can get these twelve people to speak the same text. We have no tradition of that. It is not only our theatre that has lost it, Greek tragedy itself also dispensed with it. Euripides' plays can easily be played without a chorus. In Aeschylus it's different. In *The Oresteia*, the chorus is extremely important. Two-thirds of the text is chorus text. The chorus gives birth to everything and at the end the chorus is the protagonist. It is the public prosecutor in the process against Orestes. It takes a part. So, the decision is normally to let them sing, because we are informed that the Greek chorus sung and danced. It is normally done like that with masks, singing and dancing. Nobody understands anything and everyone is extremely bored because two-thirds of the text is sung and danced on a monotone.

I thought this approach impossible, especially because the chorus text is the most 'modern' part of the play, that which is most interesting for us. It's interesting not because it's poetic but because it's so highly political. It is about politics. The chorus are speaking about their problems in the town. They are speaking politically in the way that is really reflecting the role of the rulers and the community, and not unilaterally but from different sides. They are changing their positions, arguing from all sides and finding no exit. For example, they speak about Agamemnon their king and pray that, having won the war, he is coming home and taking over the government once more. He comes back, and whilst praying they say, 'Oh God, no, what has he done over there? Perhaps this has terrible consequences for us, because of the sins he committed there killing all these people. Oh God, I don't want this revenge', and so on. Then at the end they say, 'I do not want to be a winner, absolutely not. I do not want to be a winner and a destroyer of cities. I want to live my life calmly.' And then in the following instant they go on, 'But on the other hand I do not want to spend the rest of my life in slavery.' This kind of chorus language is so stunning and fantastic for us, who at the end of the twentieth century understand that real political thinking involves thinking in contradictions, not having a security exit through some ideology or other. Fighting every moment for the truth, evaluating each side, this is at the heart of all politics. We have been forced to rediscover that at the end of the twentieth century.

It was because of this that I decided to cut all the music, to cut all the dancing and go totally on the sense of the plays. That is the only thing that is really transmitted to us. So what I proposed to the Germans when I worked with the Germans was the same principle that I proposed to the Russians: to speak these texts making yourself understood. And this has the consequence of a kind of noise made by twelve people trying to speak, trying to deliver the sense of what

is to be said. And then slowly they find the means to get this together; speaking, sometimes singing, saying 'You take the first three words and then you take the next three words but it must sound as one phrase', and so on. This is an enormous exercise in discipline, in thought, and in reflection. And if you work it out by the end it is music. With the Russian actors, it was wonderful.

The Russian language is very apt because it's much more musical than German, and much nearer to how the specialists think the Ancient Greeks sounded. All the chorus sections were, from the musical side, much better than in the German production. On the other hand, however, the Russians had problems with the Greek philosophy. Although Greek philosophy is the basis of European philosophy and thinking, the Germans and the English also have a problem with it, but it is nowhere near as desperate as that of the Russians. They cannot understand that in a Greek play, a prayer to a god starts with a reflection about the meaning of that god. The big prayer to Zeus in *Agamemnon* begins with doubts: 'Whatever your name may be'. The Russians found it impossible to pray to 'Whatever your name may be'. All Russians are deeply orthodox, even the most atheistic. So it was terribly difficult. The prayer goes on to state how Zeus came to power, commiting a terrible act against his father. How can you introduce that into a prayer? If you are telling of this kind of fighting, talking first of Uranos then Cronos and then Zeus, it is clear that Zeus perhaps also is in danger of being toppled. This is Greek thinking. It is very difficult to transmit that to Russians. I did not anticipate this and it was my biggest problem. The end of the prayer is when Zeus gives us the possibility of obtaining wisdom through suffering. That is the famous law of *The Oresteia*, taken out of the reality of human existence. The only help is that you get the wisdom through suffering. That is the law that Zeus gives. The end of the prayer says that apparently the gifts of the gods are rather terribly forced on us because the gods can do what they want, governing the whole world. This is full of irony, full of contrast, and full of profane anti-god behaviour.

The Russians didn't understand what they were speaking because they do not feel that. They are pious, they are profoundly irrational throughout Russian history. They have a completely different feeling of time from us. Certain types of Western European thinking are difficult for the Russians to follow. This is especially clear in their acting because their strength is to feel the emotion or to make the feeling profound, to prolong it, something that no German can ever do. Germans can produce enormous emotions but always in outbreaks – pow! – and then it is over. Then you have to wait until – pow! – the next outbreak. This is the German acting style, an expres-

sionistic acting style. The Russians can go into one emotion and can continue within it, weeping for twenty-five or even forty minutes. They can also speak at the same time. It is a wonder for me that they can do both: weeping and speaking Tolstoy or whatever they want. It's incredible. It's also necessary at times to say, 'Stop now!' Nevertheless, for Greek tragedy, it is absolutely stunning to have this kind of visible power there at your disposal.

GIORGIO STREHLER

REGARDED by Bertolt Brecht as the natural inheritor of his work, Giorgio Strehler, the founder of the Théâtre de l'Europe in Paris, is one of the most important Italian artists of the twentieth century. For over forty years, Strehler has created an astonishing theatrical repertoire, and in the process evolved a production style that has synthesised the most significant elements of European theatre.

Born in Trieste on 14 August 1921, Strehler was seven when he moved to Milan, where in 1947 he would establish the Piccolo Teatro, with which his name has been associated ever since. Having trained as an actor at the Academia dei Filodrammatici from 1938 to 1940, he began his directorial career in 1943 after three years of acting in a number of established and experimental theatre companies. His first production was of three one-act plays by Pirandello, an author to whom Strehler has returned at various times. It is a hallmark of Strehler's long directorial career that he returns not only to the same playwrights, but frequently re-directs the same play at significant moments. His first steps as a director were interrupted by war service and internment in a prisoner-of-war camp (where, characteristically, he repeated the production of the Pirandello triple bill), but after the end of the war he returned to Milan and joined forces with the critic Paolo Grassi to persuade the Milanese civic authorities to fund a new theatre in the city. In May 1947, the Piccolo Teatro opened with Strehler's production of Gorky's *L'albergo dei poveri (The Lower Depths),* in a season which also included his first production of Goldoni's *Arlecchino, servitore di due padroni (Harlequin, the Servant of Two Masters),* which has remained in the repertoire of the Piccolo ever since. Strehler has directed it six times, on the last occasion in 1987 (the 'farewell edition'), although only two actors have played the role of Arlecchino.

The founding principles of the Piccolo Teatro established what has continued to be influential in Strehler's work: theatre as public service and the attempt to gain a new and wider audience through working in depth on the text. As the Piccolo established itself over the first decade of its work, Strehler was gradually able to reduce the astonishing volume of work that he achieved in the opening years, when he had been regularly directing twelve or more productions every season in addition to a stream of opera productions at Teatro alla Scala, Milan. By the 1962–3 season, the only new play he

directed for the Piccolo was Brecht's *Vita di Galilei (The Life of Galileo)*. The range of playwrights and styles of texts Strehler directed during this period is staggering, but gradually certain key authors and plays were emerging. Of the numerous he has revisited, Shakespeare, Goldoni, Chekhov, Pirandello, and Brecht stand as markers on a distinctive theatrical journey. His desire to return to certain authors and texts gives some idea of the coherence of Strehler's continuing and unending theatrical quest for a theatre in which 'humanity is called upon to recognize itself' (Strehler, *Per un teatro umano*, pp. 151–2). The continuity of his work also owes much to his extended working relationship with two designers: Luciano Damiani and Ezio Frigerio. Strehler's practice, based always on detailed research, demonstrates an interest in the methodologies of performance and the fluidity of the historical and contemporary function of a play text. Above all, it shows that Strehler's theatre is about tradition and transformation.

Brecht attended the final weeks of Strehler's rehearsals *L'opera da tre soldi (The Threepenny Opera)* in 1956 and hailed it as a better production than his own original in 1928. Since then Strehler has directed another fourteen Brecht productions, including different versions of the same plays and stage adaptations of Brecht's writings. The objective analysis that Brecht brought to the theatre, Strehler has sought to merge with naturalistic acting traditions and the lyrical style of the Italian stage, to create a distinctive quality that has characterised all his work. He claims that what Brecht has taught him is the value of a human theatre that functions beyond the theatre itself.

In four key productions during the 1980s, he elaborated the theme of the power of illusion through critical restagings of *La tempesta (The Tempest)* by Shakespeare in 1983, *Temporale (The Storm)* by Strindberg in 1984, *L'illusione (The Illusion)* by Corneille in 1985, and *La grande magia (The Grand Magic Act)* by De Filippo in 1986. *La tempesta* was the play he chose to open his first season at the Odéon in Paris as director of the Théâtre de l'Europe, which he founded with the support of the Council of the European Community and the French government. Although he did not leave the Piccolo entirely, this new phase of his work away from Milan was an important break for Strehler, and he directed the Théâtre de l'Europe until 1989, when he handed over to his former assistant Lluís Pasqual. Even before commencing his period at the Odéon, Strehler had been intent on the creation of a European theatre at the Piccolo in the belief that people of culture had to play their part in the establishment of an idea of Europe that went beyond political institutions. Where the Piccolo had been conceived as having a clear social role

within the Milanese municipality, Strehler now sought to find a critical function for a theatre in Europe, that acknowledged, respected and challenged boundaries of identity, language and culture. As ever, he pursued his vision of theatre as a means to shape the contours of a new reality, to engender doubts, to ask questions and to demystify the supposed problems of our world.

'The *Faust* Project', seen in various forms at the Piccolo between 1989 and 1992, represents what Strehler has described as the ideal endpoint of all his work in theatre. Characterised by exhaustive research and extended rehearsals, the evolving production of both parts of Goethe's *Faust* plays brought Strehler to the stage to act as the protagonist. He pitched the length and profundity of this classic of European humanist literature against what he sees as the deplorable wasteland of contemporary mass-media culture. The unique and unrepeatable event of theatre as a collective human activity that is both moral in intent and educative in purpose continues to stand at the centre of Strehler's work.

OTHER MAJOR PRODUCTIONS INCLUDE

I giganti della montagna (The Mountain Giants) by Luigi Pirandello. Piccolo
Teatro, Milan, 1947. Schauspielhaus, Zürich, 1949. Schauspielhaus,
Düsseldorf, 1958. Teatro Lirico, Milan, 1965. Teatro Lirico, Milan, 1966.
Sei personaggi in cerca d'autore (Six Characters in Search of an Author) by Luigi
Pirandello. Théâtre Marigny, Paris, 1953.
The *Villeggiatura* trilogy by Carlo Goldoni. Piccolo Teatro, Milan, 1954.
Burgtheater, Vienna, 1974. Théâtre de l'Odéon, Paris, 1978.
Il giardino dei ciliegi (The Cherry Orchard) by Anton Chekhov. Piccolo
Teatro, Milan, 1955, 1974.
Coriolano (Coriolanus) by William Shakespeare. Piccolo Teatro, Milan, 1956.
Io, Bertolt Brecht by Bertolt Brecht. Piccolo Teatro, Milan, 1965, 1975, 1979.
L'anima buona di Setzuan (The Good Woman of Setzuan) by Bertolt Brecht.
Piccolo Teatro, Milan, 1958. Schauspiel, Hamburg, 1977. Teatro
Comunale, Modena, 1981.
Il gioco dei potenti (The Game of the Powerful) adapted from *Henry VI, parts
I–III* by William Shakespeare. Teatro Lirico, Milan, 1965.
Felsenreitschule, Salzburg, 1973. Burgtheater, Vienna, 1975.
Re Lear (King Lear) by William Shakespeare. Piccolo Teatro, Milan, 1972.
Don Giovanni by W. A. Mozart. Teatro alla Scala, Milan, 1987.
L'isola degli schiavi (The Island of the Slaves) by Pierre Marivaux. Piccolo
Teatro, Milan, 1995.

CRITICS ON HIS WORK

Strehler offers us a condensed form of dramatization, an unparalleled command of the theatre's total capacities. He combines an aesthetic sense of beauty with an efficient and critical examination of our society, and he endeavours to bring the spectator the joy of theatre as well as matter for serious reflection about human nature and the world.

(Odette Aslan, 'From Giorgio Strehler to Víctor García'. *Modern Drama*, 25, No. 1, March 1982, p. 124).

Strehler represents the great post-war cultural tradition of Brecht, Jean Vilar and our own Edinburgh Festival. It represents the humanitarian, humanist strain in the European enlightenment and culture, and it defies absolutely the local critical trend, which defines art as Schwarzenegger and TV sitcom. Strehler works in the world he has inherited.

(Michael Coveney, 'An Island Free from Arnie's Grip', *Observer Review*, 8 January 1995, p. 10).

SIGNIFICANT BIBLIOGRAPHICAL MATERIAL

Balme, Christopher. 'Giorgio Strehler's Faust Project: Signification and Reception Strategies'. *New Theatre Quarterly*, 9, No. 35, August 1993, pp. 211–24.
Battistini, Fabio. *Giorgio Strehler*. Rome: Gremese, 1980.
Hurst, David L. *Giorgio Strehler*. Cambridge: Cambridge University Press, 1993.
Kennedy, Dennis, ed. *Foreign Shakespeare: Contemporary Performance*. Cambridge: Cambridge University Press, 1993.
Nadotti, Maria. 'Stages of Strehler'. *Artforum*, 28, December 1989, pp. 117–24.
Ronfani, Ugo. *Io Strehler: Conversazioni con Ugo Ronfani*. Milan: Rusconi, 1986.
Strehler, Giorgio. *Per un teatro umano*. Milan: Feltrinelli, 1974.
Trousdell, Richard. 'Giorgio Strehler in Rehearsal'. *Drama Review*, 30, 1986, pp. 65–83.

Giorgio Strehler – in response to questions put to him by the editors and Eli Malke, 4 October 1995, translated by Peter Snowdon

QUESTION Is it important that every director should have had the experience of acting?

STREHLER Personally, I think that it is indispensable that a director should have some experience of acting. I'd even say that he should have the experience of 'being an actor', and of being a good actor. I don't mean that someone who wants to be and to call himself a director does not need to have qualitites that are specific to that function: the ability to communicate, to offer pertinent criticism, a deep and wide-ranging culture – by which I mean not merely a literary culture. For instance, I think it is crucial that a director should know music and have a truly musical sensibility. I don't like and I don't trust 'literary' directors, or directors whose main preoccupation is the 'visual'. Moreover, I think that without a certain dialectical frame of mind, the ability to see and argue through many diverse points of view, the ability to work collectively with actors, design-

ers, musicians, and so forth, it would be wrong to take on a trade which is, in the last analysis, as imperfect and imprecisely defined as that of directing for the stage.

I love the theatre which is 'made', not the theatre which is 'talked about'. I think of the stage as a place of truth, where we discover our own truths, those of others and those of the text itself, which is the prime mover of every show we put on. The undeviating search for the truth of the text, the painstaking search for the dramatic work of art, these are the essential tasks of the director. He must work not only from 'outside', but also from 'within'. He must be entirely involved in the performance, and at the same time be able to 'see himself', as if he were looking on. That is why it is useful, necessary even, to know the theatre from within, to know the trade of those who interpret texts through their own voices, their own bodies, their own intelligence and sensibility. For the theatre is made of these: flesh, blood, sound and thought.

Only through the final test of the stage, only by 'playing' the part or parts himself, whether for real or potentially, can the director discover that truth for which he is searching. Mere knowledge, whether poetic or literary or plastic or phonic, is not enough.

The case of the orchestral conductor is very instructive. It would be unthinkable, not only that a conductor should not know music, but that he should not also know how to play at least one of the instruments of the orchestra. Conductors must know how to play (and some of them have been great pianists, violinists, or cellists – such as Toscanini). They must understand the techniques of the different instruments, their different characteristics, in order to be able to 'direct'. I don't understand why all this is not obligatory also for those who want to direct theatrical performances. It is by beginning in humility, as a simple interpreter, that is, as an actor, that one may slowly discover in oneself a series of mental dispositions, characteristics, qualities or even defects, which lead one to think of becoming a 'director'. For by a director, I mean an actor who has left the chorus of actors and has come to stand between them and the audience to help them to co-ordinate their gestures, to understand themselves better, and to understand better the action which they seek to represent.

There is no such thing as pure 'directing', or at least there should be no such thing. Certainly, I think those directors are highly ridiculous who, for example, put on an opera, that is a piece of theatre set to music, bragging that they know nothing and care nothing for music. And there are so many of them!

QUESTION How has the Piccolo Teatro evolved up to the present day, in response to changing political realities?

STREHLER The relationship of the Piccolo to politics has always been very important. I'm not talking about the 'little politics' of the politicians, even if I have been one of them and still am one, and have as a citizen taken on the burden of sitting in the Italian senate and the European parliament. I'm talking about politics as a set of 'founding ideas'. The Piccolo's history is my history. I am involved in history as a man, and so the theatre I make is inevitably involved in the same way – 'committed'. This is a word which people shun nowadays, and in some ways they are right because too many artistic crimes have been justified in the name of 'ideological art'. But my commitments are part of my life, and I do not consider my art as taking place outside of life. It is not an escape from life, a holiday. For me, art is a reflection of the life of the world. But at the same time, I have never loved a dramatic text for its 'content', independently of its aesthetic truth. In art, form and content are one and the same thing. There is no content which is truly in need of theatrical representation which does not already, at the same time, have a poetic, aesthetic reality – or is seeking after that reality. Just as no aesthetic beauty, no harmony or discord of forms, can have a reason to exist in the theatre if it does not contain within it something which has to be said.

That is why the story of the Piccolo is one with the historical and aesthetic experiences of the present time. It has followed their contradictions, espousing certain points of view and opposing others. It has tried to speak to its audience about doubt and hope, certainty and confusion, using poetry as its means – what we call inappropriately 'beauty', the organic unity of meaning and feeling. Every day is different from every other. Every idea or form changes with time, changes imperceptibly for the actors every evening that they perform. Over a period of years, these changes can be seen more clearly. What is difficult is to be faithful to one's own authentic vocation, in the midst of changing fashions, and despite one's own faults, one's own weaknesses and blind spots. However, if one is always searching, one is never truly blind. If one is always searching, one never stands still, even if that doesn't mean that you don't have a certain idea of the world, and a certain attitude towards life.

QUESTION What does the idea of an 'ensemble' mean to you? What changes for you when you work outside the Piccolo?

STREHLER I have a deep-rooted and ancient idea of what an ensemble is. I love the theatre only when it is a family, a fraternity, a house filled with parents, children and cousins. I don't mean by this that I think of the family as a pure harmony. For a family is also a space of dissent, and of abandonment. But the theatre-as-home is the only

one that for me is worth the effort. Not because it is easier to work with people whom you know and who know you well, but because the moment of truth for any 'theatre' is not producing a single show, but constructing something all together which lasts through time. A theatre which doesn't last, which cannot bring together many different talents (women and men) so that they live together and stay together, with a single aim – to tell, as well as they know how, human stories, (true or made up, who cares?), to other human beings, every night – such a theatre isn't worth anything. And that is why my life in the theatre has been identified with the life of *a* theatre. That is why the Piccolo ensemble has changed over the space of fifty years, necessarily, inevitably, not through rupture and conflict, but rather by the handing on of witness from the older members to the younger, who have then in their turn aged and handed on their witness to yet others who have come after them.

The Piccolo is a theatre which has, and for me this is its great glory, the vision of a family troupe. Of course, I have put on shows elsewhere (though not many), for example abroad, in Germany, Austria and France. Each time, the composition of the company was decided according to different criteria. But I think that each time I was able to recreate in some way the impossible ensemble I'm always looking for, and in the space of a few months to build a company up right from the foundations. My actors who are not Piccolo actors are still today my companions and my friends in the different parts of Europe to which they belong – they are not simply for me actors or technicians by profession. And this has made me think that finally, the idea of a theatre as a group of people who come together to work hard, yet joyfully, who know how to love and how to forgive each other, and who are happy in what is both the most terrible and the most beautiful trade in the world, does not depend simply on a place and a time. Perhaps it depends as much on the human capacities – the merits and the faults – of their director. On whether he has love for them, respect for them, or not.

QUESTION Why did you found the Union des Théâtres de l'Europe in Paris? What are the aims and the function of this association? Why is it important for you?

STREHLER The Union of the Theatres of Europe was created after the foundation of the Theatre of Europe in Paris. It is a free association which as of today counts sixteen public theatres in Europe as its members, with the aim of helping them to exchange work, shows, ideas and impressions. And also to exchange directors, actors, designers. It is an instrument of mutual understanding and assistance to us in our work. The potential of such an undertaking in the

field of the theatre is enormous. However, the limited funds made available to us by the European Community and by France (which, nevertheless, is the only European country to contribute financially) hinder us in achieving what we could and should be doing. Yet we have already done much. At this moment, there is a production of Shakespeare's *A Midsummer Night's Dream* currently in rehearsal with actors from five different nations, each speaking their own language on stage. Perhaps this is, for my taste, an extreme example – a 'dare', a challenge. But we are close now to the moment when there will be a generation of European actors who are bilingual or trilingual, and these actors will form the basis for a new European theatre. Everything points in that direction.

This doesn't mean that the national theatres of the different countries should stop performing in their own languages and their own traditions. The Europe I look forward to is one of diversity and particularity. Not a 'standardised' Europe, but a Europe of an ever easier and more meaningful exchange of ideas, talent, abilities, methods and styles. Such a Europe may be a great source of strength to sustain our common humanistic culture which is today suffering a profound crisis.

QUESTION Who were your masters? And in what ways did they influence you?

STREHLER My masters were both many and few. Many because many people, even without their knowing it, have given me much, while I was learning my craft and still today. I never go to the theatre and leave without having learnt something. I have never learnt nothing from a performance. At the very least, I have learnt how *not* to do something. And that's already a lot.

There are countless ways of being a master to someone. But my most direct and essential apprenticeship I owe to Jacques Copeau (and through him, to Saint-Denis). I got from him a sense of the sacredness of the theatre and of the text, a sort of 'nudity', and along with this, the struggle with oneself to be modest, not to do everything one wants to, but all that the work itself wants and only that. It is essentially a Jansenist idea of the theatre, a religious conception, even though I am not a religious person. But what is religious, if it is not the act (to go back to the etymological meaning of the word) of putting together, and binding together (*religere*) things, words and people, into theatre? What is the search for truth, for authenticity? The only prayer perhaps that is possible for someone who has no metaphysical faith.

Next in order among my masters, I place Louis Jouvet – and he was indeed a master! He too was a student of Copeau, but his work

had quite another emphasis. Jouvet was the person who taught me to enslave myself to the theatre; who showed me the triumph of the theatre, but also its extreme vanity. There was in Jouvet a contradiction between an ascetic vision of his craft, and an irrepressible theatricality always avid for 'success'. He was not like Copeau used to imply towards the end of his life, when he would say: 'Ah! Jouvet is only interested in success.' For Jouvet, success was the only way of being together with others. He sought it, but not at any price: on the contrary. You only have to think of his *Don Juan* or his *Tartuffe*. Especially the latter – impetuous, hard, without concessions. 'Molière is a tragic author', he would say, 'who worked as a comic actor!' And that is why he was so notorious, so often criticised or hated, even if he was a success with the audience.

Perhaps that is why I, too, believe in this encounter with the audience. But without making any concessions to achieve it. I am extremely hard on myself, on the audience, and on the work of art. I don't do anything in order to 'please'. But at the same time it's obvious that our job as performers is to give pleasure to the spectators. The quality of this pleasure depends upon our ability to be artists and, at the same time, beings whose purpose is to communicate.

Jouvet also gave me his conception of the actor – that is, of his solitude, his extremity, his self-restraint in the face of humanity. This is one of the dangers of the theatre, that shuts its people away in a circle of customs and rituals, cutting them off in many ways from life. That is why at a certain point this happened even to Brecht.

Brecht was my last true master in art and in life. He resolved for me the dilemma with which I found myself confronted at that time: if we have to give everything to the theatre, if the theatre is a mysterious, sacred, inviolable place, then where is man in all of this? Man with his ideas, his contradictions, his beliefs? Are all these things opposed to the theatre?

Jouvet had no sense of history. He was not really a part of life. Brecht taught me, taught all of us, that only by living as men, with our own particularities, our own thoughts, can we face up to the task of the theatre. The more you assume your role as a member of society, the more you take your place beside other men, the more you participate in history, on whatever side, then the more you will discover about the characters you have to play. For a character is not an immutable abstraction. It is a changing reality, even though it remains fundamentally one. You must see the theatre as a place of mutability, of dialectical fact, and you must have the courage to be one thing and not everything, to express one possibility contained in

the character and in the text, and not all of them. A theatre in which there is no point of view is an empty theatre.

Brecht taught me doubt, the fundamental essence of dialectics. To live dialectically with oneself and with the world is difficult, but for me it is essential. Dialectics doesn't mean that you believe that everything is only ever contradiction and that it is impossible to have your own ideas and to fight for them, whether in life or in art. But it means that you are always able to change your ideas, that you are not bound for life to an 'ideology', and that you can also seek for truth in opposites. For those of us who were his students ourselves, the image of Brecht as a Stalinist and a rhetorician of authoritarian Marxism has always seemed a grotesque mistake. Brecht was a libertarian socialist for most of his life. He belonged to the great minority current of real socialism, that of Rosa Luxembourg, Korsch and many others. He detested the socialist realism of Zdhanov. He fought for a theatre of reason which would not exclude the emotions. For him, critical thought could not be deprived of its irrational dimension, its poetic dimension. A theatre of reason, therefore, should be able to move people more than a theatre that was made only with emotions.

There is also a technical side to what I learned from Brecht. Brecht, in my opinion, was a very great director. His vision of the craft of actor and director is the most comprehensive that I know of, even if it is true that his writings on the subject are often too theoretical, too dry. Anyone who was close to him for a time, as I was, will have drawn from this experience a fundamental lesson.

And then in the end there is also myself, of course, as master of myself. I too have taught myself much, and have learned through my experience my own way of making theatre. We are all of us our own masters, for better or for worse.

And behind all these figures there is, as ever, the shade of Stanislavsky, and the great, contradictory experiences of his students, first among them, Vakhtangov.

Can you have a master whose shows you have never seen? I believe that you can, if you have the love and patience to know how to read what he has left behind and to try it out on stage. But such a legacy always has its limitations. The theatre does not last. We are part of it only as long as we survive ourselves. Poets, on the other hand, do survive. That is the great difference between the performer and the poet who writes. Many directors and actors end up thinking that they are themselves the authors of the works they perform. This is a fundamental mistake.

QUESTION What would you most like to change in the way actors are trained nowadays? Are there things which actors now do not know

how to do, compared with their predecessors in former generations? And what are they able to bring that marks them out as different?

STREHLER My work with an actor is to bring him awareness, help, encouragement and criticism, and to encourage his love and stimulate him to criticism, so that he should not be merely a passive actor. In this sense, I think contemporary actors are either too 'personal', that is, believe only in themselves and in what they think is the text and the character, or they are 'objects' who wait for the director to tell them what to do and think. Neither of these categories of actor is much use to me. For me, the actor must be at once the 'object' of the text, and at the same time a being endowed with fantasy, freedom, creativity. He must be able to propose new, original solutions. Actors of the preceding generation had to fend for themselves, do everything on their own. This led them into terrible misunderstandings, and to theatrical solutions which were often false or too comfortable; but it did oblige them to be creative, and not mere instruments. The whole problem is to be an instrument that plays by itself the music that is to be played, an instrument which is its own character, has its own personality. For ultimately, the terrible difficulty of being an actor is that you have to become an instrument that plays itself but follows the notes set down by another. For me, this work must always be an act of love. Without love, without sharing in this work together, the theatre doesn't exist.

QUESTION Is it possible to train directors? If so, how?

STREHLER It is difficult to train someone to be a director. There are no approved methods. The only way I know is to give young people a grounding in the craft of the actor (and that in itself contains so many problems!), and then, for some of these students, have them stand beside me during rehearsals. In this way I show them what I do, not because they will want to do the same thing in the same way, but so that they can see 'how' theatre is made. Then I give them some direct, though limited, responsibilities. Then greater responsibilities to those who seem to me to have the most obvious predisposition to guide a performance. And so on, up to the point at which they themselves become directly and solely responsible for a theatrical work. And then each must act for himself. Notwithstanding the training which I, like others, have received, in the theatre every performer is alone in finding his way. He may have had someone to stand behind him, to offer help from time to time. But that is all.

QUESTION How has the role of the director evolved over the years? Have these changes been beneficial to the theatre?

STREHLER Certainly the role of the director is what we might call a 'contemporary' problem. Since, say, Stanislavsky, this role, and above all the methods that go with it, have changed. But this is not a fundamental change. Styles have changed, but very often, too often, this is only a change of mannerisms or of fashion. The work of the director remains the same as ever. That is not the problem. The problem is the excessive emphasis given to the director's role, which has in the last few decades gone far beyond that which has been placed upon the actor since the eighteenth century. This is not healthy. Instead of going to see how Mr X or Ms Y are in such and such a role, now the audience goes to see what the production of Mr X or Ms Y is like. But in the theatre, you should go to see and to hear what the work of art has to say to you. You shouldn't go to see how an actor interprets Hamlet, or what a director thinks about Hamlet. You should go in the hope of being given only *Hamlet*, produced and acted artistically, correctly. The director has become too much of a star, like the great actors of the eighteenth and early nineteenth centuries. Everything has to be brought back down to scale. Our role is to help people to love the theatre in all its complexity, and, above all, the text. This isn't easy; the theatre is an art that has to be communicated by others. These others exist, they are there, they speak, they cry, they laugh, they die, and the audience ends up identifying them as the sole protagonists of the spectacle. But they are not. And if they are, this is the fault of the performers, and of the spectators who often need to love or hate the performers in order to love the theatre. Directors have contributed much to the invention of modern theatre, but they have also often given a skewed image of what the 'Theatre' is.

QUESTION Do you sometimes (often) continue to work on a show after the first night? Why do you choose to produce for a second or third time plays which you have already directed?

STREHLER I never rework a show once it has opened. I don't have the time, and perhaps I don't have the desire either. But from time to time I bring the actors together and I point out their mistakes to them. Often, moreover, it is they who tell me where I've gone wrong, and who point out to me how the audience reacts. But we only rehearse again if there has been a pause of more than four months in the run, or if there's been a change in the cast.

As for the fact that I sometimes do new productions of works that I've already directed, this is an opportunity to refute a claim that has often been made. For decades now people have given credence to this lie, perhaps because the life of *Harlequin, the Servant of Two Masters* has extended to forty years almost without interruption, and some people thought that this was the same production. On the con-

trary: there have been at least six different versions of *Harlequin*, with different actors, and only Ferruccio Soleri in the title role remaining unchanged. Before him, the role was played for fifteen years by Soleri's master, Marcello Moretti. All this story would deserve a section to itself, for this has truly been an extraordinary adventure. Besides *Harlequin*, in fifty years of working in the theatre I have put on around 250 straight theatre shows and forty-five operas. The so-called continuous 'remakes' constitute a tiny proportion of the whole. But this has been blown out of proportion by a number of those who worked on these shows, in a manner which, if not directly denigratory, is at the least historically inexact.

Let us look at the reality. I have produced *The Tempest* by Shakespeare twice and each time quite differently. After so many years, I felt the need to converse with the play again, after my youthful version – certainly *too* youthful. The second *Tempest*, more than twenty years after the first, is one of the shows that is dearest to me, and which was for me, in a certain sense, intended to cancel out the other, which had been an open-air show, and critically quite insufficient. After many long years, I think I have understood what *The Tempest* is about, at least in part, what an absolute masterpiece it is, how inexhaustibly profound, and how much maturity is required to produce it.

Twice I've mounted *The Cherry Orchard* by Chekhov. My motives were the same: to produce another show. Not a remake, but a new and completely different version of a text which has the same title.

Three times I've done *The Threepenny Opera* by Brecht: once in 1956, and then again a few years later, mainly because around half the original cast were dead, or no longer in my company. The second show was very like the first, but with a radical change in period and costume. The third production was a few years ago in Paris. I worked with French, German, Polish and Italian actors. It was an example of a Theatre of Europe. This version seemed to me right, and quite close to the other two even though we were in a different country. The audience liked the show a lot; the critics hated it. I still don't know why, and I don't suppose I ever will. Certainly it was in large part a political judgement: it was the last days of the socialist government in France. There was a great sense of the coming restoration. But that's not sufficient. For me it is still a mystery. I've had the opportunity to watch extracts from the show that were shown on television, and I still can't see the horror of what I'd done. Pretty much the reverse, in fact. When a French journalist asked me what I thought about this response, I replied that it was the only time in my life I'd been at a complete loss for an explanation. In any case, that is the past. What interests me now is the future.

QUESTION What are your theatrical projects, in both the short and the long term.

STREHLER Right now I am beginning rehearsals of *The Miser* by Molière. It is my second Molière (which is too few), after *The Misanthrope*. Meanwhile in the Studio Theatre, there is a season opening devoted to Brecht (aptly enough). The Brecht Festival will run for a year and will force the intelligentsia and the audience to come to terms again with Brecht, who in these last few years has become something of a *poète maudit*. For my part, I will be producing *The Good Woman of Setzuan*, which I think is a masterpiece. I will put on *Mother Courage*, with no fussing over its 'modernity', but with music and linked to the present day, as has been done in France. I'm preparing a new programme of Brecht songs, I will give a reading of the *The Life of Galileo*, and in the first person will present an evening around 'Brecht, the forgotten poet'. And I will give three public lectures, with demonstrations by pupils from my school, on 'Epical-dialectical theatre'. The European tour of *The Island of Slaves*, which has been a great success with both critics and audiences, will continue. And in Vienna, at the Burgtheater, the performances of the German version of *The Giants of the Mountain* will continue.

As for the future, 1997 will be the fiftieth anniversary of the Piccolo Theatre. And we expect that finally, after ten years of waiting, the new theatre building will be finished. A 1,100-seater modern theatre. But not a science-fiction, ultra-mechanised theatre. It will be a theatre where many things are worked by hand.

At the moment, I am musing on future projects. I will certainly put on the *Memoirs* of Carlo Goldoni, a theatrical event which I have created myself from the text of Goldoni's memoirs. As for the rest, I cannot say much. For what seems like an eternity, I have been unable to find the courage to take on *Antony and Cleopatra*, and *Hamlet*. Perhaps this will be the moment?

QUESTION What is the relationship between Strehler the man of the theatre, and Strehler the politician.

STREHLER The relationship between myself and myself is a relationship of dialectical loyalty. The politician Strehler is not a politician *tout court*, his politics are also a 'theatrical politics'. This does not mean that I do not intervene in the European debate, or the debate in my country (whose tone has now sunk so low). But I do so 'after' or 'alongside' the theatre. The theatre always comes first. But it is not unrelated to the rest. I think I have one fault or one quality, I'm not sure which: that of being always consistent with myself, or almost always. What I am and what I think, I express through politics as

through the theatre, using different means in the two cases. There is no conflict, no gap. My theatre is not political theatre as such, but it cannot help being political, as it is other things. It has to be so, because I am so: a man of the theatre, but also a man in history. I cannot be just one without the other. I am always looking for what is just, what is true, what is poetic.

QUESTION You have set up several large-scale projects – *Faust*, the Brecht year, etc. Tell us about how they were planned, how you manage to draw an audience for such long and often demanding projects, what the financial risks are, and how you explain the success you've always had in these ventures.

STREHLER The *Faust* project was designed to lead to the performance of the whole of *Faust* over a period of four years. Then we realised, and I was the first to admit this, that this would not be possible, for reasons of time, ability and money. Thus the Project became 'Research on *Faust*-Fragments'.

In this way at the end of the four years, we performed, with myself taking the role of Faust, about 6,500 verses taken from the two parts which form the work. We didn't make 'cuts', we were looking for a different way of representing the work. Some parts were left out entirely, and we said which and why. Others were performed as a full-blown production, others again were simply read by myself and by other actors. We divided the fragments into four evenings, each of which lasted about two and a half hours. So out of *Faust* we made a show which lasted ten hours. We would need about as much time again if we were to do the whole text.

Of course, this work included the making of a completely new translation of all the parts we performed, which was for me the greatest literary task I have ever undertaken in my life. To manage to produce at least half of *Faust*, in fact more than half, we all of us had to give up four years of our lives. And during that time I could not think only of *Faust* – I also had to keep the Piccolo Theatre going. But through all that time, *Faust* was our principal obsession. Financially it was a very expensive undertaking, but in its form the show was quite 'poor': a lot of lighting, of music and costumes, minimal sets (a circular space, a small pool of water sometimes in the centre, a magic spiral for a ceiling – that was about all).

Faust was also a living exercise for the school. All my students in the first and second years took part in it, as if it was a class. I think that this lesson, which took place not in a classroom but on the stage, surrounded by an audience, taught the students more than ten years of an ordinary education. Today I am more convinced than ever that, apart from a few special aspects, the craft of the actor is to be

learned not by reciting a scene on a dais before a professor, but on the real stage, even if one has only a walk-on part with no lines.

As far as the audience was concerned, *Faust* taught us also that sometimes we should have faith in great works and in contemporary audiences, even when so much television may have led to a general degeneration of taste. Every evening the Studio theatre (410 seats) was full. And the make-up of this public was new and surprising: about 70 per cent of them were young, very young. For many it was the first time they had been to a theatre. I am sure that this first experience will have set a decisive and demanding standard in their spiritual lives.

JATINDER VERMA

IN October 1994, James Woodall, writing in the *Observer*, proclaimed Jatinder Verma to be 'one of the most talented directors working in British theatre today', confirming the reputation of a man who, for twenty years, has been confronting audiences with his provocative fusions of Indian and European theatrical traditions.

Born in Dar-es-Salaam, Tanzania, on 17 July 1954, Verma arrived in Britain at the age of fourteen with the exodus of Kenyan Asians from Nairobi. After taking a First Class Honours degree in History at York University, he completed an M.A. (South Asian Studies) at Sussex University before co-founding Tara Arts in 1976 in response to the murder of a South London teenager in the Southall riots. Although Tara Arts began as a community theatre company, only touring out of London at weekends, it has subsequently acquired national prestige and an international reputation. In twenty years it has toured nearly fifty productions, ranging from contemporary issue-based plays to the classics of the world stage. In 1986 the company moved from local and regional funding to become the only Asian company revenue-funded by the Arts Council of Great Britain, a status it has maintained for ten years. Verma has directed, written and adapted most of Tara's productions and remains its artistic director. The early plays, such as *Chilli in Your Eyes* (1984) (about unemployed Asian youth in London) and *Salt of the Earth* (1986) (based on Gandhi's life in London), dealt directly with Asian experiences in Britain, examining the internal tensions of an immigrant community within a racist society. This perspective has not been lost in recent years when adapting classic texts to Indian settings, which highlight the uncertainties and aspirations of postcolonial Britain by fresh and often irreverent re-readings of familiar texts.

Following the success of his dazzling adaptation of Gogol's *The Government Inspector* in 1989, the following year Verma became the first director from among Britain's migrant communities to be invited to stage a play at the Royal National Theatre, where he created his own adaptation of Molière's *Tartuffe* (1990). Verma drew on existing English and Hindi translations as well as the original French, to create a transformation of the original into what he called an 'Indian play'. The distinctive 'text' for the production came as much from the confrontation of high and low art forms as it did from the meeting of European and Indian cultures. Verma delights in the interplay of performance styles and seeks always to reveal both the

resonance and dissonance in the cultural encounters he creates. The production skilfully incorporated techniques from Kathak dance and Khayal music with Bhavai and other popular forms of Indian entertainment, to create a richly sensual and intensely physical production, that never lost its comic force in the powerful philosophical and political reading that Verma sought for the play.

The eclecticism that is identified with Verma's work is neither casual nor random. The connections that he makes between Indian and European culture are integral to his own search for an understanding of what it is to be Indian in Britain today. He draws on hundreds of centuries of Indian performance tradition and reveals that European theatre is still in its adolescence, but also acknowledges the European literary tradition that formed his education and still informs his work. The relationship he explores between India and Britain has been a part of the British literary legacy this century, but never before has it been explored with such vitality, integrity and theatricality, nor with such intellectual rigour.

In October 1993, Verma directed Tara Arts in their first Shakespeare production and he chose the conflict-strewn battleground of *Troilus and Cressida* to pitch his visually powerful theatrical challenge. The production found a strong racist context for the play in its historical origins and its reflection in contemporary events in Bosnia, while the mixed company of actors played the Trojan battles out with the costumes, props and instruments of an ancient Indian civilisation. The emotionally charged, elegiac production did not always find critical favour but it provoked intense debate and much respect for Verma's continued quest to deal with the realities of multicultural theatre and society.

With *The Bourgeois Gentilhomme* (1994) Verma returned to Molière and produced a farcical, robust reading of the play, which experimented with the physical and verbal language of theatre. His exploration of the English language (and its linguistic shifts and migrations) engaged the text and the audience in a series of negotiations that reflect Verma's belief that Asians, by the act of immigration, are in themselves a 'translated' or transformed people. In 1995, Verma returned to the Royal National Theatre to coproduce with Tara Arts a version of Edmond Rostand's *Cyrano de Bergerac*, updating the play to the British Raj of the 1930s. Once again working with Magdalen Rubalcava, who has designed productions for Tara Arts over the last ten years, Verma translated and adapted the play in association with the distinguished translator Ranjit Bolt.

Verma is a frequent speaker at conferences, universities, on radio and television in Britain and overseas. He gave the 1989 Sir George Birdwood Lecture at the Royal Society of Arts and the keynote

speech at the First Asian Theatre Conference in Birmingham, 1994. In 1990 he was awarded the *Time Out* Special Award for his bonding of Asian, European and British cultures.

OTHER MAJOR PRODUCTIONS INCLUDE

Danton's Death by Georg Büchner. Tara Arts, London and British tour, 1989.
Oedipus the King by Sophocles. Tara Arts, London and British tour, 1990.
Heer-Ranjha adapted from the epic poem by Waris Shah. Tara Arts, London and British tour, 1992.

CRITICS ON HIS WORK

[Jatinder Verma's productions] are the most consistently shining example for the whole of British theatre, of how many possibilities lie beyond realist drama. They are a window on the world every bit as successful as our international seasons, and it is a *modern* sensibility at work. They re-invent the classics. These are not mere classic revivals.
(Jim Hiley, *Kaleidoscope*, BBC Radio Four, September 1994).

Working with Jatinder is always an enriching and exciting experience. He has an amazing gift of reaching over the cultural and language barriers in theatre to encompass both traditional and modern idioms and forms: he makes you rethink them. He is both inspiring, and very human and witty – only he could find the word 'Binglish'.
(Cicely Berry, voice director of the Royal Shakespeare Company, unpublished interview, September 1995).

SIGNIFICANT BIBLIOGRAPHICAL MATERIAL

Brace, Marianne. 'After Bollywood, Binglish'. *Independent*, 9 November, 1994, p. 25.
Owesu, Kwesi, ed. *An Anthology of Black Arts and Culture: Storms of the Heart.* London: Camden Press Ltd, 1986.
Verma, Jatinder. 'The Challenge of Binglish', in Patrick Campbell, ed. *Analysing Performance.* Manchester: Manchester University Press, 1996, pp. 193–202.
Woodall, James. 'An Indian Gentilhomme'. *Observer Review*, 30 October 1994, p. 6.

Jatinder Verma at the Manchester University Drama Department, 10 February 1995

VERMA I'll start with a story that I like very much which sums up why I'm in the theatre and the kind of attitude I have to the theatre. The story is about the origin of theatre and it comes from an Indian treatise on the art of performance that was written around the fourth

century AD. In my view it is the most comprehensive theatre manual anywhere in the world. It not only looks at how performers are to achieve their various effects, but it also analyses the different types of plays, the different types of spaces in which these plays are to be performed, and the different types of audiences for these different types of plays. A most extraordinary treatise.

But it starts off with the origin of how this new art form came about. The story goes that there was a time, of course before mortals were around, when the Gods got into a state of absolute sin – boozing away all the time, having all sorts of pleasures, you name it they were doing it. So a moment came when the three great Gods came to a man called Bharata. Bharata is also a generic name for India, but for the moment let's assume that there was this man called Bharata. And the Gods said, 'Listen, we are really in a bad state, can you come up with a new form of knowledge. A form of knowledge that will be a delight to the eyes and ears, and most importantly teach us, the Gods, a better conduct of life.' Bharata agreed to take the commission on and went into the Himalayas for a year and a day to write his treatise on this new art. When he'd completed it he passed on the new form of knowledge to his hundred sons (Indians were also very prolific in those days), and they became the first theatre company in the world. Quite naturally they had to do their first performance, so all the Gods assembled to see the inauguration of the new art form and this troupe began their work. For some reason, during the course of the performance these hundred sons of Bharata ended up taking the piss out of the Gods. As you can imagine the Gods became terribly angry and they all rose up and banished these hundred sons of Bharata to the earth to ply their trade amongst mere mortals as perpetual outsiders.

That is why I am in the theatre. It is an absolutely perfect story and I can pick out three strands from it. The first is the notion of provocation. I keep asking myself, 'Why?' They were commissioned by the Gods, so why did they feel it necessary to lampoon them? Couldn't they have restrained themselves? Couldn't they just do a nice show? Why did they feel it imperative to do what they did? It could be that it's because they were unruly children. It could be that they were playful. It could be that they were mischievous. All those qualities are what makes a performer. A performer is weird. We're out of joint with society in some way. We either have great highs without the use of any drugs, or we have great lows. Usually the lows are when we are out of work. But we cannot resist this one thing, which I think holds all performers in common, which is the spirit of playfulness: wanting to play is endemic to the nature of performance. It's that spirit of playfulness which is initially a

provocation, because anywhere in the world, the audience is not usually one which can 'hang out'; theatre requires some kind of foil against which to perform.

Theatre is defined as a conflict between two contesting forces which in some way or another is resolved. That is also, essentially, the nature of being a performer. That sense of provocation is something which, with Tara Arts, we have acquired rather than consciously thought of. I came across this story half way through a twenty-year career, so it was not something that inspired me at the very beginning and therefore led me into this course of wanting to be provocative. The very first Tara Arts production was of a play written in 1917 by a man called Tagore. In 1913 he became the first non-European to win the Nobel Prize for Literature. Today of course no-one knows him. In the early years of this century he was greatly influential in Fabian philosophy, which is very much a part of the current British Labour Party's thinking.

Tagore wrote this play in 1917 because he was opposed to the First World War. He was a confirmed pacifist and decided the only way to get his point across was to write this play. Extraordinarily enough, he did not write what was expected of him, which would be a contemporary play. He wrote a play set in sixteenth-century Bengal, which is where he was from. The play dealt with the vicious power of dogmatism, of people holding on to an idea without any notion of humanity and therefore leading to bloodshed. It seemed to us amazing that here was this writer writing about events which were of concern to the world, but who was not known to our time. And we chose that as our first play to do.

That very act of finding a text which was unknown or part of the hidden history of England, put us on a line of provocation. Certainly it was a confrontation: who is this person? How come you're doing this play? We went further in that we adapted the play to make it comment about contemporary events: Ireland, the relationship between whites and Asians, and indeed amongst Asians themselves. It was a pained look. Without knowing it, what we had arrived at was a position as critics of society. That will always force us into some awkward situations, but that's the only thing that is of any value. That's the only responsibility that we have if we are in the theatre, given that we'd accepted that we were not in the theatre simply to have a good time: though naturally we also had a good time.

But there's another thing that comes out very obviously from the story: always bite the hand that feeds you. This is something very dear to my heart given that at the moment we are supported by the Arts Council and various other funding bodies. Increasingly, given

that the arts funding structures are beginning to dismantle, we are all forced more and more into commercial sponsorship. How much do we toe the line? Barclays Bank or Lloyds Bank or someone else gives us money to produce a play. What is our responsibility? To give them what they expected? Once again I look back at the story and say, 'No. Fool them. Use them by all means. Tell them every lie in the book. Please them, but then do what you feel is necessary and what you feel is right. If that means trampling on their feet, then take your chances.' You might be surprised at how many people can actually take criticism. It's easier said than done, and again I have to refer to some earlier experiences.

After doing our first play, we'd begun to get around within our own community in South London. People thought we were a bit odd, but at least we were doing something which was part of our culture: 'at least they haven't gone bad and are doing Shakespeare, so maybe we can tolerate them.' Within the local community there is a yearly festival which is the Ramayan festival, and this particular community organises a big day with a variety of shows. And usually they want to have a play. After about three years they said to us, 'Why don't you do a play on *Ramayan*.' And I thought, 'What a wonderful idea as the whole festival is based upon this epic.'

There are only two major epics out of India, one is *The Ramayan* the other is the *The Mahabharata*. *The Ramayan* is sort of the equivalent to *The Odyssey*, except that *The Odyssey* in comparison looks more like travels along the Adriatic coast, whereas *The Ramayan* is massive and really does traverse the entire continent. *The Ramayan* has over the years been appropriated by a variety of religious forces, so the characters have now become iconic. They are very much 'holier than thou'. The relationship between the husband and his wife is extremely pure; she's terribly loyal and all the rest of it. But in the original epic there was no religious connotation to it; it was simply to do with this particular man and this particular woman and the kind of adventures they went through. She willingly shares exile with him for fourteen years, and then is abducted by some evil guy. He wins her back and then exiles her. The reason for exiling her is that she had been with another man, and so she had dishonoured him. This is not his feeling but this is the feeling of the society, so she has to put up with the exile. We felt this was worthy of examination, so we concentrated the whole play on this woman and the way she saw her husband. Quite naturally the play didn't go down well at all in the midst of this celebration and our grant, the money that we were going to be paid and on which we were supposed to be basing our next play, was withdrawn. We survived through it, but it was not our intention to have the grant withdrawn. The intention

had been to use the money to do what we wanted to do. We hoped, of course, that people would come along with us. It didn't quite happen; so be it.

There is a third notion that comes out of the story and it is the one which is dearest to my heart. It is the moment when the Gods turn round to the sons of Bharata and say that you are exiled to ply your trade amongst mere mortals as perpetual outsiders. Now why this is so obviously important to me is that it is precisely my situation as a person, let alone a theatre person. Look at what I have in front of me. Essentially I am the outsider simply by the tinge of my colour. That is not to say that there's a chip on my shoulder, but that is the fact of modern England. Modern England is characterised by certain kinds of opposing forces, certain kinds of fences. One of the fences is of colour, specifically of coloured immigrants or their descendants. That is a reality which is more gross, more profound, than I'd hoped would be the case. When we grew up, in the sense of beginning to do our theatre, the inspiration for it was certainly racism. It was the killing of a young Sikh boy in Southall in West London, a predominantly Asian area. A seventeen-year-old boy was killed. At the time the founders of the company were nowhere near Southall; we were all over the place. But each one of us in our different places reacted in the same way. 'But for the grace of god, there go I.' He was not killed because he was Gurdip Singh Chaggar. He was killed because he was a Paki and we could substitute ourselves for that. Any one of us could have been in that situation. That mixture of anger and of trying to understand what's happened and of trying to say something, led us to make our theatre. But there was also hope that this may well be a generational thing; after all we were the first generation of immigrants. 'This can't carry on, it can't last.' To my horror I have to accept that, if anything, it has accelerated.

When I hear of sixty-year-old men, shopkeepers in South Wales, being dragged out of their shop and clubbed with iron bars to the point where they're senseless, when I hear of a seventeen-year-old Bengali boy in London being beaten and kicked so badly that his scalp hangs off his skull, I wonder what is happening. I certainly have to accept that the opposition of colour is not something that we have come to terms with. It is there; it may now be less heard of, but it is infecting us. We have to recognise it. We have to talk about it. We have to deal with it in some way; silence is not to be the legacy that we give to the next generation. The attitude of 'Well, let's not talk about it', what Walpole called 'Let sleeping dogs lie', will not resolve this particular kind of problem for this particular relationship. It is a fraught one.

Within that, I say to myself, 'Okay, I accept the fact the I am an outsider', but an outsider with a certain kind of ambivalence: I speak like anyone else speaks, I've been through the same system. I can be on the inside, but I'm also aware of the fact that I never will be. What is the virtue of being an outsider in the work that I'm doing as a theatre person? Precisely that a theatre person is part of no society. We cannot afford to be part of any society, if we are to have any critical perspective on it. All that I've said in terms of white society I can say equally of Asian society. I can be empathetic, I am a part of that society and yet apart from it.

These are all paradoxes which are vestiges of my Indianness which still exists. Indian thought is riddled with paradoxes. There is no God, there is only you. It's in that paradoxical sense that I use the term outsider. I know I'm apart from society, and yet I'm also a part of the society. That's the only way in which I can refract. I can talk about things which maybe others don't find interesting, or maybe don't wish to look at. And that feeds into the nature of the work.

Recently the most common characteristic of our work has been the adaptations that we've done. Or rather the dialogue that we have initiated with the classics of the Western stage: Gogol, Molière, Shakespeare and soon Rostand. For us it was a very important development to take something which was known within the theatre-going community, or the theatre-going public of this country: an iconic text, which one must not question is a text. Molière is a playwright. If I was to say, 'We are going to do Kalidas', most people will say, 'Who?' And then I have to explain that he's a playwright and he comes from the classical period of India, by that time everyone's got bored stiff. So I say, 'Molière', and they say, 'Okay, we'll book you.' Fine if that's the case, but what Molière? Whose Molière?

The first Molière that we worked on was *Tartuffe*. One of my interests has been always to do background research, not just on the play itself, but the playwright and his times. Partly because I'm trying to think of equivalences. Doing the research I realised Molière's whole background was in a touring company. That's great, so is ours; we are also a touring company. Molière eventually ended up at Louis XIV's court. And I thought, 'That's brilliant. Look what's happened to us. Here I've been part of this touring company and now I'm going to be at the National Theatre; if that's not the King's court, what else is?' Molière's touring work was heavily influenced by *Commedia dell'arte* which is a kind of terribly irreverent folk form using movement, music and masks. What about a folk form from India which has exactly the same characteristics, using acrobatics, music and masks? So that began one type of journey. But during this

285

JATINDER
VERMA

I came across a set of letters written by a man called François Bernier, a contemporary compatriot of Molière. They knew each other at college before Bernier became one of those great European travellers of the seventeenth, eighteenth, and nineteenth centuries. He would go around all the different parts of the world and write about these weird and exotic places he'd been to. And he just happened to be in India at the time when one emperor was dying and another one was replacing him. An emperor who happened to be more or less the equivalent of Louis XIV. He wrote back a number of letters about India and about the various people that he encountered there. One letter was most memorable, he was referring to a group of people called fakirs who are wandering beggars: holy men who can still be seen all over the place. You've got to give money to them or food or something. Now Bernier wrote that these fakirs were all over the place. 'Heaven help the family that does not give them a good welcome, even though everyone in the family knows they have eyes only for the women of the family.' This letter was written in 1667. Molière wrote *Tartuffe* precisely about the same type of person. A man who pretends at religiosity, but his eyes are firmly fixed on the wife of a man called Orgon whose house and wealth he also wants to take.

My point is not to say that *Tartuffe* was inspired by India. It is simply to say that there are connections; for me it bears the road into the play. I set the whole play in India at an equivalent period to the writing of *Tartuffe*, when an emperor, much like Louis XIV, was pursuing a religious policy as opposed to a social policy. And so that meant having turned it completely so that it becomes, in effect, an Indian play. We have to look upon it in another way. We have to look upon it from different eyes; we have to look upon it from the eyes of seeing Asian performers on stage. One of my most memorable reminiscences of the time at the National was that whenever the play began I would never fail to hear people saying 'This is Molière? I thought we had come to see Molière', and they would open their programmes and say, 'No, they are all Indian names.' The first sight that greeted them was this bunch of darkies, beautifully costumed, terribly lush, coming out to the strains of some Eastern flute and speaking in Urdu, which of course devastated people: 'What the hell are they saying? Indeed, are they saying anything?'

Then the whole thing would get blown away, because we realised that we can take people up to a certain point in this alienation, but then we have to create some sort of commonality. The commonality was achieved by doing translations in the midst of the play from the Urdu to the English. The question became how do you translate? How do you say, 'This is a translation'? We picked on the best device

that was available, because that's the device by which we are seen: Peter Sellers. The line that made the translation was a very simple one. The actress had a beautiful command of English and could have said, 'That was a translation.' So she did it like Peter Sellers. And everybody suddenly went, 'Oh my God. What are they doing? Are they laughing at themselves? Are they laughing at me? What's happening?' But it cracked the ice and so then people would begin to come along with us.

That play offers a view of what I mean by the outsider; it is an ambivalent position. It has offered me a way of looking upon how I am to present my work and really try to initiate what I think is the heart of any theatre dialogue. You cannot have a dialogue by agreeing with each other. If we constantly agree with each other then one of us will think the other one is a jerk or a moron, or is doing something to wind the other up. We're not going to progress. If you disagree with me then there's a possibility of us progressing. One can't take that too far because one can easily say let's fight each other; I don't think there's any particular progress in fighting. But that's where this notion of the outsider is central in terms of the work. The ambivalence of the outsider initiates and provokes a dialogue. There is no point in having a piece of theatre if all it does is just reconfirm all of us in our certainties. Today we're living in a world which is far from certain.

There is another sense in which the outsider is quite germane to my own experience. Tara Arts has been a touring company for twenty years and for the foreseeable future will remain so. One of the joys of being a touring company has been that we have had no home. This is partly my immigrant background, because I've had to travel. I came here; I had no choice. As a result, I'm conscious that nothing in my life will ever recover what I have lost. The most central thing I have lost is a sense of home. It's a very powerful word. Had I remained in Africa I don't think I'd have even thought about home, but I know that is something that is no longer mine; it will never be part of my life. Along with that of course I have lost what one could call a culture – a huge and ridiculous term which can be captured in a small sound. It's a sound which I can just make, but which I know is increasingly going. The sound doesn't exist in English. In fact it doesn't appear in most European languages and only exists in Indian languages. It will constantly come out. In the losing of that sound an entire world will disappear. A world of literature, a world of poems, a world of music, a world of song. I'm conscious that that is slipping away and that it is inevitable. There's nothing really that'll stop that. Re-learning the language is not necessarily going to stop it, because the context no longer exists.

However, I also firmly believe that it is only because I am so conscious of what I have lost, and what I'm losing, that I'm equally conscious of what I have gained. If you have not lost anything, you have no idea of what you have gained. To me that is how I would also equate our own situation as a touring company. We have no home. We therefore know a lot of the virtues of not having a home.

There's no community in terms of audience because each time it's like pitching your tent and trying desperately to attract some people to come and see your work. Each time you're building over and over again. If you had a building you could settle down and there are lots of other things you could do. But we haven't a building and we are not likely to have one. I think in many ways that has kept us in touch with the nature of theatre.

The axiom of theatre is that it is not television or film. You cannot rewind, you cannot fast forward. If a mistake happens on stage, you live with it. If a line has gone or you've invented a new move, it's part of the performance. It'll not be repeated. But when you look at the work of repertory companies, indeed when we reflect on our own work when we've stayed in one building for three to four weeks, you realise that there's a fine line after which you are on auto-pilot. You're doing the same scene, you know where the laughs are coming, or you know where the points are coming and that's all that you are going for. That is not theatre. Theatre must always be living in that dangerous moment of the unexpected; quite how is this audience going to respond? Is it indeed going to respond at all? Probably it won't; we've had experiences where people have just fallen asleep. What do you do in that situation? You've got to go through those two hours; how do you wake this person up? You keep on saying to yourself in the midst of the show, 'Why do people come to the theatre to go to sleep? Haven't they got a home to sleep in?' You've got to do something, you've got to move in some way. Only by touring do you constantly keep coming up with these challenges of the 'liveness' of what is theatre. Today's audience is different from yesterday's simply because yesterday we were in London and today we are in Manchester.

As far as I'm concerned that's the only way to keep in touch with the nature of theatre. The space changes, time and time again, and how you work within the space changes you. We may have rehearsed within one space, configured the play in one way. That same design placed somewhere else makes a mockery of whatever you are creating. So you have to re-invent: re-find a relationship with that space and with those people.

Sometimes we have been amazed. A few years ago I did a production called *Heer-Ranjha* which is the Indian version of *Romeo and*

Juliet. It's a kind of folk epic. In the play there was a substantial amount of Punjabi, including jokes in Punjabi. I expected that in the urban areas there was likely to be a response, in that there would be some members of the audience who would understand Punjabi and would therefore be able to access it, but there would be other members of the audience who wouldn't and that's fine. That is the nature of multiculturalism; we have amidst us a group of people, or types of people, who we don't understand. We get angry and irritated and so on and so forth, but at the same time find some ways of living with it.

But we also had a gig in Buxton, Derbyshire, and I thought the audience would probably appreciate it as an exotic spectacle. I was totally amazed by that audience. It was a vast space; 150 people turned up and they all turned up again the following day for the second performance. They sent letters to us while we were on tour. I was amazed that they were responding to the Punjabi jokes. This was extraordinary; they were reading the Punjabi. Talking to them it was quite clear none of them knew any Punjabi; none of them knew any other language than English. How did they respond to Punjabi? How did they know what was a joke? It was simply because, having no preconceptions, having no darkies amidst their midst, they responded to a piece of theatre. They responded to the tones, rhythm and action of the actors to give them meaning. They weren't relying on the spoken word. It was the clearest demonstration I could have ever asked for, of how to get meaning out of a performance. These people simply had that one amazing gift: they were prepared to be open. In that openness they received and they responded.

Those are extraordinary moments, when you realise that coming in as an outsider, suddenly you've established new insiders. That community of people, that particular audience of 150 and the twelve of us who were on the stage, we were the new city at that time. Of course later on we might disagree but at that point we were enriched. They were enriched because they got something quite alien, and we were enriched because we had not expected anything like that from them. We realised that it is possible to communicate; it is possible to go beyond the barriers of foreigners.

In that sense touring has been axiomatic. I firmly believe that although there are great temptations to move into a building – I might even succumb to one of those temptations at some point – something will die when we stop touring. What will die will be the heart of the theatre. No doubt we will be doing great shows and attracting lots of audiences, but we'll be missing the danger which is implicit in every show of every touring performance: the danger of not knowing quite what is going to happen.

289

◆

JATINDER
VERMA

That same sort of ambivalence is something which is quite naturally part of myself: of who I am. Being an Asian makes me also English. I'm not English and I have learnt over the past two years to stop saying British. This is England; Britain is something else. I am all too aware how English I am and in what senses I am English, particularly when I am overseas and particularly when I'm in India.

But I'm equally also aware that I am not quite English. Hence I've come up with the term to describe the spoken text of our work: Binglish. It raises a laugh, because it doesn't quite sound English and that seems to me perfect. It's the right concept both to articulate my position and also what is actually happening to the English language.

We require a genius. The last genius we had was in the sixteenth century, a very similar period in history and his name was Shakespeare. The period was similar in that it was a period of enormous diversity, great uncertainties, great collisions of languages and different ways of speaking. Out of that arose this genius who invented words, an entire vocabulary, which we now consider the pinnacle of all achievements. If we were just to find a way of being like Martians and go into any city in England and listen to the English language that is being spoken, we'd be amazed at the variety and the richness that's happening around us, and how it's changed.

Just think about food. When I came here, twenty-six years ago, and went out to eat, my diet was restricted essentially to shepherd's pie and fish and chips since I couldn't afford to go into the better restaurants where they have steaks and stuff. Now I don't need to go out to experience the world's cuisine; I can just go down to my local supermarket and pick it up, and we all do that. It's amazing how familiar we have become with the samosas and the chop suey, the biriyanis and the pizzas and the tortillas and all the rest of it. That familiarity also means, whether we are aware or unaware of it, that they've become part of our vocabulary. This was brought home to me in one of our productions. At one point some character was interrupted by someone he did not want to be interrupted by and he turned round to him and said, 'Why must you forever be a bone in the kebab.' This is from a Hindustani phrase which literally means 'stick in the mud' and which I adapted to form a part of the text. By the audience responses I knew that they had picked up exactly the same imagery as a Hindi audience would pick up in Hindi. They knew what a kebab is and if there's a bone in the kebab it's not a particularly tasty kebab. With a whole other vocabulary, we are acquiring other kinds of sensibilities as well. We need playwrights who can tap this and create the emerging language.

AUDIENCE QUESTION 1 You said that once you stop being a touring company that the heart of the theatre will die. Is that not underestimating your actors and your audience in relying on an actual physical space to bring a new dynamic to theatre?

VERMA No, I didn't mean it in the sense that that's the only thing I rely upon. To put it simply, the people of Manchester are different from the people of London. If all I was doing was sitting in London, I could not expect to have a diverse audience coming to my theatre. It is our job to go to the audiences. Those audiences, in their different spaces, are the most important ingredient, and every space has its own local history. People might have associated that space with a dance, so they come with a particular notion of what they will want to see. You go to another space, like the one in Derbyshire which was an opera house, and people come into that space expecting to see something spectacular. Each space has its own history and you can't be unaware of that, and that's part of the pot of considerations that you take along with you as you're touring. But what makes a space, of course, is the people. And they are the most vital ingredient.

AUDIENCE QUESTION 2 I'm aware from reading and listening to the radio that Indian or Asian culture can last for hours. One song I was listening to lasted for about three hours. British audiences at home nip out every half an hour for a cup of tea; in the theatre they nip out every three-quarters of an hour and run to the bar. How does an Asian audience sustain twelve hours of acting?

VERMA In that particular example that you've given of the lady singing it's even more profound than that. The song would probably have consisted of no more than two lines – a meditation on two lines. The whole concept of Indian music is radically different from Western music. Western music seeks to achieve the universe in quantity: in the number of notes that goes across. Indian music is similar to William Blake's idea of the universe in a grain of sand. It's the endless permutations within one or one and a half notes.

There's a particular mindset which can still do that today. In terms of India, there's a whole range of things available. In the countryside you can still see a play which will last the whole night, and that's just one scene. There is a sense of time which is different. In Northern Indian languages the same word for tomorrow is also the word for yesterday: *kull*. So one has no notion of what we would have here of past, present and future. There is only the present, which has sort of extensions.

Having said all these vaguely mystical and philosophical things, the fact is that India today is experiencing exactly what you've said; if a show lasts for more than forty-five minutes, then let's throw

tomatoes. This is to do with MTV and a technologically advanced society.

This new sense of time is infecting everyone. Several years ago I met up with a master of a particular art form in South India who was about eighty-seven, and I could not resist asking him for demonstrations of various aspects of his art. We discovered that we had one classical playwright whom we liked in common. He had a thirty-year career performing this particular playwright, doing his plays over several days. I couldn't resist asking him if there was a difference between when he first started performing and his latter years. What was in the back of my mind was that there is this impression of traditional Indian classical theatre as being rigid. We've all heard stories of actors who have trained over twenty years to do one role and then they keep that for the rest of their lives and these plays are unchanging. I always thought there was something wrong about this notion; it can't be true. So I asked him about his experience and he cited a particular scene by this playwright. The hero dies and there's a funeral with a huge procession which eventually leads to the cremation grounds. He said, 'Thirty years ago when I began I would spend five hours detailing that funeral, all the different people there; those who liked the man, those who didn't like him. The children who were using the occasion as a celebration rather than as a funeral; all the myriad details, the smells, the scents of the flowers, the colour of the sky, and my audience would be with me. In the latter end of my career I went through that in five minutes, because I knew that no-one has got the time to spend watching me detailing those characters. They are now influenced by television and film. So I cut it all down to just the action moments and forget about the elaborate philosophical discourses, or lyrical passages. I can still retain my art, but I can make that choice. And that's something that I'm having to do not as a pre-planned exercise; it was something that came as a result of watching a particular audience and realising they were not there with me. So these are liberties that I can take.' That's one way of realising that in India the same thing is happening in terms of time, but also the story has another lesson about the notion of an unchanging Indian theatre. Even within its strictures it was possible to change, but there were limits within which it occurred.

AUDIENCE QUESTION 3 Where are your actors drawn from?

VERMA The last one was from here, Manchester University Drama Department! A number have come from drama schools, a number have drifted into the theatre, rather like we did. Those of us who founded the company had nothing more than a passionate interest in the theatre. We were quite prepared to copy everyone who we

thought was better than us, which was a lot of people. Unashamedly we would copy them as a way of learning. We had one thing going for us: we knew what was good and what was bad and people drifted to us. We also ran an active community theatre company, which evolved from the original company. Even when we turned professional we maintained that and though we don't have it anymore, its ramifications are now all around us. This year I've been horrified at my age because I have visited a number of places where someone suddenly spoke up and said, 'I was fifteen when you came to my school to speak and that's now why I'm doing drama.' I think, 'Oh, bloody hell.' But it's great that there are some Asians who are coming in to theatre.

Amongst Asians, theatre is on the fringe. The form itself is an outsider thing for Asians in this country. For most young people when they think about performance, they'll think of film. Quite obviously that is the dominant form of entertainment and video has made it even more dominant. There are very few people who would come into the theatre for itself. It is the same experience at virtually every drama school; they are now having to be much more conscious of television and film, and not of the theatre. They are in effect training students to be good at those media, because students want to come out and work in TV. It pays infinitely more than theatre ever will. And theatre is hard work. Who the hell wants to do hard work for the rest of one's life? Life is short anyway; the quicker corners one can cut the better.

But I think it is a loss, not so much that so many people are going into television and film, but that people aren't staying in the theatre long enough and getting sufficient grounding in it. People who've had their initial youthful career in television want to do theatre and are simply incapable. They're an embarrassment to be on the stage because it's a wholly different media. Whereas if they'd reversed that and gone the other way, resisted temptation at the early stages, then they may have been more versatile. They would have more opportunities available for them.

AUDIENCE QUESTION 4 Do you find it easier to get attention by using Asian, European or English plays?

VERMA It goes beyond that. The fact of us is sometimes attention enough. It's amazing that we can go to various places and people still say to us 'My God I thought you were a dance group'. Or 'Do you do this for a living?'. There's already a provocative air surrounding us. Working, or having a discourse, with European plays has amplified that to an extent. With the Indian plays there's no surprise element: they're Indians so naturally they do Indian plays. Whenever we have done Indian plays the provocation has been more

one-off. The audience discovers a writer who could handle themes which are similar to themes that we know of.

Now it's much more a question of what play do I want to do? For 1996, for example, I've got two plays in mind, both of which I desperately want to do and both of which I will do. One is a new play written by an Indian called Girish Karnad whose play revolves around the story I began with today. What he's done is created the story underneath the story. It's a tremendous play about modernity, about the place of religion, about theatre. Alongside that there is another one which is by David Rudkin called *The Saxon Shore*, which is set in fourth century BC Britain. The Saxons were, of course, the new immigrants and it's all set along Hadrian's wall. So the Saxons are on one side of the wall and the Celts are on the other. The whole play is a theatrical poem about integration and confrontation. How do these immigrants come to terms with the natives and vice versa? We've recently had a discussion and we're very eager to do the play without changing its setting in any way. But I want to have Asians play Saxons. Why not Anglo-Saxons? We may not be Anglos but we certainly are Saxons.

AUDIENCE QUESTION 5 You were talking about being an Indian in England and I wonder whether that sense of being an outsider came from being an Indian in Africa?

VERMA Very astute. I think you are absolutely right. I lived through a period which also witnessed independence. My first sight of the Duke of Edinburgh was in Nairobi at midnight in his white costume and plumed hat, bringing the flag down.

In Kenya, we lived an extreme form of apartheid. In our city there was the Indian area, there was the African area and there was the English area. We never went into each other's areas, so these were entirely independent. We had our schooling, hospitals, houses, in the same area. The only place where we all met was in the market place in the centre of town. That kept on up to 1964. Then independence came and things began to change.

I've always been conscious that as a result we were more Indian than Indians, rather like when I first went to New Zealand and there was a sense of England of the fifties. It always happens with any kind of immigrant group; you take whatever you knew at the time was your culture and you try and hold on to it and transplant it to another place. You don't realise that in some senses it ossifies; it distorts. To an extent that was the case in East Africa.

There were lots of institutions around which were sustaining a sense of another place. I'd never been to India, neither had my immediate family. My father had left India at the age of seventeen

and never went back. Yet the stories and the geography of India, particularly the Ganges, had, and still has, a greater emotive pull than any physical feature of Africa. Of late I have come to worry that there's something wrong with me, that I have no real attachment to Africa. It sort of passed by. Yet the generation above me, who were our parents, are deeply attached to Africa as opposed to India.

AUDIENCE QUESTION 6 You seem to suggest that English society has regressed in terms of its willingness to accept other cultures, and particularly perhaps Asian culture. Doesn't your example of Derbyshire suggest that the opposite may actually be the case? Certain people are far more willing than ever before to be interested and engaged by theatre of other cultures and other places?

VERMA I think that there are no certainties one way or the other. Every period will always bear witness to that, even in the height of the Holocaust, or the partition in India. At the height of the cruelty of one group to another, there are stories replete of help and understanding.

I do feel nevertheless that one difference between twenty years ago and today is that now we seem to talk less about race. In the seventies and up to the late eighties, race as a subject was part of public discourse. It was in the newspapers, it was in the media. It isn't any longer and that is dangerous. I'm convinced that there's some sort of self-censorship going on and that we get things coming out in dribs and drabs which are much more extreme. We should talk about it; otherwise we are paying lip service to multiculturalism and it'll rebound on us badly, because we will have not really understood each other. Understanding is to realise that apart from colour of skin, possible tastes, little emotional hangovers and memories, we are similar people.

AUDIENCE QUESTION 7 Do you not think that because it's less in the public debate, that there is less of a problem?

VERMA Let's look at it in terms of the theatre. What I've seen is that integrated casting is now not a peculiarity or even worthy of note: it's become quite common. So in that sense we can certainly say that the theatre has advanced. Fifteen, twenty years ago it was an issue. I don't deny that this is a kind of advance, but what is the nature of that advance and on whose terms? Often when we talk about multiculturalism we have a sense that it means 'be like me, accede to my demands'. We certainly do not mean by it a parody of culture.

A good example of that was Trevor Nunn's production of *Timon of Athens* at the beginning of the nineties at the Young Vic. It was a very good modern dress production about this particular man and his rapaciousness. Trevor Nunn had an Asian actor in the cast; he's

been saying for some time that we have got to reflect our contemporary society in our casts. However Nunn's production was very much in the RSC mode. Primarily the language that was spoken was the kind of RSC received pronunciation. In the cast he had people like David Suchet, a Lancastrian, and others who were Cornish and so forth, but you never heard any of this, because it had all been battoned down. The problem was that the Asian actor could not speak received pronunciation. His Gujarati rhythm was just too obvious. When I watched that show I thought, 'Why is he standing out? Why doesn't he just shut up?' I thought he had failed. But Nunn had also failed to look at the weakest link in his cast. Could he not hear that this guy's English was not the same? He couldn't do received pronunciation. Some other rhythm was coming in. Had he paid proper attention to the weakest link in his cast, he could have turned round to all of his cast and said, 'Bugger this received pronunciation. Look, you're from Manchester, give me some Mancunian.' If you look at Shakespeare's language it is active and those sounds are dynamic. They are not pretty sounds and it's unfortunate that RSC tradition made them into pretty sounds; they are earthy sounds. That's why Northern Broadsides is today one of the best companies to perform Shakespeare. Don't bother going to the RSC, see Northern Broadsides and you get a far more alive experience of Shakespeare than any of this other stuff.

Why had this happened? Is it because he was a minor character? In which case why bother casting an Asian? You've made a decision, you've cast an Asian. Then take the consequences: listen to him and that might have implications on your practise. Be prepared to go that way. Who knows, you might have created quite another kind of text.

Recognise the differences and work with those with whatever cast you have, and in some way that must be reflected in the work. What we are dealing with is not so much the colour, but the underlying imagery, memory and stories that might come as a result of that difference and therefore one might actually enrich a piece of text. One could make it bad as well, but why not take the risk?

AUDIENCE QUESTION 8 How confident are you about the theatre as a medium for change, in the light of the dominance of TV. Despite the fact that you're touring are you really reaching people who could be positively affected by your experience?

VERMA If by change we mean policy change, where people have suddenly turned over a new leaf, I think that kind of revolutionary social change cannot be handled by one medium and certainly not the theatre. But I do think the theatre has this unique power of affecting people and that though it is a momentary effect, that is part

of the two hours and that effect has ripples. You can't escape this person, you can't stop the action, you can't rewind it, you can't erase that tape, it's happening in front of you in all it's glories or defects. There is a power of just being touched, or being affected. How that affects each individual then is another business. But the live image will live with you for a lot longer than any television image.

AUDIENCE QUESTION 9 Do you think that theatre still has a different form of knowledge than any of the other ways in which knowledge works?

VERMA Yes. The first dish which I experienced in England which made me feel very much at home was the Lancashire hotpot, because it seemed to me a mixture of everything. Amongst Northern Indians there is a dish called *kichri* which is much like that; it's a mixture of everything: lentils, rice and potatoes and whatever. That is what theatre is. Its uniqueness is that it is a bastard art. Literature is quite clear: it's got books. With paintings, it's quite clear that there is a purity about the art. Theatre is the only art form which is totally and utterly and fundamentally impure. It has borrowed from every art form. It takes a bit of literature, a bit of painting, a bit of sculpture, a bit of music, a bit of dance, a bit of architecture, a bit of everything really and puts it together and tosses it up like a salad. Some of the salads are good – that depends upon the producers, who sometimes come up with a concoction which is a good one to taste – and sometimes it's bloody awful. But in both cases it still remains a salad, a mixed bag of things. It is not a pure art at all. That is its greatness and it is in that sense that theatre is the fifth branch of knowledge that we need today, because we live in a world which is so riddled with impurities. It faces us all the time. What is the pure English? What is the pure Asian? God knows. What is the English state? What is the European nation? What is the American nation? All these boundaries are constantly being tossed around, more so than at any other time.

I spent last night talking to someone in Alaska. Obviously I didn't go to Alaska; I was just having a chat on the Internet on migration. We were having this discussion about migration, nationality, identity in this extraordinary space. Boundaries have collapsed, certainties are going, purities are going away and that is where I think theatre is uniquely equipped to reflect the nature of our society. It is a terribly eclectic and often contradictory society. There are stories that have come up and that are still to come that we need to tell about this society. But only this form can handle these stories. It's perfectly possible to have live action which is intercut with film on the screen. An actor can have a dialogue with someone on the

screen, but on TV and film you can't do that. You can only do it on the one flat dimension. In the midst of the play the actor can just say, 'Sod it! I've had enough, I'm dried up, I want to talk about something else.' What are you going to do? You're not going to turn around and say, 'Well, bugger off and leave.' You wait to see what's going to happen next and maybe something very interesting will happen, in which case something completely unique has been created for the day, or maybe he turns out to be even worse as a free-flowing actor. In which case you will justifiably throw things at him and demand your money back. But those are things that in no other medium can occur. It only can occur in this one.

One of the things we lack today is an ability to think in metaphor. Theatre from Eastern European countries, before the Wall came down, was forced to have to deal metaphorically and not call a spade a spade, because to do that would basically mean that they would be castrated. I'm not saying that metaphor is the only aesthetic, but that was a particular kind of language that did develop under these sorts of conditions.

The only oppression we have is the tedious sort from the Tory party. But it's not really an oppression that is doing anything more than simply aggravating us. No-one can be bothered to stand up and say, 'Shut up John Major.' No-one can be more bothered than that. It's one of the reasons we do not have a dynamic popular theatre, because there is no over-arching, clear oppression in front of us which is stopping us from doing what we want to do.

In many other sorts of societies, those which have been oppressed, there is a kind of language that emerges which is reflected in artistic forms, especially popular forms. They take on a kind of vitality, because people realise that they have to find some other means to talk about things which are terribly urgent. A means to talk about the one thing that any human being needs: hope. Our horror is that we don't think about hope because nothing is screwing us down and forcing us to think in those terms. The only hope that we think about is: 'Am I going to get my pay cheque tomorrow? Or what will I do when I can't graduate?' Or whatever else. It is quite different.

This is not an argument for war or a totalitarian government, but the experience of colonisation does do something to you. Theatre requires some kind of foil against which to perform.

ROBERT WILSON

ONCE described by Jerome Robbins as 'one of the most extraordinary creative artists of our time' (*New York Times*, 22 December 1974, p. 1), Robert Wilson has, over the past twenty-five years, forged an unprecedented career in theatre as a director-designer-performer who has, in creating hundreds of mixed media productions of staggering beauty, challenged the stability of representational art and fractured the traditional boundaries which separate theatre, opera, film and the plastic arts.

Born in Waco, Texas, on 4 October 1941, Wilson performed with the Waco Children's Theatre and the Baylor University Teenage Theatre in the mid-fifties before going on to study Business Administration at the University of Texas. Abandoning the degree course, he moved to New York in 1962 where he trained in interior design at New York's Pratt Institute, gaining a B.A. in Fine Arts in 1966. During this time he continued to work with brain-damaged children and children's theatre groups as he had done in Texas, and took part in student theatre productions as both a performer and designer. He continued his training in the visual arts by studying painting with George McNeil in Paris before serving a one-year apprenticeship with the architect Paolo Solari in Arizona. His early dance pieces presented under the auspices of the Byrd Hoffman School of Birds (the company/foundation he established in 1968 and named after a dance teacher he met in the fifties), performed in both alternative and more traditional spaces, demonstrated the influence of the 'happenings' movement, an older generation of performers and choreographers including Merce Cunningham and George Balanchine, and his fine art background. Rejecting the more conservative facets of theatre practice by emphasising the pictorial qualities of stage composition, his performance pieces in the mid-late sixties provided a kaleidoscopic fusion of stage elements: multiple spatial and temporal layers unfolding over a longer duration of time, and questioning the idolatry of the word which has dominated Western theatre since the Renaissance. Collaborating with a range of 'alternative' performers including autistic and brain-damaged children over extensive periods of time at his School of Birds, Wilson developed a number of evolving pieces including *The Life and Times of Sigmund Freud* (1969) and, more importantly, *Deafman Glance* (1970), premiered in New York in February of that year before embarking on a major European tour

where Wilson's distinctive idiosyncratic style won him a series of prizes and accolades including the Prix de la Critique Française for best foreign play. Experiments in time, form and the disjunction between word and image continued with such pieces as *KA MOUN-TAIN AND GUARDenia* (1972), lasting over 168 hours and enjoying a single performance at the Haft Tan Mountain in Shiraz, Iran, and the silent opera *The Life and Times of Joseph Stalin* (1973), which followed a brief New York run with a European and South American tour.

The acclaim generated in Europe by this production, his successive opera *A Letter for Queen Victoria* (1974) and, especially, his first collaboration with Philip Glass, *Einstein on the Beach* (1976, revived in 1984 and 1992) resulted in extensive invitations to work in the major state-subsidised European theatres where he continued to develop projects (such as *Death, Destruction and Detroit* [1979] and *Death, Destruction and Detroit II* [1987] with Berlin's Schaubühne Theatre company). He also tackled the more established repertoire, such as Strauss's *Salomé* at Milan's Teatro alla Scala (1987), *Madama Butterfly* at Paris's Opéra Bastille (1993), Bartok's *Herzog Blaubert* and Schoenberg's *Erwartung* for the Salzburg Festival (1995) and reviving Mozart's *Die Zauberflöte* (1991) for a fifth time at the Opéra Bastille in May 1995.

Throughout the eighties and nineties Wilson has enjoyed productive collaborations with prominent musicians (Laurie Anderson on *Alcestis* [1986–7], David Byrne on *the CIVIL warS: a tree is best measured when it is down/the knee plays [AMERICAN SECTION]* [1985–8] and *The Forest* [1988], and Tom Waits on *The Black Rider: The Casting of the Magic Bullets* [1991]), and playwrights (most conspicuously Heiner Müller on *the CIVIL warS: a tree is best measured when it is down [GERMAN SECTION]* and *Hamletmachine* [1986]). Although Wilson has continued his association with European theatres, the nineties have also seen him work more extensively in America, especially in his native Texas at the Alley Theatre, Houston (where he is an associate artist), and at the Houston Grand Opera where his production of Virgil Thomson and Gertrude Stein's opera *Four Saints in Three Acts* will open in 1996.

Despite his prolific work in theatre, Wilson continues to work as an installation artist, painter and sculptor. Prominent exhibitions and/or installations of his work have been seen at the Museum of Fine Arts, Boston (1991), the Centre Georges Pompidou, Paris (1991–2), the Círculo de Bellas Artes, Madrid (1992), and the Clink Street Vaults, London (1995). His prints, drawings, and sculptures are held in museums (including the New York Museum of Modern Art) and private collections around the world. He is the recipient of

numerous fellowships and awards including the Drama Desk Award for Outstanding Direction for *Deafman Glance* (1971), the Prix de la Critique du Syndicat de la Critique à Paris for *Einstein on the Beach* (1976), an Obie for the direction of *Hamletmachine* (1986), and a Golden Lion for Sculpture at the Venice Biennale for *Memory/Loss* (1993).

OTHER MAJOR PRODUCTIONS AS DIRECTOR/DESIGNER
INCLUDE

I was sitting on my patio this guy appeared I thought I was hallucinating, a play in two acts by Robert Wilson. Co-directed with Lucinda Childs. Quirk Auditorium, East Michigan University, Ypsilanti, 1977, then touring USA and Europe. Produced by Richard Barr.

Medea, an opera in five acts by Gavin Bryars and Robert Wilson, after Euripedes. Opéra de Lyon. Co-production with Théâtre des Champs-Elysées, and Opéra de Paris, 1984.

The Golden Windows by Robert Wilson. Brooklyn Academy of Music, New York, 1985.

Quartett by Heiner Müller (suggested by Choderlos de Laclos' *Les Liaisons Dangereuses*). Stuttgart Schauspiel, 1987.

Le Martyre de Saint Sébastien by Claude Debussy. Maison de la Culture de la Seine-Saint Denis, Bobigny, Paris. Co-production with Théâtre National de l'Opéra de Paris, 1988.

Doktor Faustus, an opera in three acts by Giacomo Manzoni based on the novella by Thomas Mann. Teatro alla Scala, Milan, 1989.

Alice by Robert Wilson with music by Tom Waits. Thalia Theater, Hamburg, 1993.

Hamlet a monologue adapted by Wolfgang Wiens and Robert Wilson from the play by William Shakespeare. Alley Theatre, Houston. Co-production with Change Performing Arts, Milan and the Commune di Venezia, 1995.

CRITICS ON HIS WORK

While traditional western art since the Renaissance has been obsessively single-minded, monoscopic, intensive and dialectical, Wilson's work is many-minded, multiscopic, extensive and varilectical.

(Richard Schechner, *Performance Theory*, London: Routledge, 1994, p. 219).

I never saw anything more beautiful in the world since I was born. Never never has any play come anywhere near this one, because it is at once life awake and the life of closed eyes, the confusion between everyday life and the life of each night, reality mingles with dream, all that's inexplainable in the life of a dead man ... Bob Wilson is ... surrealist through silence – it's the wedding of gesture and silence, of movement and the ineffable.

(Louis Aragon, 'An Open Letter to André Breton on Robert Wilson's *Deafman's Glance*', *Performing Arts Journal*, Spring 1976, pp. 6–7).

SIGNIFICANT BIBLIOGRAPHICAL MATERIAL

Bradby, David and Williams, David. *Directors' Theatre*. London and Hampshire: Macmillan, 1988.

Brecht, Stefan. *The Theatre of Visions: Robert Wilson. The Original Theatre of New York. From the mid-sixties to the mid-seventies, Book One.* Frankfurt: Suhrkamp, 1978.

Fairbrother, Trevor. *Robert Wilson's Vision.* Boston: Museum of Fine Arts, 1991.

Holmberg, Arthur. 'A Conversation with Robert Wilson and Heiner Müller'. *Modern Drama*, 31, No. 3, September 1988, pp. 454–58.

Holmberg, Arthur. *Robert Wilson.* Cambridge: Cambridge University Press, forthcoming.

Letzler Cole, Susan. *Directors in Rehearsal.* London and New York: Routledge, 1992.

Nelson, Craig, ed. *Robert Wilson: The Theater of Images.* New York: Harper and Row, 1984.

Shevtsova, Maria. '"Of Butterfly" and Men: Robert Wilson Directs Diana Soviero at the Paris Opéra'. *New Theatre Quarterly*, 11, No. 44, February 1995, pp. 3–11.

Shyer, Laurence. *Robert Wilson and His Collaborators.* New York: Theatre Communications Group, 1989.

'A Robert Wilson Retrospective'. *Performing Arts Journal*, No. 43, January 1993.

Robert Wilson in conversation with Ariel Goldenberg at the Opéra Bastille, Paris, 1 May 1995

GOLDENBERG How is our definition of what is radical in the theatre affected by the 'fin de siècle' conservatism that grips Europe and North America?

WILSON Artists are recording our times, and the artists are the diaries of our time. In the future this is what society will look back on as a record of our time, of what artists are saying.

GOLDENBERG Despite the crossovers between opera, theatre and dance they still remain divided art forms. Are these divisions relevant or creative in your work? Or do you see no division?

WILSON For me it's all opera and it's opera in the Latin sense of the word, in that it means work: and this means something I hear, it's something I see, it's something I smell. It includes architecture, painting, sculpture, light: all of the arts are in opera. So in a sense all of my work or works are operas, in the Latin sense of the word meaning 'opus'.

GOLDENBERG Tom Waits has described your relationship to theatre as being like 'kicking an invalid to make it walk'. Do you still have hope that theatre can recover, or is its condition terminal?

WILSON I think society will always have a theatre because it's a form where people come together to have an exchange of ideas and feel-

ings. It's something that's necessary in society, so man will always find a place for these forms.

GOLDENBERG What is the greatest abuse in contemporary theatre?

WILSON I think television.

GOLDENBERG What do you consider the least understood aspect of theatre in modern times? I suspect it is the approach to the contemporary story?

WILSON I think that we now have become, in this century, much more aware of material visually. You see in textbooks diagrams, drawings and more pictorial imagery. You see plays being performed in theatres through signs, signals, gestures and movements, so that we are developing a theatrical language with the body that can parallel the language of literature.

GOLDENBERG You defy the fragmentation of the creative artist in theatre by being director, designer, actor and illuminator of the stage. Is there any sense in which these roles are separate in your vision? If so, why?

WILSON No I see it as all one work; I'm an artist.

GOLDENBERG Your work has constantly challenged the idolatry of the word, providing a disjunction of word and image, so that the visual does not function as a mere illustration of the spoken text. Nevertheless the majority of Western directors still use the production as a means of 'illustrating' the play text. What do you find limiting about such practices?

WILSON I think that what is limited is that we have failed to develop an adequate visual book for a theatre of literature. That is not to say that words are not important, it's just to say that the visual can be also important. When I was in Shanghai two months ago, I saw a fifteen-year-old girl sing an aria for an hour and forty minutes. She had 550 different ways of moving the sleeve of her dress. She's been studying since she was three. It's a visual language that parallels the text that she has to speak or sing.

GOLDENBERG It's like the flamenco people that have never sung in their lives. Then they discover at forty that they are wonderful singers and actors and dancers and everything.

By the way, how can you explain with words the examples that you give when somebody is with you? What's interesting is to see you with an audience, and to see how you move your hands, your body and your arms. How can you say that in words without images?

WILSON It's not really something that you can explain intellectually. It's something that you have to experience.

GOLDENBERG And also it depends on your surroundings. I remember when we made a presentation last year, that everybody was hypnotised when you started explaining with a piece of paper.

WILSON With a drawing of something. Yes, it's something you experience.

GOLDENBERG You've often stated that your responsibility as an artist is to create rather than interpret.

WILSON I wouldn't say necessarily create but it's to ask questions. I feel my responsibility as an artist is not to say what something is, but to ask what it is.

GOLDENBERG Do you not feel that the creation of another text involves a degree of interpretation?

WILSON Of course, there's always interpretation. It's just that we don't insist on one point of view. There's nothing wrong in having interpretation, but we must not insist that it's the whole truth.

GOLDENBERG But is your point still the same now that you are staging *Die Zauberflöte* for the fifth time? Or have you changed something?

WILSON No it changes all the time and I think one's always changing, even if you're doing exactly the same thing, because one's experience is different. So that's why we must not close something with a fixed interpretation. You have to leave it open.

In that sense, even though you're doing the same thing every time, it's always an improvisation, because every second it will always be completely different from any other second.

GOLDENBERG You are turning more and more to written texts – *King Lear, Die Zauberflöte* – you've even mentioned an interest in staging *Our Town* and Mamet's work. What attracts you to such texts?

WILSON I try to do works that contradict one another. Doing something like David Mamet or *Our Town* is very different than doing Shakespeare. Working with Heiner Müller is very different from William Burroughs. And I think that you sometimes say 'What is the wrong thing to do next?' and do the wrong thing. Or if you have to turn left you turn right, so that they're contradictions.

GOLDENBERG You've often worked with unorthodox actors, i.e. rock stars, autistic children, those with impaired hearing, dancers. What is the attraction of such collaborators? What do they offer that traditionally trained actors do not?

WILSON I think that what's necessary in the theatre in this form that we talked about earlier, is that ideally we allow for any voice to be heard. The people on stage represent the people in the public. They are a catalyst for the public, because anyone can come into the

auditorium to watch, be it a deaf person or blind person or whatever. The people on the stage can reflect their voices.

GOLDENBERG What is the nature of your ongoing relationship with your productions after the first public performance? When do you know you can leave?

WILSON I think that a work is never finished and I'm now doing the fifth revival of *Die Zauberflöte*. I'm still working on it: I just made changes this morning.

GOLDENBERG What do you identify as common starting points for your work in the nineties? Are they different from where you used to begin?

WILSON No, I think that I've always begun with the body. For me the body is our resource. I start with the body first.

GOLDENBERG There's no technological innovation that conditions your work? How are you preparing this show that you are doing now with Philip Glass where there will be no actors?

WILSON I sit down with Phil and I make drawings and diagrams. We talk about it and I make a form in the structure. Then I fill it in more intuitively.

GOLDENBERG But how can you consider a theatre show without actors? Why is that theatre?

WILSON It's an architectural arrangement in time and space and it's the same if you have an actor or don't have an actor. A light moves or a prop moves and it's timing, it's a construction in time and space. And that's what I think is the architecture, the construction of anything, whether it's Mozart or Wagner or Shakespeare.

GOLDENBERG But in any case there will be something or somebody on stage? The musicians will be on stage?

WILSON The musicians are in the orchestra pit. No-one's on stage: only objects moving and film. We're still creating it.

GOLDENBERG Is there any sense in which personal nationality is still relevant in your work? Or indeed any sense in which you are still a Texan after so many years working primarily in Europe?

WILSON I think that the landscape of Texas is in all my work and that although I work primarily in Europe that it's very American. When I'm in America people say it's more European. But I think definitely it's a work by an American and it's by someone who was born in Texas and grew up in that landscape.

GOLDENBERG What do you take from Europe back to the Americas and vice versa?

WILSON I think that I've been fortunate enough to work in the Far East, in the Middle East, in Europe, in Latin America, and North America, and I've borrowed things from all these cultures. I see influences from Japan or influences of working in Persia; from having worked in Berlin at the Schaubühne, or from working in Munich at the Kammerspiele with a great actor, or having met Madeleine Renaud in Paris, or having worked with Montserrat Caballé at La Scala. It's a whole conglomeration.

GOLDENBERG A couple of years ago you worked with students at the University of Texas on Genet's *The Balcony*. You've recently purchased the Western Union Laboratory in Water Mill, Long Island, and are planning to turn it into a interdisciplinary centre for theatre research. Do either of these ventures reflect the way you think actors/directors should be trained? What's the Water Mill exactly for you? What do you want to make from the Water Mill?

WILSON The Water Mill for me is a place in the United States – I've worked mostly in Europe and outside of the United States. It's in New York where I live. It's a bit like having my own studio and my own home. I've chosen to put this studio in a natural environment. It's fifteen minutes from the ocean; it's a forest of trees; it's potato fields; it's farming land around.

GOLDENBERG And how are you going to open it to other people? Are you going to invite other people to be there with you?

WILSON I see it as a place where people who normally wouldn't come together, could meet to work, to explore new ideas. It could be an anthropologist; it could be someone who's in an institution; it could be someone who feels outside of the arts. Then we'll see what happens when we get together. I don't see it as a place where work is going to be formed, or presented, but it's work where ideas are developed. It's a kind of think tank or laboratory space.

GOLDENBERG Do you believe directors can be 'trained'?

WILSON I think it's difficult to teach anything and I think the learning process is a mystery. We don't know anything about it. At best maybe we can encourage people.

GOLDENBERG Is there any way, in that sense, to systematise teaching?

WILSON I think there are skills that one can learn and one learns skills. I learned certain skills even just watching Visconti lighting for a few days. I learned there was a whole new world for me, the way he was thinking about light, the way he was painting with light. I learned from Strehler certain techniques that he uses in lighting, back lighting. So I think that there are skills which we can learn.

GOLDENBERG But do you also believe in academic ways of learning?

WILSON I do. I think that there's no one way to learn. Some people learn best through a structured environment, some people learn best from a free environment and it's very different with each individual. There's no one way; and we still don't know anything about the creative process.

GOLDENBERG That's true. That's what's wrong in our society, because everybody's getting specialised now, even a doctor or a lawyer.

What would you most like to change or introduce into an actor's training?

WILSON I think the thing that I find often with an actor that's lacking is a sense of the uniqueness of his own body – if he's thin or fat, or if he's tall or short, or whatever. You have to learn your own body, the weight of your own body.

GOLDENBERG How to put your body in the space, and how you fight against the force of gravity.

WILSON Your body is a resource. Socrates said that 'the baby was born knowing everything, it's the uncovering of the knowledge that's the learning process'. And I think that for me, in my work, that's very formal and it's usually in the beginning very close to structure; but at the same time it's filled in in a very free and emotional way. It's not rational.

EPILOGUE
'Six hemispheres in search of ...'

❖

PETER BROOK
JONATHAN MILLER
AND OLIVER SACKS

in conversation at Contact Theatre,
Manchester, 20 March 1994

MILLER I think we should ask Peter what it was that actually drew him to *The Man Who Mistook His Wife for a Hat* in order to dramatise it and why it was that he chose that as material to be staged and represented rather than read?

SACKS Represented – *re*presented in a completely different way.

BROOK To answer that one has to go right back to the beginning: what is the purpose of doing anything whatsoever on a stage in front of other people, why do it at all? There are so many other things that one can do in life, so why have anything to do whatsoever with this curious form that has existed over many thousands of years, of getting up and doing something which is not what you would normally be doing, in front of other people. If you go right back to the simplest level you see that playing something is almost as natural for all human beings as eating, breathing, making love. One of our basic activities is speaking, relating, playing out. So what in fact is one playing out? Children and grown-ups are always playing out human situations so that something about them can come out more clearly. I see that as I am speaking I can't help moving my hands. Why? I want to make something more vivid than the words carry. I start playing it outwards, so that it can be clearer – that's the only reason. Let's go from that starting point of early mankind and skip three to five thousand years to why we're doing *The Man Who* today.

I've noticed over the years that continually I'm either drawn to very great classics or to a need to get away from what one calls a classic and make something of our life today. Broadly speaking, I've avoided present-day playwrights, and this is a subject of reproach. 'You believe in new plays, yes, you like going to see new plays, yes, why don't you do new plays, why is it that you are doing a play of Shakespeare, why are you doing an old opera?' There's a reason. And the reason, I think, first came into sharp light when we did something a number of years ago that for all of those concerned directly relates to this, which was a play called *The Ik*. The reason was very simple. The present-day writer – with exceptions of course – whether of novels, or particularly of theatre, seems to lack a certain tremendous compassionate generosity that the very great authors of other periods have had, of which Shakespeare is the finest example. That compassionate generosity enables the author to enter fully into totally contradictory human beings. Every actor who's ever played

in Shakespeare knows that any one of his five thousand or more characters is a fully resolved human being. In *King John*, the actor playing James Gurney (the shortest character in Shakespeare, isn't that right?), who I think either does nothing, or only says one single word, still finds a real human being there, otherwise he wouldn't have been called James Gurney. And this is the essence of playwriting, that if you have two people and they're sharing something through dialogue, each one of them is equally, fully, objectively alive. For some series of complex, social, psychological reasons, the capacity to be generous in that way has shrunk with perhaps the general shrinking of humanity on so many levels in our time. An author's point of view or an author's style is never what really matters, so to do a play out of admiration and respect for the author is not something that has interested me – only the potential quality of the human material behind it. Because of this, when we had the possibility in our Centre in Paris of working freely and finding our own material, having done Shakespeare's *Timon of Athens*, which was the first play that we did in our theatre in Paris, the next thing we did was to take a book about a small African tribe in process of dying, not only dying of starvation, but their entire culture, their entire way of life, their entire beliefs and civilisation being gradually eaten away by starvation. This theme seemed so close to us that I was immediately drawn to it. Furthermore this was a book not by a novelist or a playwright, but by an anthropologist. Colin Turnbull was an unusual anthropologist. Instead of preserving a correct objective distance, he allowed himself to be not only a good observer, but also a human being who, against all the rules of scientific impartiality, is deeply concerned and caught up in each one of the people that he's observing, so his documents gave material that in working on them had something of that richness of real playwriting.

Time goes by. I get to know Oliver. I read one book after another of his until reading the *The Man Who Mistook His Wife for a Hat*, immediately I had the same feeling. Here there's no narrative; it's a series of human cases. And there is Oliver Sacks, like a nineteenth-century novelist, with the richness of compassion for the widest range of human beings that one finds in nineteenth-century writing from Dickens, Zola, Balzac through to the Russian novelists. He observes as a doctor, so the material is very precisely observed and not invented, for he does not search for a personal thumbprint to impose on the way people speak, on the way they behave. The behaviour is simply there, and the behaviour is not coldly observed: it's observed with insight because there is a rich, unknown human continent behind the outside form. For this reason, it seemed to be

for us (and I can say 'us' all the time because the whole of this work has been totally collaborative between a very small group of people), totally dramatic theatre – raw material to make the sort of theatre where you play out for other people something that draws you into what's hidden within. That's why we turn to Oliver.

SACKS My own favourite reading as a boy was probably nineteenth-century explorers and scientific travellers: Wallace, Bates, Darwin. I do feel a little bit like an anthropologist myself. Jonathan and I have known one another for . . .

MILLER Forty-eight years

SACKS So this isn't the first time we have appeared together. We met as biology pupils at school. Although the term 'life forms' sounds 'Star Trekky' and all that, I think I am fundamentally interested in forms of life, and in particular the lives and biographies of people under extreme conditions of one sort or another (usually, but not necessarily, illness). So, for example, I know an astronaut and I've been very interested in the nature of her experience when removed from the universal of gravitation, and how it compares to the experience of patients with no sensation from the neck down or whatever, like the 'disembodied lady' I wrote about in *The Man Who Mistook His Wife for a Hat*. When I was working with the *Awakenings* patients, I would sometimes get the feeling that I was a sort of observatory looking at a post-encephalitic planet, but I also really lived with these patients and shared their lives as much as possible: this doubleness was constantly there. I suppose, in a sense, there is also a sort of natural theatre in the clinical encounter and the desire to know how an organism and a nervous system works, which one can learn partly by experiment, and partly by observing the often tragic natural experiment seeing functions removed or imposed on people. That for me has always been associated with some sort of novelistic wish to feel from the inside what life is like if one is blind or Tourettic or whatever. Jonathan, of course, sort of combines both of us because he is equally a neurologist and a theatre man.

MILLER Well, I'm not – I'm a neurological tourist now. I don't live as Oliver does with patients. I occasionally visit them and have had the privilege of even making a documentary film about them. But I think that what Peter and Oliver have done is valuable in its contribution towards something which is very important in the late twentieth century. There is a mood amongst neural scientists, and even amongst philosophers who have drunk too deeply at the wells of neural science, that what is characteristic of us will finally be reducible to a language which is entirely synaptic, nervous and neuro-transmitting. What I am about to criticise goes under various

titles – the famous title is 'eliminative materialism'. In other words, that we can describe what we *are* entirely in the language first of neurology, then of neuro-chemistry and finally even in the language of physics, and that we can eliminate, by means of materialism, any reference to what is disparagingly referred to as 'folk psychology'. Hoping, wishing, believing and all the stuff that we normally use to describe ourselves is what they call folk psychology, which in fact these people regard as discreditable and primitive. I am thinking of Paul and Patricia Churchland at San Diego who are prime exponents of this doctrine of eliminative materialism. They believe that it will eventually yield to and dissolve into and become replaced by (or 'reduced to' as they would say) the language of physics, and that the language in which we commonly talk about the patients' views when describing what it's like to be them, bears the same relationship to the real language of physics that flagitium and witchcraft does to the more realistic language which has now replaced it. There are a number of people, a number of philosophers and a number of neural scientists, who believe that this is nonsense and that actually there is no way you can actually eliminate the language which we normally use to discuss ourselves and that, as is shown very vividly in what Oliver wrote and what Peter did dramatically with what Oliver and others wrote, actually there is something unparaphraseable about what it's like to be one of these people.

What is so valuable about this sort of demonstration on a stage is that there is something it's like to be each of us. I'm using the phrase of the philosopher Thomas Nagel that there is something it's like to be a bat whereas there is nothing it is like to be an electron. Electrons do not have opinions about themselves and that's not because they're too small to be opinionated. It's not ontologically in their repertoire. There is something it is like to be a bat, to be a frog, to be us, to be damaged, to be mutilated, to be bereft or short of cognitive mental and conscious capabilities. And what is important about a book such as Oliver's and a demonstration and dramatic occasion such as Peter's, is that they once again make a bid for and stake out a claim for the irreplaceable credibility of the report from the interior of these entities for which it is true to say there is something it is like to be them. And the Churchlands can go on guzzling at the springs of neural science until they become hydroptic but they will never, ever convince anyone that there is nothing it is like to be us and that these are illusions which will eventually be replaced by the hard facts of neural science or by the hard facts of physics. Because, constituted though we are by all this stuff, and there is certainly nothing magical or mysterious, no super added material which enables us to be the sort of thing about which it's

true to say there is 'something in life to be us', nevertheless the fact that there is no magic involved in being something like that does not mean that there is nothing it is like to be us. And one of the things which is so instructive and interesting about the neurologically damaged, the bereft and the altered in some way, is not so much that it gives us an insight into how odd it is to be them, but that it turns our eyes into how very peculiar it is to be us at all and how very odd it is that something made out of something as unpromising as electrons could, when bunched together in this rather idiosyncratic way, in this rather sleazy province of the cosmos, come up with something which it is something like to be.

SACKS I sometimes think of myself as a clinical ontologist. I get different perspectives on what it is like to be, from lives which have been bereft or intruded on in various ways. I have also become very much reattracted by what used to be called neuro-physiology in our day and what is now called neuro-science, which is advancing far beyond the level of synapses and receptors to look at the complex forms of organisation and integration in the nervous system. And yet there always seems to be a doubleness – I think sometimes deaf people may express this. I don't know if the same convention exists here in England, but in America 'deaf' is sometimes spelt with a small 'd' which means hearing impaired and with a large 'D' which means member of a linguistic minority, a person with a sensibility, a perspective, a form of language and a form of community of their own, a form of life which is special and unique. Similarly, I think, Tourette's Syndrome, while it can be seen as a syndrome and a disease, must also be seen as a form of life, a mode of being. I know a number of Tourettic artists, athletes, actors who can somehow achieve a very intriguing creative amalgamation between themselves and their Tourette's. I remember one such young man who once wrote to me about having a 'Tourettised soul'. But equally his Tourette's had become individualised and personalised. If one has had Tourette's from the age of four, its nature and yours can interweave in the most complex way. And so I am somehow caught in the doubleness which Jonathan speaks of. Interestingly, although biology and psychology are often so reductive now, I think physics is perhaps going in the opposite direction, becoming less reductive, more sensitive to the large-scale organisations of the world – this is well brought out in complexity theory and chaos theory.

MILLER But you see I rather dread the search in some of the new physics for the yearning for the larger transcendental truths. People leap into Hawking – and I use it as a verb as well as a name. It's a way of securing some sort of validation for the idea that there's more to

it than we know; a vague sense of what William James referred to as 'a tender-minded sense of oneness' and that way madness lies or that way idiocy lies. I'm rather frightened of that sort of physics for it seems, in a rather incohate way, to validate some sort of idea that it's all much more vibrant than we are aware of. I am actually committed to the idea of hard science and that is what will produce the results in the nervous system, not because we're going to find ourselves in a black hole equivalent of string theory which will explain how it is and why it is that something like that can be conscious. I don't think we'll ever know that because, as my friend Colin McGinn, a philosopher, says, there is cognitive closure. There's something about us being the sort of thing that we are which probably prevents us from finding out how it is that consciousness can in fact be dependent upon matter, although it's obviously not dependent on anything else. But being in the midst of this tangle rules out the possibility of finding out why it is that this sort of thing can be conscious.

BROOK But what's so interesting in that is one sees that the brain cannot jump out of its own skull and that in the end every single form of observation and theory that is structured by the brain carries the limitation of the brain, for obviously there is something beyond which this instrument cannot become aware of by using the tools of this instrument. For that reason I would agree with Jonathan. When physics becomes less reductionist, it is actually becoming hyper-reductionist. In the end it is saying there is nothing in human experience that can't be enclosed by the tools of words, observations, data, formulae, diagrams, programs, and so on. The bigger the catalogue of tools, the more life is reduced to being no more than what these tools can do. But if eventually you look at the total mystery – because the unknown by its very nature is a mystery – and the total enigma of human existence, and if you put 'limited cognitive closure' in front of that, you see that whatever the circle of cognitive possibility, there is always an unknown. Now, if there is always an unknown, one doesn't have to even begin to take sides on whether that unknown is vibrant or non-vibrant, because it is very simply unknown.

Now, to relate this directly to what can happen on a stage. There is one possibility that belongs uniquely to the theatre, and that is the possibility of entering into the area that lies in between the words, in the tiny spaces between the words. You can even tell a good playwright from a bad playwright in this way. A play comes through the post, you open it. If it says 'Brenda, hesitating, stifling back her tears with a half smile', you think this isn't as good as an Elizabethan

writer who just says what she says and leaves it at that. Why? Because the practical Elizabethan writer working day after day with actors doesn't waste time, he recognises that however long his description, it doesn't begin to touch on what the actor can make crystal clear in a flash. An actor is all the time entering into these infinitesimal gaps between the most compact words. And why is this? It's because there is one basic area, out of which all theatre comes and to which it returns, which is silence. This was the secret of the Ancient Greek theatre where you had fifty thousand people watching and listening with an attention where you could hear a pin drop. That silence has such intensity that a single word or a single gesture carries with it both the full richness of its meaning and also the overtones of the unknown. I think that it's just there that one can see eventually the necessity, the constant human need to recapture the experience that Jonathan was speaking about – the experience of being. Certainly this experience can be exchanged, shared, made meaningful in a book – provided a talented writer has the particular capacity through a certain tension, pressure, excitement and energy in his words to set up a silence within the reader in which overtones can be felt. But an experience with a different taste and another intensity is there when those same experiences take place in front of other people.

SACKS I think there's a fundamental thing here about the density of reality and the likeness. Recently, I've been seeing a very gifted Parkinsonian artist and a very articulate one as well. The more I see of him, the more I feel that everything I've written about Parkinsonism is as thin as inter-stellar gas. I feel that I would need thirty pages to describe how this man rises from a chair, that one would need a thousand pages to describe an average day and that wouldn't be enough, nothing would be enough, no description is enough for the reality of what it is like for him. Perhaps that reality, however, can be shown easily on the stage. This may be beside the point and a silly 'neurological' thing to say, but I'm not actually sure whether one can *act* Parkinsonism without *being* Parkinsonian, although I sometimes think that being Parkinsonian is, in a sense, being *compelled* to act Parkinsonian. Sometimes when people take L-dopa or listen to music they suddenly change and they say 'I have forgotten what it is like to be Parkinsonian' or 'Now I remember what it's like to be non-Parkinsonian'. I think transformations like this perhaps would be much easier on the stage.

MILLER Oliver talks about the problem of the thousands of words which would be necessary to describe the movement of a Parkinsonian. I agree with that to some extent, of course, but the reason for that is that so much effort goes into that first movement,

so that a thousand words seems to fill the space between the desire to do something and the effort, and then the thwarted fulfilment of it. What is valuable about the clinical is that it concentrates attention on something which requires just as much as a thousand words and that is the extraordinary capability of something to which we do not have to apply any effort at all. I can reach out toward and pick up that glass without crushing the glass in my hand as I do it, and when I raise the glass to my lips and drain the water, as the glass gets lighter it doesn't levitate in my hand. That seems to me to be something requiring a thousand words just as much as the abnormal condition. I know that Peter, quite rightly I think, has a feeling that if you become didactic or explanatory on the stage you destroy what is valuable in these extraordinary tense silences and the tense showingness of the stage. Nevertheless, I feel it is in the act of showing and explaining what is exhibited, what is exemplified by the disorder, that you are shown the connection between it and what it is like to lift a glass effortlessly to your lips.

SACKS This particular example has been dealt with by all three of us in the patient whom I wrote about under the title of 'The Disembodied Lady' who had lost all sensation from the neck down and in fact was in danger of crushing the glass or dropping it at any moment and had to make extraordinarily elaborate calculations not to do so. Jonathan filmed her and something very similar was shown by Peter yesterday with the man without proprioception who, when his attention was diverted for a moment, did crush the . . .

MILLER But the case, for example, of the person with the unilateral neglect and the inability to identify his own face as part of himself, illustrates something which is frightfully important and which directs attention towards the notion of the body image. And it is more tellingly made if it is done in conjunction with the notion, for example, of the phantom limb. You have here two complementary disorders – one is someone who in the absence of a limb feels that they have got one, and here is someone else who in the presence of a limb is unaware of the fact that they've got it. There is a third case which is that we all exist inside a phantom. The phantom limb happens to be occupied by a real one in the same way that a limb fits into a stocking. But I believe that the case of neglect is only, as it were, intelligible or is finally legible to an audience, if demonstrated in relationship to what it exemplifies, which is the case of the body image. The body image is such an intoxicatingly interesting idea that in some sense I don't agree with Peter that explanation cannot be dramatic. There are moments in which the explications can in fact be part of the . . .

BROOK I don't think one rules out the other. I think that this really is an argument case by case. In the *Marat/Sade*, for example, there is one level on which Peter Weiss sets up an extraordinary, powerful, very emotional and striking image that is carrying as a super-structure two closely argued points of view – between Marat and the Marquis de Sade. Then there are various middle levels. And so

at almost one and the same moment the audience is being pushed in different directions, shaken emotionally, shaken physically and then given food for thought. And that is, I think, one very legitimate

pattern which you're referring to. Sometimes it's really related to the power of silence. Sometimes an impression is made more acute by somebody putting the question in words – like the question of what is a brain? What does it mean to be, to have the sensation of being alive within this great envelope? And in other cases the questions are better put through the other language of theatre, which is the language of action and silence, the language of suggestion.

When we rehearsed *The Man Who*, during the whole period of rehearsal we didn't trouble much with explanations. In the book there are indeed many extremely eloquently written passages that develop the implication of these cases, and we tried using them; we had somebody speaking to the audience and giving these as pointers and sub-titles. Eventually we rejected all of this. It seemed very clear that because the physical actions of the patients are so unexpected, and so vivid, the elimination of anything that's an explanation keeps them sharper than if they're helped and put into place by any form of verbal pinpointing. Many people say that they feel at the end of the play a powerful need to carry away a question for themselves. They do not wish for this to be explained away, they wanted to stay with a very personal interrogation, about what it means to have what we all take for granted – an incredibly complex mystery which, for want of a better word, we call a brain.

MILLER But it's not just taking for granted the highly complex thing called a brain, because I think one could get through life very interestingly without ever knowing that you had one at all. One should go away with the extremely complex thing of what it is like to, as it were, have the raw feeling of a body, and the raw feeling – whether or not it happens to be executable by and implemented by a brain – of what it's like to be able to pick up a glass of water without having to think about it. That seems to me to be so centrally mysterious and is a question asked by philosophers, and I think very dramatically. Danto, for example, suggests that we could make a distinction between a basic and a mediated action, by which he means those actions for which there is an intelligible answer to the question

'What do you have to do in order to do it?' – such as, 'What do you have to do in order to start your car?' The intelligible reply is that you turn the ignition. And what do you have to do to turn the ignition? You press the key this way with the thumb and index finger. But if someone then says to you, 'What do you have to do to turn your wrist clockwise?', there is no answer that you can give to such a question. We can get through life being thoroughly engaged without knowing anything about the complexities of the brain and have our time cut out thinking simply about how is it that we can segregate these actions into those things for which we can give an intelligible answer – 'How do you do it?' – and those things for which there is not even a conceivable answer to 'How do you do it?'.

BROOK So what, therefore, is the most valuable element that can take one through life? It would seem to me that the constantly renewed sense of awe in front of the mystery is more important and needs constantly to be renewed beyond anything else. So one comes back to the question of silence. What is more vital to enable one to reach the next moment in life with a heightened sense of awareness? The inner silence that comes of being in front of a mystery? Or the awakening of a next question through the first question being made more precise? I don't think they're quite the same.

MILLER I agree with that. I think this has been a temperamental difference ultimately. For example, I happen to know, as all of us do, that whatever it is that does 'glass picking up' is a sort of squidgy envelope enclosing stuff which contracts and which is dividable up into named muscles. But we can get up from our seats, pick up glasses, without knowing, 'Oh oh! Get the biceps going darling', or 'You're completely screwed if you want to pick up that glass!'. All of that can be done, all of that apparatus gets put into action without my having to think about it, nor is there any moment in which I was given tuition on the biceps. And it seems to me that there are complicated and interesting questions to be asked without penetrating the brain, simply about the details of doing something normal long before the disease gets to us and stops us from doing it.

SACKS But one of the things that Nietsche says is that suffering disease doesn't make us better, it makes us more profound. It makes us question, he says, more severely, more deeply than ever before. Now, if the wonderful, inaccessible, unconscious, automatic fluency is interfered with by disease, you may then actually have to think about it, find some clumsy, conscious sort of approximation as to how to do it, which is exactly how it may be with the person who has lost all sensation and who has to monitor the movement. One way of approaching the wonder of the taken-for-granted is to see what

happens when it can't be taken for granted. Jonathan wrote a book called *The Body in Question* which was a title I wanted to use myself. Normally the body is never in question, but under certain physiological conditions, like the one I describe in *A Leg to Stand On* (Jonathan himself suggested this title), a part of the body may become acutely in question. I agree that body image is the start of consciousness; it is the model for memory, and it is at the centre of our being. An insect has no body image, but I think that all vertebrates have a body image. To find part of the body missing and not under one's command is the most problematic thing in the world. It is the point at which Wittgenstein starts his book on Certainty. He says right at the start, 'If you can say "Here is one hand" does it make sense to doubt it?' I have often wondered whether this has some connection with the fact that his brother had had an arm amputated but had an extremely efficient phantom arm there. The 'Leg' book was originally 300,000 words long, but was cut very much shorter. I despaired of being able to say what it was like. Right at the end in a recent edition I suggest that the reader actually read the book under spinal anaesthesia – then and only then will he be able to know what I am talking about.

MILLER You see. There's a hidden agenda here. Oliver and I are both children of doctors who were trained by the person who really introduced the notion of the body image. Henry Head – a wonderfully named neurologist beaten only by Russell Brain, another neurologist – invented the notion of the body schemer, the body image, and it is something which is intensely dramatic. One of the things I was questioning is that there are clusters of reportable and dramatisable things which if presented together do force attention upon this most mysterious thing called the body image, of which Dickens had a very vague or perhaps very acute awareness. He actually quotes it in a joke in *Hard Times* when Mrs Gradgrind, that vague, woolly-minded and woolly-imaged person, is on her death bed. Her daughter says to her, 'Mother do you have a pain?', to which she replies, 'There is a pain somewhere in the room but I cannot be certain that I have got it.' Why do we laugh? We laugh because intuitively we know that pains can't get into the room outside the body and yet in some interesting and paradoxical way pains are not in the body in the way that, for example, a steel pin in my hip if I broke my hip is in my hip; they're in my body image. I remember saying this in *The Body in Question:* that if I have a ring on my finger, and I say that my hand is on the table, it somehow makes sense to say that my ring is on the table, but if I have a pain in my hand and my hand is on the table and I say the pain is on the table, it sounds nonsensical.

There are these paradoxes which enforce the awe, the interest, the peculiar spiteful 'what is it that it is like to be inside this thing?'.

BROOK What is very interesting this afternoon is that on the one hand we have three completely different experiences and different temperaments and different points of view, but behind that there is something on which we're in total agreement. I think this is very important because the point on which we're in agreement is that it's impossible to separate the vast from the specific. If one remains in the vast, one's in woolliness, and the great danger, whether it's of poets, philosophers, or present-day physicists, is that there is a moment when the vastness becomes so vague that it loses its credibility and one has to constantly tie this with the specific. On the other hand, anybody who knows he's right up against specifics becomes reductionist, pedantic and eliminates the mystery. So listening to you just now, using this example of the glass of water, I couldn't fail to follow another association, which is that if you ask anybody what a Buddhist is looking for, most sceptical people, most non-Buddhists seeing a Buddhist sitting in meditation will say that he's looking for Nirvana, after which the next person will give a smile because that's an even bigger vague piece of woolliness. It's clear that Nirvana is something that's made of pure wool, a cloud. But in Zen monasteries the most difficult and specific daily disciplines exist. The ultimate aim that has been expressed by countless people who have been through this enormous, rigorous and exacting discipline, is to be able, quite simply, to carry a glass of water or a bowl of tea – to be able to take a bowl of tea, to carry it and set it down fully alive to every aspect of the experience. Thus the whole relationship which includes body image and transcends body image reaches the point where the specific is there every second that the body is breathing, that the cells are buzzing, that the muscles are moving – that the whole structure is aware to itself. The sense of weight and weightlessness are both there – the purpose, the aim, the direction, all the observable aspects of a moment of human life are there – but the discipline, the rigorous discipline involving in it a constant space created by a respect for what can only be perceived through silence, is there at the same time. If that can be reached, nothing more is needed than to take a glass of water and walk with it to the point where you put it down. That is the highest point that a human body can reach.

SACKS Luria, the great neuro-psychologist, used to like to quote an aphorism, I think from Marx, that 'science is the ascent to the concrete'. This is a very paradoxical, interesting sort of formulation which one feels might apply to art but not science. Coming back to

the water and body image, the construction of the body involves also the construction of space and time. Just as you can't say there is a pain somewhere in the room, when I had my experience of subjectively losing the leg, I couldn't say 'Well, don't worry, there is a leg somewhere', because the very idea of a possible place for the leg disappeared. Nor could I quite say to myself 'Well, I had a leg before, I will get it back some time', because the sense of its place in time had disappeared. The leg disappeared taking its place and its time with it. And you see something fundamental here about the constitution of being. I think this was very beautifully brought out in the play.

MILLER Presumably the reason why you lose space and time if you lose limbs is that you lose implementability. Space and time are simply dimensions in which exist the possibilities of changing the direction that we wish to go in, or imagining a transformation which we, as agents, can bring about. If we lose them, we are reduced to the state of pure patient, and it is very interesting that that is the word we use for those who suffer. We are en route to a passivity which preempts any possibility of an action taking place and being agents, but agency is what creates time. Time is that dimension along which we as agents can perpetrate things, along which things will occur because we can do something. As mere spectators, probably time and space wouldn't exist, because there would be no theatre in which, in either space or time, things could occur, because things occurring must be seen to be things which we can make to occur. And making things happen is the prototype of all that happens.

BROOK That's where perception can give us an evidence that nothing else can give. We can't in any rational way escape from time, other than through a form of perception.

MILLER No, I put it the other way. Although I disagree with him on almost every other point, I feel that Merleau Ponty, who derived a lot of his ideas from Hughlings Jackson (who Oliver and I both admire very much), had the idea that prior to perception is action. Without action, perception is almost inconceivable, and the world comes to us as a result of our taking action in it; we encounter the world and something happens. Stop the eye from moving and a spot on a contact lens, a reflected spot on a contact lens, disappears. The eye must move in order to see. Jackson said, 'We cannot feel anything without moving our hands.' Actually perception is probably secondary to action, but action is where perception really arrives.

BROOK But that's a local view; that's a Western-conditioned, philosophical view. You wouldn't say that five thousand years of tes-

timony of human experience over the whole world would confirm that. I think you would find that the quality of what's perceived in a moment of total non-action is something that has been constantly witnessed and expressed (in the way that what's non-verbal can be expressed in music), through many great civilisations and traditions. One has to temper the observation of the Western-conditioned philosophical and scientific mind, which is a little corner of human experience, very local in time.

MILLER But the extraordinary power of the inactive or the motority inactive, of someone in the meditative position, is because it is seen by contrast to what is prior to all perception, which is in fact activity; we are movers and doers. And it is by the strenuous act of abstaining from that thing which is our nature, which is to act upon the world and have the world act back upon us as a result of our action, that we perceive. Therefore it is by contrast to that, that these acts of spectacular abstention from action actually bring us to a clear sense of what it's like to be conscious at all.

BROOK Or you could say that the dialectic is permanently created – without giving preference to either – between doing/not doing, life and death, that these are permanent interchanging aspects of the same experience, each of which is equally legitimate.

MILLER I do believe that really, finally, what we have is a motor perceptual circle. This is after all what would be the proprioception to the patient. What is it that makes proprioception so extraordinary? Proprioception – perhaps we need to explain what it is. It is the sense which comes from the muscles as a result of the action of muscles and of the resistance to action taken by muscles; the little spring-loaded devices inside our muscles which record the degree of stretch in them. They will record nothing unless there is an action which we take which puts them into some sort of sensory communication with us. So that sensation comes as a result of action taken. The action taken itself produces sensation. The sensation perhaps invites further action, so that what you get is a very complicated and ceaseless reciprocity between these two. But I actually do believe that without action there is no consciousness at all.

SACKS I agree with this. I think that it is exceedingly rare for action and perception ever to stop completely, though one such very rare situation was with some of the post-encephalitic patients whom I saw. With them, in effect, consciousness didn't exist and there was a loss of being for minutes or hours or years. So, yes, I think all perception, all consciousness, is normally active. You know, three centuries ago, Leibniz used to say: 'Existence is action.'

BROOK The patient is not inactive in a fully normal state, the post-encephalitic patient is an injured organism.

SACKS He's an annihilated organism in a way.

BROOK Yes, so that that is not the same as a state of inaction achieved by the hardest work of all – going beyond action.

SACKS I agree entirely and once more to be clinical, I spoke earlier of a Parkinsonian but not post-encephalitic patient of mine, a gifted artist. He prefers to go to art galleries without his medication, because he feels his power to behold is greater, although he then can't *do* any painting. But he has not come to a complete halt, as at such times he is in some other mode of perception and activity.

AUDIENCE QUESTION 1 As theatre creators and doctors, I would like to hear from you what you notice about the healing processes in theatre for actors and for audience.

BROOK I think there's a very simple comment on that, which goes along with Jonathan saying that everything comes through action: theatre is an action in front of an audience. Because it's an action in front of the audience it can have many effects and this is a responsibility one must be aware of. You can pollute an audience. This is something which is in the widest sense of the word porno-graphic. You can cheapen the sensibility. You can make an audience more violent and lessen the potential of each individual in the audi-ence by a certain hyperspectacle. You can brutalise an audience. An audience comes into a theatre as a confused mass of fragments. Obviously, each person is different. Each person comes in with his own preoccupations and gradually what is going on is that the stage has an influence. And potentially the opposite is also true – some-thing instead of being polluted can be clarified. And the clarifica-tion, the bringing together of the fragments, the taste of unity is life-giving. This experience in itself can bring about an individual and social healing – not through the ideas that one takes away from a theatre but through what actually happens for a brief or prolonged moment when everyone together is living moments in which they're breathing and feeling together, with a finer perception, in other words, in a healthier way. And it's easier to pollute than to heal.

MILLER Yes, I'm very mystified sometimes – I really don't think about healing or anything like that when I'm working with actors or singers. I'm simply struck time and time again by the curious way in which some divine afflatus – I don't know what it is exactly and it's obviously not something super-added, it's not some sort of equivalent, spiritual transcendental equivalent of lighter fluid which is given to them – but there is some moment at which a sort of unmediated fluency comes

over a performer's movement, over their action. They do something and they know they've got it; they can't analyse it. It's like learning to ride a bike, you can't put it into words, you can't describe what it is that enables you to do it, you just do it, and suddenly it happens with a graceful, completely unmediated ballistic singleness. I use the word ballistic, because I've taken it from Kenneth Cate's description of an action for which there are not constant guidances. It just simply is. You choose the trajectory without having any open choice and it happens beautifully and excellently to the end; you simply do what you have to do. You can use the word 'cure' or 'heal', but it certainly leaves the performer, the protagonist, at the end with a sense of exhilarated consummation, that something has happened, some sort of performance. They just come off high at the end of the evening and say 'I don't know how I did it, I don't know what happened, but whatever it was, was done with a grace that I know, and without having to be arrogant about it, it was perfect', and they don't know how they did it and the next night they'll fall flat on their faces. They're not healed. In a sense what happens is that we're all permanent patients in this condition; being alive at all is actually to be a patient, and there are these absolutely unsolicited remissions in our condition.

SACKS Sometimes literally with patients you can see a temporary wholing or healing (these are etymologically the same word). Sometimes very disorganised people with retardation or dementia or autism, may be able to take on a role and act, and in so doing can take on the coherence and the unity of an active identity, if only for a little while. Acting, like music, can sometimes sort of bring a very damaged person into a brief unity which could not otherwise be imagined of them. I've seen this very beautifully recently with a young autistic man.

MILLER Sometimes these healings take place as a result of something which is properly called a crutch or a prop. For example, actors might be disabled throughout the entire rehearsal period. Some sort of almost orthopaedic disability overtakes them; they cannot actually do the person they are meant to be. And then someone will say 'I'm going to give you a handkerchief', and quite suddenly their body image is extended into the handkerchief in the way that Henry James described the body image of the woman extending into the plume on her hat. A person who was orthopaedically disabled at one moment, can express and do something with the handkerchief, or with a pencil, and a fluency overtakes them.

SACKS But didn't you show this yourself so beautifully in your film, how Ivan the Parkinsonian achieves fluency with an object of some sort?

MILLER Yes, or else by also doing that other thing of pretending not to do what he was actually trying to do. There is a way in which you can actually become fluent by cheating yourself into thinking that: 'I'm not trying to do what I can't do, I'll try and as it were ricochet off doing something which is incidental to what I'm trying to do. And in the course of concentrating my mind on the incidental I will fluently execute the intended.' Ivan did in fact do this. There's a long scene in this film where this man tries to have a meal of porridge, tries to get some sugar into the porridge. In no way can he address himself to the spoon. He is simply unable to get himself to the spoon, but he fluently moved his arm gracefully to the radiator and ricocheted off it. Why was it that he was not disabled by the intention to ricochet himself off the radiator?

BROOK This leads back to what's essentially the relation with theatre. Theatre shows more than anything else how everything is temperate and that anything like that is miraculous but that it's a moment, and it doesn't mean it can happen the next moment. But it has happened.

MILLER But they are remissions rather than healings.

AUDIENCE QUESTION 2 Dr Sacks, what is your success rate with your patients and with people's language disorders? Are you able to help them? Because I've got the impression from *The Man Who* that the man with the language disorder was not able to be helped.

SACKS I don't quite know how one might define 'success' or 'healing' when seeing the sort of patients I work with in chronic disease hospitals. Most neurological conditions – well many of them at least – are irreversible. But even with these I think that all sorts of adaptations and rehabilitations can sometimes be achieved. Now here I may not be much more than a catalyst or a guide. For example, I had one patient, and wrote about him, an artist who suffered from a head injury and suddenly lost all colour perception. This at first was experienced as a catastrophic situation; he felt he could not go on as an artist or a man. Basically, he asked, 'Can you fix me? Can you fix it?' And I said, 'I don't think I can fix it, but something may come back.' In the meantime, I encouraged him to recreate himself and his sensibility in his art in terms of what he had, in terms of his now black and white or grey vision, although I think he himself was moving in that direction anyhow. He then became a wonderfully successful black and white artist. Everyone remarked on the originality and power in these late paintings. No-one knew, or very few people knew, of the physiological antecedents of this. I don't know whether this was success or not. I think of myself chiefly as helping adaptations, as searching, with patients, for a new organisation and way of life.

MILLER We wish to see and visualise the notion of the patient in relation to all sorts of other constraints upon existence and being. The question should be asked of Terry Waite or the people who live in Sarajevo as well. There are all sorts of ways in which people do manage to negotiate full forms of life without necessarily becoming a great black and white artist. But there is a way – with the help of a colleague, a friend, a spouse, a member of family, a community – that enables there to be a way of being, although profoundly disordered and disabled. Imagine what it must be like, for example, to be disabled by the constant fear of being shelled or being confined to a room in which you're shackled to a radiator. All these are forms of being in which curtailments upon action, curtailments upon the possibility of fulfilment are given to you. And yet there are people who come out of all these experiences of one form or another, from all different types of shacklings and curtailments, having said that they are more human as a result rather than less human as a result. It is visited upon very few people to live in this way, and we have to be careful not to romanticise the damaged and the curtailed and the exiled and the orphaned and the besieged, and think that they are necessarily ennobled by the experience. Anyone who has done any medicine at all knows there are people who are permanently impoverished, alienated, reduced and totally smashed by what happened and that there is no healing. One of the things we have to confront is that we are in a condition in which we are all, in some senses, on this raft of the Medusa and that there are people on that raft who will die and be eaten alive by the others, and some who will be able to leave a record of ennoblement and of some sort of transcending of their condition. There's nothing particularly romantic about the ill or the sick. There's just something very noble about those in reduced circumstances who make something rather remarkable of themselves in spite of it all.

AUDIENCE QUESTION 3 Is some of your treatment improvisation, Dr Sacks? When you're not sure how to help these people, do you just improvise and see what works?

SACKS Yes, a lot has to be improvised because whatever the universals, everyone is different. Occasionally students will come to see my 'methods', what they encounter is less 'method' than continual improvisation.

MILLER This is the same as Peter and myself as directors – there's no method. It's community. What happens is that you live with people and find out that you get on well with them and it's nice to work knowing that you're paid to do this sort of thing.

AUDIENCE QUESTION 4 I want to ask something following on from what Dr Miller was saying about whether these people are impoverished

or ennobled, and it's about part of the book that the play didn't address where Dr Sacks describes the twins who can find prime numbers beyond what computers at that time could calculate, and the man who could draw incredibly minutely detailed representations of fauna. I wonder if in dealing with these people who you called 'simple', whether you felt that there was, in the process of acquiring consciousness abilities that we have to accumulate in order to live a normal life, a kind of floor and a ceiling in our perceptions, in our consciousness, which these people were perhaps able to break through upwards and downwards, and if that is true whether theatre is possibly a means for us as audiences to, in turn, break through the floor and the ceiling?

SACKS A very interesting question which is about paradoxes in a way. I'm working at the moment with another savant artist, at least a fabulous drawer. It's really extraordinary seeing prodigious skills, including reproductive, mimetic and computational skills, sometimes in the near absence of what one might call personality or mind of much substance. One of these savants is able to do a jigsaw puzzle of 500 pieces in three minutes, unless you put them face down and then he'll do it in ninety seconds. The face, the meaning, actually interferes with him. He has this prodigious ability to see abstract patterns and how they go together. But mostly he is *below* the level of meaning here. One doesn't know how apocryphal this description is, but Caspar Hauser, a mute boy of sixteen or so, was found in the streets of Heidelberg in 1828 with a notice saying that he had been chained in a cellar isolated from human contact since the age of three. At first Caspar Hauser was described as having prodigious powers of perception and perceptual memory, and then when he acquired language, he lost these. Whether this shows in very acute form what may happen in the third or fourth year anyhow I don't know. I feel Jonathan's discomfort as I say this, but there may be some impulse in me, as it were, to romanticise the primitive. Certainly the mind has developed, and cognition has developed, through many different stages and it may be that some of the earlier ones, although they get incorporated into later ones, also get somewhat reduced.

MILLER Oliver's right in the sense that I do have an intuitive suspicion. I have two intuitive suspicions – one is of the noble savage and one is of the talented patient, and I think that they are cognate creatures of the post-enlightenment imagination. The idea that in some way there are capabilities in the human soul which are suppressed by the subsequent acquisition of cognitive capability I actually think is nonsense. The reason why Raphael was such a wonderful draughtsman was that he was intelligent and what is so startling

about the drawings of the disabled and these cognitively disabled is that it's amazing that they can do it at all but not that they ever draw well. Their drawings are aridly pedantic rather than having that amazing, graceful fluency that the really able artist does. It is odd that they draw in the way that they do, but also there is an idiosyncratic peculiarity about the drawing of the autistic. They are strangely pedantic drawings as opposed to the drawings of the cognitively total person, like Watteau for example, who no matter what angle he uses, is promiscuously creative with the drawings. Whereas, I think, in the drawings that I've seen of the autistic, they are strangely dry, constricted productions which don't illustrate a view of the world at all.

BROOK There is another very clear question. Imagine a tenth-rate orchestra. In this tenth-rate orchestra the brass is so aggressive and plays so loud that you never hear the strings. One day the brass don't turn up for the concert and suddenly the audience hear the strings for the first time. It is very thrilling. That doesn't alter the fact that it's a second-rate orchestra. And the other question, which is the opposite side to what we are discussing, is what brings that group of musicians (when the brass and the strings are there) to the next point, which is of being more and more and more acutely attuned so that all those parts play together beyond what seem to be the natural level for that orchestra in its natural state.

MILLER And the way in which it is facilitated often by the presence of one person – the conductor.

BROOK Yes, and how does that happen? I think that one must, all the time, look at the question of the negative, the neglect, the deficit, the 'what's missing', with the implied question (which is always there within the so-called normal state that we're all in which is of the fiftieth-rate orchestra) – what factors can bring what we have in us to a finer point?

MILLER Well, it's very interesting. The notion of the second- or third-rate orchestra is very intriguing because you see orchestras that have been traditionally registered as being second-rate and a conductor of a particularly charismatic sort – Klaus Kleiber is one like this – will arrive with an orchestra which has really been rebellious, difficult, awkward and mediocre and within three days a transcendental transformation occurs under this rather undemonstrative baton of his and I don't know what it is, and that is very mysterious.

BROOK And does it persist?

MILLER Well, no it tails off, and somehow, something's got to be there in a collective action.

AUDIENCE QUESTION 5 The play is called *The Man Who* and in the presentation there are no women represented on the stage. I was just very interested to know why that choice was taken, what you were exploring in fact.

BROOK Forgive me, but it's a false question. Because it carries with it all sorts of unspoken implications which are condemned in the word 'represented'. When you do any piece of theatre, you cast with available means what seems most appropriate. Now, over the years in our Centre, we've had project after project with men, with women, with people from all parts of the world, and never have we tried to represent any artificial social pattern. In this case, we worked for a long time, we needed a very small group. Within that group there were four people who were very, very strongly touched and motivated by it and they try as best they can to represent everyone – old people, young people, men and women. But the play is not about gender differences. The play is about certain conditions and not about the relationship between men and women. We worked with our group; we are making no political statement and don't feel the need for political excuses to be made.

The interesting thing is that by simplifying in the theatre very mysteriously the essential emerges. Recently I saw Declan Donnellan's production of *As You Like It* with an all-male cast and very young Rosalind. And this didn't in any way make a statement that for all time women must be abolished from the stage. It was a single event, in which something that I've never seen in that play, a certain very fine quality of relation between Rosalind and Orlando, came through passionately. And I think one mustn't look farther. Today it's too easy to see actions in terms of statements and I would have been deeply ashamed if we had introduced a token woman just to show that we were on the right side of the fence in relation to all the women that we respect. We don't feel the need to call it 'The Man and Woman Who'.

SACKS Essential certainly does not mean literal. Everything in *The Man Who* moved me immensely, but one of the things that moved me most was the Japanese man who heard Japanese music and Japanese songs. Now, as I tell it in *The Man Who Mistook His Wife for a Hat* and as it was, it was an old Irish woman, but Irishness is not of the essence, and the transposition seems to catch the whole strangeness and wonder of the episode.

MILLER Doesn't this have a bearing on something roughly fundamental to the theatre which Peter has enabled all of us in the theatre to do, and that is that the notion of representational detail is not really required any more in a very large tract of theatre. In representing

something you don't necessarily have to have all parts of the representation being or having a corresponding part in what is represented. Someone comes on to a stage, be it a man, woman or a child, and they simply are a cypher for what is being demonstrated about the case, whether it's a clinical case or some sort of human case. For example, I'm thinking of Trevor Nunn's *Nicholas Nickleby* in which a party had a group of women sitting around in bonnets. There were at least five men with beards playing these women. At no point did anyone say, 'This is a party in which bearded women . . .' We knew immediately that the presence of the beard was to be set aside in the representational system, that it was not part of the representational system, that these were not bearded ladies at a party, but these were people representing all that was necessary to show that a party was going on.

It goes back to something which we started with at the very beginning when Peter began talking about his hand movements. We have, as we talk, a series of tiny actors that appear in this little arena in front of us, which don't look anything like any of the things that we're talking about. But in certain respects, parts of the action are representational. We say 'And then the plane came down' and the actual trajectory of the hand is all that's required in talking about the plane. The fact that my hand is so totally unlike a Boeing is beside the point. In the case of Peter's men playing the patients, their gender was, as it were, beside the point. One of the things that is interesting about the theatre in Europe – and we owe this almost entirely to Peter – is the liberation that has taken place from a scrupulously detailed and dense representational network where every part of what is on the stage must be taken to represent something in reality. Peter's work allows us now to go and do what we do with each other all the time, which is to tell stories with quasi-representational gestures and I think that these actors are quasi-representations of men and women.

AUDIENCE QUESTION 6 I wanted to go back to something Dr Miller said, which was: 'Did the audience need more explication?' As a member of the audience what I felt was that I was invited to become part of the creation of a poem, part of a series of impressions which tapped into and interrogated me on an intellectual and emotional level, and I wondered – and the question is to Peter Brook – whether you feel that there's a strong link between your ability to create that kind of work and your commitment to working collaboratively on pieces? I wonder whether that enables you to tap into the psyche of storytelling in a very particular way?

BROOK I think that we come back to silence. The most precious thing in working towards an inner collaboration from everyone is the

capacity to listen. And in listening you penetrate more deeply to meaning and the inessential falls away. But in noisy, aggressive exchanges, nothing's exchanged at all, only the surface predominates. Whatever the activity, whatever the noise, whatever manifestation there is, there can also be a quality of silence. It's a process and through it something more valuable can appear. This listening had to be there in the collaboration – not only the collaboration between ourselves, but also in the collaboration between the doctors, the patients, the many people that we could work with including Oliver when he was available. At the beginning, it seemed to me that I couldn't enter what was a completely new world for all of us without at once turning to a very good old friend, which was Jonathan Miller. I asked Jonathan to come and spend a couple of days with us when we were exploring and working, and we talked and showed and discussed various things. And, as always, there is one detail, just one thing that is more precious than anything else. Out of these thousand things that Jonathan said, one phrase was a key: this is not like what happens in an actor's normal work. Normally, a good actor magnifies, until it takes an outward form, something that's already present in his imagination. A good actor has, in the mysterious world of his imagination, all sorts of tiny threads. He doesn't have to be a violent killer who can kill out of jealousy, but he somewhere has to have the tiniest flicker of what jealousy could mean, the tiniest smell of what it can be to be so carried away that you kill. And out of that with his creative imagination he can build eventually the person who, with absolute truth, kills on stage. What Jonathan said was 'Watch out, this is different; nobody with an undamaged brain can conceive through his imagination what happens in a damaged brain'. And out of the thousands of different provocative and entertaining things that happened in those two days, that was the point which constantly illuminated the problem. In this case the actors, inspired by the whole field that Oliver had opened up, knew that their imagination could not help them. Their work had to be based on watching, listening and observing the specifics. The work had to be from the outside in, provided that as one looked at the outside, one was trying to listen to what that outside was telling. In that way, in performance we must bring about that listening in the audience, by drawing the audience's attention onto the detail of the outside as a clue to what's going on within.

MILLER This question of silence and attention, the drama of attending. You talk, quite rightly Peter, about the strange sort of tense, creative, enabling silence that the audience produces by the clear attentive listening. But the notion of shared attention is at the centre

of our being, something which has been talked about by psychologist Jerry Bruner: the idea of watching another's attention, their attention being the subject of your attention. One of the most beautiful paintings in the world is a tiny, almost neglected canvas in the Vienna Art Gallery by Taeuber of a mother peeling an apple. The mother sits there, her eyes downcast, watching, concentrating on what she is doing, and there is a table behind, and the round face of a chubby Dutch child watching. But what is that chubby Dutch child watching? She's not watching the apple being peeled, she's watching Mummy's face. And it is the act of attending to the act of mother's attention which gives that picture its curious sense of what is peculiar and special about us. We are mind readers of each other. We don't just simply watch each other's activities; we watch each other's outward signs of our opinions about our activities. And then what goes on in a rehearsal is the capacity to share not merely attention but the attention of each other's attention. And that's what creates this strange thing that happens in the theatre. I'm paraphrasing what for me, what for you, is this extraordinary thing of silence. It's the silence of listening to another person's mind.

CONTRIBUTORS

◆

CHRISTOPHER BARRON is the director of the Brighton Festival. He was formerly Director of Manchester's City of Drama (1994) and Associate Director of the Edinburgh Festival.

MICHAEL BILLINGTON has been drama critic of the *Guardian* since 1971. He is also a regular broadcaster on radio and television arts programmes and the author of several books including studies of the work of Alan Ayckbourn and Tom Stoppard and the authorised biography of Peggy Ashcroft. A collection of his reviews has been published under the title *One Night Stands*. Currently he is working on a book about Harold Pinter for Faber and Faber.

MARIA M. DELGADO is a lecturer in Drama Studies in the Department of English and History at the Manchester Metropolitan University. She is editor of *Valle-Inclán Plays: One* (London: Methuen, 1993) and the forthcoming edition of *Contemporary Theatre Review* entitled 'Spanish Theatre 1920–95: Strategies in Protest and Imagination'. She is author of numerous articles on Hispanic and British theatre, and Editor of the forthcoming Methuen series on Directors. For the last two years she has been co-programmer of the Manchester Spanish Film Festival.

ARIEL GOLDENBERG is Director of MC Bobigny 93. He was previously Director of the Munich and Madrid theatre festivals.

PAUL HERITAGE is a lecturer in Drama at the University of Manchester where he is also co-director of the Theatre in Prisons and Probation Research and Development Centre. Formerly a director with The Gay Sweatshop Theatre Company, he is Chair of *It's Queer Up North*, for which he has just co-edited a live art catalogue on performance and sexualities. He is the author of articles on Shakespeare, contemporary British and Brazilian theatre, AIDS and culture, etc. In association with The British Council he has been establishing theatre programmes in Brazilian prisons since 1992.

PETER LICHTENFELS is Tutor in Acting at Manchester Metropolitan University. He is co-editor of the forthcoming edition of the Arden *Romeo and Juliet*. He has been Artistic Director of the Traverse Theatre,

Edinburgh (1981–6) and Artistic Director and Chief Executive of the Leicester Haymarket Theatre (1987–91).

ELI MALKA is Director of the Union of Theatres of Europe based at the Odéon Théâtre de l'Europe, Paris.

ALISON MCALPINE is a Canadian playwright currently living in Toronto. Upcoming productions include *Still Moon on Fire*, which will premiere in the Autumn of 1996 at du Maurier Theatre, Harbourfront, Toronto.

OLIVER SACKS is a practising neurologist who lives in New York. He is the author of *Migraine, Awakenings, A Leg to Stand On, The Man Who Mistook his Wife for a Hat, Seeing Voices* and *An Anthropologist on Mars*.

PAUL TAYLOR is theatre critic of the *Independent*.

ROBIN THORNBER is a journalist. He has been writing about theatre in the north of England for the *Guardian* newspaper since 1967. He also edits a monthly magazine, ... *the buzz* ... covering the arts outside London.

ROD WOODEN's plays include *Your Home in the West* (Mobil Playwriting Competition winner 1990, Manchester Royal Exchange 1991, Steppenwolf Theatre Chicago, 1991, John Whiting Award, 1992), *High Brave Boy* ('Off the RSC' Fringe Festival 1992), *Anti/Gone* for the RSC Education Department (The Other Place, Stratford upon Avon 1992), a new version of *Moby Dick* for the RSC (The Other Place 1993, London Barbican 1994), and *Smoke* (Manchester Royal Exchange 1993, Amsterdam Toneelschool 1994). He has recently completed *Each Way and Move*, a commission for the Royal Court.

INDEX

\diamondsuit